PINK CHIMNEYS

PINK CHIMNEYS

A NOVEL OF NINETEENTH-CENTURY MAINE

by Ardeana Hamlin

BOOKMARCS PUBLISHING

BANGOR, MAINE 2007

12 11 10 09 08 07 1 2 3 4 5

The paper used in this publication meets the minimum requirements of the American National Standard for Information Sciences—Permanence of Paper for Printed Library Materials, ANSI z39.48-1984. Printed and bound in the United States of America.

Book design by Michael Alpert. Cover art by Collette King.

ISBN: 0-9712469-3-9
 978-0-9712469-3-5

TABLE OF CONTENTS

A gallery of photographs showing nineteenth-century
Penobscot Valley houses follows the Introduction

For Janet Elliott Danforth, for believing
and Cathryn Piippo Marquez, for caring

INTRODUCTION

When I reread *Pink Chimneys* recently I was struck by the words that conclude the prologue: ". . . the ghosts of the past are persistent. Eventually, they find a voice, and tell their story." I shivered, knowing what Ardeana Hamlin was talking about. She has been a medium for the ghosts of Bangor much to the delight of thousands of readers for two decades. Never having believed much in spirits, I have, nevertheless, since immersing myself in Bangor history, heard those same ghosts, or perhaps their offspring, muttering about the price of lumber or the arrival of ice in the Penobscot or the prevalence of bad liquor and loose women in the dives on Exchange Street. The Penobscot River was a mighty thoroughfare on which lumber and ice were carried to points around the world on thousands of sailing ships that returned with hundreds of thousands of tons of coal to power the new factories and railroads and to heat the mansions of the lumber barons and other rich men who once benefitted from this frenzied activity. Their spirits and those of the Bangor Tigers and the Irish barkeeps still hang over the river on a foggy morning, and they swirl around the gravestones in Mount Hope Cemetery on the blackest of nights or, if the imagination is particularly well informed, one can see them floating up about where the lighted clock tower of Union Station used to glow. He who is blessed with imagination can still lift a glass to the old days with a few thousand grizzled loggers and sailors in a few hundred taverns from Joppa to Peppermint Row, and from the Devil's Half Acre to Paddy's

Hollow. Or he can take tea with the barons and society matrons in their mansions on Broadway, if he prefers.

Every great city has history books telling the founding date and listing the rich men and cataloguing the important events. But to capture the heart and soul of a great city, its myths and legends, its exultations and sorrows, its sins and acts of human kindness, takes a novel like *Pink Chimneys*. Hamlin collected and reglued the shards of the Bangor myth—the lumber barons and the seamen, the strong women and the whores (who are sometimes the same people), the mansions and the dives, the many-masted ships and the fancy carriages—that tower above the mundane landscape of mere history like the giant cumulus clouds in an N. C. Wyeth painting. She infused all this with the atmosphere of a frontier crowned for a few brief shining years "the lumber capital of the world." Hamlin captured the raw spirit of the place when she wrote "no one . . . knew anyone else; no one inquired too closely into one's family connections or social background. The newcomers, adventurers and opportunists who flocked to the infant town on the edge of the vast northern wilderness . . . didn't care two cents about anyone's personal pedigree. What counted was how quickly one became affluent enough to build a house like the elegant mansions already entrenched on Broadway. Bangor produced a surprising number of wealthy men and women in a very short amount of time—that this was often accomplished in less than legal ways didn't bother anyone much at all."

The reader is holding the fourth edition of *Pink Chimneys*. The first appeared in 1987, two decades ago. Most published novels don't get beyond a first edition of a few hundred copies. *Pink Chimneys* in those three previous lives has sold upwards of 20,000 copies, attesting to its popularity. Most people who walk the streets of Bangor day after day start wondering what it might have been a century or two ago. *Pink Chimneys* has addressed that curiosity for thousands. When I bought my copy in an antique shop, the sales clerk, a complete stranger, said, "That's a good book. Have you read it?" What a testimony to the quality of an out-of-print novel so many years after it was first published.

Everyone likes to know how closely a historical novel sticks to the

facts so here's a little history, but not too much. It's well known that *Pink Chimneys* is based to some extent on the life of Bangor's famous madam, Fan Jones, the Brooksville girl who was in an out of the courtroom, and even the jailhouse on at least one occasion, back in the late nineteenth and early twentieth century. She remains a shadowy figure to this day, not having kept a diary or attracted a biographer. But the loggers who arrived in Bangor's muddy streets in the spring and the river drivers who came to town a few months later were all familiar with Fan's place on Harlow Street. That's attested to in items from the police beat in the old Bangor newspapers and in the testimony from elderly folks stored at the Maine Folklife Center at the University of Maine. Stewart Holbrook in his popular 1938 history of the logger, *Holy Old Mackinaw*, presented the first vivid, if brief portrait of Fan, making her famous beyond the banks of the Penobscot River. He may have stretched things a bit, especially the part about the blue chimneys one could see from down in the river, but he captured the spirit of the place and made it and Fan immortal.

Hamlin turned Holbrook's glimpse into a universe with Fan at the center. Doing research of her own, she created a whole society of heroes and heroines and a few scoundrels around this shrewd "Fallen Woman." She put Fan in an earlier setting between 1814 and 1852 that opens with the Battle of Hampden during the War of 1812, takes readers through the days of land speculation and temperance reform and ends in a fire of biblical proportions that made me think of Bangor's great blaze of 1911, but was only one of the lesser conflagrations that periodically ripped through the city. The Fallen Woman was a powerful metaphor for our grandparents and some of our parents. This Fallen Woman, Fanny Abbott, became a force to be reckoned with, however, as she gained money and power and began to act like the powerful men around her, casting off the truly evil forces that launched her like the insidious Joshua Stetson. Real people like Gen. Samuel Veazie and Hamlin's ancestors, Gen. Jedediah Herrick and Perez Hamlin, make appearances, as well as made up characters whose lives parallel those of real people. The most memorable is Maude Richmond

Webber, a midwife modeled after the famous Dame Martha Moore Ballard of Hallowell. At times she steals the stage from Fan.

Pink Chimneys has been called a feminist novel, which is certainly the case in that it is about women asserting their strength of character in a world in which they had few rights but plenty of responsibilities, and some men were waiting to take advantage. "Women have little enough to say about what happens to them as it is. It seemed to me that I had some rights. I simply could not submit without a whimper," Maude Richmond explains to her father to justify why she took the risk of telling off a marauding British military officer during the Battle of Hamden. The book continues in that vein, with women waiting to assert themselves loudly or quietly, when the time is just right. The opening chapters explore the beliefs surrounding midwifery at the time, one of the few professions in which a woman could make a living. And the ending chapters tell how the midwife and the madam team up to do good in the moral chaos that was frontier Bangor. The center-piece for all this of course is one of those old Bangor mansions—*Pink Chimneys*—where the lives of three women become entwined in a drama of good and evil that entertains as well as informs us about what life was like in old Bangor. Hamlin told their story well.

<div align="right">

–Wayne E. Reilly
Hampden, Maine

</div>

GALLERY

Representative nineteenth-century Penobscot Valley houses

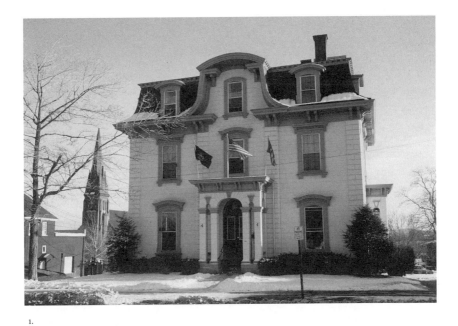

1.

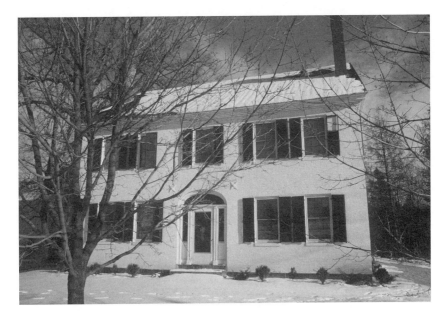

2.

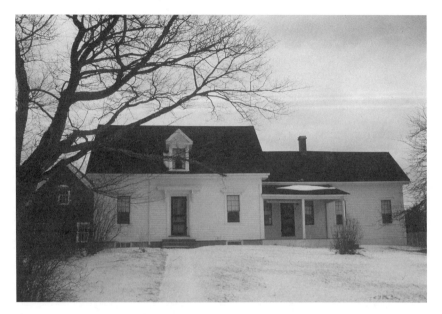

3.

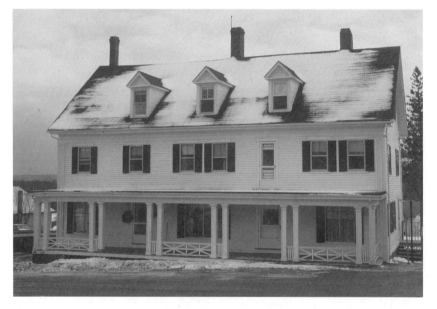

4.

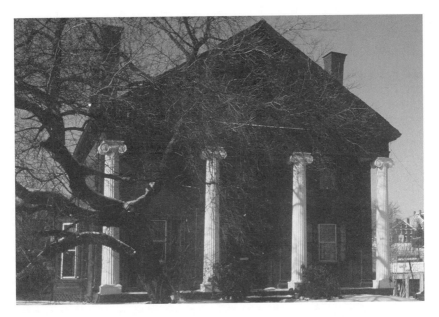

5.

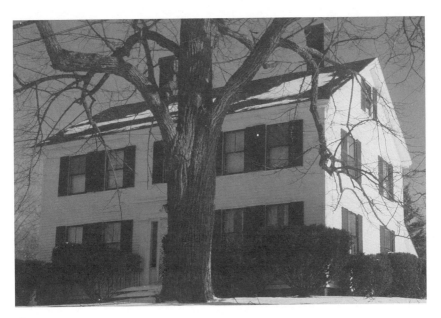

6.

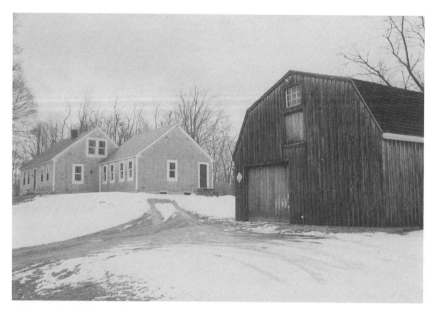

7.

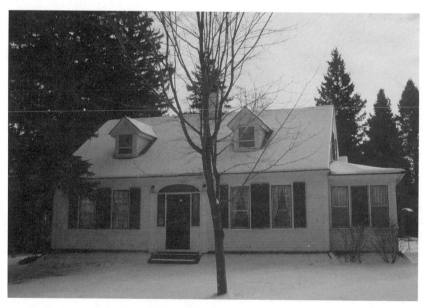

8.

PINK CHIMNEYS

PROLOGUE

LOCAL HISTORIANS DO NOT mention the house on Oak Street called Pink Chimneys where sexual secrets were kept. There is no record of the events that led Fanny Hogan to become Joshua Stetson's notorious mistress. If Maude Richmond Webber, the midwife, left a diary giving accounts of her personal association with Pink Chimneys and its occupants, it has not been found. Nor are there any letters from Abner Giddings, the master mariner, addressed to Elizabeth Emerson, the seamstress at Pink Chimneys.

You will not find their graves at Mt. Hope Cemetery. Nor will you find Pink Chimneys sitting behind the green discretion of a cedar hedge. The house no longer stands.

Some say the house had blue chimneys. Some say it never existed. Others say the women whose lives were affected by the events at Pink Chimneys aren't worth including in any bricks-and-mortar local history. But the ghosts of the past are persistent. Eventually, they find a voice, and tell their story.

PART ONE: MAUDE

1

MAUDE RICHMOND SHIVERED as she hurried into the house close behind her father, Eli Richmond. She was small, not above five feet. Her dark blue, high-waisted dress swirled and snagged at her feet, but she did not stumble. She moved with quick determination as if intent on keeping as close to Eli as possible.

At fourteen, her face still contained the rounded contours of childhood. Even after she grew into her final face, she would never be called beautiful. She resembled her father too much. She already knew this, but she did not mind. Her chin held lines of stubbornness. Her nose was straight and finely made giving her face a look of refinement. Her eyes were large and dark—black, some said. Everything she felt showed in her eyes, remodelled the contours of her mouth, dictated the very way she carried herself.

It was early September, 1814. She was not cold. She was frightened. There had been rumors for days, but Maude had ignored them. Eli was all she had. She did not want him to go to war. But the fact remained. War had come to the villages along the Penobscot.

The messenger who had brought the news to the Richmond house in Bangor had come across the Penobscot River from Brewer on a raft. The Militia was mustering to go to the defense of Hampden, five miles

downriver. The Adams, an American privateer, lay at anchor there. The Adams had captured several British vessels since the United States had declared war two years ago. In retaliation, the British were on their way to Hampden from Castine, which they occupied, to capture the Adams. The messenger had come to alert the Militia. There was going to be a battle. Eli was the only physician in the Penobscot region who belonged to the Militia. He had to go.

Maude watched Eli pack his medicine chest with instruments she'd never seen before. She was surprised since she supposed Eli had taught her everything he knew about doctoring, except for childbirth. Childbirth was performed by midwives, and Eli believed it was not a skill that belonged to the realm of simple doctoring.

Eli added a generous supply of heavily linted bandages to the medicine chest. He was thin and spare, a head taller than Maude. He moved with intense concentration. A worried expression deepened the lines around his mouth. His hair had turned gray after his wife's death, when Maude was five. A few wisps fell across his brow. His eyes were the same color as Maude's, very dark, almost black. They were kind eyes. He was quick to sense pain, of the body or of the soul.

"What are those?" Maude asked, pointing to the instruments. She lifted one. It felt cold and menacing in her hand.

"Probes and forceps. For extracting musket balls," Eli answered in clipped tones that were very unlike his usual manner of speaking. As a young man, before he'd come to settle in the frontier of the District of Maine, he had served time with General Washington's troops. He rarely spoke of it. He rolled several bottles of rum in thick towels and added them to his stores. He used rum to ease pain.

"I don't suppose I can go with you," Maude said. It was not a question. She already knew the answer. She laced and unlaced her fingers, rested her hands in the folds of her dress. She fingered the fabric, picked at it like a chicken pecking the ground. She hung her head and a hank of dark brown hair slid out from beneath the narrow band of her white muslin cap. The expression on her face mirrored the concern etched in the lines of Eli's face.

"War is no place for a child," Eli said. He snapped the lid of his medicine chest shut and buckled the leather straps tight. Maude regarded him patiently, trying, unsuccessfully, to conceal her feelings. She wanted to contradict him. She wasn't a child. She was a young woman. She had nursed several people through serious illnesses. She had even splinted a broken arm not long ago, had had the sense to know it was broken. Now she kept still. She knew perfectly well why she couldn't go. It had to do with a snatch of conversation she'd overheard between Mrs. Howard, who kept house for them, and a neighbor lady. The conversation had been about what British soldiers did to women in times of war. Rape, they had said, in hushed tones.

Maude knew what that was. Some of the women whose ills she tended had talked of sexual matters in those same hushed tones. She remembered listening with a curious mixture of intense interest and sheer outrage that women could be so used.

She was, too, more than a little hurt that Eli had been short with her.

Eli sensed her feelings. He took her hand, patted it, and reached for his old gray jacket. Maude had sewn a button on it the day before.

"Someone's got to stay here and tend the sick while I'm gone Maude," Eli said. "You're quite capable of bandaging a cut or dispensing a cough elixir without my supervision. People won't stop getting sick just because President Madison's war is about to arrive downriver." His face was grave, a little pale beneath the wisps of gray hair drooping on his forehead. He was fifty-two, but his anxiety over the impending invasion added years to his looks.

In spite of her intense concern, a small smile of self-pride crept across Maude's lips. She knew how to crush powders with the big wooden mortar and pestle. She knew how to strain leaves from the herbal tonics Eli prepared in his tiny dispensary just off the kitchen. She knew how to tie on a bandage as neatly as if she'd been born knowing how. She'd read Eli's medical textbooks, the few he had, and had delved into his pharmacopia.

As Eli gathered his things together, Maude's little smile faded. She bit her lip and sniffed back the tears stinging her eyes. It frightened her

to see Eli leaving, looking so old, so worried, so distant from her. Suddenly, she was no longer fourteen. She was five years old and her mother was lying cold and silent, distant, in the upstairs chamber. She was terrified, hysterically terrified, to let Eli out of her sight.

"Take me with you, Papa," she pleaded in a little girl voice. She flung her arms around Eli's neck. Her cap fell off. She dove into the safety of Eli's arms. "Please take me with you."

Eli pried Maude's arms off his neck. He was gentle, though, and left a comforting arm around her shoulders. She was shaking again.

"I'll be in no danger, Maude. I'll set up a hospital in the town hall or someone's barn if need be. I won't be where the musket balls are flying. I'll send word to you as soon as I can. I'm counting on you to look after Mrs. Howard and take care of things until I get back. Will you do that, Maude?" Eli's eyes pierced through her fear. His worried expression was gone. It was replaced by one of caring and concern.

Maude composed herself, reminded herself she was a grown-up young lady with serious responsibilities. Eli needed her to be strong.

Maude watched him ride away. She memorized the slight stoop of his shoulders, the gray of his hair laying against the darker gray of his jacket. She stood on the rock that served as a doorstep and waved as he disappeared down the Atlantic Highway toward Hampden. She smoothed her dress and brushed back the hank of dark hair that had worked loose. She put her cap back on. A warm, damp breeze blew the crisp smell of September across the river and lifted a fold of her dress. She stood watching a long time after Eli was out of sight.

2

THE NEXT DAY dawned fair and promised to be warm. It seemed impossible to Maude that barely five miles down the road men were shooting muskets at one another, that British soldiers were invading her small corner of the earth.

Eli had not returned nor had there been any word from him. Maude went about her duties with a sense of unease that set her jumping at the

smallest sound. By tacit consent, she and Mrs. Howard avoided one another. Neither wanted the other to see how worried they were.

Widow Howard had kept house for Maude and Eli ever since Mrs. Richmond's death. She had taken a dim view of Maude reading Eli's medical books and visiting the sick with him. She held to the beliefs of her own generation. It was far better, she maintained, for a girl's sensitive brain to remain uncluttered with book-learning. Girls ought to concentrate on the things suited to the female temperament, like baking, brewing, spinning, weaving, and keeping a decent house. She had taught Maude all these skills. Maude did them willingly and well, but she simply refused to accept that her lot in life, according to God's plan because of Eve's indiscretion, was just to marry, keep house, and raise children. She did not share Mrs. Howard's belief that intellectual pursuits were best left to the menfolk.

Maude paused in her application of linseed oil to the pine table in the kitchen. She thought she heard several dull, heavy thuds coming from the direction of Hampden. She went to the window. The river was devoid of shipping, an unusual and curious occurrence. The Atlantic Highway, which ran by the front door, was deserted, too. It was midmorning and no people had yet passed by.

Maud spied a lone figure trudging past the house, coming from the direction of Hampden. She dropped her dust cloth and flew out into the yard to stop him. It was old Hatevil Colson. He was an itinerant laborer who some said was touched in the head. He lived from hand to mouth in old barns and never stayed long in one place.

"Mr. Colson," Maude called, "is there news from Hampden?" The sun warmed her bare head. Her dress was too short in the sleeves and she tugged at them absently.

Hatevil grinned a toothless greeting. He clawed his battered hat off his stringy hair and made a courtly bow.

"Oh, there is, Miss, there sartenly is news." There were holes in the elbows of his black jacket.

"Please, Mr. Colson, I must know—" Maude gripped the fence rail. She was wearing a pale blue muslin dress laced up the back. The waist

was high per the current mode. It was not only too short in the sleeves, it barely covered her ankles. Maude had little interest in fashion. She tugged at the narrow sleeves again.

"Well, now I tell you, Miss, there's been a battle. And there's some as been killed and some as haven't. And some, and that's the most of them, yes indeedy, that has run all the way from the Penobscot to the Kennebec." This amused him and he cackled with laughter.

"But who won, Mr. Colson?" Maude asked. Her voice was urgent

"WON! Why the cussed Redcoats, Miss. And threatening to burn Hampden to the ground. On their way to Bangor, too, I heard one of the devils say. I'd hide in the cellar if I was you, Miss. I've heard tell those Redcoat soldiers ain't very perticaler about how they treat handy little ladies like yourself." He scratched his straggly beard and leaned wearily on the fence rail. The knees of his breeches sagged around his ragged wool stockings.

"I'm waiting for news of Eli Richmond, the physician. Did You see him by any chance?"

"Oh, aye, I saw him all right. He was took prisoner along with all the other townsmen. Held for a ransom, too. On a prison boat. I was lucky to git away when I did. You'd better run, Miss. That's what I be doin'! Good day to you, Miss." Hatevil plunked the battered straw hat onto his head and went off up the road toward Bangor village.

Maude hiked up her skirts and ran.

"Mrs. Howard! Mrs. Howard!" she screamed.

The widow appeared at the door with an alacrity quite out of keeping with her stout figure. She was dressed in the old style in dark red linsey-woolsey. A white gauze fichu was folded across her breast and tucked into the band of her skirt. She had come to the Penobscot as a bride in 1775. She could remember other encounters with the British. Her husband had been killed at Bunker Hill. She had never remarried and had no children.

"Lord in Heaven, Maude, what has happened?" The pads of flesh around her jaws trembled. Her small green eyes were wide with fright.

"It's Papa! The British have taken him prisoner! What can we do!

We must do something." Maude's skirts snapped and swished as she moved.

Mrs. Howard wrung her hands. Her plump knuckles had bits of bread dough stuck to them.

"Oh, dear Heaven," she breathed. "I'm all aflutter, Maude. Help me to the kitchen." The ruffles on her elbow-length sleeves fluttered too.

Mrs. Howard lowered herself into a chair by the pine table. Everything in the kitchen shone. Everything had a place and was in its place.

"Now you listen to me, Maude. There's no sense in flying off the handle. Let's think about this. If he's been taken prisoner and held for ransom, then he'll go free when the money's paid. That's how it works, isn't it? And there's money in Hampden. Why John Crosby alone is worth thousands. And Jeremiah Herrick, the merchant. I've heard he's already made his fortune. And Simeon Stinson, the trader. They'll pay. Never you fear, Maude. Your father will be home safe. Never you fear." She didn't sound like she believed it. Maude laid her head in Mrs. Howard's lap and wept.

A timid rap sounded outside and a small boy stuck his head in the open doorway. He was about nine years old and barefoot. His expression was serious, too serious for so young a child.

"Can the doctor come, ma'am? It's me little sister Samanthy. She's been cut and bleedin' fit to die. Ma says come quick 'cause she's afeared Samanthy's gon'ta leave this world."

Maude dried her eyes with the back of her hand. Mrs. Howard got up and reached for a dipper of water to give the child. The boy was dressed in patched and faded blue linsey-woolsey. He was one of Nathan Thatcher's brood. Maude knew the family. There would be little else but water at the boy's house to do with. Maude's fear for Eli abated. He had told her to take care of things until he got back. She was glad to have something to do. She hurried to the dispensary, chose salves, bandages, and other things she thought she'd need. "I'll be back as soon as I can, Mrs. Howard," Maude said.

Mrs. Howard was horrified. Her small mouth pursed and unpursed.

"But you mustn't, Maude. The Thatchers live right at the edge of the river. The British are coming. You'll be in harm's way!"

For a moment, Maude thought Mrs. Howard would have one of her spells. The widow's face was flushed and beads of sweat appeared on her upper lip. Maude patted Mrs. Howard's arm.

"I'll be all right, Mrs. Howard. There's nothing at Thatchers that the British would want anyway. I won't be gone long. Besides, there's no sign of the British. We'd have seen their ships. I'm needed." Maude's fingers were busy with bonnet strings. "I expect to be back by noon-time. If I'm delayed, I'll send this boy back with word when to expect me."

3

THE RICHMOND HOUSE sat a little ways back from the Penobscot on the river side of the Atlantic Highway. It was barely half a mile from the Bangor-Hampden town line. Long pastures rolled away to the river's edge. Each one was bounded by sturdy rock walls. The house was built in the snug Cape Cod style preferred by most. Large elms drooped leafy pools of cool shade into the dooryard. Already the landscape had taken on its autumn aura of red and gold. The sky was intensely blue. A few asters, a little paler than the sky, bloomed by the door rock. The river sparkled in the sun.

Maude, with Nathan Thatcher plodding along beside her, walked away from the house, up the Atlantic Highway. Despite its grand name, it was hardly more than two rutted tracks thick with dust. The day was unseasonably warm, just as Maude had anticipated it would be. The boy trudged along without speaking. His white-blond hair lay in damp clumps on his skinny head. If he had any worries about the British, he kept them to himself. In fact, Maude thought no one seemed unduly alarmed about the British. Some of the men had gone, of course. Others had not. There had been no exodus from town.

Perhaps, Maude thought, the danger had been greatly exaggerated. Hatevil Colson was not a reliable source of news. Perhaps the British

had subdued Hampden and were content with that. Perhaps they were on their way back to Castine, and Eli was on his way home. Her spirits lifted then settled back to earth like a feather.

Before the War for Independence, everyone had been a British subject. Maude understood the reasons for fighting for independence but she didn't understand, entirely, the politics of the present war with Britain. She knew it had something to do with the impressing of American seamen to serve on British vessels and an Embargo Act which barred any kind of commerce with Britain. It seemed, on such a pleasant day, to have little to do with her. She tried to imagine cannon balls flying through the village, and failed. Yet, there was an unusual stillness to the day, a wariness, a waiting feeling. She scanned the river again. There were no ships on it. If the British did come, she would be safely back at home before they arrived.

The Thatchers lived at the very end of Exchange Street where Kenduskeag Stream met the Penobscot River. Their dwelling was small and mean, one of the last of the log cabins that had housed Bangor's early settlers. The Thatchers, like nearly everyone else, had come to the District of Maine from Cape Cod right after the War for Independence to take up land granted to them for service in the Continental Army. Most of the log cabins had been replaced by more desirable frame dwellings. The Thatchers had not prospered and could not afford to make the change.

Mary Thatcher leaned heavily on the door frame. A clutter of children clung to her skirts. They moved in and out the door in a swarm of flies and shrill voices. Mary had the broad beam and heavy breasts of a woman closely acquainted with lying-in. Her hair was a shade darker than her son's. Her apron, tied high to accommodate her bulging belly, was bloodstained. She was far gone with child.

"I told you to bring the doctor, Nathan," Mary said. Nathan squeezed through the clutter of his brothers and sisters and went inside.

"My father went to Hampden yesterday, Mrs. Thatcher. I came in his place."

Mary's red, work-roughened hand flew to her mouth. Her lips tightened into a small round o. She stepped aside and let Maude into the cabin's one room. The place looked as if a mad bull had charged through. The floors were unswept. An iron kettle sat like a black mushroom on the hearth. It was caked with the remains of baked beans. Maude cleared a space on the table and set her basket down.

"Samanthy's over there," Mary said indicating a small trundle bed near the big bed in the corner nearest the hearth. "Mr. Thatcher went to Hampden, too. He said I was to take the young ones and head for the Kennebec if the British came upriver. But I'm too far gone to get far. Then Samanthy fell and hurt herself."

Samanthy Thatcher was, Maude judged, upwards of four years old. She lay in a pale spindly huddle, blonde braids coming undone, all arms and legs like a new foal. She looked like all the rest of the Thatcher brood. A clumsy bandage fashioned from a wad of linen toweling was tied around her leg. It was soaked with blood. Maude undid the bandage carefully. The cut was long and deep, but clean. It bled a slow ooze of dark red. Not so bad as she had feared. Still she had never treated so serious a wound all by herself. She had watched Eli and assisted him a number of times. She asked for a basin of water and soap. She cleaned the wound and applied a fresh bandage made from strips of an old sheet. Samanthy whimpered and buried her head in the small remaining space of Mary's lap.

"It's in a bad place;," Maude said. "Every time she bends her knee the wound opens and begins to bleed. I need two good solid laths for a splint. To keep her from moving the leg."

Mary called to Nathan and sent him to forage for the laths. She spoke to her other children. They dispersed and settled in various places in the room.

"Ma! Ma!" Nathan cried as he spilled through the doorway waving two laths. "There's six big ships on the river. It's the British. Mr. Barker's put a white flag out the window of his store!" Barker's store sat on a small rise of ground right on the very edge of the river.

Maude reached instinctively for her basket. Her feet moved he

toward the door. The thought of home, of Mrs. Howard and safety cancelled all other thinking. But before Maude could do more than rise from the side of the trundle bed where she sat, Mary took charge.

"Nathan," she commanded, "shutter the windows and bolt the door." Nathan's small frame moved quickly. The other children sprang up to help. Mary grabbed the basin of water Maude had washed Samanthy's wound with and doused the fire with it. It was a drastic action. It meant, once the danger was over, walking to a neighbor's house to ask for live coals to rekindle a blaze. It meant, in the meantime, no cooked food, no lighted candles, no warm water. "If there's no smoke going up the chimney, maybe the British won't bother us."

Maude sat down by Samanthy again. She set the laths against the child's leg and busied herself with bandaging them in place.

Mary reached into a pitcher and drew out two plain silver spoons, She ran her thumb lovingly along the bowl of one. She handed them to Maude.

"Quick," Mary said, "wrap these in Samanthy's bandages. You young ones go to the loft and lay down. And stay quiet or I'll take a stick to you!" Many pairs of small bare feet scuffled up the loft ladder. Then there was silence.

Mary tucked a tattered quilt around Samanthy.

Maude and Mary exchanged glances, gauging one another's fright. Mary steered Maude to the settle. They sat. For a long while the only sound was the hiss of the coals on the hearth as they slowly turned cold. Gradually, the distant shouts and curses of men replaced the hissing. Oars dipped water. Ships' rigging creaked and groaned. There came a bedlam of screeching chickens, bawling cows and barking dogs. Then, beneath the sounds of frightened animals came the unmistakable tread of marching feet.

Maude twisted her hands in her lap. She tugged at her too-short sleeves. She picked at the fabric of her gown.

Mary's hands rested on the bulge of her belly. She fidgeted, as if she were not comfortable. She leaned close to Maude and whispered, "What do you know about lying-in?"

Maude's stomach flopped like a frog in a dried up bog. She had never attended the birth of a child. Most girls her age had witnessed and assisted at the lying-in of elder sisters, in-laws, mothers, aunts and in some cases, grandmothers. But Maude had no near female relatives. She was ignorant of practical experience in the matter. Nor had Eli ever spoken to her about childbirth. Eli believed, and often said as much, that midwifery was a profession best suited to women. He felt a man's presence was immodest, unnecessary as long as there were skilled childbirth operators to summon. Childbearing was not a subject a father discussed with his daughter. That was women's work.

Embarrassment colored Maude's face. "I don't know anything about childbirth, Mrs. Thatcher," Maude whispered back.

"You're about to learn then, Miss Richmond. It won't be long. I'm always spry around the house until the last minute. This one's my ninth. About all you have to do is catch it when it comes out. Tie the cord, then cut it. I'll tell you what to do." Her whisper was a little louder.

Maude tried to remember what she'd heard other women say about the childbirth operation. Her mind was blank. All she could think of was what Eli had told her about cleanliness.

"I'll need water. For my hands. And to wash the knife and twine with." Her whisper was just a little stronger than Mary's.

Mary frowned. Her blonde eyebrows puckered over her pale eyes.

"No need to go to all that trouble. I never heard of such a thing." Mary spoke out loud.

"Oh, it's no trouble, Mrs. Thatcher. My father says it's like cheeses. If you didn't wash your cheeses carefully, they'd go bad and you couldn't eat them. It's the same way with people. Uncleanliness causes sickness, makes one's health go bad."

The frown left Mary's face.

"Now that makes sense. I lost all my cheeses once and I never could figure out what it was I'd done wrong."

Time inched on. The din of British feet invaded their silence, ebbed and flowed around the cabin. They were not disturbed.

Eventually, the young ones in the loft rebelled at the long spell of

inactivity. Their restlessness rustled and scratched like a nest of mice. Mary fed them cold porridge. She gave them bits of charcoal and told them to draw pictures on the chimney bricks to amuse themselves. Shortly after, she retired to her bed. Samanthy was asleep.

Worry rode Maude's heart like a heavy stone. Could she be of use to Mary when the time came? But surely, she thought, childbirth was no worse than Samanthy's bloody wound. Or gutting chickens for supper. Or cleaning hog's intestines for sausage casing. Or emptying chamber pots every day. Those things did not turn her stomach. It was her lack of skill that set her heart racing with fright. The one story she remembered hearing about childbirth had resulted in the death of the mother and deformity of the infant. But when Mary's travail had progressed to the point of bearing down, of panting and perspiring, Maude's misgivings about her lack of skill fell away. She delivered the infant without any difficulty. It was as Mary had said. She laid the infant on Mary's bare belly. It breathed by itself. It did not wail. It's eyes were wide open, searching for something. They found Maude. Maude was caught in the infant's amazement of the newness of life. They regarded one another with soft intensity. Maude was mesmerized.

Mary reached for the infant.

"Another girl. I'm glad for that. I've already got six boys. You did a fine job helping me, Miss Richmond. I'd be pleased if you'd give her a name . . ."

A loud banging came at the door. Male voices, shouting in British accents, demanded to be let in.

4

"OPEN UP IN the name of the King or we'll break the door down!" a man called. Shoulders battered at the door.

"Quick!" Maude called to Nathan. "Help me push the chest against the door!" Nathan jumped down from the loft to help. With the chest firmly across the door, Maude dashed to the loft ladder and climbed up halfway. She poked her head into the loft. The children huddled fear-

fully near the chimney. Their faces, streaked with charcoal, were as white as goose down. They had drawn a fierce looking soldier on the chimney bricks. Joseph, the littlest boy, leaped up and held out his arms. Maude gathered him up. "Hush!" she commanded the children.

The thudding against the door increased. Mary drew the bed covers up around her chin to hide the infant. The Thatcher brood whimpered and cried out in terror. The cabin went up in a wave of screams and wails. The door splintered and cracked, then gave way with a sickening crash. Four British soldiers tripped over the chest and spilled headlong into the cabin. They lay scattered on the dirt floor like discarded lobster shells.

Maude was frozen on the sixth rung of the ladder. Joseph clung to her neck and screamed in her ear.

The soldiers scrambled to sort out a maze of arms, legs, and dented hats.

Joseph stopped screaming in mid-wail and stared. His small, narrow face relaxed into a beaming smile, showing his four new teeth. He threw up his grubby little hands and crowed, "Aw faw down."

Joseph's innocent assessment of the situation, and the sight of four soldiers divested of their composure, struck Maude as ludicrous. A quick grin flashed across her face. The children saw it. Abruptly, their wails turned to giggles.

The soldiers glanced sheepishly at one another.

The one with the red hair spoke. With as much dignity as he could muster, he said, "You're to surrender your weapons and make all foodstuffs available to the quartermaster, ma'am." He was firm but polite.

"We have no weapons, sir," Maude replied. She regarded the soldier from her perch. "And no food. There's little enough to feed the ten mouths that live here. There's nothing to give you." She was no longer frightened.

"Sorry, ma'am," the red-haired soldier replied. "We've got our orders. Captain Barrie wants troops quartered here. You'll all have to clear off." He shoved the chest aside with his foot.

Anger rose in Maude like a high tide on a full moon night.

"Sir," she said carefully, as if the soldier were slow-witted, "you cannot turn an injured child, a newborn infant, a lying-in woman and eight young children out into the dooryard with nowhere else to go and no food. It's uncivilized! We will not leave. You tell that to your Captain Barrie!"

Joseph squeezed Maude's neck more tightly. She nearly lost her footing on the ladder. She set the child back on the loft floor.

"Please don't defy them, Miss Richmond," Mary pleaded. She was sick with fright.

The soldiers shuffled their feet. They were ill at ease and unsure what to do. The Soldiers' Manual did not cover all situations concerning civilians. They milled around, tripping over one another.

Maude jumped off the ladder. She picked up a few pieces of the splintered door and flung them in the soldiers' direction. "Shoo," she said firmly. The men ducked and retreated as far as the doorway.

"Now we're in for it," the red-headed soldier said. "There's Captain Barrie."

The four stiffened to attention and saluted with precision. Captain Barrie's eyes were protruberant with pouches beneath them. They contrasted oddly with the sharper lines of his nose and cheekbones. His sword clanked ominously as he strode toward his men.

"Sir," Maude said, "I beg you to order your men away. They have made a mistake . . ."

"Mistake, ma'am?" Captain Barrie cut in harshly. "There's been no mistake." His pouchy lids narrowed around his flinty eyes. "You are the enemy. My orders are to burn and destroy. Private Williams, carry on."

Williams, the red-headed one, snapped a salute.

Maude's mind refused to work coherently. She did not think about the consequences of her action. She rushed back into the cabin and reappeared with the infant in her arms and Joseph by the hand. The infant was wrapped in a quilt with dark red sashing. Joseph's dress was grimy at the hem. She planted Joseph squarely in front of Private Williams. Joseph lurched, tripped on his dress, and sat down heavily.

"Faw down," he sang.

Private Williams reached down instinctively to break Joseph's fall.

Before Captain Barrie could do more than open his mouth to protest, Maude thrust the infant into his arms. Barrie was shocked into inaction. His mouth hung open. He stared at the wailing child. The infant's tiny fists waved in jerky, impotent circles.

Sweat trickled down Maude's back and her bodice stuck to her skin. The lacings up the back of her dress felt as if they'd shrunk. She was terrified and furious, but she pulled her spine into a rigid straight line and faced Captain Barrie.

Captain Barrie's lips compressed into a straight line. His sword rattled.

"Very well then, sir," Maude said evenly, "you do it. You throw this babe, who is hardly an hour old, into the road. There's an injured child inside, too, who will bleed to death if she is moved. And a lying-in woman. And seven young children. You throw them into the road, sir. I'll be damned if I'll be part of any such goings on."

Maude turned on her heel, appalled that she had resorted to profanity. She was so agitated she did not see the British officer. She crashed into him, lost her balance for a moment, was quickly righted by a firm hand. The officer bowed slightly from the waist. His uniform accoutrements far outshone those of Captain Barrie. He was very tall and his dark hair was misted with gray at the temple. There was a white plume in his hat. He was not wearing a sword.

"Colonel John, at your service, ma'am," he said. "Your name, please." His manner was respectful, yet implied he had a duty and would not hesitate to perform it.

"Maude Richmond." Her voice was tight. She knit her fingers into the fabric of her dress to hide their trembling.

"And this is where you live, Miss Richmond?"

"No, sir," Maude tugged at her too-short sleeves. She was acutely aware that her dress did not quite cover her ankles.

"Then what are you doing here?"

Maude explained. Colonel John turned to his men.

"We are not barbarians, gentlemen. You are dismissed."

Colonel John took the infant from Captain Barrie and handed the child to Maude. Nathan crept out of the cabin and hauled Joseph back inside.

Captain Barrie's face was unreadable. He stalked off. His boot heels left deep prints in the ground. The four soldiers marched smartly, in double time, after him.

"You are very courageous, Miss Richmond," Colonel John said as soon as his men were out of earshot.

"No, sir," Maude replied. "I'm just mad as a wet hen at such unjust treatment."

A smile played around Colonel John's mouth. Maude stared at the ground. She waited for Colonel John to arrest her.

"Is everyone in Bangor this poor?" Colonel John asked. He peered into the dim interior of the cabin, inspected the dirt floor, the sparse furnishings, the huddle of thin children clustered around Mary in the big bed.

"No, not everyone. Most are. The Embargo beggared many."

The Embargo Act, enacted in 1807, was designed to prohibit trade with Great Britain. After the Embargo Act, the British had stepped up their interference with American shipping. In retaliation for that, American privateers like the USS Adams increased their harassment of British ships. Businesses of all kinds had declined because good markets for lumber and fish, the primary products of the Penobscot River settlements, could not be reached without extreme danger of capture by British ships. A few of the wealthier shipowners got around the dilemma, and managed to salvage their fortunes, by registering their ships under flags of neutral countries. They continued to do business with the British. Others had simply ignored the embargo and smuggled much demanded British goods from Canada into Bangor. Still, most people had suffered. Maude remembered Eli telling about dwelling houses left unfinished, how local merchants had found themselves hopelessly in debt to the Boston merchants who supplied them with goods and capital. Even Eli had had to be content with fees paid in bushels of apples, a pair of shoes, or a few pounds of raw wool.

"My orders from General Sherbrooke are to evict all inhabitants on the Penobscot and burn every village I find," Colonel John said quietly.

Maude leaned heavily against the cabin. The fight was gone out of her. Tears flooded her eyes. One great drop rolled down her cheek. She hid her face in one hand for a moment before she dared look at Colonel John again.

He regarded her from his great height. He shifted his gaze to the river. Maude followed his glance. Fires consumed the ships that made up Bangor's small merchant fleet.

"I had no choice but to burn the ships. The villages are another matter. General Sherbrooke will accept my recommendation if I advise him not to destroy the towns. If the inhabitants pledge not to take up arms against us, they will go unmolested. The prisoners will be released. Would you say that's fair, Miss Richmond?"

Maude nodded dumbly, yes. She was incredulous.

"How old are you, Miss Richmond?"

"Nearly fifteen, sir." Maude eased away from the cabin's support and stood erect. She shifted the infant to her other arm.

"I thought as much. Barely out of walking strings. I pray my own daughter will never be faced with the necessity of defending her home and the people in her care at so tender an age." Colonel John paused as if uncertain of what else to say.

Maude was speechless. She had never imagined that her defense of the Thatchers would result in the salvation of the Penobscot villages.

"War is a beastly business," Colonel John said. He swept his hat off his head and placed it over his heart. He bowed deeply, replaced his hat, and turned to go.

"Wait," Maude said. It was another of her impulses. "What is your daughter's name?"

"It's Sarah," Colonel John's face softened into an expression that Maude interpreted as homesickness.

"This babe hasn't been named yet," Maude said. "Mrs. Thatcher asked me to choose one. I'd like to call her Sarah, if you don't mind, sir. Sarah John Thatcher."

The Colonel's face relaxed into an admiring smile. He bowed deeply again. The fringe on his epaulets trembled.

"I should be most honored, ma'am. If this wretched country you call America ever comes to anything, it will be because there are ladies like you in it. Good day."

Maude knew she'd never see nor hear of Colonel John again. She had the distinct sensation that a page in her life had been written, a new page had turned. She could not name the feeling, but she felt as if something deep within herself had taken root and was already sending up strong new stalks. She felt a blooming that she had never imagined possible. She touched Sarah John's tiny fist. The child opened her eyes, found Maude's face, made a bond with her.

"Nathan," Maude said with a new confidence, "you go get some wood and run over to Barker's store. Ask for some live coals. I want the fire going as soon as you get back. You little ones come here and see Sarah John, your new sister. The soldiers are gone. You can come outside. One of you bring a bucket of water. Watch after Joseph." She took command of the Thatcher household as if she'd been giving orders all her life.

The cabin hummed and thrived and settled back into a rhythm of its own.

<div align="center">5</div>

BY EVENING, the British had burned every vessel capable of floating. Dark billows of smoke blotted the sky. Nathan told Maude he'd seen some soldiers help themselves to boots from John Barker's store. He'd heard Mr. Barker say that Captain Barrie's men were getting soused on rum at Hatch's Tavern. The news put Maude ill at ease, but no citizen was molested, no house burned. Colonel John kept his promise. At dawn, the British ships sailed back down the Penobscot leaving the villages intact.

Maude sent Nathan to Mrs. Howard to say she was safe. Nathan brought back word that Eli, too, was safe and expected home by

evening. Three British soldiers and a man from Frankfort had been killed at Hampden.

Eli arrived at the Thatchers early the following morning. He was unshaven, his cravat was slightly askew, and he was hatless. A button was missing on his coat. The lines that ran from his nose to his chin were curved into a smile. Still, his eyes showed concern. Eli had a face that was easy to trust. He had a knack for not interfering if it wasn't warranted. It was one of the things Maude loved most about him. He surveyed the room. The Thatcher brood eyed him solemnly. They were eating a breakfast Maude had prepared. Cornmeal porridge sweetened with molasses. She had baked bread and churned butter from the gill of cream she'd discovered hanging in the well. She had washed the children's hands and faces. They fairly shone in the dim light. The room was neat and tidy. Mary, sitting up in bed with her hair neatly plaited and covered with her best muslin cap, nursed Sarah John.

Maude did not rush into Eli's arms with sobs of relief as she would have done two days ago. Instead, she strode purposefully toward him. She kissed his cheek.

"I'm quite well, Papa," she said with great calm and dignity. She carried herself with a new assurance. Eli noticed the change.

"Well, Maude, I see everything here is in good hands."

Maude led Eli to Samanthy. The child's leg was propped up on a wadded up quilt. She was sucking her thumb.

"I want you to look at Samanthy's leg," Maude said.

Eli stroked Samanthy's smooth blonde braids. He inspected the wound and bent to sniff it.

"No odor. No putrification. I'd say you've done a fine day's work daughter." His eyes were full of pride.

"And that's not all, Papa, I helped Mrs. Thatcher with her illness." Maude adjusted the pillow Mary was propped against.

"Aye, that she did," Mary said. She removed Sarah John from her breast and held the infant up for Eli to see.

"Your Maude was as handy as any I've ever come across. Gentle as a lamb. I'll send for her again when the time comes. The cradle is never empty for long in this house."

Maude sent the children outside to play. She settled Samanthy for a nap and Mary for a rest. She jiggled Sarah John in her arms. She and Eli sat down at the table. Eli crossed his legs and folded his hands across his spare middle.

"And what of you, Papa?" Maude inquired. "What happened at Hampden?"

"The Militia got there all right. Most of them without weapons except pitchforks or flails. None of them trained to know what they were supposed to do. The whole kit and caboodle ran the minute the first British soldier came over Academy Hill. They scattered from here to Belfast and back again on both sides of the river. Morris, the captain of the Adams, put the ship to the torch before he and his men got away. I thought I'd be spared the prison ship. A few men got banged up in their haste to get away and needed my attention. But a British officer by name of Barrie said he had no humanity for any of us. Several dozen of us were locked up in the hold of the Decatur without food or water. The man had no decency whatsoever. We spent a pretty cramped night. The people of Hampden raised the $30,000 bond the British demanded. None of the townspeople suffered any hurt. But the British dumped molasses and feather ticks in the wheel of Mr. Crosby's grist mill. Made an ungodly mess. Some cattle and sheep were killed. Some property trespassed on. But the British were put in their place a time or two. I saw Judge Kinsley's wife empty a chamber pot onto the heads of some British officers. And I heard Hatey Colson went up to a colonel and asked if it was true that his name was Gosling. The colonel said it was and old Hatey said, 'Then damned be the goose that hatched ye!'"

At the mention of Captain Barrie, Maude and Mary exchanged significant glances. A tacit agreement passed between them. Maude turned the conversation to other things. She was not yet ready to tell Eli of her adventures with the British.

Shortly thereafter, Nathan Thatcher, the elder, returned and Maude and Eli started for home.

They walked slowly. The golden September weather had held. Red and amber leaves dappled both sides of the river. Maude tugged at her

sleeves. Her basket swung from her left elbow. People came out into their dooryards to pass on and receive news of the Battle of Hampden. One woman rushed up to Maude and grasped her arm.

"I heard how you put that brute Barrie to shame. Why, no one's talking of anything else but how you won Colonel John's heart and made him promise not to burn the roofs over our heads," the woman said. Her nose was, Maude thought, exactly the right sharpness for delving into other people's business. Maude protested that she had done nothing of the kind.

"Well," the woman sputtered, indignant that she had been contradicted, "that's not the way John Barker told it. You are much too modest, Miss." She sailed away in a flurry of brown skirts and red petticoats to pass on her gossip to anyone inclined to listen.

Maude dreaded to think what kind of tales would be tacked on to the story before it got done making the rounds of the Penobscot villages. Not that it mattered. Better the town should think she'd captured the affections of a British officer, which she had not, than accuse her of acting foolishly and bringing harm to the Thatchers.

"Apparently, Maude," Eli commented quietly, "your adventure was somewhat more entertaining than mine." He wore his stern father face and his mouth was firm. His eyes searched hers, but he was neither teasing nor chastising.

Without embellishment or omission, Maude told Eli the story of her encounter with Captain Barrie and Colonel John.

Eli closed his eyes a moment and shook his head.

"I thought you had more sense than that, Maude."

"Please don't scold me, Papa. If I hadn't acted the way I did Samanthy could have died. Or Mrs. Thatcher's condition could have become dangerous. The children were hungry and discomforted enough as it was. No one should have such authority over anyone else. Especially over women and children. It isn't right." Maud hesitated. She tried to think of a way to say what it was that had infuriated her when Captain Barrie had ordered them away. "Women," she went on, "have little enough to say about what happens to them as it is. It

seemed to me that I had some rights. I simply could not submit without a whimper." The set of her face grew stubborn and determined.

Eli's face softened into the quizzical expression Maude had noticed several times since he'd come to conduct her home.

"Where do you get such ideas, Maude?"

"The last parcel of books you had sent from Boston had A Vindication of the Rights of Women in it. By Mary Wollstonecraft. She believes women ought to have power over themselves, that they ought to be educated, and have the same rights as men to determine the outcome of their lives. It sounded very sensible to me."

Maude had read the book twice.

"I thought it was a collection of learned essays on the proper sphere for women. The household arts. Raising a family. Those things."

They had had similar conversations before. The idea of spending the rest of her life beating rugs and dusting tables made Maude uneasy. She wanted something more, but she had not been able to make Eli understand.

Eli chewed on his bottom lip. He was thinking. They walked more slowly.

"I was some upset," Eli went on, "when Mrs. Howard told me you'd gone to Thatcher's. Poor lady, she's been fit to be tied ever since you left. All I could think of was how my little girl was in danger. I didn't know what to expect when I got to Thatcher's. That you were harmed in some way, I guess. I certainly didn't expect to find a very capable young woman completely in charge of the situation." He paused and looked hard at Maude, appraising the difference he sensed in her attitude. "Forgive me, Maude, for not realizing that you had grown up."

Maude was touched, but she saw how difficult it was for him to adjust his perception of her. Her instinct was to protect him because all they had was one another.

"Oh, Papa, you know I'm grown up. I take very good care of you and help you very much."

"No, Maude. I'm serious. Until this very moment, I hadn't dared to admit to myself that you are no longer a child." He drew a deep breath.

"You've followed me around since you were five years old. Mixing medicines. Reading my books. Learning the doctoring trade. I never once thought that one day you'd be able to do, all by yourself, the things I've taught you. And even a few I didn't."

Eli clasped his hands behind him as he was apt to do when he was in a reflective mood. They walked in silence a few moments letting the immensity of what he had said sink in. Maude matched his contemplative stride and did her best to match his mood. It puzzled her.

"I suppose you'll be wanting a husband and have no need for a father before too long," Eli said thoughtfully. He kept his eyes fixed on the road.

"I want to be a physician like you, Papa. The husband can wait." She had said as much to him before. He had merely smiled indulgently and given some vague answer that neither encouraged or discouraged.

Eli stopped in mid-stride, wiped his brow with his handkerchief, and sat down in the shade of an elm.

Maude set her basket down. She pulled on her sleeves.

"Rest a minute, Maude. I'm not as young as I used to be. This won't surprise you, but I always hoped that one of your brothers would follow in my footsteps. That's the way God meant it to be, a son learning his father's work. I always expected you'd be like your mother, well-versed in the housewifely arts, glad to share the yoke of matrimony with a strong husband of your own choosing." Eli took Maude's small, square hand in his. He sighed deeply, pained by the memory. "Your brothers went off to sea and went down with their ships. Then your mother died. And you have been the one to follow me around to visit the sick. You read my medical books as easily as you read a recipe for gingerbread. I never gave any thought to whether or not it was seemly for a young lady. I just liked your company very much. And watching you learn. I liked watching you learn. But you weren't a boy and I didn't take your interest seriously. It seems you have become my apprentice and I scarcely know how it has happened."

"I've only done what I want most in the world to do, Papa." Maude's voice was earnest.

"You're certain you wouldn't rather be at Miss Stanley's Young Ladies' Academy learning the gentle art of embroidery or the genteel way to step a reel?" His tone was teasing. Eli released her hand and wiped his forehead again.

"No, Papa. I want to be a physician like you."

"Some men won't want you to doctor them."

"I know, Papa. But some women won't want a man to doctor them either."

The quizzical look registered again on Eli's face. He had never thought of it that way.

"You've a caring heart, Maude. I saw that very clearly at the Thatchers. I guess that's what set me thinking. Mary Thatcher is right. Women will be glad of your presence when their travail begins. You have the makings of an excellent midwife. Midwifing is a proper sphere for women. More so than simple doctoring. Would you consider the art of midwifery a proper calling?"

"Yes," Maude said simply. She thought of the amazed questing of Sarah John's newborn eyes. She thought of Mary immersed in the intense work of her travail. "Yes," she repeated.

"When you're eighteen, I'll apprentice you to Sally Cobb Robinson, the midwife across the river at Orrington. Does that sound agreeable?"

"Yes," Maude said again, more strongly.

"You wouldn't rather have a husband? Perhaps one in a military uniform who calls himself Captain or General?"

"Perhaps, Papa. Someday. If the right one comes along."

She picked up her basket. Eli pocketed his handkerchief.

They walked on down the rutted, grass-tufted track of the Atlantic Highway, in step, heads tilted slightly down, hands clasped loosely behind their backs.

"THIS IS Miss Anne Stinson, Miss Richmond. She has lately become engaged to my dear grandson, John, of Hampden. She is staying with me while her parents journey to Boston," Mrs. Crosby said.

Old lady Crosby was as wide as she was tall. She was gouty, spoke her mind, and cared nothing for what anyone else thought. She set the social tone of Bangor. Her face was crosshatched with wrinkles. Everyone said she was upwards of eighty, but she admitted to no more than seventy. Her husband and sons were among the few who had salvaged their fortunes during the embargo. No one was quite sure how.

Her gown was in an old style of black silk. A sheer white gauze fichu lay in precise folds across her broad breast. She looked something like a pouter pigeon. Her invitations to tea were understood to be a summons.

Maude stood in Mrs. Crosby's parlor. She had arrived precisely at two o'clock. Mrs. Crosby did not like tardiness. Maude's gown was new. Mrs. Howard, recognizing the importance of such an invitation, had insisted. It was dark blue calico with a small figure dotted over it. Her hair was parted in the middle, looped loosely over her ears, and caught up behind with a carved shell comb.

Mrs. Crosby's tea parties were known for two things. She served her guests from exquisite blue and white English porcelain cups and saucers. Secondly, the company was invariably dull. Mrs. Crosby liked to make "pronouncements." These dictated the social and moral standards of behavior in the Bangor region. The penalty for disregarding these pronouncements was to become the subject of one at the very next tea party. Mrs. Crosby built and destroyed reputations the way some men built and destroyed businesses.

Anne Stinson, however, was anything but dull. Her curly hair was a hazy shade of yellow. Her eyes were the color of robins' eggs. Her lips were full and red. She was airy and ethereal in a soft gauzy pink gown. She trailed the deep fringe of her rose silk shawl behind her with an affected disdain for the garment.

"Pleased to meet you," Anne said. She inclined her perfectly mod-elled head. Little pale yellow ringlets bobbed. Her eyes snapped with restless sparks. She was the daughter of Simeon Stinson, of Hampden. Maude remembered going with Eli to tend Mrs. Stinson when she'd scalded her hand.

"The same, I'm sure," Maude said.

They smiled their best tea party smiles. Mrs. Crosby went to see to the tea.

"Is it true what they say about you and that British officer?" Anne asked. Her voice was low and musical. Her dimples played.

Maude bristled. The story of her defiance of the British had in four years, become legendary. It was extremely embarrassing.

"It most certainly is not!" Maude's chin jutted out with just a touch of challenge.

"No, I don't suppose it is," Anne replied. She moved restlessly drag-ging her shawl behind her. "I so hoped it was. But I knew the minute I saw you. You aren't the type to turn the head of an older man. Or ever get into a scrape."

"No, I'm not," Maude said firmly. "Are you?"

Anne poured her shawl into an untidy pile in the corner of the sofa. Her laughter was a quick fluted melody.

"Oh, yes. That's why I'm here really. I was attending a young ladies' academy in Boston. I've been sent home in disgrace. That's why Mother and Father are away. To fix things so my reputation won't be tarnished forever." She sat down on top of the shawl. Maude took a chair with a needlepoint seat.

"What did you do?" Maude asked. Her interest was piqued.

"I shocked the headmistress, straight old stick of a thing. I shinned up the maple tree in the garden. Am I shocking you? No, I think not. I'd had a note from my older brother, Reuben. He's master of father's ship, the *John Hampden*. I hadn't seen him or been home in an age. I was just sick for the sight of something that reminded me of home. So I climbed the tree. To see if I could catch a glimpse of the ship in the harbor. I got caught."

"You seem very happy about it," Maude said, smiling.

"Oh, I am. But now they've sent me here to benefit my character with Mrs. Crosby's superior wisdom."

The hired woman came in with a tray of tea things. Mrs. Crosby followed. Anne and Maude assumed proper tea party expressions.

Mrs. Crosby settled heavily into a large wing chair. She planted her little feet on a low stool. Voluminous black silk skirts sighed. The keys hanging from her waist on a chain jingled. Her white mob cap was stiffly starched and covered her hair completely.

"Anne, dear," Mrs. Crosby said, "bring a chair and sit by me. Shake out your shawl. It's wrinkled. Have one of these little cakes, Miss Richmond. I understand you leave for your apprenticeship in Orrington next week." Tea cups made polite rattles. Maude was handed a cup. Exotic birds strutting in a fairy tale forest of blue decorated it.

"Apprenticed," Anne said. "Whatever for?"

"Miss Richmond is to learn the art of midwifery. It is very sensible of her to give herself to such an honorable calling. But it is my duty to warn her." Mrs. Crosby made a significant pause. The pronouncement was imminent. "Sally Robinson is a lady of the utmost respectability. She is wise beyond the wisdom naturally bestowed on women. She is, as I am sure you know, the widow of a physician. When he died, she simply continued his practice as so many doctor's wives do. I have heard, on the best authority, that before her marriage, Mrs. Robinson received midwifery training in France. The French entertain some very popish ideas. Mrs. Robinson has been known to attend women of low moral character, if you understand my meaning."

Mrs. Crosby's lips were prim.

Anne stared at her knees and fussed with her shawl.

Maude understood perfectly. She had heard the gossip about widows who produced infants a year after a spouse's death. She knew of women with three or four children and no husband in sight. She tended their ills if they called her. So did Eli. She opened her mouth to speak, but Mrs. Crosby interjected.

"Oh, I know the town has a regulation that requires a midwife to

attend any who calls. But I think it most unwise. One of their own ought to be trained to attend them. These things should not be allowed to filter out to decent women. You are very young, Miss Richmond. You must stay on your guard against the corrupting influences you will encounter. There. I've had my say. Won't you have more tea?"

Maude's indignation flared like a bonfire on an October evening. But she said nothing. She and Eli had talked of these things in a general way. To Mrs. Crosby, and most other people, fallen women were Eve incarnate. They deserved the punishment of social segregation. But Eli did not share that sentiment. It was one thing, he had counseled, to refuse to condone such behavior in oneself, but quite, another to condemn it in someone else. Especially if you knew nothing of the circumstances that compelled people to behave in such a way in the first place.

"Hasn't the weather been perfect for apple picking," Anne said brightly.

The rest of the tea party passed in similar polite conversation. Maude was relieved when the time came to leave. Mrs. Crosby shifted her bulk and yawned.

"Anne, see Miss Richmond to the door. It's time for my nap."

Maude rose to go. Anne followed her to the door.

"I never met anyone of our sex who does such interesting things as you do, Miss Richmond. If I invite you, would you come to a gathering at my home? An assembly, perhaps. My four brothers would dance with you."

"I'd like that very much, Miss Stinson. But I'd have to receive Mrs. Robinson's permission." Maude put on her bonnet and went home.

That had been a week ago.

Now, the day Maude had dreamed of and dreaded had arrived. It was the day she left for Orrington to begin her apprenticeship She tied her best bonnet firmly under her chin. It was plaited of yellow straw and trimmed with blue silk ribbons. Her gown was an indefinite shade of brown. Neither the bonnet nor the gown was fashionable. The decoration was not lavish enough, the waist not low enough, and the skirt was not full enough. Maude seldom thought about how her clothing

looked. She was too busy visiting the sick. And when there were no calls, there was the endless round of baking, mending, spinning, preserving, scrubbing, and all the other heavy tasks of housekeeping to do.

In a sense, visiting the sick was simply an extension of the housework Maude was familiar with. On the day Mrs. Howard taught her to darn, she learned to stitch a wound. After she'd mended a broken chair leg, she splinted a broken bone. The same morning she'd spent an hour trying to blow cold coals into a blaze, she learned to breathe life back into a half-dead child.

Maude reached for the door latch and glanced fondly around the room that had been hers since her mother's death. The braided rugs were faded and worn but still cherished because her mother had made them. The log cabin quilt she and Mrs. Howard had pieced was spread neatly on the bed. The sampler Maude had completed in the twelfth year of her life hung on the gable wall. It said:

> May learning, science, useful art,
> Adorn thy life, improve thy heart.
> May kind affection, love so dear,
> Hereafter bless and guide you here."

It was a cozy room tucked up under the eaves where she could listen to rain on the roof. In winter she could almost hear snowflakes fall on the shingles. She knew she would miss the way the morning sun slanted through the window and fell in a warm patch on the pine floor.

She went downstairs to find Eli. He was in the small dispensary just off the kitchen ell. He was writing in a big leather-bound ledger, spectacles balanced on the end of his nose. They were a recent acquirement. His dark gray jacket was the same one he'd worn to the Battle of Hampden. The same button was still hanging loose. It never stayed on no matter how often Maude sewed it.

Maude picked up a cobalt blue bottle and examined it while she waited for Eli to finish.

"I've always loved this color. It looks so pretty when you hold it up to the light."

"Maybe that's why I have such a time keeping any." Eli grumbled. "You always have them filled with flowers, or stuffed full of dried rose petals." His pen scratched noisily as he made a grand flourish with it. He handed Maude a small piece of paper.

"This is a check for five dollars drawn on the Bangor Bank. You'll need things. Spend it however you like."

Maude thanked him and tucked it into her little leather reticule. Like most of her possessions it was well worn and out of fashion. Its click, as she snapped it shut, hung loudly in the air. Silence replaced the snap of the reticule. Eli removed his spectacles and made a large business of putting the ledger away.

"Papa," Maude said softly, "I want to go, but I don't want to go." A wail stuck in her throat, but she managed to keep the plaintive tone threatening her words at bay.

Eli stood up very quickly and took Maude by the shoulders. She had not grown beyond five feet. She would always have to look up to him. She thought of a strong oak and leaned against him.

Eli's mouth worked a moment before any words came. "I know you'd rather live here with me than at Mrs. Robinson's, but you'd miss out on too much if you did that. She's called to all the villages on both sides of the river. From Old Town to Frankfort. Even as far inland as Dixmont. Don't change your mind now, Maude." He pushed her gently out of his arms, establishing a tangible distance between them.

"It's not that, Papa. I just hate leaving you all by yourself."

"Mrs. Howard will see that I'm taken care of."

"Promise me you'll send for me if the least thing is the matter, if you are ill, or have too much to do . . ." Maude's voice broke.

"Goodbyes still aren't easy for you, are they, Maude?" Eli understood how deep the wound of her mother's death was.

"Maybe it's a mistake . . ." Maude began.

"Go. Now. Nathan Thatcher has had his team waiting for quarter of an hour. Your trunk is already on the cart." Eli's eyes were overbright. Maude's stung with unshed tears.

Maude kissed Eli's cheek and felt a bit of moisture on her lips; her own or his, she couldn't tell.

Her life was at a crossroads. One way was safe and familiar, the terrain easily traveled. The other direction was uncharted, unknown. The feeling she'd first encountered at Thatcher's cabin four years ago stirred. Once again, she sensed herself preparing to bloom in a way few women ever did.

<div align="center">7</div>

THE CART YOUNG Nathan Thatcher had brought to carry Maude and her trunk to the ferry had two high wheels and a small seat perched near the front. The oxen hitched to it stood with dumb patience. They slapped their ropey tails at the flies worrying their black haunches.

Nathan had changed dramatically in four years. He was a strapping tall youth able to do a man's work to earn his keep.

"Good day to you, Nathan," Maude called. Mindful of his recent arrival into manhood, he allowed a small smile and nod to serve as a greeting. He helped Maude climb up onto the seat beside him.

"Gon'ta be a good one, Miss Richmond," Nathan answered. His voice was deep, but his white-blonde hair was still plastered in damp clumps to his head. His shirt sleeves were rolled up. "Sarah John's been acting up all morning. She ain't happy about you goin' off over to Orrington. Ma says tell you to be sure to wave to Sarah John when we get to the ferry."

"I'll do that, Nathan," Maude said. She folded her hands in her lap. "I'm ready if you are."

Nathan spoke to the oxen and prodded them with his wooden goad. They moved with slow heaviness. The cart lurched and creaked as they swung round and lumbered down the road.

"I'll write often," Maude called to Eli and Mrs. Howard. They stood together on the door rock. Mrs. Howard waved a large white handkerchief with one hand and dabbed at her eyes with the other. Her smile was brave. Eli lifted his hand more slowly, as if in salute. His gray coat

hung a bit crooked from his shoulders. It occurred to Maude that nothing would ever be the same again. For a moment she was afraid again.

As if he'd read her thoughts, Eli squared his shoulders and bowed from the waist to her. The gesture conveyed his pride and confidence in her more than mere words ever could.

At the ferry, Nathan stopped the cart. Maude climbed down to speak to Sarah John. The child stood on a pile of lumber. Her white pinafore, over her woolen dress, was rumpled and grass-stained. One finger was in her mouth. Her hair was pale blonde, almost white. She was very composed. Too composed.

"You ain't never gon'ta come back," she said. Tears welled up in her hazel eyes.

"Of course I'll come back, Sarah John." Maude lifted the child off the lumber pile and sat down with her in her lap. Sarah John buried her face in Maude's neck to hide her misery. "While I'm gone, Sarah John, Mrs. Howard and Papa will need a little girl to look after them. Do you think you could do that?"

Sarah John stirred and regarded Maude with a serious expression. Anything Maude suggested always made sense to her. Her attachment to Maude was absolute. She nodded gravely, yes. Maude set her on her feet.

"I'll come to see you when I can. And look, I brought you a hair ribbon." It was bright red. Maude tied it around Sarah John's braids. Sarah John hugged Maude's knees. She let Nathan put her up on the back of the ox cart and she stood there and waved as the ferry drew Maude across the Penobscot to Brewer. Another carter waited on the other side of the river. Maude's trunk was transferred to the cart and they headed toward Orrington, five miles downriver.

Orrington consisted of a church, a school, a cemetery, and a handful of one- and two-story frame dwellings clustered near a corner where two roads met. One road led west down to a ferry slip directly across from Hampden, the largest town on the Penobscot. The other road led north back to Brewer, or south to Bucksport.

Maude's thoughts wandered as the cart bumped and trundled along.

Since the British invasion, Bangor's population had grown to more than a thousand. The Penobscot was still the most important source of livelihood. Fishermen caught bushels of salmon and alewives in the spring of the year. The fish were smoked and packed into wooden barrels and shipped to Boston. An increasing number of men cut trees in the vast pine forests north of Bangor. They floated logs downriver to sawmills where the logs were sawn into boards. The boards were in great demand in cities up and down the eastern seaboard.

After the Treaty of Ghent was signed in 1815, officially ending what local inhabitants had dubbed "Mr. Madison's war," the British and Americans maintained peaceful relations. Local politicians turned their attention elsewhere. Wherever she went, Maude heard talk that the District of Maine would separate from Massachusetts and become a State of the Union within two years. There was also a lot of talk about temperance and how the free flow of rum ought to be curbed.

Maude was interested in temperance. She had, more than once, tended men, women, and children whose health had been ruined by too much spirituous drink.

The cart bounced and swayed. Maude held onto the side of the seat. Her thoughts went to the apprenticeship she would serve with Sally Robinson. Very few midwives, she knew, had any kind of formal training. Most women learned to be childbirth operators because they were good neighbors helping a friend or relative in need. Most lying-in women stayed abed for six weeks. It was imperative that friends or family care for older children, wash clothes, milk the cow, tend the fire, and carry on the tasks only female hands were best suited to. These same women also aided with the birth. In this way, the skills of birthing were acquired as easily and naturally as swapping a quilt pattern or memorizing a recipe for blueberry cake, making birthing just one more aspect of women's work.

But not all women chose to exercise their skill on a regular basis. Those who did choose to call themselves a midwife charged a fee. Their good-neighborly work then became their calling, or profession.

Eli was quick to point out, Maude remembered, that women mid-

wives were fast disappearing. As more men studied medicine, and women continued to be barred from the same study, man midwives gained in popularity. The reason for this, Eli believed, was the use of forceps which the man midwives were trained to use. Female midwives had no experience with forceps. Forceps plucked the infant from the womb quickly, thereby shortening the birth and greatly easing the pangs of travail. This, in Eli's opinion, was a mixed blessing. The employment of a male midwife went against nature, violated a woman's right to modesty and chastity. Moreover, forceps in the hands of an ill-trained person, male or female, often caused more damage than good. There were many deaths associated with their use. Man midwives with forceps removed from women's hands one of the occupations they were best suited to. Eli had discussed these things with Maude.

The cart rolled up to a modest two-story dwelling on the outskirts of Orrington village and stopped. The house was painted a dull shade of red, the same color many preferred for their barns. Several smaller out-buildings stood behind. There were four small panes of glass over the front door. A kitchen ell was attached to the rear. It was a Cape Cod house very much like Eli's house. For the first time, Maude felt easy about living at Sally Robinson's.

The girl who opened the door was, Maude judged, about sixteen. Her hair was an unremarkable shade of brown. Her features were not striking in any way. She did not speak. She stepped back to let Maude in and led the way to the kitchen with her hands clasped modestly in front of her, eyes on the floor. Maude's first impression of the house was one of comfort and neatness. The scent of pine oil and unidentified herbs lingered in the air.

The kitchen was dominated by a huge fireplace. The mantel boards were painted a soft shade of green. The fire was low. A kettle simmered on the coals. A flax wheel sat in the far corner. The table was polished to a soft sheen. Several splint baskets of different sizes sat about the floor. One contained a cat and a litter of kittens. Another contained balls of undyed yarn.

A spare-framed woman sat by the fireside puffing gently on a clay

pipe. A halo of soft September sun filtered into the room. Motes of transparent dust drifted like a miniature blizzard within the shaft of light. The woman was dressed in the old manner. She wore a rayle which served as a combination shirt, petticoat, and sleeping garment. It had elbow sleeves with modest ruffles. A woolen bodice of deep red was laced over the rayle, flattening her breasts and increasing her royal bearing. Below the bodice, she wore a dark blue skirt with a spotless white apron tied over it. A much worn and mended pocked hung from her waist. Her head was covered by a curious cap with a wide band which hugged her head at the hairline. It puffed out slightly at the crown. She was, Maude guessed, about fifty. Her face was chiseled with a serene expression. Her features were thin and fine, stopping just short of being sharp. She was not handsome, nor was she plain. She did not rise. She indicated a vacant chair and Maude sat.

"I'm Mistress Robinson."

Maude felt as if she'd been ordered to sit by an empress. She straightened her spine, folded her hands in her lap, and arranged her feet squarely in front of her, as if she were in church. It was an instinctive response. There was no doubt that Sally Robinson was accustomed to being in command.

"Your father is the only physician in these parts who is opposed to man midwives. I have great respect for your father. I understand he has trained you in doctoring," Sally said. She puffed a bit on her pipe.

"Yes, ma'am. Since I was very young."

Sally took a long draft on her pipe. She let her gaze wander from Maude's face to her feet. Maude didn't dare to fidget. She lifted her chin and met Sally's frank assessment.

"I believe the greatest reason the man midwives are employed is because childbirth operators have not been properly trained. I believe they do not maintain a proper degree of cleanliness."

Maude leaned forward eagerly.

"That's exactly what Papa says."

"It is a canker to me, Miss Richmond, to see man midwives called to birthing women. Your training with me will be more rigorous than the

few months of book-reading these upstart physicians obtain. You will be out at all hours in all kinds of weather. There is the matter of the washing. Records must be kept in exact detail. I go where I am called when I am called. I expect you to do as I say until I decide you are ready to attend births alone. Is that understood?" The mother cat jumped into Sally's lap and she stroked the cat's back. Her hands moved with quiet grace. Her fingernails, Maude noticed, were clean.

"Yes ma'am," Maude said. Her impulse was to cross her heart and hope to die. She didn't do it.

Sally set her pipe down.

"I take it you brought clothing more suitable for midwifing than that frivolous gown you're wearing?"

Maude had never thought of her old brown gown as frivolous, but she dared not say so.

"Mrs. Howard saw to it that I packed rayles. I've also brought old sheeting, an oil cloth, some of my father's medicines, and other herbs I thought might come in handy."

Sally nodded.

"Betsey," Sally called softly. The girl who had shown Maude in appeared. "Betsey doesn't speak. She was born that way. A deformity of the tongue. She was left under a bridge to starve when she was three days old. I found her and took her to live with a childless woman down the road. Now Betsey keeps house for me. She will show you to your chamber. Suppertime is at four."

For the first time, Sally smiled. The transformation was instantaneous. The sharp angular planes of her face evolved into kind curves. Her eyes softened from icy granite to warm linsey-woolsey.

"We'll get along, you and I, Maude Richmond," Sally said.

8

THE WASH HOUSE emitted plumes of steam in the brisk late October chill. The sharp odor of vinegar and lye soap made Maude wrinkle her nose in distaste. Every scrap of cloth that touched any of

Sally's patients was soaked in the vile concoction. This chore was performed every week. It was heavy labor. The night before wash day, which was every Monday, a fire was kindled under the great iron pot. Endless buckets of water were hauled from the well to fill the pot. In the morning, the hot water was ladled into wooden tubs. Sheets, bandages, and other linens were then scrubbed, rinsed, wrung out, and returned to the big pot to simmer. The sound of the hired man's axe seldom stopped. It took a lot of wood to keep the wash house in business.

Babies, Maude had quickly discovered, arrived at the most inconvenient times. Almost immediately she learned why Sally insisted on the old-fashioned rayle as her professional costume. Dressing in the middle of the night was as simple as dropping a skirt over her head, fastening it, stuffing her feet into her shoes, and grabbing her cloak as she went out the door. It took less than five minutes.

Maude stirred the mass of washing with a long-handled paddle and fished out the dripping fabric. Wringing out, the part she hated most, was still to come. Her hands, chapped and sore, were relieved only by copious applications of a salve Sally compounded in her kitchen. Once, Maude had dared to question Sally about the necessity of such constant cleanliness. Sally had replied sharply.

"Women in my care don't die of childbed fever. If you care nothing for the safety of those under your care, I suggest you go home to your father." Maude had quickly closed her mouth and got on with her work. Usually, Sally presided in the wash house, doing her share and making the work less onerous, but on this day she had been called away to visit an aged relative whose life was drawing to a close.

Maude wiped her hands on the back of her wool skirt. She straightened her back wearily. A sharp gust of cool air cut through the warm dampness of the wash house. Eben Wheeldon poked his head cautiously through the door.

For six entire weeks, from the first day Maude had made his acquaintance, Eben had followed her around like a puppy, an adoring look in his cloudy gray eyes. He was the village schoolmaster, a bookish man in his early thirties. He had a homely face and a receding hairline. He boarded at Sally's.

"Here, Miss Richmond, let me do that," Eben said. He lifted a tub of wet washing awkwardly. He was not used to heavy work and set the tub down twice before he reached the clothesline. Maude thanked him.

"You are much too delicate of stature, Miss Richmond, to carry such a burden. You must call me whenever you feel yourself unable to accomplish such a heavy task. I'm quite willing to be of service to you." Eben smiled, crookedly, warmly.

Too eager, Maude thought, and pitied him for it.

"I rather doubt you'd much appreciate it if I called you away when you were in the middle of conjugating Latin verbs, Mr. Wheeldon."

"Why, no. I was referring, of course, to those times when I am here."

"The only time you are here, Mr. Wheeldon, is *after* the heavy work is done. Why aren't you at the schoolhouse?"

"I called recess and left one of the older boys in charge for a few moments while I called on you."

Maude tipped her face up close to Eben's and smiled as sweetly as she knew how.

"Oh," she said, "there's another tub inside, Mr. Wheeldon. I'd be so obliged if you'd carry it out." Eben's face registered mild surprise, but he did as he was asked. He breathed a bit heavily as he set the second tub down, coughed discreetly into his handkerchief, and wiped his brow.

Eben's clothes, Maude observed with distaste, needed washing. His jacket was threadbare at the elbows, his pantaloons bagged at the knees. His boots were nearly worn out and sadly scuffed.

"I was wondering, Miss Richmond, if you planned to attend the gathering at the Severance place?" Eben's eyes were hopeful. For a moment Maude thought he was about to declare himself. She hoped he wouldn't. Even though there was so little about him to admire, she preferred not to have to decline a proposal and hurt his feelings. Certainly, Eben was intelligent and well read, qualities Maude admired in a man, but there was something about Eben's humility, his cringing deference to everyone that put her off. And worse, he craved pity. He had, he'd once confided at the dinner table where he was assured of a sympa-

thetic audience, been disappointed in a matter of the heart. He had pledged never to offer his affections to anyone again. He spoke with an odd vulnerability that clung to him like burdocks. This quality had, thus far, enabled Maude to treat him kindly, if not seriously. Unfortunately, Maude had discovered that while Eben was not inclined to pledge his heart, he was more than willing to wear it on his sleeve.

Maude hesitated before she answered his question, wanting to phrase it in a way that would let her off the hook if Eben forgot himself.

"If Mrs. Robinson and I are not called away, I believe we will attend for a short while."

"Then would you deem it an impertinence if I asked you to partner me in a reel?

"Impertinent of you, Mr. Wheeldon? Why certainly not. But you surely understand that I am in a position where I must look after my reputation. People will talk. Might I suggest, sir, that you dance a few times with Betsey first. That should still any wagging tongues, don't you think?"

"I assure you, Miss Richmond, that I will do my utmost to preserve the honor of your name. How very clever of you to suggest it. Betsey is a dear child. Poor silent creature. I consider it my duty to see that she has a bit of fun."

Maude had seen Betsey's eyes follow Eben. She had noted how Betsey saw to it that the tenderest chicken leg, the largest portions of pudding fell on Eben's plate. She had seen the quiet look of compassion on Betsey's face whenever Eben recited his oft told story of his "disappointment."

"How very kind of you, Mr. Wheeldon. I'll put you at the top of my list. And Mr. Wheeldon, as a special kindness to me, would you carry an armful of wood to the kitchen? Good day."

Maude bent to retrieve the empty tubs. Sally came around the corner of the wash house.

"What in the world has got into Eben Wheeldon? He looks like the cat that got the cream." Sally eyed Maude curiously. There was a hint of laughter in her expression.

"I promised to dance with him tomorrow at Severance's."

"Don't count on being at the gathering too long. Mr. Stone spoke to me about his wife today. She's nearing her time. And the Fowler children have the quinsy. You've finished, I see. Well, no time to waste. The kitchen needs scrubbing." Sally headed for the house. Her skirts flapped busily in the breeze. Maude sighed and trailed along behind.

<p style="text-align:center">9</p>

MAUDE'S MOUTH WATERED. Baked beans, bread, stew, pickles, jellies, and an assortment of cakes and puddings crowded the tables set up just inside the door of Severance's barn. Everyone had brought something to contribute to the supper. Maude had brought gingerbread. Sally had brought applesauce.

The barn was dim even with sunlight streaming through the open doors. The loft was full of hay. It had been a good year for hay. Leather harnesses hung from wooden pegs. A cow mooed from a stall. Several chickens pecked around in the hay strewed over the hard dirt floor.

Mothers left their infants on a pile of hay provided for that purpose. Older children were assigned to mind the smaller ones. The atmosphere in the barn was convivial now that the hard work of harvest was nearly done.

An easy buzz of talk filled the barn. Two fiddlers tuned their violins with the tentative scrape of bows on strings. They launched into a lively jig. Couples formed for the first reel.

A good many demi-johns of hard cider were handed around. The squeak of cork stopples pulled from bottle necks punctuated the rolling strains of music. Maude tapped her foot to the music. She tucked her unlovely hands into the folds of her dark blue, white-figured dress.

Most of the menfolk had adopted the shorter haircuts made popular by the poet Lord Byron. Some of the elderly gentlemen still wore their hair long, in a queue tied with a black grosgrain ribbon. These men wore knee britches in the old style. The younger men wore the newer-fashioned pantaloons which extended all the way to the ankle. The

ladies wore their best gowns of muslin, linen, or wool. The sleeves were wide, skirts full, and the waistline had dropped from just under the breasts to its natural place. Aprons had been left at home. Married women wore ruffled white caps tied under their chins. Unmarried women were bareheaded.

Sally put the food she and Maude had brought on a table.

"Where's Betsey, Maude? I haven't seen her since we got here. Perhaps I shouldn't have let her come on ahead of us," Sally said. She searched the barn's dim interior with her eyes. A note of impatience girdled her voice. Sally liked to keep track of the people entrusted to her care.

"She's dancing, Mrs. Robinson," Maude said pointing to the center of the barn floor.

Sally manuevered for a better look. She was handsome in a dark red wool gown.

"Dancing? Betsey never dances. There's not a lad on the river that's ever looked twice at her. I was beginning to think she might never have a chance. Who's she dancing with?"

"Eben Wheeldon."

Sally's eyebrows rose in surprised arches. She fixed Maude with a bland stare. "Matchmaking are you, miss?"

"No, not entirely. I fear Mr. Wheeldon has formed an attachment for me. I do not share it. I hoped to divert him by suggesting he dance with Betsey. Betsey admires him very much."

"Yes, I know. Betsey doesn't speak, but her eyes do. I've seen her watch Eben. She's eighteen. Time for her to start a family of her own. She could do worse than Eben Wheeldon. He's steady enough for all his affected ways."

Betsey's yellow skirt flew and flashed around her ankles. She skipped and swayed through the figures of the dance. Her plain face was alight with a radiant smile. Eben was equally plain. His jacket, the one he always wore, was brushed cleaner than Maude had ever seen it. He steered Betsey competently through the dance.

A man in knee breeches came up to Sally. He took her elbow and they joined the dance.

People milled about the barn like moths in bright light. Maude stood a little apart and watched. She was not, by nature, a joiner. Observation was as natural to her as breathing. She thought how women's labor had provided the food on the table, and how men's labor had provided the ingredients that went into the food. Why was it, she wondered, that only women cooked and only men planted?

Eben came to claim his dance. It was, to Maude's dismay, a round dance. It required a great deal of arms around the waist and clasped hands. Eben handled Maude as if she were glass. His manners were rigidly correct, but he took every opportunity to press her against his side. He murmured how delightfully she danced, how very handsome her dress was. By the end of the figure, Maude felt as if she'd been mapped, surveyed, and fenced in.

"Perhaps another, Miss Richmond, after you've rested a bit," Eben suggested eagerly. He clung tightly to Maude's hand. She had difficulty drawing it away.

"I'm very fatigued, Mr. Wheeldon. Perhaps you could engage some-one else. Betsey is sitting alone. I know she admires your dancing very much."

"Is that so? I've never thought of Betsey," Eben said. He paused before he went on. "But you said yourself, Miss Richmond, that one mustn't dance too often with the same person. Talk, you know. I'll sit here with you while you get your breath. Speaking of talk, now there's talk for you." Eben inclined his head toward a man dressed in a sober shade of gray. "Edmund Damon. The man midwife. Delicacy forbids me to say more. I dare say Mrs. Robinson is none too pleased to see him here. I hear he's been called by several women who usually call her. Even Mrs. Severance, I have been given to understand, has lately made use of his service."

Maude stared openly at Edmund Damon. After all she'd heard about man midwives from Eli and Sally, she half expected he'd have horns and a forked tail. Instead, Damon was handsome. His eyes were as dark as his curly hair. He carried himself with an assured air. He was the cen-ter of attention in a group of giggling young women, none yet married.

Sally strayed across Maude's line of sight, blocking Maude's view of Damon. She was making beckoning gestures.

"Excuse me, Mr. Wheeldon. Mrs. Robinson is looking for me."

As Maude rose to leave, Edmund Damon fastened his dark eyes on her. His glance held hers for an instant. There was no warmth, no friendliness in his look. It was like peering into a frozen pond and seeing no depth. She tripped on the hem of her gown. Eben sprang to her assistance. She shook him off, nettled.

Something about Edmund Damon irritated Maude. She did not know what it was. She made her way to Sally's side.

"I've been called to see a woman by the name of Mollie Smith. She's bad off. We must leave now," Sally said.

Maude and Sally made their excuses to Mrs. Severance. Maude was not sorry to leave. She had had about all she wanted of Eben Wheeldon.

There was no time to go home to change into rayles. Maude did not fret about the possibility that her best gown would be ruined. She had long since resigned herself to the fact that as long as she tended the sick, her clothing would get soiled with sweat, vomit, urine, and every other body fluid imaginable.

It wasn't much more than two miles to the edge of the village where the Smith woman was.

The village road wove up and down several steep hills then veered away from the river. The leaves splashed the day with crimson and gold. It was warm for October. Maude slung her gray knitted shawl over one shoulder. Every so often she ran a step or two in order to keep up with Sally's longer strides.

They spoke of some of the lying-in cases they had recently attended. Sally did not mention Edmund Damon, but Maude broached the subject.

"Eben Wheeldon says there was a man midwife at the gathering, that he has been in town for several weeks."

Sally kept her eyes fixed on the road unfolding before them. A shadow of annoyance sharpened her face.

"Edmund Damon won't be around for long. He'll stay just long enough to line his pockets. Then he'll head for greener pastures. I've seen his like before. He's already been called to two who have died from childbed fever." Sally's voice was hard. Childbed fever was the most frequent cause of death to birthing women. Sally's cases rarely contracted the deadly disease. "Two infants he delivered were still-born," Sally went on. "Damon has put it about that others would have died, too, if he hadn't had his forceps to fall back on."

Sally's steps were small attacks on the road. Dust clung to the hem of her gown. She adjusted the pocket tied at her waist. The pocket contained a few packets of powdered herbs, scissors, a thimble, needles and thread, and a small Testament in case it was necessary to read prayers for the dying.

Maude knit her eyebrows together. What Sally had said troubled her.

"Why do women call a man midwife if his methods are dangerous?" she asked.

"Some still owe me my fee from the last time I attended them and are embarrassed to call me again. Some just want the rest of the town to know they can afford the man midwife. Some think that because his fees are superior, he possesses superior skills." Sally strode on, then stopped. "Maude, you already know that every two years, as soon as the last babe is weaned, a married woman will be brought to bed with another infant. She gives birth so often she doesn't have time to forget the pain of the last birth. The man midwife promises his forceps will shorten travail and lessen the birth pangs. Women believe this. They believe the old way is no longer the best way."

"Then why not just leave the business of lying-in to men and be done with it?" Maude asked.

Sally's annoyed expression deepened.

"As women, we have little to say about the events that shape our lives, Maude. We cannot vote. We have no voice in how we are governed. When we marry, everything we have, our household goods, the clothes on our back, even our children ceases to be ours and becomes

the husband's property. An abused or deserted wife has no recourse in the courts. She cannot divorce her husband. If she wished to live apart from him, or is widowed, there are few ways to earn an honest living."

"She takes in sewing or teaches school. Or keeps an inn or keeps house for someone," Maude said. She thought of Mrs. Howard.

"Or she practices the art of midwifery. It is the one proud profession women have possessed for centuries. We are the keepers the mysteries of birth. That belongs to us. Now it is being stolen from us. I have taken you as my apprentice because I am too old for the battles that must be fought to keep our profession in our hands. My duty is to hand on what I know. It must not die with me. Your task is greater than mine, Maude. You must enlighten others. Men as well as women."

Sally's words settled in Maude's head like homing pigeons, nourishing the seeds that had taken root the day she had delivered Sarah John Thatcher.

Sally's footsteps were no longer attacks on the road. She had spoken her piece. Her annoyance was relieved.

"We are going to see a young woman whom most brand as one of easy virtue," Sally said after a long silence. "She was compelled to sell herself in the streets in order to live. She has been unfortunate enough to get herself with child. She came here from Bucksport. The constable arrested her several times for lewd conduct there, and she was sent off. Orrington doesn't want her either. She has nowhere else to go."

Mollie Smith's dwelling was little more than a hovel, a place most people would hesitate to house animals, let alone people. The roof was sagging. The bare boards were weathered to a dull gray. The walls were full of cracks. There was no window glass. The yard was littered with rusty barrel hoops, rotten staves, a dead chicken, and an old dilapidated trunk. Shards of glass and pottery glittered fiercely in the sun.

Sally and Maude picked their way through the mess to the door. It did not close properly. The floor inside the shack was an uneven mass of hard-packed dirt. There was no fireplace, no well, no comforts or conveniences of any kind. It was the worst place Maude had ever been in.

Mollie Smith lay on a heap of mouldy straw covered with a tattered

blanket. Her filthy hair was loose and matted around her face. She was fine-featured and might once have been pretty, but a life of want and hardship had erased whatever beauty she might once have enjoyed. She was, Maude thought, in her twenties. She was big with child.

"If I ever lay my hands on the bastid what did this to me, I'll knock his rotten teeth clear down his filthy throat!" Mollie screamed.

Maude wadded her shawl into a ball and placed it under Mollie's head.

"Simmer down, Miss Smith," Sally said. "Wages of sin are paid in coins of travail." She was matter-of-fact, unfluttered.

"Wages of sin my arse. That swine swore we was gonta be married."

"How long have you been in travail?" Sally asked. She knelt on the damp floor beside Mollie.

"All night long and all day and I ain't never hurt so hellish bad in all my borned days. The rotten bastid!" Mollie writhed and thrashed. Her face was contorted with pain. Maude laid a hand on Mollie's arm. When the pain had eased, Mollie lay spent and sweating. The anger was gone out of her.

"That's right, Miss Smith, you just lie there quiet while Mrs. Robinson makes an examination," Maude said soothingly. Fire flashed in Mollie's eyes seeking a target.

"Who the hell are you to be tellin' me what to do! Miss Priss that butter wouldn't melt in your mouth. No bastid ever got you knocked up and left yer to fend for yerself, did they?"

Maude ignored the harsh words. She stroked Mollie's arm, slowly, easily.

"Anchor yourself, Miss Smith," Sally said. "We sympathize with your difficulty. We are here to help you. But we cannot if you don't allow us."

Sally arranged Mollie's knees up so she could make a visual examination. Midwives did not make vaginal examinations. Another pain clamped across Mollie's belly. Sally held her hands on Mollie's abdomen to feel the strength of the contraction and assess the position of the infant.

"The child ought to be farther down in the pelvis by this time," Sally said to Maude. Her eyes were troubled.

Mollie's lower lip trembled.

"I'm gonta die, ain't I?" She was very calm.

"Death is in God's hands, Mollie. Birth is in mine. You can't stay here. I'll take you to my house. Maude, go back to Severance's and borrow a wagon. Don't be long."

<div align="center">10</div>

MOLLIE SMITH'S TRAVAIL went on for two days. It was Maude's first encounter with a complicated birth. Nothing had prepared her for the ordeal. She had seen people die. She had sat with the dying, prayed with them, eased their last moments. That had been easy compared to Mollie's suffering.

The household crept through its normal functions. The pace was slowed by the abnormal hours Maude and Sally kept. Maude did not sleep more than an hour at a time. Fatigue dulled her senses.

Mollie's screams had finally subsided into strangled gasps for breath. There was no place in the house that did not harbor the excruciating hiss of air escaping reluctantly from lungs too weak to empty themselves. Maude thought of an animal in the hands of an inexpert slaughterer and shuddered. She wanted to lash out. She wanted to break something.

Maude was just outside the kitchen, on her way to fetch some broth. Eben and Betsey were sitting at the table peeling apples.

"It's God's will. It's his punishment for her sinful ways," Eben said. He alluded to the fact that Mollie was a fallen woman. Maude marched into the kitchen, and the black presence of her anger engulfed her. Frayed nerves, lack of sleep, the utter helplessness of the situation flowed upward from a hidden core of Maude's heart. It ignited and exploded in Eben's face.

"God's will? That woman should suffer the tortures of the damned to do His bidding? To be fruitful and multiply? All women risk this

savagery, Mr. Wheeldoon. Not just the fallen. Praise God you were disappointed in love, sir, that no woman will ever suffer to bear your seed!"

The imminence of Mollie's death chilled the air. It soured the regard Eben held for Maude. His face went white, then crimson. He set down the paring knife. His hands balled into fists.

Betsey's eyes melted into an eloquent message of sympathy. Eben turned instinctively to her for comfort.

Maude poured broth into the invalid feeder and went back to the small chamber where Mollie lay.

The chamber jutted out from the main part of the house. It was tucked behind the parlor. Plain white curtains were drawn across the only window. The narrow bed was set on blocks of wood to make it high enough to spare Sally's back from too much bending. Mollie's face was like wax. Her hands rested across her belly. She did not move. Her eyes were closed.

Strangled breathing lacerated the air. Sally was on her knees near the window reading aloud from the small Testament she always carried with her. Her face was tense and haggard with lack of sleep. She was not wearing a cap. Her hair was braided and bound around her head. Her hair was mostly gray.

"I've sent for Dr. Livermore," Sally said tiredly. She had discussed that possibility with Maude early that morning. In difficult cases, it was Sally's practice to send for someone whose skill was greater than her own. "I've told him to bring his crotchets."

The crotchet was an instrument used to dismember an unborn infant and thereby empty the womb. It was a drastic measure. It was used only when the life of the mother was despaired for and the chances of survival for the infant were nil.

Maude's courage faded like the leaves that trembled on the maple outside the window. Her knees buckled slightly. She grasped the bedpost for support.

"You needn't stay if you don't wish to, Maude," Sally said gently. "It's not a sight anyone ever gets used to. I'll not think less of you."

Maude tipped her head back and took a deep breath. She swallowed hard. She shook her head firmly. "No. I'm a midwife. I'll stay."

"Then all that's left to do is wait and pray."

Maude knelt on the bare pine floor beside Sally. Her gown cushioned her knees. She felt numb and cold. She could not pray the usual prayers. Anger lay heavy as a granite stone around her heart. She had seen death before. Young and old alike. Death was as much a part of everyday life as birth.

Maude knit her fingers together tightly. Her knuckles turned white. Please God, she prayed. Nothing else followed. It became a litany. Please God, Please God, over and over. The prayer washed over the stony place in her heart and gave no relief. There was no change in Mollie. Her life continued to batter itself away like a bird flown against a window pane.

Dr. Livermore arrived, did his work, and left. Shortly after, with an almost inaudible sigh, like air eased from a bellows, it was over. The house was unreasonably quiet. The room was suddenly empty.

Maude reached for the looking glass and held it to Mollie's lips. No vapor clouded it. She reached for the record book Sally had taught her to keep.

Died this day, Oct 19, 1818, Mollie Smith of South Orrington, 10 Morn, in Childbed. Anger clenched Maude's hand around the pen, but it was steady as she wrote. She burned with a glassy heat. It suffused her with a deadly calm. A vicious voice whispered inside her head. It said, only women become the victims of the act of love.

Maude had never encountered such an alien idea. It stunned her to think it emanated from her own mind. Mollie Smith, Maude thought, had known and accepted it. Sally understood it, too. She spent her life confronting the consequences of what the act of love did to women. Women who partook of the pleasures of the flesh risked the tortures of childbirth. All women. Not just fallen women. All women old enough to bear children.

Edmund Damon snaked into Maude's thought. Was he privy to this knowledge? Could he have helped Mollie with his forceps, with his

secret method, a method unknown to midwives? Would Mollie have died anyway, if not during this lying-in, then in a subsequent one? Did Edmund Damon ever think how the act of love made women its victims? The questions rolled and thundered.

Sally touched Maude's shoulder. Her hand was a reminder that life does not stop. Together, they combed Mollie's hair and tied a blue ribbon in it. They washed her body and dressed her in grave clothes. They arranged her hands in a loose clasp on her chest. They performed the final acts of kindness one woman could do for another.

Maude spent the five dollars Eli had given her on a marking stone.

Autumn turned to winter with a bold slice of deeply cold wind. Snow drifted and nearly covered Mollie's marking stone. Her death receded in Maude's memory, but it did not disappear. The heavy weight of anger settled at the core of Maude's being. She carried it close to her heart like a precious gem. It gave her eyes a flinty look. It sharpened the edge of her tongue.

Eben Wheeldon kept his distance and spent more time with Betsey. At the end of December, he asked for Betsey's hand. They were married at the New Year.

If Sally noticed any change in Maude, she kept it to herself.

In February, a call came from Mrs. Jones. Her fifth child was about to be born. Her previous deliveries had been easy and uncomplicated. Sally told Maude to go, that she was skilled enough for a simple birth like the ones Mrs. Jones presented. The specter of Mollie's death formed and troubled Maude for a moment. Her confidence in her own growing skill was stronger. Sally had other cases to see. Maude rode off into the rolling hills of Orrington.

The weather had turned bitterly cold. Maude was riding Sally's gray mare along a snow-packed road near Swett's Pond. She scanned the horizon. A thick pall of dull gray clouds covered the sky. The wind was from the northeast. She knew from the signs that a bad storm was about to break.

Maude rode as far as Mr. Flood's, the Jones's nearest neighbor. She left the mare at his farm. He took her in his sleigh as far as the road that

led to the Jones's place. Mr. Jones met her and conducted her the last several miles. Snow began to fall heavily.

Mr. Jones left to take his other children to their grandmother. Then he would fetch Mrs. Jones's women.

Mrs. Jones had taken to her bed. She complained that her travail was somehow different than her other births. A small flutter of anxiety twitched at Maude, but gave way as Mrs. Jones declared herself perfectly comfortable.

Several hours after Mr. Jones left, there was a knock at the door.

Edmund Damon stood on the step. Snow covered his hat and shoulders. He was huddled into a heavy black cloak.

"You got here first I see," Edmund said. He sounded disappointed.

Maude was not surprised to see him. It was common for the husband of a lying-in woman to summon three or four midwives at once. The theory was that one out of four would be sure to arrive in time. Every so often, everyone summoned arrived. The case belonged to whoever arrived first.

"Come in," Maude said. Her face was closed.

"No need to look so stern. I'll be on my way as soon as I dry out a little," Edmund said.

Maude stirred the fire in the kitchen. She added another stick of wood. This gave her time to observe Edmund Damon, to think what she would say to him. She did not like him and she faulted herself for that feeling. She didn't really know very much about him except for what the village grapevine divulged. She had heard that he was most apprehensive of the modesty of his cases. He conducted his examination by touch alone. He never allowed his eyes to leave those of his patient, thus assuring her that he would not view her private parts and infringe on delicate sensibilities. Women who had been delivered by Damon swore they'd never have anyone else. Others declared they'd never let him come near again. There were several disgruntled husbands who did not like the idea of a strange man, midwife or not, touching their wives' bodies.

Maude didn't know what to think. She only knew that being in the same room with him made her uncomfortable.

"The storm has worsened," Maude said politely. She felt small and inept in Edmund's presence. He was very tall and seemed very sure of his right to be there.

"It's a bad one. I don't dare to stay too long. The drifts are a foot deep in some places already. If this keeps up all night, we'll have two feet of snow by morning."

A nibble of uneasiness bit at Maude. She peered out the window.

"Mr. Jones may not be able to get back here."

"I wouldn't think so. I had a hard enough time as it was. Will you need help?" It was a casual question. It implied that Maude was not skilled enough to deliver Mrs. Jones.

Edmund lifted his coattails to let the heat dry the seat of his gray wool pantaloons.

"No," Maude replied quickly, coolly. "Mrs. Jones has an easy time of it. Thank you just the same. Could I fix you a hot drink? Tea, perhaps?"

Edmund smiled politely.

"I seem to have forgot my manners. Please permit me to introduce myself . . ."

"I know who you are, Mr. Damon."

"And I know who you are, Miss Richmond." Edmund looked out into the storm and paced uneasily. "By the look of those drifts, I'd better not try to get back to town tonight."

"You're quite welcome to stay until the storm is over, Mr. Damon. I'll inform Mrs. Jones."

Maude checked on Mrs. Jones's progress. She was dissatisfied with it and didn't know precisely why. Mrs. Jones was certain she was having bearing down pains and wanted relief. Maude returned to the kitchen to prepare an infusion of willow bark. Willow bark eased the discomfort of many kinds of pain, including childbirth.

Edmund had removed his cloak. He stood in the reddish light cast by the fire. Evening was drawing in.

"Will Mrs. Robinson have fits when she discovers her prize pupil is in the company of the terrible man midwife?" His tone was teasing. He, too, partook of the fruits of the village grapevine.

Maude bristled. She was in no mood for teasing. She plunged the willow bark into a mug of hot water and let it steep, like tea.

"Mrs. Robinson is not given to having fits about anything, Mr. Damon. She believes her opinion of you is well founded." She said it more coolly than she felt.

"Local gossip, Miss Richmond, is not the way to form an opinion of one's character or skill."

Little ripples of anger cut across Maude's tongue.

"But it is your cases who die rather steadily, Mr. Damon. Not Mrs. Robinson's."

Edmund's eyes narrowed and grew darker, almost black. His full lips tightened.

"It's no fault of mine if I am not called soon enough. The Smith woman might have lived had Mrs. Robinson had sense enough to call me at the first sign of trouble."

Anger rumbled in Maude's breast and swelled to huge proportions.

"You are too self-satisfied, sir! You could have done nothing. The Smith woman's child was crosswise and could not be born."

But even in the indignation of her disavowel, the question haunted Maude. It stuck like a burr to a wool stocking. The more she picked at it to make it go away, the more deeply it matted into the fibers of her thought. Could Edmund Damon have helped?

Edmund sat down on the settle with his wet feet to the fire. His expression was sullen.

"The storm is much worse. We'll be here for days," he complained, ignoring Maude's last remark.

"Mr. Damon, since we are obliged to remain under the same roof until the storm passes, can't we call a truce? Mrs. Jones time is very near. If you would be so kind as to bring some wood and set another kettle to boil . . ."

Edmund rose and made a mocking salute, as if Maude were a general in charge of troops.

"Yes, ma'am," he said. Maude let it pass.

When Edmund returned with an armful of wood, Maude was scrubbing her hands. She wiped them on a linen towel. She dropped her scissors and a length of fine cord into a pot hanging from a crane over the fire.

Edmund put the wood into the wood box with icy clattering. He watched Maude prepare for Mrs. Jones's delivery.

"What are you doing?" he asked.

"Cleanliness, Mr. Damon, is next to Godliness," Maude replied tersely.

"I'm serious, Miss Richmond. I've never seen anyone scrub the skin off their hands or make soup out of twine and scissors as a means of preparing to attend a birth."

"My father is a physician, Mr. Damon. He taught me that infection is spread by contact with unclean things. He, and Mrs. Robinson, believe cleanliness helps prevent childbed fever. We boil everything that may touch the mother and babe."

She put another stick of wood onto the fire.

Edmund peered into the pot. Skepticism played across his face.

"There was a lot of talk about the connection between unwashed instruments and the spread of disease when I studied in England. Quite a controversy. No one took it too seriously. Waste of time, most thought. I tend to agree."

Maude tied on a clean apron.

"But it is your cases who take childbed fever, Mr. Damon. Not Mrs. Robinson's."

Maude returned to Mrs. Jones's chamber. She knew immediately, instinctively, something was amiss. The infant's head did not present itself in the usual way. She thought she saw a tiny elbow squashed to the infant's head. She tried to manipulate it into a better position as Sally had taught her to do. It did not help.

For a split second, Maude gave in to panic. She was wrong in her assessment, she told herself. She watched a few more contractions. Nothing changed. The child was lodged in the birth canal as tightly as a cork stopple in last year's vinegar jug.

Outside, the fury of the storm increased. It beat its head about the corners of the house. There was no hope of sending for Sally or anyone else. There was no one to turn to for help except Edmund Damon.

Maude weighed the idea in her mind. A sound similar to the dying breaths of Mollie Smith oozed into the chamber. It was the wind moaning in the evergreens beside the house. Anger hummed its jagged tune.

Maude found Edmund dozing by the fire. His cloak was spread over him to keep out the drafts. The fire had burned down to embers. Maude stirred it and laid more wood on. The sound disturbed Edmund and he woke with a start.

"Mrs. Jones is in difficulty. The child won't come down. I need your help."

Edmund got to his feet. He flung his cloak aside.

"Are you sure?" he demanded.

"Yes. I'm sure. I've tried manipulation. It didn't help. You'll need the forceps." Maude hated to say the last word. But the lash of her anger would not allow her to abandon Mrs. Jones to a fate similar to Mollie Smith's. Edmund reached for his medicine box. He drew out a cloth bag about as long as a man's forearm.

"I assume, Miss Richmond, that you are handing this case over to me."

He started for Mrs. Jones's chamber.

"No, sir, I am not," Maude said firmly.

Edmund stopped in his tracks. He fixed his hard, dark eyes on Maude. The logs hissed and crackled. For a moment, Maude thought he would refuse to help.

"A third of the fee goes to me," he said coldly.

"A half, Mr. Damon, if you boil the instrument and scrub your hands." If he refused her demand, Maude was prepared to capitulate and give up the entire fee.

"Now that's a bargain I can't refuse."

Edmund drew the forceps out of the cloth bag. The instrument consisted of two enlarged spoons of metal with wooden handles. There was a slot on one and a button on the other so they could be joined

together once they'd been inserted into the birth canal. The spoons cupped the infant's head to draw it out. He dropped the instrument into the pot. He took some soap and washed his hands.

By midnight they had finished their work. Maude sat in a straight chair near Mrs. Jones. Edmund sat further away by the chamber door. Except for the application of the forceps and the successful extraction of the infant, Maude had stayed in charge.

She was amazed at how the forceps had eased the birth. But she was equally dismayed by the bruises it left on the child's head and the tearing it had caused Mrs. Jones's body. Maude had stitched the tears and soothed Mrs. Jones. She had dressed the infant.

Now had come the time for watching. If Mrs. Jones's condition was to become dangerous and decline into childbed fever, signs would appear before morning.

Mrs. Jones and her infant son slept peacefully. The silence between Maude and Edmund stretched out, cat-like, in the chamber.

Maude folded her red hands in her lap. She tried to sort out the impressions she had received as Edmund Damon wielded the forceps. She had seen, she was convinced, how midwifing would change. For good and ill. Forceps could be an ally. They had saved the lives of Mrs. Jones and her infant. In order to win the battle to keep midwifery in the hands of women, Maude knew she must learn the new methods or be broken by them.

But forceps were also an enemy. For births which progressed normally, as most did, forceps inflicted more hurt than help. Their indiscriminate use by man midwives overpowered the patient skills of female midwives.

The dilemma, as Maude now understood it, was how to resolve those two points of view. She was certain Edmund Damon, and others like him, would use the instrument in every case, needed or not. She was equally certain that if female midwives learned to use forceps only when it was necessary, they would become more skilled in their work. Lives could be saved. Needless suffering would be averted.

Midwifing, she saw, would change as all things changed. If she did

not recognize those changes as they happened, and adapt to them, Sally's prophecy of the demise of female midwives would surely fulfill itself.

Maude made up her mind. She would learn the proper use of forceps. She would ask Eli.

Maude glanced at Edmund Damon. He sat easily with one leg crossed over the other. His dark wavy hair was fluffed around his ears. He had made no attempt to ease Mrs. Jones's fears as he applied the forceps. He had laid no understanding hand on hers. It had been the same when Dr. Livermore had come to do his grisly business to Mollie Smith. Even Eli, as kind and caring as he was, left those things to women. That was woman's work. Edmund caught Maude's glance and smiled. Maude felt no attraction toward him. She did not return his smile.

Mrs. Jones slept quietly. No symptoms of fever troubled her.

Outside, the storm raged through the night. Its clamoring was a suitable accompaniment for Maude's thoughts. She stared at her hands as if seeing them for the first time. They were red and ugly from doing useful work. Women's work. They scrubbed and dug and soothed. Sometimes they closed lids on coffins and dressed motherless infants all in the same hour. They were not like the merely functional, mechanical hands of Edmund Damon.

Maude remembered how she'd changed Mollie Smith's bedgown as it became soiled with blood and sweat and excrement. She'd rubbed Mollie's back for hours. She had even sung to her when nothing else would ease her. These were the things women did for other women because they too had been, or would be, baptized by the blood of childbirth.

Maude turned her palms upward. Her hands were as raw as her heart. For the first time since Mollie's death, tears escaped from the citadel of her anger. The granite stones in her throat dissolved and slid away into the blackness of the storm.

WHEN THE STORM finally blew itself out, the deep drifts held the house in a muffled grip. The wind lifted snow in soft feathery swirls in the fields beyond.

Edmund Damon tended the animals in the barn. He found a pair of snowshoes and set off for town. Mrs. Jones awoke refreshed, with no signs of fever. By evening Mr. Jones returned with Mr. Flood in the sleigh, and Maude was conducted safely back to Mrs. Robinson's.

Sally sat in the kitchen, puffed her pipe, and heard Maude's story with her usual calm gravity. The wisdom of her years of experience as a midwife was deep in her eyes.

"Female midwives are barred from receiving training in medicine. We are barred from buying forceps. Those conditions are centuries old, Maude. Some things do not change. Learn to trust your hands. They are your instruments," Sally said. She remained convinced that Edmund Damon and the changes he represented must be avoided. Female midwives, she believed, did not need forceps.

It did not long remain a point of contention between them. In the spring, Damon married one of the Brewer girls. They went to Ohio to settle. Eben and Betsey Wheeldon, along with others from the Penobscot region, soon followed.

But for weeks, Maude turned the events at Mrs. Jones's over in her mind. Sally's way of midwifery was centuries old. It was shaped by a tradition of women helping women. It was viewed as an art. Damon's way was new. It was the product of a male mind which saw women as mere vessels of birth. A container to be emptied in the most expedient manner possible.

Damon's way, Maude reasoned, inflicted hurt as easily as it gave help. But Sally's way also had its drawbacks. When a midwife exhausted her skills, death was the inevitable result. Death, in turn, inflicted a greater hurt. It produced motherless children. The depth of that hurt could not be measured in the size of the bruises on an infant's head or the number of stitches required to close the loin.

Maude walked to the burying ground. It was late March. The sun held a new warmth. The hood of her dark green cloak was thrown back. She broke off a bunch of pussy willows, waded through an old drift, and placed them on Mollie Smith's grave.

Maude's anger was gone. It had been replaced by a growing conviction that what Edmund Damon knew, she must learn in order to augment Sally's teachings.

Mollie Smith's life was not saved because there was nothing else to try. Mrs. Jones's life was saved because there *was* a new way to try.

The ground was just beginning to tilt its warmth into the season. All around the burying ground were stirrings of new beginnings. It was spring. It was time for sending up new shoots.

Maude walked back to Sally's. She wrote to Eli and asked him to come visit her.

Eli arrived the very next week. The roads had broken up, and in some places mud was deep as a horse's fetlocks. Icy water ran in the ditches in wide, rapid rivulets. Trees hadn't yet budded out. A hazy shadow of palest yellow etched the hillsides. Orrington looked raw and poor. On the north sides of buildings, patches of rotten snow waited for warmer days.

Maude and Eli sat together in the parlor even though Eli preferred the cozy order of Sally's kitchen. The parlor was used only on important occasions—when the minister came to call or after weddings and funerals.

Eli looked very fit, Maude thought. He was clear of eye, strong of wind and limb, full of his usual energy. His boots were spattered with mud and a button was missing on his jacket. It was a new jacket of heavy navy blue wool.

Maude's little-girl feelings of safety and security settled over her as comfortable as the red shawl wrapped around her shoulders. A white muslin apron was tied over her old brown gown.

The fire snapped cozily. The room was bright from the light spilling in through the three windows. It was a corner room at the front of the

house. It was pleasant despite an arctic nip that still sliced the April weather.

"Won't be long before it'll be fiddleheadin' time," Eli remarked. He greatly relished the tender fiddlehead ferns. He liked to gather them just as they poked their tightly rolled heads through the cool spring earth. Everyone ate them as a tonic after the long winter of dried fruits and smoked meats.

"I don't want to talk about fiddleheads and make polite conversation," Maude said. She worried the fringe on her shawl.

"I gathered from your letter," Eli said, "that you want to talk about forceps." He shifted in his chair near the hearth.

"Yes," Maude said. She rose from the wing chair and paced the floor impatiently. When she had things on her mind, she couldn't settle. She wrapped her arms more closely in the shawl and hugged them to her chest.

"They were invented by Peter Chamberlen in England in the early seventeenth century. If used improperly, by anyone, they can tear the mother's body, or cause fatal hemorrhage. They can crush the infant's head. There are no laws or regulations, that I know of, to govern their use. In my opinion, there is no safe way to use them."

"Papa, after what I saw at Mrs. Jones's I am convinced I must learn how to use them."

"That's a pretty tall order, Maude. I don't know of anyone who'd teach you how. Even if you could afford to buy a pair. And you need a lot of strength to use forceps. It takes a very strong arm. You know, Maude, physicians have come to believe that they should have a share in the midwife's profession. Forceps get them that share. It's a bad business for everyone. I don't like it and I've stayed away from it. I think you should, too."

"I know, Papa. I know how you feel. But Mrs. Jones would have died if Edmund Damon hadn't been there."

"Perhaps not, my dear. You are still inexperienced. Mrs. Robinson might have delivered Mrs. Jones without any difficulty whatsoever."

"I know, Papa. But there are other things that trouble me about this.

Edmund Damon is not the last man midwife who will come here. You said yourself that physicians are now trained to use forceps. They have an advantage that I do not. How can I ever compete with them? And if I can't, if fewer and fewer women call midwives, if midwifery is a dying art, then there is no point in continuing my apprenticeship."

Maude paused by the hearth. She poked the fire with vicious thrusts of the poker. A shower of sparks flew up the chimney.

Eli balanced his fingertips together. His face was thoughtful.

"What you are learning from Mrs. Robinson goes beyond knowing the signs and symptoms of travail, Maude. Women understand the workings of the internal mysteries of one another better than men do. There's an instinct, a natural empathy, a complicity of feeling men don't know how to employ. Only women know how to give this to one another. It makes the pangs of childbirth endurable. Without you, and others like you, to carry on the art, it will die out all the sooner. Perhaps be lost forever. And womankind will be the worse for it. Perhaps, Maude, you have been chosen. Have a little faith."

"I understand, Papa. I don't want to abandon what is good and right in Mrs. Robinson's teaching. But neither do I want to stand by and watch midwifery die from a lack of new ideas. Or because it fails to adapt to a new idea. It seems to me, Papa, there has to be a meeting of the two philosophies of thought. The use of forceps has already changed the art of midwifery. If I do not adapt to that change, I will be broken by the weight of it. I must learn to use forceps. Will you help me find a way to do that?"

Eli shifted uneasily in his chair. He opened his mouth to speak. He closed it again. He reached for Maude's hand to stay her restless pacing.

"I have complete faith that you intend to use forceps only when all other measures fail, Maude. Make no mistake about that. But first you must be certain that all other measures *have* failed. It takes longer than six months to learn that. So my answer to your question for now is no. We'll discuss the matter again when you leave Mrs. Robinson's teaching."

Maude agreed without reluctance. She had expected as much. She was not disappointed with Eli's answer. He would think on it. They would talk again.

Eli had other news. Mrs. Howard missed Maude so much that half the time she still set another place at the table. She had had a bad bout with rheumatism, and Eli had hired Mary Thatcher's oldest girl to help with the heavier housekeeping chores. Sarah John was often at the house, too. Mrs. Thatcher's husband had had more ill luck and their finances were very poor. They were talking about Ohio. There was a good possibility they would leave Sarah John behind with Eli and Mrs. Howard. It had not yet been settled. He would let Maude know.

Eli recited other news—who had died, been married, or given birth. Old Hatevil Colson had disappeared and was thought to have drowned in the river. Mrs. Crosby's latest pronouncement condemned those who went to Ohio as disloyal to the United States.

Eli reached inside his jacket and drew out a letter.

"Anne Stinson asked me to carry this to you, my dear. Sprightly little thing she is. Mrs. Howard sent you a supply of pen wipers, a new pincushion, and a dozen molasses cookies. And wait 'til you see what I've brought you."

Eli stepped out of the parlor a few moments. He returned with a square wooden box. It was finely made with dovetail joinery. It had brass handles on either side so it could be tied securely to a saddle. It was small enough to be carried easily. Its dark wood was polished to a satin sheen.

"Oh, Papa," Maude said excitedly, "my very own medicine box!"

"Look," Eli said, "there's even a special compartment for your pens and record book." He lifted the lid. Maude exclaimed with delight. Inside, in neatly tied down rows, were a set of various sized pill bottles in the deep cobalt blue Maude admired so much.

"I had Perez Hamlin over in Hampden make it just for you. I took care of a bad wound on his arm and took this in trade as my fee."

"Thank you, Papa. I don't know what to say," Maude said. She stroked the glossy wood with her fingers.

"The happy look on your face is thanks enough, daughter. It's a rare man who's fortunate enough to have a child such as you."

MAUDE READ Anne Stinson's letter as soon as Eli left.

April 2, 1819
Hampden

Dear Miss Richmond,

It has seemed to me somewhat Ridiculous that we should be separated by a Mere ripple of water and not have had the Pleasure of one another's company since we first met at Mrs. Crosby's. I consulted your father about coming to Call, but he advised Restraint on my Part lest, I suppose, I distract you from your Duties with Mrs. Robinson. Thus I have done as he asked. Do you remember that I told you I had been sent Home from School in Disgrace? Father smoothed that over rather Nicely. He's such a dear. But Mother has spent the Winter lecturing on my Duties—horrid word—as a Respectable young lady about to be Married. She has led me through the Intricacies of preparing a Trousseau against the day Mr. Crosby and I are married. I have nagged her Constantly to let me have a few Ready-made gowns from Boston, but she insists dressmakers are far too Dear and it is to my Benefit to ply my Needle with Industry, the one Virtue sure to impress old lady Crosby. Since I have bowed to Mother's bidding with as much Grace as I am capable of, she has decided to Reward me with a Quilting party. And it is for this Reason that I write. I have set the date for May 2nd— a bit Distant, to be sure, but given your singular Duties, I thought it Wise to warn you in plenty of Time. We will be a large Party—30 or so—the Gentlemen will join us in the evening. I expect you to remain the Night with me. The Mud should be most dried up by then, don't you think? Do write immediately and say you will join the Party. If you won't I shall call it off, as no one there will be nearly so Interesting as yourself. I have told all my Brothers that you will be here and they have agreed to Partner you for every Dance. They are fine dancers.

With sincere Felicitations and Fond Remembrances of our first
Meeting, I remain your Friend,
Anne Stinson

Maude received Sally's permission to make the visit and wrote to accept the invitation.

April 4, 1819
So. Orrington

Dear Miss Stinson,

Mrs. Robinson has kindly Agreed to your Proposal for the 2nd of May and I will take Mr. Brazier's ferry across the River, arriving at 10 in the morning of your quilting. There is no need to send a conveyance as my baggage is Small. My hands are in Poor condition for wielding a Needle, but I shall do my Best to be agreeable company. In the meantime, I shall be Diligent in applying the salve my father left for me. I have often thought of our Afternoon with Mrs. Crosby and am Delighted at the prospect of enjoying your Company once again.

With sincere Thanks for your Kind invitation, I remain your friend,
Maude Richmond

Anne was waiting when Maude stepped off Mr. Brazier's ferry. Her doll-like face was lit with smiling. Her cloak was a soft shade of blue. Her gloves were soft gray leather. She sat in a handsome little cart behind a dapple gray pony the very color of the ribbons on her smart bonnet. The pony shook his head and nickered softly. His harness jingled. Anne held the reins firmly. "Call me Anne," she said. Little blonde ringlets danced around her face.

"Call me Maude," Maude said. She pushed back several strands of hair escaping from beneath her red hood. She adjusted her black cape around her shoulders. She set her valise in the cart and climbed up beside Anne.

"Is it true the man midwife left town because of you? I heard it whis-

p e red everywhere that you and he got snowed in at Mrs. Jones's. I heard that you spent the night there together and he was obliged to leave town so as not to dishonor your good name," Anne said with her customary directness. Her words were bright arrows with no sharpness.

Maude had not heard that particular version of the events concerning Edmund Damon and herself.

"No, it is not true," Maude said firmly.

"I thought not. Pity. I was so hoping for a bit of *good* gossip. Nothing scandalous has happened for such a long time."

Anne spoke to the pony. He picked up his feet with slow daintiness and drew them up the hill from the ferry slip and on up the road to the Lower Corner of Hampden. They turned right and rode past the homes of Judge Kinsley, Mr. Patten, and Mr. Emery. They crossed Reed's Brook where the British had come ashore back in 1814. They went past the Academy where scholars from the surrounding towns ciphered and translated Homer and Virgil from the Greek and Latin.

Presently, they pulled up at a large brick dwelling. This part of town was known as the Upper Corner. It maintained a somewhat separate identity from the Lower Corner. The house sat very near the road. A fan light with graceful leading ornamented the front. A forsythia bush bloomed by the door.

"Here we are," Anne said. A hired man came to hold the pony while Maude and Anne climbed down from the cart.

"That's where John lives, across the road." Anne pointed to a large three-story frame house. A barn almost as large as the house was attached to the rear. "I see John every day. Just like when we were children."

The hall, in the center of the Stinson house, was wide and spacious. Carpets from England lay on the floors. The staircase rose gracefully in a slender curve. The wainscoting was painted white.

They found Mrs. Stinson in the dining room calmly sorting out the details of arranging Anne's party. She was much like Anne, but in a faded, less spirited way. She was dressed in a morning gown of green plaid calico. Her hair was the color of dried weeds. Her hands were covered by little black mitts.

Anne introduced Maude.

"Eli Richmond's girl. So good of you to come, Maude. Anne has not stopped talking of you since she met you. I remember your dear mother, rest her soul. Lydia. She was known for her good works to the poor. Anne, dear, ask the hired girl to put out another tea table in the north parlor. And will two quilting frames in each parlor be enough? That's ample space for sixteen. We could squeeze in one more and make room for twenty."

Mrs. Stinson sorted napkins as she spoke.

"I'll see to it, Mother," Anne said. "You go tend to the cakes and pies."

Mrs. Stinson smiled vaguely and went into the kitchen. Anne took Maude into the library. They laid their outer garments on a leather chair.

"Your mother is very busy with your party, Anne. How fortunate you are."

"Mother is enjoying this more than I am. I'm the only girl, and the youngest. Mother wants to do this with all the proper fanfare. She won't get to do it again. I'm certainly enjoying all this attention. But I do confess to a certain sense of being taken over and left out of the deciding what should be done. Mother says I am altogether too missish and spoiled. Perhaps I will have a fit of vapors and refuse to appear this evening," Anne said a trifle peevishly. There was a tenseness in her expression that did not blend with the more joyous feelings the party was intended to elicit.

"Please don't," Maude said with mock seriousness. "I left my smelling salts at home. Should I send to my father for an emetic or a purgative? Surely, there's some remedy that will restore you to the proper state of excitement."

Anne wrinkled her lovely, straight nose in disgust.

"What we need is a romp," she said.

Anne took Maude's hand. They ran out into the hallway and up the stairs two at a time. Anne ignored the sound of a torn hem. "I'll go first," she said. She straddled the banister in a most unladylike way and

slid all the way to the bottom. Her soft-soled shoes made no noise as she landed gracefully on her feet. The trick was obviously the result of years of practice.

"Your turn, Maude," Anne called up the stairwell. Maude hesitated. There was something desperate in Anne's playfulness and she did not quite understand it. She walked slowly back down the steps and sat down on the lower one.

"Are you always like this?" Maude asked quietly. She sensed conflict in Anne.

Anne ignored the question. She sighed deeply.

"You are much too serious, Maude," she admonished playfully.

"And you, Anne Stinson, are a romp," Maude said.

Anne's good humor bubbled out again. It seemed genuine this time.

"Oh, how true! But once I marry John, I'll become properly sedate. I'll have a child every two years. I'll pour endless cups of tea for old ladies."

There was something unstated and prickly beneath Anne's words.

"Perhaps you are not yet ready for the duties of marriage," Maude said.

"Oh, of course I am! I admire John so much. I've known him since we were in walking strings. Everyone says how perfectly matched we are. Father has hoped we'd marry one day. He's always wanted a connection with the Crosbys. If you can't be one, marry one. That's what he says. John is very good to me. So attentive. And so affectionate." She inserted a sigh into a pause. A line of seriousness appeared in her eyes and remained. "Marriage is for such a long time."

"I've never given it much thought. At least for myself. I want to be a midwife. Not a wife. Papa seems to think I'll want a husband someday, though."

"Everyone marries. And women must if they are ever to have a home of their own, something that belongs to them. You could have one of my brothers and live near John and me. We'd be sisters. Charles is the handsomest, but Reuben will be the wealthiest. He's already a master mariner and barely twenty. Isaiah is the most fun, but Father doesn't

think he'll amount to much. George is very intelligent but tends to be a bit dull. You'll meet them this evening."

Anne's odd mood seemed to have disappeared.

"I'm looking forward to their company," Maude said.

"Let's go look at your gown. If it's as demure as that one you're wearing, *something* will have to be done!"

13

THE STINSON HOUSE overflowed with the light laughter and soft chatter of female voices. Each woman at the quilting had brought a scrap bag. They traded treasured bits of fabric with one another. They shared news of local happenings. While they talked, intricate patterns sprang from their fingers and flowed into the quilts. The day was darned with invisible filaments of women's work. Every woman in the room manufactured a strand of it. They were women among women doing women's work.

Maude stabbed her needle in and out of the log cabin quilt in the frame. She looked around the room. The Misses Herrick and the Misses Patten, the Misses Emery and the Misses Crosby chattered and laughed and drank innumerable cups of tea. They will all have need of me sooner or later, Maude thought. They are all made equal in childbed. Maude misjudged the position of her needle and pricked her finger. A bright drop of blood oozed from the tip. Women, she thought, are bound together by the blood they shed doing women's work.

Anne nudged Maude sharply.

"Maude, you are looking much too serious and far away," Anne admonished.

"I was thinking about women's work," Maude said.

"Well, stop it at once. Here, let me thread your needle."

Precisely at four, Mrs. Stinson rose. The ladies, as if on cue, put away their quilting. They went home to rest and change into their evening clothes.

Upstairs, Anne and Maude helped one another dress. Anne fussed

with Maude's hair. She arranged it into an ornate coil and applied the curling iron to the little tendrils escaping around Maude's ears. She sprinkled sugar water on the curls so they wouldn't droop later on.

Maude's cheeks were bright with excitement. The fluff of dark hair around her face softened the broad lines of her cheekbones. She was almost pretty.

Anne settled a gauze shawl around Maude's shoulders. The shawl was silk, the color of moonbeams, fine as a spider web. Maude's pale pink dress was not silk. It was a finely woven cotton, simply made with puffed sleeves and a wide, low neckline.

The rattle of carriages and chaises signaled the return of the guests. Anne and Maude went downstairs to greet them.

The sedate conversation of the afternoon rose to a higher pitch. It was laced with the heavier baritones of the gentlemen. Gowns shimmered in the light of a hundred candles. Young ladies favored silks of blue, yellow, green, and pink. Older ladies preferred deeper blues, browns, and rusts. The rougher textures of the men's short waisted jackets lay darkly against the extravagant embroidery of their waistcoats.

The evening progressed with music and dancing. Maude was never without a Stinson brother at her side. She laughed and flirted and conversed. She forgot about her chapped, red hands. She forgot about man midwives and forceps and time passed very agreeably.

It was after midnight when the party ended. Maude and Anne were in Anne's chamber in their night clothes. It was a frilly room. The bed curtains were edged with knitted lace and the sheets were edged with delicate cutwork. The counterpane was embroidered white on white. Anne sat on a stool near the hearth. The fire snapped cozily. The only light in the room came from the fire. Shadows hovered in the corners. They pressed down from the ceiling. Anne and Maude were hemmed in the circle of firelight. Maude brushed Anne's hair with slow, careful strokes.

"I think Charles was quite taken with you, Maude," Anne said dreamily. Charles had been the most attentive of the four brothers. He was extremely handsome. Maude had found him amusing.

"He was only being polite because you asked him to," Maude said.

She had been very flattered by his attentions. But she knew that Charles Stinson's interest did not go beyond social civility.

"Well, Reuben was certainly being more than polite. I saw him keep your hand longer than was necessary when we said good night. He's not handsome like Charles, but he's very nice to be with. Mariners usually are, for some reason."

Anne hugged her knees and gazed into the fire. It was impossible to tell where her thoughts led. Maude tied Anne's hair back with a blue ribbon.

"Reuben was less interested in me than in making the Herrick girls jealous, I suspect," Maude said. The four Herrick sisters had been the center of attention all evening. Maude had been impressed with their flair for socializing.

"Yes, that's true. They are as gauzy as the shawl I let you wear. I hate to say it, because Reuben is my favorite brother, but he doesn't have a chance. But you needn't despair, Maude. George danced more than once with you. And I noticed Isaiah made it a point to lead you into supper."

"I'm not in despair, Anne. And you know it. I like your brothers very much, but I am not yet ready to look upon them, or anyone else, as a candidate for a husband." Maude gave Anne's hair a playful jerk. Anne yelped, overdoing her reaction. She darted to the bed, grabbed a pillow and smacked Maude on the backside with it. Maude grabbed the other pillow and smacked her back. The pillow fight was over quickly. It was late and they were tired. They collapsed into the middle of the bed and the feather tick rose up around them in a heavy billow.

Maude lay on her back with her hands relaxed across her belly. Anne lay beside her with her arms flung over her head. A vast expanse of dark and light hair flowed and spread beneath their heads.

The firelight flickered. The shadows leaped suddenly closer.

"Maude," Anne whispered in a tearful voice. Maude's instincts flared. She had sensed an edge in Anne's mood all day. "You're so much wiser than I am." Ann went on, "So very sensible. I knew I could talk to you about anything from the very first day we met."

Maude reached for Anne's hand. It was tense, like that of a lying-in woman in the midst of a bearing down pain.

"I'm listening, Anne," Maude said gently, soothingly.

There was a long silence. Maude did not prompt. She was accustomed to waiting for the inner workings of human nature.

"Last year, right after I was engaged to John, Mother had a talk with me. I had planned to marry right away. But after what Mother said, I changed my mind. I've been putting the wedding off ever since. Now I've agreed to marry early in June, but I want to put it off again." Anne's voice was so small, Maude strained to hear.

"What your mother told you must have been very serious," Maude said. She lay her head very near Anne's. It was a gesture of comfort.

"Mother told me that men, even dear John, are possessed by certain animal passions that women do not share. She said that John, after we are married, because he is my husband, will have the right to—to use my body, to be physically intimate anytime, in any way he chooses. She said that as his wife I cannot refuse, that it's my duty to please him. She said the—the unpleasanter aspects of this are compensated by the joys of mothering the children that will result."

Maude was not surprised by Anne's fear and misinformation. She had often encountered the ignorance of women concerning the workings of their bodies and the act of love. Women frequently did not understand that their husband's seed was the source of their constant state of childbearing. Nor did they perceive that they had any choice in the matter of coupling.

Sally Robinson did what she could to enlighten her lying-in cases about the basic workings of their monthly cycles, conception, and childbirth. She had taught Maude to do the same. It was not an easy task. The workings of a woman's body were not well understood. No one knew how conception was actually achieved. Or at what point in the lunar cycle a woman was most likely, or least likely, to conceive. And once conception occurred, there was no certain way to be sure of it until the woman was four or five months gone with child. As for the act of coupling, men were assumed to have a greater capacity for passion

and pleasure than women. It was widely believed that God had intended women to be vessels for men's seed, the means for men's pleasure. Women were expected to submit without complaint.

Childbirth was as intimate as the act of love. Women spoke of these things to one another. Maude had gleaned a great deal of information listening to her lying-in cases talk. She knew the most important thing for Anne to do was rid herself of the fear ignorance caused.

Maude sat up and reached for the pillow Anne had smacked her with. She folded it in two as Sally once instructed her.

"I can help you understand the workings of men's and women's bodies, Anne," Maude said.

Anne rolled over on her side to watch. She wiped her cheeks with the back of her hand.

"This," Maude went on, indicating the folded pillow, "is something like a woman's exterior parts are shaped. Up here, where the pillow doubles, is an opening. It's very small. Urine flows out of it. Down here is another opening. For the bowel. Between these two there is a third opening. Where the monthly blood flows from. This is the opening that is important in the physical union of marriage."

Anne's eyes widened in surprise. Her face opened into an expression of curiosity.

"I had no idea," she murmured.

"If the monthly flow ceases, then it is likely that a woman is with child."

Maude reached for the unlit candle in the holder by the bed. "Surely, you've seen little boys without their diapers and know what the male member looks like?"

Anne nodded her head, yes.

"When a man is desirous of sexual pleasure, his member becomes firm, like this candle. And the woman, desiring the intimate attention of her husband, becomes moist and willing to receive him. Like this." Maude inserted the candle between the folds of the pillow to illustrate. "I am told that if the husband and wife are patient and tender with one another, it is a very pleasurable sensation for both. Of course, children are the inevitable result of such a union."

"But what if it isn't pleasant and I don't like it?" Anne asked. She sat up and drew her knees up to her chest. She folded her bedgown down around her feet.

"Then it must be as your mother says. A duty to be performed."

"Duty." Anne's hair spilled around her in a tumble of blonde. "And part of my duty is to bear a child every two years. I will lose my looks and ruin my health. John will not love me anymore if that happens."

It was a reasonable fear. For many women, the act of love was fraught with humiliation, pain, and even death. Wombs fell from the strain of being occupied by infants so frequently. This condition caused difficulty with urination, painful backaches, and a variety of unpleasant infections from which there was little, if any, relief. Waists thickened. Veins in legs bulged. Teeth fell out.

There were few ways to delay or avoid childbearing. Abstinence from the marriage act was the only certain way. But men seldom agreed to that, and women, too, found it disagreeable. Abstaining women complained of melancholy.

"There are certain things you can do, Anne, that might prove helpful in keeping your health," Maude said. "The female opening leads to the womb where the infant grows until it is born. The womb, in turn, has a tiny opening where where the male seed is taken in. If the seed can be prevented from entering the womb, a woman will not conceive. Mrs. Robinson advises a pessary of lamb's wool soaked in olive oil, if it can be obtained. Melted candle wax if the olive oil can't be had. The pessary is then inserted all the way to the opening of the womb to block it so nothing can enter."

Maude searched about for materials to illustrate. She retrieved Anne's sewing basket and removed a ball of yarn about the size of the large marbles boys played games with. She undid the yarn so that a strand of it was left unwound. She inserted it between the folds of the pillow in the place where she had inserted the candle. The end of the strand of yarn remained visible.

"See?" Maude said. "The end of the yarn makes the pessary easy to remove. All you do is pull. Carefully. You must use a pessary each time

you desire a connection with your husband. And allow it to remain until morning."

Many women used Sally's pessaries. Some even managed to avoid conception for three or four years. But nothing was completely reliable. Inevitably, pregnancy succeeded pregnancy until the monthly flow dried up completely when a woman reached her fifties.

The tenseness left Anne's face. Maude smoothed out the pillow and replaced the candle and yarn.

"I love John very much," Anne said quietly. Her words were muffled against the counterpane. "But I dreaded the thought of becoming his possession, as if I were a chair to be sat in, or a pet dog to be tied up on a leash. It seemed to me that if he had the right to make such demands, as Mother said, then I was little better than a slave."

"But now you are enlightened, Anne. You can speak to John of your fears and tell him what I've told you. If he truly loves you, he will not wish to ask, or demand anything that gives you hurt. A woman's body should not be a prison. It should be a fountain from which flow the generations of mankind, not as man demands, but as woman desires."

They tucked themselves under the counterpane. Anne lay quiet and relaxed.

It occurred to Maude again how inextricably women were bound together by the work of their hands and the workings of their bodies.

The fire's dying flickers danced on one spot on the ceiling. Shadows settled like a gauze shawl into the room and troubled no one's sleep.

14

THE STRANDS OF social connection Maude darned into her life at Anne Stinson's quilting were sturdy ones. That summer she witnessed Anne's marriage to John Crosby, Jr. Maude's private gift to Anne was several dozen lamb's wool pessaries with instructions for making them and Anne did not conceive on her wedding journey as brides often did. John, Anne had confided, was more ignorant than herself about the act of love. Maude's information had greatly eased their awkwardness with

one another. The entire proceeding had, Anne said, been rather pleasant.

The days spent on rare visits with Anne were interspersed with days in the wash house and long nights sitting in kitchens waiting for infants to burrow their way into the world. 1819 was a busy year of comings and goings—to mean hovel and grand house, to married lady and woman of easy ways. In childbirth, Maude saw, all women needed her equally.

There was a certain sameness to the lying-in cases Maude visited, but it was not the kind of predictability that inspired boredom or caused her to wish for other employment. Women about to give birth, Maude observed, turned inward, centered their very spirits on the life about to leave their bodies. It manifested itself in the early stages of travail. Those most turned in on themselves, most attuned to the workings of their bodies, often had shorter, easier travail. It always mystified Maude how the women in her care were able to lay aside their fears of pain, of deformed infants, of stillbirths, of death, and endure the time of travail. She wondered why women did not rise up and cry in one voice, "No more!" But they did not. Year after year they did their duty. They bore children. They fulfilled their destiny as women.

Yet, Maude observed, if a woman was lying-in for the fifth or sixth or tenth or twelfth time, despair and melancholy often set in immediately after the birth of the child. It was a difficult affliction to address. Even Sally was baffled by it. Maude suspected that not every birth was considered a gift or a joy as women had been taught to believe. Sometimes, women in a state of melancholy refused to nurse their infants. In extreme cases, women abandoned their infants, left them under bridges or in ditches. But more often, melancholic women simply refused to recover from lying-in. They spent the rest of their lives as invalids. In such cases, little could be done. Maude noticed, however, that those women taught to make and use Sally's lamb's wool pessaries often had a lift in spirits and resumed their normal wifely functions.

The time not spent in the wash house or visiting the sick was taken up with long talks of instruction with Sally.

1819 was also a time of great political change. Much of the talk Maude heard on her visits to the sick was about the impending event of statehood, and the following year, 1820, on the fifteenth of March, Maine separated from Massachusetts and became a state. Church bells rang all day. Taverns filled with revelers bent on lifting their mugs in endless salutes to the brand new state of Maine. Bonfires were lit. And General Jeremiah Herrick of Hampden decided to hold a gathering to celebrate the occasion. Maude and Eli were invited. Maude did not want to go.

Maude and Eli were in Eli's chamber, a room filled with the clutter of the doctoring profession, as if the contents of Eli's mind had spilled over and taken up residence. A book of botanicals lay open on the bed. A chart depicting the circulation of blood was tacked to the wall. A well-worn anatomy book lay on the wooden chair. It was a comforting place to be. That was why Maude wanted to be there.

There were dark circles under Maude's eyes. Her expression was tense in an effort to express what she felt without letting the weight of it rule her life. She leaned against the door frame as if her body had become too heavy for her spine to support. She was wearing her old brown gown. It had been refurbished with a new collar and a set of plain lace cuffs.

"It will do you good, Maude," Eli insisted. "A change of scene will help you take your mind off Sally's accident. For a little while anyway. Then you'll be able to think about it more easily. And it won't hurt so much."

Eli brushed the collar of his best black wool jacket. He shook the wrinkles out of the maroon silk cravat he always wore to social gatherings. His face, too, bore the strain of the past weeks. The lines in his forehead, it seemed to Maude, were deeper.

Three weeks ago Sally had been crossing the ice on Swett's Pond. People often used the ice as a shortcut during the winter months. But a thaw at the end of February had weakened the ice in spots. Sally had fallen through. An ice fisherman found her. Her fingers were frozen into the edge of the ice. Sally had not drowned. She had waited for

death as she had waited for life. She had frozen to death. Maude received the news with a shock of horror and disbelief. For days, she had felt as if she, too, were on thin ice and about to go down into the awful icy dark. But Eli had heard and he had come. And Maude had come home. Gradually, the horror of it had subsided, but she still dreaded going to a gathering where the conversation might turn to the circumstances of Sally's death.

Eli folded his cravat around his neck. He tied it with the quick, deft movements that made his surgery successful.

"I think talk about Sally's accident has pretty well died down. All anyone will want to talk about tonight is statehood and the Missouri Compromise. Anne and John Crosby will be there. I spoke to her father just this morning down at the wharf. She's just back from Boston visiting relatives. You haven't seen Anne for months."

Maude's eyes would not meet Eli's. Her head drooped like that of a tired horse's. She stirred as she became aware he was waiting for an answer.

"Perhaps you're right, Papa. I would like to see Anne. She always has some outrageous tale to tell that makes me laugh. It would be nice to laugh again after so much sadness."

Eli put on his stern father face. In a playfully gruff voice he said, "If you don't go, daughter, I'll declare you possessed of the melancholy and put you to bed with one of my nastiest tonics."

Maude smiled a small smile.

"Perhaps you're right, Papa. Moping is of no use to anyone. It might do me good to get away from my frets for a while."

Maude's biggest fret was the void Sally's death had left. The other midwives in the region did not subscribe to Sally's frenchified methods. They were of an older generation. They were cowed by the superior education of the physicians in the region. They were only marginally upset when they were not called. They grumbled some about the loss of their fees to the physicians, but they did nothing to improve their ways. They weren't ones to give any thought to what would happen to their calling once they were dead and gone. And that was the heart of Maude's

grief. The hungry depth of Swett's Pond had swallowed not only a human life, but the irreplaceable intelligence it contained.

"Sally was a good woman," Eli murmured, deliberately understating Maude's feelings. He buttoned his vest and brushed his gray hair away from his temples.

At one time, Maude had entertained hopes that Eli and Sally might look favorably on one another and consider matrimony. But they had not.

"And a good teacher," Maude said. She let silence stretch out into the room. Eli removed the anatomy book from the chair. He sat down to pull on his boots. Maude moved from the door and sat down on the bed opposite Eli.

"Even without the rest of the time you were supposed to spend with Sally, you're the best midwife you can be, Maude."

"She told me that the night before her accident. As if she knew what was going to happen and she'd never have another chance to say so. I learned to use my hands as instruments just as you said I would, Papa. Sally showed me how to trust them. Of course, I still make it my business to know which physicians own forceps and are most skilled in applying them. Just in case. Sally never minded me doing that. But she would never have done so herself. It just wasn't her way."

The matter of forceps had lost its urgency as Maude came to rely more and more on the skill of her hands and the intuition of her touch. She and Eli had had several conversations about the matter. Each time Eli had counseled patience. Maude had complied, but she still believed she must acquire the skill to use forceps. Eli could not teach her. He had never used the instrument in childbirth. And none of the other physicians cared to entrust a mere midwife with the very device that got them called to lying-in cases in the first place.

Eli sat back in the chair and thought a minute.

"You only know for sure something has changed after it's actually been transformed into something different. Sally knew that. Most changes are random, not predictable. I think that's part of the reason she took you on. She wanted to influence, in some small way, how the changes in midwifery would happen. She had great faith in you,

Maude, and in your ability to bend in unusual ways. I think that's why she didn't put up any fuss about you calling in a physician with forceps if you believed there was a need."

Some of the tension left her face. Her shoulders relaxed a bit. "Losing Sally was like losing a part of myself," Maude said quietly. She hadn't thought of it quite like that before. It felt like an elemental truth. Until she discovered someone else who could replace that loss, she would never be quite complete. In a sense, Maude thought, Sally had created a new entity. Maude Richmond, Midwife. And in doing so Sally had fused a part of her spirit into her creation. Perhaps, Maude thought, it was a kind of birth, being made a part of someone else, then separated by a very painful event, and having to learn to be yourself.

The icy place of Sally's death began to melt, just a little.

Eli laid his hand on Maude's.

"Goodbyes won't ever be easy for you, Maude. Your caring heart will hang on until it's certain there's nothing left to be done but let go. Sally knew you were the right one to carry on her ideas."

Eli rose and handed his jacket to Maude. She held it as he slipped his arms into the sleeves. Eli understood how familiar, ordinary tasks soothed the spirit.

Eli enjoyed gatherings. He was, by nature, an outgoing man. He would worry if Maude stayed at home brooding. She knew it would cloud his pleasure, and so she capitulated and took his prescription.

"All right," she said. "I'll go. Sarah John can help me get dressed."

The previous fall, the Thatchers had finally gone off to Ohio to try their fortunes there. Sarah John had had several tantrums about the impending move, and Eli had been appealed to. A satisfactory arrangement had been worked out for all concerned. Sarah John would help Mrs. Howard with the housekeeping in return for room and board for a year. But they all knew that after the year was up, there would be another, and another. Sarah John was in the Richmond household to stay. Even at six, Sarah John had great patience for keeping things well ordered. She was already indispensable.

"I'll have the sleigh ready in fifteen minutes," Eli said.

MAUDE STOOD NEAR a window in General Herrick's parlor. The windows were draped in dark gold velvet. The room occupied one corner of the front of the house which was situated on Kennebec Road. It was a gracious room. The windows were tall and narrow. The doorways between the rooms were gracefully arched. The woodwork and wainscoting were painted a pale shade of gold. Several sofas and chairs upholstered in dark brown stuff were placed around the perimeter of a carpet with a geometric design in turkey red and dark, dark green.

After paying her respects to the Herrick girls, Maude had retreated, as inconspicuously as possible, from their innocuous chatter. Anne had not yet arrived.

Maude's pink gown was the same one she'd worn to Anne's gathering. She carried a painted paper fan with carved wood ends.

It was early evening. The sun was just setting. Mauve and pink shadows fell across the snow in the General's yard. Bits of conversation floated to Maude, but she only half heard.

"Hasn't this been a long winter? Did you hear . . ."

"Betsey Patten's been in Boston all winter, and she says the latest gowns have much lower waistlines this season. And shorter skirts . . ."

"Good lambing this season, Mr. Emery. That old ewe of mine . . ."

"I heard they caught some rum smugglers hauling two, three hogsheads of rum on a big sled. All the way from Canada in the dead of winter . . ."

"A woman from Hermon was seen riding astride. And wearing leggings like a common Indian!"

Maude was so deep in her effort to avoid the frivolous chatter, she did not notice anyone approach. She was startled when a male voice spoke her name.

"I presume you are Maude Richmond, the heroine of the infamous British invasion of Bangor."

Maude faced the intruder. She expected an ill-mannered boor she could dispatch with the sharp edge of her tongue.

Instead, she found herself facing a man not much taller than herself. He was by far the shortest man in the room, in his mid-twenties, she judged. His eyes dominated his face. They were the color of blueberries. Sweet blue eyes. His nose was finely made above a wide, handsome mouth. His lips hovered near a smile. His hair was the color of an autumn leaf—golden bronze. It was thick with just a hint of a wave and brushed neatly back at his ears. Rebellious little wisps fell across his brow. His face was deeply tanned, as if he spent much time outdoors in all seasons. There was a boyish quality about him.

Maude decided the man was too ill-mannered to be taken seriously. She drew aside her pink skirts and opened her fan with a loud, authoritative snap.

"I don't believe we've been introduced. Please excuse me," Maude said brusquely. She tried to step around the man, but to her surprise, he did not move and her retreat was blocked.

"Quite right, Miss Richmond, but if my cousin Anne Crosby were here, she'd remedy that in an instant. I'm Samuel Webber. Anne sent me in her place. She caught a chill and I advised her not to stir from her bed. She asked me to look after you." His eyes were warm with a light that reminded Maude of the blue haze that hung over the hills of Orrington on a fine June afternoon.

"I can look after myself, Mr. Webber," Maude said. She closed her fan with another sharp snap. The smile on Sam's lips relaxed into an engaging grin. It increased his resemblance to a ten-year-old boy.

"So I have heard, Miss Richmond." There was unmistakable admiration in his voice. The sound matched the message in his eyes.

Maude no longer wanted to move away from him.

Sam extended his right hand instead of bowing as was the proper custom at social gatherings.

Maude took his hand. His hands were small, not much larger than her own, a little rough on the palm. His fingers were fine, his grasp firm, yet gentle, as if he understood how to handle fragile things.

"How do you do," Maude said in her best formal manner. She kept her tone cool. His reference to her actions when the British invaded

Bangor had ruffled her. The story of her encounter with Captain Barrie and Colonel John had been embellished to such a degree half the town believed the Captain had sworn to shoot her on sight and the other half believed the Colonel had pledged undying affection and had died of a broken heart. In fact, so far as Maude knew, the British had simply left the Penobscot region and returned to England.

Sam laughed softly.

"Anne said you'd bristle like a raspberry thicket if I dared mention the British. Please forgive me. I couldn't think of any other way to engage you in conversation without going through the dreary formality of asking one of the Herrick girls to introduce me. If I'd done that, you'd have been the topic of tomorrow's tea party gossip. Or worse, the subject of old Mrs. Crosby's pronouncements. I was sure you'd forgive me less quickly for that than for a breach of good manners. Anne told me so much about you. I wanted very much to make your acquaintance while I'm visiting with her. Besides, you're the only woman in the room shorter than I am." Sam smiled, and the blue field of his eyes deepened in intensity to an expression of kindness and concern. Maude's ruffled feathers smoothed out. Despite her efforts not to, she found Sam Webber endearing.

Maude tilted her head to one side and regarded Sam thoughtfully.

"Perhaps, Mr. Webber, you are like cheese and improve with time. If you can assure me your conversation is even the smallest bit better than your manners, then I won't mind making your acquaintance." Maude watched Sam's face to see what affect her words had.

Sam's eyes crinkled at the corners. He laughed the same soft laugh. His eyes left her face for an instant, and it was if she were without a shawl on a chill evening.

"You have my word on it," Sam said. He offered his arm. They joined a small group near the punch bowl. The group included the General.

General Jeremiah Herrick was a bit younger than Eli, in his mid-fifties. He was very tall, and used his height to either condescend to his listeners or to intimidate them. His eyes were yellow-brown, like a

dog's. He owned the store at the Lower Corner, a stone's throw from his house, and held a controlling interest in several schooners engaged in various trades. He was a member of the militia, but the title, General, was purely ceremonial. He had been noticeably absent from town in 1814 during the invasion. He was thought to be a cultured man because he had introduced the playing of religious music on the bass viol to Sunday meeting.

"My dear, Miss Richmond," the General said. "I'm so pleased you joined us to celebrate the happy occasion of acquiring statehood. It has been a long time in the making. It is indeed an accomplishment to be proud of." The General had been a delegate to the various conventions which had lobbied for separation from Massachusetts. He inclined his shoulders, deferentially, toward Maude. She heard he had hoped for the governorship of the new state of Maine. That honor, however, had gone to William King despite a lot of talk about how King had traded with the British during the embargo. King had registered his ships under the flag of a neutral country. This had sat ill with those few who had obeyed the Embargo Act and had gone bankrupt as a result.

The question of statehood, bound up as it was with the issue of slavery, had been hotly debated in every kitchen Maude had sat in for the last year. She had listened to the talk, read newspapers when she could get them, and had had long discussions with Sally on the subject. She was completely opposed to slavery. She did not stop to consider her words.

"I should think the slaves in Missouri are wondering what all the celebration is about." As soon as the words left her mouth, Maude regretted them. It was one thing to discuss political questions in kitchens with other women, but quite another to cast them out into the gurgling waters of social conversation with gentlemen present. Politics was the sphere of men. It was too heavy a subject for the delicate sensibilities of women. Anne had told Maude repeatedly that men did not admire women with opinions, especially political ones.

The General pulled himself up to his full height. Conversation stopped. Amos Patten cleared his throat several times as if a sentence had stuck in his craw. One of the Herrick girls inquired brightly if any-

one cared for more punch. Sam Webber's lips curled into a small smile. His face registered an oh-you've-done-it-now expression which neither condoned nor condemned.

"How like you, Miss Richmond, given your noble calling, to concern yourself with the welfare of those God has seen fit to make less fortunate than others," the General said. His shoulders drooped again.

Maude measured her response. She had never learned the niceties of meaningless social chatter despite Anne's best attempt to teach her. If she ignored the General's remark, it would imply tacit agreement with a concept she was opposed to. But Anne had made it clear that gentlemen did not admire ladies with opinions. Maude wanted Sam Webber's admiration very much. But she wanted to be true to herself even more.

"I find your views on the Missouri question very interesting, Miss Richmond," Sam said, as if he'd read her mind. There was safe mooring in his words.

"Statehood is too dear when the price of purchase is slavery," Maude said.

General Herrick raised his eyebrows and squared his shoulders. Maude thought of the Thatchers' huge ox team plodding steadily on, capable of trampling anything in its path.

"Perhaps," he said, "you don't comprehend the broader aspects of the issue, my dear. The Missouri question was resolved by great statesmen. It was a long and careful process." The general was clearly annoyed.

Only Maude, Sam, and the General remained by the punch bowl. The others had drifted to other, safer groups in the room. Maude was very aware of Sam being aware of her. She glanced at him, liking what she saw. He stood quietly, hands clasped behind his back, feet planted a little apart, like a mariner, able to ride out any tempest.

"I'm perfectly aware that Maine came into the Union as a free state and Missouri as a slave state to preserve the balance of power in government," Maude said. She also knew that separation from Massachusetts had caused ill-feeling between Federalist and

Republican factions about whether or not separation would injure the coasting trade. She commented on it.

"How very clever of you to have comprehended such a complex subject, Miss Richmond," the General said. A lance of fury pierced Maude. She tightened her grip on her fan. She wanted to rap him with it.

"If Maine is worthy of statehood, sir, she deserves to come into the Union on her own merits instead of being yoked to Missouri with an issue that debases both." The merits of statehood, Maude knew, were many. Maine tended toward Republicanism; Massachusetts toward Federalism. The population of Maine was growing faster than that of Massachusetts. The Federalists feared Maine's faster increase in population would, in time, shift the balance of the power in favor of the Republicans. Added to that was the fact Maine was very far from the seat of government at Boston. Separation would simplify any number of governmental matters and, some felt, free Maine from a government on the path to corruption and ruin. Maude said as much.

"You are very outspoken, Miss Richmond," the General said. "I suppose next you'll be advocating suffrage for the ladies." There was a hearty attempt at humor in his voice which did not cover a note of alarm. He took a small step backward. The General was a Federalist. That party's numbers were composed of persons of social position – merchants, lawyers, and Congregational ministers. He never knowingly invited a Republican into his home. Republicans were mostly farmers, physicians, and the poorer, discontented elements of society.

It nettled Maude to have her opinions so completely disregarded. It nettled her ever more to think that Anne, and indeed every woman at the General's gathering, had been trained to believe politics did not affect their lives and was a subject better left to the gentlemen.

"The thought of woman's suffrage had occurred to me, sir," Maude replied. She wished for a magic spell to transform the General into a female.

The General allowed himself to be distracted by a conversation about highways and bridges going on just behind him. He excused himself with a tight little smile and joined the other group.

Maude's stomach was in knots. It was not the first time she had encountered condescension, but it was the first time she had felt shackled by it. There were, she thought, many kinds of slavery for women. Childbirth was only the beginning.

Her fury fought for expression.

"If you say one word, Mr. Webber, I shall forget my manners entirely," Maude said. She snapped her fan open and closed, open and closed.

"Under the circumstances, Miss Richmond, I should say you were entitled to."

Maude allowed Sam to take her hand and draw it through the bend of his elbow. He propelled her toward an empty sofa at the far end of the room near the window where she had stood earlier. It was full dark now, but a new moon had risen. The snow in the yard gleamed silver like the scales of an Atlantic salmon.

"I suspect, Miss Richmond, you will be the subject of tomorrow's tea party gossip for reasons other than the fact that you and I are sitting alone together on this sofa. I can just hear old Mrs. Crosby's pronouncement. 'Midwives with opinions give birth to anarchy,'" Sam said. His eyes folded into the beginnings of laughter. Maude gave in and laughed with him.

"Alas, Mr. Webber, you are quite right. I fear I'll never learn to govern my tongue. Anne despairs of me."

"But I do not, Miss Richmond. I am most interested in your views on separation and the coasting trade. I've been engaged in coasting these past several years."

Ships engaged in coasting sailed the waters of the Atlantic from the St. Croix River to Florida and back, trading at various ports along the way including Portland, Boston, New York, Baltimore, and Charleston. They carried smoked fish, lumber, leather, and textiles from northern cities to the south where they picked up cotton, tobacco, indigo, and other goods. Massachusetts had recently enacted a law which allowed coasters access to its harbors without entering or clearing customs.

The crews of the coasters were seldom the same from port to port.

They came and went with the regularity of the tides. Most of them were tough and liked their grog. They were frequently in brawls of one kind or another.

"Then you are a mariner," Maude said.

"Yes and no. I'm a physician by trade, but I sail as ship's surgeon on the Stetson Lines out of Portland."

"I've never heard of such a thing, unless it was in the navy. A ship's surgeon. How did you come to that, Mr. Webber?"

"It's something of a long story."

"Since I am obviously welcome nowhere else unless I keep my opinions to myself, the rest of the evening is at your disposal."

Sam crossed his legs comfortably and settled himself into the corner of the sofa. His eyes lingered on Maude's face, slid quickly to her feet and back to her face. It was an appraisal. Maude was not discomforted by it. His manner contained more that was curious and admiring and little that was conquest.

"Maybe you remember my father, Moses Webber?" Maude did, but vaguely. "Your father tended him years ago when he broke his leg. My father was a mariner in his younger years and I always thought I'd follow in his path, me being the only boy. Well, Father had other ideas, wanted something better for me than he had, so he pressed me to try my hand at something else. I remembered how interested I was in bones and muscles and how they worked and how your father explained those things to me while he tended Father's leg. So I thought I'd give doctoring a try. Old Doctor Livermore apprenticed me about five years back. I stayed with him a couple of years, then I read medicine at Harvard for another year."

"My father read medicine there just before the War for Independence."

"There's been some changes since then. Man midwives. Controversy over venesection and questions about just how effective bleeding is as a cure for certain ills. A lot of talk about antisepsis. There's even a whole new field of study pertaining to childbirth called obstetrics. I studied it for several months. Got to be pretty good with a

pair of forceps. But I just couldn't reconcile myself to the fact we were being taught that forceps were a necessity in all the lying-in cases I saw. I knew perfectly well the ladies handled the event more naturally and easily when left in the hands of a competent female midwife."

Maude warmed to Sam Webber. She certainly approved of his views. "What has all this to do with your work as ship's surgeon?"

"While I was at Harvard, I made the acquaintance of another student by the name of Joshua Stetson. He studied law. Wild as a hawk. But for some reason, we took to one another. We had a speaking acquaintance. Apparently he and his father didn't see eye to eye on the matter of his allowance or the company he kept. I never did learn all the ins and outs of it. But I did find out his father was Phineas Stetson, the owner of the Stetson Lines. I liked what young Stetson had to say about Portland, so I hung out my shingle there when I finished my studies. But I kept finding myself thinking more about the sea than curing croup and quinsy. On a whim I shipped out as a common seaman. Sea's in my veins like Father's, I suppose. The master of the vessel was a brute, and the crew were the dregs. I got plenty of practice setting bones and stitching knife wounds. Found I liked it better than any other kind of doctoring."

Sam paused in his recitation. He inquired of Maude if he were tiring her. Maude shook her head no. She indicated he should continue.

"When we made the Indies, I looked for another berth. And wouldn't you know it, there was a Stetson Line ship in port. With Phineas Stetson aboard as master. He had a severe case of gout and had delayed sailing because of it. Didn't trust the mate with command. Had a cargo to deliver. I proposed signing on as Stetson's personal physician and guaranteed to keep him fit enough to see the vessel home safe to Portland. And that's what I've been doing ever since. Now, Stetson confines his business to the coasting trade. He goes to sea less and less. I half expected Joshua, the son, to take over the duties of master, but he hasn't yet. Still wild as a hawk. Anyway, Phineas Stetson was quick to see that having me aboard attracted and kept decent seamen. Oh, I stitch more gashes than I care to sometimes, and there's nothing like

having a man fall from a rat line and crack his skull to take a few years off your life, but I like what I do and I plan to stick with it."

Sam paused again. A little silence grew between them. But there was speaking in his eyes. Maude's spoke back.

"And what of you, Miss Richmond? Anne has acquainted me with your history. She says you are an accomplished midwife."

"All I try to accomplish, Mr. Webber, is to alleviate the travail of my cases as best I can. The General's view notwithstanding, there is nothing noble in my calling. It is the means to earn my living. I chose it because, like you," the thought delighted her, "I wished to follow my father's example and employ myself with the love of the art of healing which he taught me."

She had not intended to reveal that important part of herself. But Sam Webber was so calm and easy, so uninvasive in his manner. She simply forgot herself. Talking with Sam Webber was very much like talking with Sally Robinson.

"There is a Miss Herrick headed our way," Sam said. "She intends to make us circulate. But before we are forced to attend to social duty, Miss Richmond, I wonder if I might receive your permission to call while I am here visiting with the Stinsons." His eyes enveloped Maude in deep blue. Again, she was acutely aware of him being aware of her.

"If you had not asked me, Mr. Webber, I would have asked you."

"And I would have said, 'yes,' Miss Richmond."

"And so do I, Mr. Webber."

Sam flashed a smile of triumph and delight.

The gathering progressed from conversation to dancing to a late supper. Maude danced once with each gentleman who asked her, including Sam Webber. She would have liked another with Sam, but the specter of tea party gossip prevented her. The General did not engage her in conversation again except to say good evening.

Maude and Eli arrived home at midnight, and Maude went up to her chamber and lit the candle. She was more happy and elated than the day Eli had hung out the sign that said, ELI RICHMOND AND DAU. PHYSICIANS.

She wished for Sarah John's nimble fingers to help with the lacings of her dress, but the child was fast asleep on her cot in the kitchen. Maude yanked impatiently at the fastenings. So much in a woman's life, she thought, was cumbersome and confining. The weight of yards of material in skirts and petticoats hampered movement. Corsets restricted breathing and deformed bodies. Laws were made by men for men. A political opinion from a female mouth was disregarded. And yet, there was Sam Webber. And her father.

Maude undid her hair. It fell only to her shoulders instead of her hips as most women's did. She kept her hair trimmed to that length to make it less time consuming to comb and care for. She did not braid her hair at night nor did she wear a cap to bed. Mrs. Howard would have been horrified had she known. In summer, when the chamber was unbearably hot, Maude abandoned her bedgown and slept naked. Wherever she could, she made a conscious effort to loosen some of the strictures enclosing her life. But some of those strictures, she knew, were less tangible. Some were deeply imbedded in everyday attitudes and perceptions of the spheres in which men and women were expected to move. They might never be loosened without some drastic measure to make those attitudes and perceptions change. The slaves of Missouri and women, Maude thought, had much in common.

Maude did not know if she would live to see attitudes towards women change. She did not know how to make the changes begin. But she thought bed caps and unbraided hair in her own life were a good place to start.

She reached for the pine-framed hand mirror that had been her mother's and stared hard at her reflection. She thought of Sam Webber's blueberry-colored eyes lingering on her face. Did he see her as she saw herself? The face in the glass was her adult face. She still resembled her father too much to be called beautiful. Yet she was not plain. Her cheeks glowed with health. Her eyes were clear and bright and deep with caring. Her nose was short, her chin strong and determined. Her mouth was shaped like a bow. It turned up slightly at the corners. She always appeared to be smiling slightly. A good face, she

thought. That was it. She had a good face. Not so beautiful as to cause women to mistrust her and not so plain as to repel men. She was certain Sam Webber did not think her plain. She believed he had seen beyond the contours of her body and was already acquainted with the more complex vistas of her heart. The thought pleased her. She smiled into the mirror and laid it aside.

She pinched out the candle and lay awake a long time. She heard the horse stamping in the stall. She heard Eli's bed ropes creak as he settled himself for what was left of the night. She fell asleep remembering the strong, hard feel of Sam Webber's arm firm as an anchor under her hand.

<div align="center">16</div>

MAUDE WAS UP TO her elbows in soap suds and soiled linens. She let her attention wander from her tasks inside the steamy wash house to the line of maples edging the field just beyond the open window. It was late May when trees appear to leaf out overnight. Everything was green and blossoming. The fields and farms along both sides of the Penobscot were suspended in the timeless ritual of renewal.

In the weeks since General Herrick's gathering to celebrate statehood, Maude had become aware of a soft haze of happiness misting the branches of her soul whenever Sam Webber was near. The feeling grew and kept pace with the leisurely greening of the Bangor countryside. Her heart raced and sang like a brook freeing itself from winter ice.

Maude hummed a few bars of "Greensleeves." She wrung out the last sheet and put it in the willow basket. She wiped her water-puckered hands on the hem of her gown. It was patched and faded to pale blue and soggy at the hem from slopped water.

"Sarah John," Maude called. She pushed several strands of straying hair away from her face.

Sarah John came into the wash house with a cautious creak of the door. Two long white-blond braids hung down her back. Her narrow, pale face was expressionless. Her gown had grass stains on the knees. She stood very still with her hands behind her back, an uncharacteris-

tic pose for Sarah John. She was usually in motion. She liked hanging the wash to dry on bushes behind the barn. It wasn't like her to be unenthusiastic.

"Are you going to help me, Sarah John?" Maude asked. She pushed her sleeves, impatiently above her elbows.

Sarah John grinned and said nothing. Maude couldn't imagine what had gotten into the child.

"Got somethin' for ya," Sarah John said. She thrust a bouquet of violets and mayflowers into Maude's hand. "Mr. Webber said bring these to surprise you."

In an instant the wash was forgotten.

"Sam? Mr. Webber? Mr. Webber is here?" Maude had not expected him. His visit with the Stinsons was over. She had thought he'd shipped out and would be away for six or eight weeks.

Sarah John nodded her head, yes. Her braids bounced.

Maude gave no thought to the work at hand, no thought to her appearance. Nothing in her reaction to Sam ever had anything to do with thought. The very mention of his name precluded rational thinking. She flew out into the yard.

Sam sat on a horse he had hired from Hatch's stable. Maude looked him over carefully, making certain nothing about him was different, that the warm message in his eyes, his smile, had not altered or disappeared. He was hatless. His hair was still the color of autumn leaves. Was there a bit more gold in it than she remembered? Was his face a bit thinner?

Sam dismounted awkwardly. He was not used to sitting on a horse. Maude found his clumsiness endearing. It aroused tenderness in her, inspired a need to shelter him. He reached into his pocket and withdrew a few dried currants. He fed them to the horse. The kindness of the gesture pulled at Maude's heart and endeared him to her all over again.

Maude thanked him for the bouquet.

"I thought you had gone until the end of July," Maude said. She tried to keep relief out of her voice. She did not wish to be a millstone around his neck and prevent him from coming and going as he wished.

"When I got to Portland, I had word there was a delay for another two weeks. So I made a short journey to Boston and came straight back here."

Sam stood with one arm flung up across the saddle. Maude leaned against the horse's thick, warm neck. She stroked its smooth shoulder. The horse's big body afforded them a kind of privacy, shielded them from the windows of the house where, Maude was certain, Mrs. Howard hovered. And Sarah John was undoubtedly spying at a crack in the wash house door.

"I'm very glad to see you, Sam," Maude said. She recognized shyness in her manner. But it was not because she knew Mrs. Howard and Sarah John were observing them. It was the intensity of her caring for Sam. She was engulfed in a flowering of feeling that left her amazed.

Maude remembered telling Eli after the British invasion how she did not want a husband. That was no longer true. More and more it seemed to her that what she thought about what she wanted was less reliable than what she felt about what she wanted.

She had a magnificent regard for Sam Webber. She had even tried on his name. Maude Richmond Webber. She liked the sound of it. She liked the feel of it. But there were other, conflicting feelings. As much as she craved Sam's presence in her life, she did not like the idea of annexing herself to him in such a way that she lost herself in the process. It was very confusing to feel one way and think another.

Sam reached for Maude's hand. He laid it against his cheek for a moment. His skin was the texture of a cat's tongue, smooth and rough at the same time.

"I couldn't wait to get back to you, Maude," he said quietly. His eyes were bluer than blueberries and very, very deep. There was such sweet safety there, such hints of other depths that Maude dared not dream of yet, such messages of ardor of an intensity that mesmerized her. Sam transformed the flow of her thinking into a river of emotion as deep and wide as the Penobscot.

"Sam," Maude said. It was a summing up of the time since she'd last seen him. "Sam."

The horse shifted his stance and broke the silent interplay between them. Maude tucked her hand into the crook of Sam's elbow. They walked to the shade of an elm near the barn. They sat down on the grass. Maude laid the bouquet aside. The fluted melody of on oriole filtered down from the highest branches. A breeze rustled the new leaves.

"I've brought you a present from Boston," Sam said. He reached inside his jacket and drew out a metal tube-shaped object. It had a wide flare at one end like a trumpet, and a smaller flare at the other end.

"What is it?" Maude asked, mystified. She turned it over in her hand and hefted it. It was not heavy. It reminded her of a toy horn, but she was certain it was not a toy.

"It's a new invention. Something a French physician dreamed up last year. I read about it in a medical journal last fall. I never thought I'd get my hands on one this soon. It's a stethescope. For listening to the heartbeat. The inventor claims that heart sounds are useful in diagnosing certain illnesses. You can hear lung sounds with it, too. Ought to be useful in cases of consumption or croup. Maybe you could find a way to apply its use to midwifery."

"But you must keep it for yourself," Maude protested.

"Oh, I'll find another. I don't really need anything like it for stitching wounds and setting bones. I bought it for you. To experiment with. Here. Let me have it. You lie down. I'll show you how it works."

Maude gave no thought to what Mrs. Howard must be thinking. She lay down on the grass under the tree. She was as close as an embrace to Sam. All thought had flown completely away.

Sam pressed the stethescope's widest end against her chest and lowered his ear to the narrow end.

"Tick-tick. Tick-tick. Tick-tick," he said. "Steady as a clock. Now if your heart sounded irregular, like a lad with a new drum, I'd have been worried. Now breathe in deep and let it out. Whoosh. Clear as the sound of the breeze up there in the elm. Just like it's supposed to be. Here, you try it."

They changed places. Sam pillowed his hands comfortably behind

his head. There was ease, comfort, and trust in his manner. It was precisely how Maude felt about being near him.

Maude set the stethescope on Sam's chest and lowered her ear to the narrow opening. The heart was the seat of the emotions, the center of all that was fierce and warm, sad and joyous. His heart held all things, she knew. He said them with his eyes. What else would she hear? She heard lub-lub, lub-lub. It was a deep, steady, predictable sound. Something you could depend on.

Sam breathed deeply and blew the air out. His lungs whooshed just as he had described.

Maude removed the stethescope and laid her hands where it had been. Her fingers absorbed the steady beat of him. The little wisp of air he breathed in and out grazed her fingers. He took her hands and kissed each knuckle, one by one.

"Maude," Sam said softly, "I know we've known one another only a short time, but I must speak. . . ."

Maude placed her fingers against his lips to stop his words. She knew what he wanted to say, but she was not ready to hear it. Not yet. She was relieved when the door slammed and Eli came striding across the yard toward them.

Sam scrambled to his feet and shook hands with Eli. Maude retrieved her bouquet.

"Come in, come in, Sam. Mrs. Howard says she's planning on you for supper," Eli said.

They settled in the parlor to talk. The windows were open. The cream-colored muslin curtains shivered in the breeze. The fireboard had been fitted into the fireplace opening. There was a pasture scene stenciled on it. Eli sat in a chair by the window. Maude chose the rocker. Sam pulled up a stool near Maude.

Maude showed Eli the stethescope and explained its use.

"Now that's the most useful thing I've seen in all the years I've been doctoring ills. What do you make of it, Maude?"

Now that she was inside the safety of the house, Maude's mind was working again. She was much less at the mercy of her feelings for Sam.

"I'm very pleased with it, Papa. I wonder if it could detect the heartbeat of an unborn babe?"

"Now that's a wonderful idea," Sam said. He leaned toward Maude with an eagerness that set her heart bouncing again.

"I'm not sure what you mean, Maude," Eli said.

"There are many instances when I am uncertain whether the unborn babe is alive. Sometimes a babe will not move for weeks before birth. If I could detect a heartbeat, then I would know there was no cause for alarm. If I didn't hear one, I'd know the birth might be a complicated one. And twins. If I heard two heartbeats, I'd be better prepared."

"I think you've really hit on something useful, Maude," Sam said. "If it works, it could take some of the guesswork out of delivery."

"I thought I might ask Anne to let me listen to her unborn babe," Maude said. The "chill" that had prevented Anne from attending the General's gathering was really the nausea associated with the early months of being with child. Anne had stopped using the pessaries and had conceived immediately. Her lying-in was expected in late August.

"I've brought you the latest medical journal, sir," Sam said.

"Why, thank you, Sam. I'll certainly enjoy that. Maybe someday Maude will write about her experiments with the stethescope as a tool for the midwife."

"Perhaps I will, Papa. But no medical journal would ever print it," Maude said.

Mrs. Howard appeared in the doorway. She set down a vase containing the bouquet Sam had given Maude.

"You've been called, Mr. Richmond. There's a man over toward Brewer that missed a stick of wood he was splitting. Split his ankle wide open instead." Mrs. Howard handed Eli a slip of paper with directions on it for finding the injured man.

Eli left and Sam closed the parlor door behind him. But before he could speak, Maude turned his question gently aside.

"Don't ask me yet, Sam," she said. "Not just yet."

Sam drew Maude into his arms. All thought fled. The heady perfume of mayflowers filled her head. She almost changed her mind.

MAUDE WALKED SLOWLY beside Sam along the river's edge in the horse pasture behind the house. The horse nickered to them from a distance, and she settled herself to graze. It was September. Sam had just returned from Portland. He had come in haste. He still wore his seaman's visored cap and a navy blue jacket with silver buttons. The cap shadowed his eyes. He did not look like a ten-year-old boy. He looked like a mature man determined to get what he wanted. While he was away, he had written and asked Maude to marry him. She had not replied to his question directly. She had written him she would give her answer when his voyage had finished and he returned to Bangor.

Maude had thought a long time about what she would say to Sam, had lain awake nights thinking of it, had wrestled with the ins and outs of it. If she listened to her head, her heart was outraged. If she listened to her heart, her head told her she'd have to give up her calling. She knew how the cares of keeping house and childbearing limited a woman's life. She loved Sam, but did not want to be limited. She did not know how to tell him so without causing him pain. She decided to be a forthright as possible.

The skirt of her russet wool gown snagged on a dried weed. She yanked at it. Sam bent and untangled the fabric.

"When I determined to be a midwife, Sam, I decided I'd never want to marry," Maude said gently. She did not look at Sam. He was too near, too essential to her idea of how a woman and man could love and care for and nurture one another. She was too much of a coward to witness the pain she knew would dull his eyes.

To Maude's surprise, Sam grasped her gently by the shoulders. He turned her so she faced him.

"That, Maude Richmond," Sam said softly, "is a bald-faced lie." There was no anger in his voice or manner. It was one of the things Maude loved best about him. He was always level-headed and reasonable.

"Oh, Sam. I didn't mean to be dishonest, to let you believe I entertained hopes of being your wife. I'm not like Anne. . . ."

"Of course you're not like Anne, thank God," Sam broke in. "I love you, Maude, because you're not content to sit in a big house, waited on hand and foot by the hired girl, with nothing more important to do than drink tea and brag about the new baby."

Anne had been successfully delivered of a son the week before. Before its birth, Maude had detected the babe's heartbeat with her stethescope. She had written Sam of it.

"That's not fair, Sam," Maude said coming to Anne's defense.

"Yes, it's fair, Maude. It's fair because I knew the minute I laid eyes on you, you'd never settle for a life of idleness like Anne has – no matter how much you groan about lost sleep and the labor of the wash house. If you'd wanted that kind of life, you could have set your cap for one of Anne's brothers."

Maude made no denial. Sam took her hand and kissed it lightly. She did not draw her hand away. The distressed expression in Sam's eyes was replaced with a crooked little smile.

"All I want, Maude," Sam went on, "is to be your ballast, not your anchor. How do I make you understand that?"

Sam released Maude's hand. She walked a little distance away and sat down on the grass. She gazed out across the river. Seagulls bobbed like cork stopples. They floated with the current without a care where it took them. Why, Maude thought, couldn't she be like a gull and let the currents of life carry her wherever they went?

"I understand, Sam. But marriage isn't in practice the way we dream it to be."

"But it can be, Maude," Sam persisted. He removed his cap and sat down beside her.

Maude watched the seagulls wheel aimlessly on the whim of random air currents. They settled heavily onto the surface of the river. How, she thought, could she make Sam understand how she feared the burden of women's work marriage imposed? Not that she wouldn't willingly do the work if she chose such a course. She was not afraid of work. She was afraid of giving up too much of herself in return for the comfort and safety of a man's love and caring.

"Because of childbearing, Sam," Maude said at last. "And the work of caring for children. Ruining my health from it. Dying . . ." She trailed off, not quite sure how to say what she felt. She remembered a dream she'd had about Mollie Smith earlier in the week. In the dream, Mollie's infant, instead of refusing birth, lay with its head and shoulders out of the womb. The infant's skin was blue. Its tiny face was contorted with some unknown emotion. Mollie writhed and moaned in agony. The child would be born no further. Then slowly Mollie's face faded away and Maude was in Mollie's place. The infant stirred and tried to claw its way back into the womb. Maude had woken with sweat running down her face. Her hair was matted against her head. Her knees were drawn up in the birthing position as if she'd really been in travail.

She told Sam about the dream.

"Are you afraid of death?" Sam asked carefully. There was concern and empathy whirling in his blueberry eyes.

"Not death, Sam. Not the end of life. The end of Maude Richmond, midwife," Maude rested her hand on Sam's arm. She comforted herself with his nearness. "I'm plagued by the notion that my affection for you is not deep enough to give up a part of myself for you."

She spoke simply, quietly, almost apologetically. She waited for pain to mark his face, waited for his anger at being rejected, waited for him to reveal a side of himself she could not love.

"Dearest Maude, I don't want you to give up any part of yourself for me. Those things you want for yourself are the things I love in you. While it is true marrying me will mean leaving Bangor and your friends and family, it is also true that what you leave behind here you can put into practice at Portland. We'll be much closer to Boston. I have access to medical libraries there. I can bring you books and ideas. You can keep learning all there is to know about birthing. And I'll keep coasting. The life suits me, patching up cracked heads and bruised knuckles. With what I earn and your fees, we'll have enough to rent a small house and hire a housekeeper. We could take Sarah John with us, if you'd like. With me gone two months to a time, you'd be free to come and go as you please. I don't want you with barnacles on your beam,

my love. I want you in full sail. I'd be lying if I said I didn't want to share your bed. But you know the uses of lamb's wool and olive oil. And the French, bless them, have devised something called a French letter. It's designed to prevent disease. But it also captures the male sperm before it can do any harm. For pity's sake, Maude, we're both familiar enough with the workings of human anatomy to figure out a way to prevent childbearing until we decide it's time."

Maude did not know what to say. Her need for Sam shrieked and clamored like the seagulls overhead whose cries hung in the air like kites. She watched their idle circles. They were greedy, boisterous birds. She'd never admired them very much. No, she thought, she wouldn't make a very good seagull. She was not content to drift along on capricious currents. She was a woman of reason, of action, of deep caring. She turned to Sam and took his face in her hands. She kissed him. She parted her lips and touched her tongue to his. Sam drew a little away and regarded her curiously. Her kisses were usually chaste and fleeting. She kissed him again, more deeply. Whatever womanhood held in store for her, she was ready to meet it. Sam was her friend, her ally. She loved him with every fiber of her heart.

Maude lay back in the brown September grass amid the dried weeds. She was unmindful of stains and damp. She gave herself up to the non-thinking tides of emotion lapping at her very foundations. Sam settled himself beside her. A happy grin lit his face, warmed the blue of his eyes. She was very aware of his body. It was neatly made, narrow of hip, small and compact, well-muscled from heaving-to with the crew of the Stetson ship. Her special woman's places grew soft and moist with want and longing.

Maude interrupted their kissing and murmured, "Do you own forceps?"

"Yes," Sam whispered back. His expression was puzzled.

"Will you teach me to use them?"

"Of course I will. I'd planned to give them to you as a wedding present."

"Then I guess I'd better marry you, dearest Sam."

Maude wrapped her arms around Sam's strong back. The rough texture of his jacket was scratchy beneath her fingertips.

Sam crushed her to him with a little yelp of joy.

The tide was far out in the channel and the seagulls had disappeared from the sky when they went to tell Eli.

PART TWO: FANNY

1

FANNY ABBOTT WALKED carefully down the narrow track along the pasture wall that led from the house to the wharf at the edge of the Penobscot River. She shivered beneath the folds of her green kinsale cloak, not so much from the chill as from the excitement of the whole thing. She strained to see across the river. Everything was dark except for small twinkles of lamplight that marked a homestead on the far shore. There was no moon, no stars.

Fanny's auburn hair was covered by the hood of her cloak. At sixteen, she was as tall as a young willow. She moved with grace. Her face reflected her determination to do as she pleased. Her eyes were an amber color and her gaze was direct. Her mouth was deceptively soft, but there was a definite firm line to her lips. She held her head high, with just a slight incline to one side. When she went to town, men's heads turned to watch her.

Presently she heard the splash of water and turned toward it, trying to determine if it was just the river current lapping at the wharf, or the sound of oars dipping rhythmically in the water. Yes! It was oars! Her heart leaped. Robert had come for her just as he said he would.

Fanny snatched up the small bundle she'd brought with her. It was her best shawl, and she'd tied it around an extra dress and some bread and cheese. Oh, wouldn't her older sister, Mercy, be aghast when she read the hastily scribbled note she'd left on the kitchen table. But Mercy would forgive her once she knew about the wedding. As for Pa, well, she'd rather not think about what Pa would say. Not that it mattered. This was 1830, not the olden days like Pa was always harping about. Pa would see it her way in time, once she was married to Robert Snow.

The thought of spending the rest of her life with Robert gave her courage, made her so pleased with their adventure, that she hugged herself with delight. She remembered every detail of the day Robert Snow had first appeared at the farm last spring. She had seen him from the window in the kitchen. It was an important event because handsome young men did not often come to the house. Fanny's father, Simon Abbott, conservative in all things, did not sanction social contact with the young people of Fort Point village. He wanted his girls kept pure, he said.

Fanny had stepped into the back bedroom which she shared with Mercy, and repinned her heavy auburn hair. She took off her soiled apron and tied on her company one. The water bucket was nearly empty. It was the perfect excuse to go out in the yard to get a better look at the visitor. She lingered at the well and eavesdropped on the conversation.

She heard Robert say he'd come to town to visit his aunt, his mother's sister. He was from Portland and wasn't familiar with the country. No one from the village knew anything about his aunt. He'd been directed to a country lane, lost his way, and ended up at the Abbott place to ask directions.

Simon scratched his beard, thought a minute. His beard was iced with gray. It fell to his chest. He was a burly man, broad as a work horse. The vague expression that had come over his brown eyes since his wife's death played on his face. Fanny remembered how he shook his head, as if "no" were the most important word he knew. Simon had never heard of Robert Snow's aunt.

It was suppertime, would soon be dark. Simon recognized the opportunity to make a little cash money and offered Robert room and board for the night. Fanny had been surprised and pleased by her father's suggestion. She was tired of living like a prisoner on the farm and never having any fun with people her own age.

Mercy responded to the situation with her usual competence. She set the table with the best dishes. She fixed dandelion greens, alewives from the river, corn bread, and pudding. She, too, responded to the rarity of the occasion. Her small, brown eyes sparkled with a vitality they usually lacked. Her plain hair was parted in the middle and combed smoothly over her ears and tucked into a tidy knot at the base of her skull. Her narrow face was unremarkable. But what she lacked in looks, she made up for in kindness and competence. Fanny knew Mercy was attracted to Robert's easy talk and dark good looks.

All during the dinner hour a current of tension crackled in the air between Fanny and Robert Snow. Simon ate and appeared not to notice.

That night, Fanny and Mercy lay together in the big bed they shared.

"Mr. Snow is so handsome. Such a gentleman. Don't you think so, Mercy?" Fanny whispered.

Mercy pressed lips together primly. She was twenty-one and had never walked-out. Fanny knew she resented it.

"Handsome is as handsome does. You'd be better off to settle yourself to learning the dressmaking I've been trying to teach you. Heaven knows we could use the extra money you'd earn by taking in sewing."

"I'd rather be married and have a house of my own," Fanny said sharply, "so I wouldn't have you and Pa always telling me what to do!"

"Then you'd have a husband telling you what to do!" Mercy retorted.

"Which is more than you'll ever have, Mercy Abbott!"

The following Sunday, Robert showed up at a meeting. He asked Simon if he could walk home with Fanny.

"Might's well," Simon grunted, to everyone's surprise. Fanny shot a

triumphant look toward Mercy and was gratified to see that Mercy was not pleased. Fanny fell into step with Robert. Pa and Mercy walked on ahead, ears turned, Fanny was certain, to everything she and Robert said. But there wasn't much of anything to hear. They hadn't talked much on the two mile walk back to the farm. Robert picked a few bluets and handed them to Fanny. As he did so, he allowed his fingers to brush hers ever so lightly. Just like a summer butterfly, Fanny remembered thinking. Robert smiled and she liked the way his teeth were white and even, not one of them missing or decayed, an uncommon occurrence in a seaman.

Robert said he was staying at an inn in the village. He would remain there until his vessel, berthed at Portland, was scraped and caulked and made ready for the next voyage. He wasn't sure how long that would be. Six or eight weeks perhaps. He had learned that his aunt had gone out to Ohio to live with her daughter. He had no further obligations. In the meantime, perhaps Fanny would permit him to call. His ice-blue eyes caught Fanny's amber ones and held. She read something glittery and adventurous there. Red-brown lights glinted in his hair. He was the most elegant-looking man she had seen in all her sixteen years.

June turned into July and heavy heat settled over the farm in a haze of scorching blue. Robert came to the house frequently and Simon, inexplicably, tolerated the visits. Robert was careful to make himself useful. He came to help with the haying and was at the house every day for a month. Fanny fought with Mercy over who would do the cooking, won out, and pretended that Robert was her husband coming home every noon to be fed.

Whenever Fanny could slip away from Mercy's watchful eye and the hated dressmaking, she sneaked down to the meadow to gaze at Robert's well-muscled arms glistening with sweat. She liked the slick sheen of him, the bronze triangle of his tanned back, the woolly mat of hair that lay like a shadow on his chest.

Simon accepted the help without comment. He remained oddly detached from conversations and took no interest in anything except the farm work.

On Sunday evening, after Simon finished reading aloud from the Bible, Mercy allowed Fanny a few minutes alone with Robert. She had decided that Robert wasn't quite the catch Fanny considered him to be, and if Fanny wanted to waste her time with him that was up to her.

Sometimes Fanny walked with Robert down the pasture track to the wharf. Once, they sat on the doorstep very close to one another to watch the moon rise. Fanny rested her head on Robert's arm. His linen shirt was soft against her cheek. She liked the sunny warm smell of him. Robert groaned and Fanny drew her head away.

"What is it, Robert?" she asked, terrified that she had irritated his sunburned arm. In reply, he kissed her lightly on the lips. From then on, everything had changed. Fanny felt it most as she lay beside Mercy trying not to toss and turn, but burning with a heat that had little to do with the humid, still air that clogged the room. But worst of all, Pa had seen the embrace and had forbidden Robert to set foot on the farm again.

"Shifty," Simon said tersely, not explaining further. Fanny begged and pleaded.

"If Ma were alive, she'd let Robert come here!" she complained. That outburst had made Simon more adamant than ever. But his eyes grew moist at the statement and Fanny knew the mention of her mother had hurt him. She didn't care. That night she saw him place flowers on her mother's grave in the little family cemetery in the grove in the home pasture. She remained unmoved. She wanted Robert.

One day in late August, Simon went to help a neighbor get in some hay from a field on the far side of the village. Mercy went the opposite way, glad, she said, to be relieved of her responsibility as Fanny's chaperone. She was going to sit with an aged relative whose wasting illness was in the final stages. Fanny was glad to be home alone, free of Simon's moroseness and irrationality and Mercy's constant lecturing.

There was a calf in the barn whose mother would not nurse it. Fanny knelt in the pen holding an invalid feeder while the calf sucked from it. She had not heard Robert approach, but she sensed his intense presence and she knew that he was there in the barn with her. Wishes, she thought with joy, do come true.

Robert looked down at her with his unusual ice-blue eyes. He said nothing, simply held out his hand. Fanny took it, not fully understanding what he wanted, but aware that it had something to do with the ache in her middle that kept her awake at night longing for him. She felt something for Robert Snow. She thought it was love.

They climbed to the loft where the new hay had been spread and piled. The air was heavy with the scent of dried grass, the pungent odors of sheep, cattle, and horses. Chickens gabbled and clucked out in the yard.

Fanny was not afraid. She was curious. She had seen farm animals mate and reproduce and understood the role of male and female. Robert kissed her hands, her neck. "You're the most beautiful creature I've ever known," he murmured. "I adore you, Fanny, you drive me wild with desire."

She had never heard such sweet words, like honey, it was that golden, that delicious. She helped him unpin her hair, and long auburn strands fluffed in the soft breeze that filtered through the hay loft. She was speechless with the delight of his attention.

Robert eased out of his trousers. He pushed her skirt high up around her soft white thighs. In summer, she did not wear under-drawers. She arched toward him and took him into her body without coherent thought for the Bible lesson Simon had read last evening, the one about Mary Magdalene.

Later, they leaned against the well and drew up a bucket of cold, sweet water and drank. She waited for Robert to beg her to marry him. He did not, but he swore undying love for her and arranged for them to meet each evening in the dense pine grove a mile downriver.

Early in September, Robert said, and Fanny remembered his exact words, "I have been called back to Portland. We can be married there."

And now he had come for her just as he had promised.

TWO DAYS LATER they were in a small sailors' rooming house on Fore Street, close to Portland Harbor. Fanny settled in with a blissful feeling of release from the drudgery and restrictions of life on the farm. Robert was going to buy a little house for her, and she would wait there while he was away at sea. She would write him passionate letters and make him a shirt and a quilted robe and embroider him a pair of slippers. But things did not go as Fanny imagined. Robert was very much occupied with the loading and impending departure of his vessel. Fanny was left alone much of the time with little to do. She was not used to being idle. She passed the time with a serving girl, Nancy, at the Fore Street Inn where she took her meals.

"Everyone calls me Nance," she said. Nance was buxom with pale hair and a quick smile. "You're new around here." She set a plate of beans on the table and wiped her hands on her apron.

"Yes, I am," Fanny confided. "I've come here to be married. Then my husband goes on a voyage to South America."

"That's what they all say, miss. They'll promise you anything. You want to hang right on to him and get him to the altar quick. Them sailor men got a girl in every port. What vessel he on?"

"The bark Lady Ellen." Fanny nibbled her food. She wasn't hungry. More and more she was worried about Robert's intentions.

"That's one of old Phineas Stetson's vessels. Oh lord, the stories I can tell about that old codger. The Lady Ellen, la-di-da. Named for his second wife and she's no lady. Ellen Brackett, she was. Got her start right here in the Inn. I was just a kid with a job scrubbing pots. But I kept my eye on what went on out front. Old Phineas, he always had and eye for a neat waist and a trim ankle. And Ellen, she sure had that and then some. She did a whole lot more than serve a round or two of ale, now let me tell you. Then Phineas took a fancy to her and she hooked up with him. He must have been close to fifty, this was fifteen years ago or so. And she barely twenty. Well, I guess Phineas was either right over the moon about her or she knew how to cast her bread on the water,

because he up and married her and wasn't that the wonder of the day. Then there was all the talk about Phineas's son, Joshua. Joshua comes in here some. Well, the story is, he didn't take much to Ellen as a stepmother. It was told around that she abused him some. But I don't see how that could be. He was about sixteen when Phineas married her. Seems more likely, and I heard this from a girl who worked up at Phineas's house, that Ellen and Joshua took a fancy to each other and Phineas caught them in the act. Wild as a hawk, he is, that Joshua. And old Phineas, he keeps his hand on the purse strings tight as a new-strung bed rope and don't give Joshua a penny. As for Ellen, well, I'd say she has ways to get what she wants out of old Phineas. But I bet poor Joshua don't like it a'tall." Nance grinned, pleased with herself for initiating a newcomer into the local gossip.

The story fascinated Fanny. She'd lived a sheltered life, had read no novels, had heard little gossip aside from who'd been born, died, got married, or injured. Nance's talk was entertaining. It passed the time while she waited for Robert to set the wedding day and find a house. But Robert put it off again and again.

Fanny bided her time until she was certain. Then she told Robert about the child she was carrying. That night Robert caught the first vessel sailing with the tide.

Fanny stayed in her room and wept. If only she'd listened to Mercy. If only she'd taken Nance's advice and made Robert keep his promises. Twice she packed her belongings. Twice, the thought of a long winter of Mercy's disapproval and Pa's terrible judgment made her unpack again. She had no money. She was too ashamed to ask Nance what to do. She lay on the bed in her room trying to think of an easy way out of her predicament. The only thing to do was go home to Pa and Mercy. But she was too ashamed to let them see how she'd been so wrong. She fell asleep with her arms around the pillow where Robert had lain his beautiful head.

By evening of the next day she knew what she had to do. She borrowed some sewing tools from Nance and spent the day letting out the seams of her other dress so it would conceal the roundness of her belly.

The material was too thin for early November, but it clung to her figure and revealed the parts she wanted revealed. She cut down the high collar so the little crevice where her breasts cleaved together was exposed. She rummaged through her cache of laces, ribbons, and feathers and found enough to retrim her straw bonnet.

When it was twilight, she dressed herself and did her hair so it swept away from her ears and fell in a long, bushy mane down her back. She pinched her cheeks hard to give them color and went out on the street. Surely, there were other men with more means than Robert, who would find her attractive and wish to take care of her.

She chose the corner of Fore Street and Union where pedestrian traffic was busy. It was not far from her lodging and near the well-frequented lanes that led to Union Wharf.

Two mariners came by and eyed her up and down.

"Look at the prow on that one, mate. How'd you like to find that between the sheets tomorrow morning?" one man said. Fanny's stomach did a flip-flop and she began to wonder if she'd made a terrible mistake. This was not what she had hoped for.

"Aw, yer in yer cups too much to get it aloft even," the other man said. He stumbled drunkenly.

Fanny pulled her shawl across her chest to conceal the cut of her dress. Her courage waned. She was frightened. The men lurched away down the street and relief calmed her stomach. She renewed her resolve. She'd wait until a more respectable man happened along and she'd ask his help. But when a man in an evening cape came in sight, she stood frozen on the street, too tongue-tied to speak. She couldn't do it. She couldn't sell herself.

Hot tears of shame and despair dripped down Fanny's cheeks. She knew she'd have to go home after all.

"Are you ill?" A pair of eyes, neither brown nor blue, peered out of the fading light. Fanny had not dreamed he would approach. Her shaking increased and her tears multiplied and she could only shake her head, no. Suddenly, she was on the verge of hysteria and couldn't stop crying. The man guided her to a nearby set of steps in front of a store and pushed her gently to sit.

Fanny saw him a little more easily now that he was closer. He was slight of frame and only a little taller than she was. He was neatly dressed in a finely-tailored black suit with a white cravat tied perfectly under his chin. He was beardless and smelled of freshly ironed linen and scented shaving soap. She had seen him before, she realized with a start. Nance had pointed him out one day. It was Joshua Stetson.

"I know you. I've seen you at the Inn. I heard Nance call you Fanny," Joshua said.

Fanny wiped her face with the back of her hand and fished for the handkerchief tucked into her wristband. Her teeth clattered and she could not answer.

Joshua helped her to her feet. "Better come with me," he said. With his arm supporting her, he guided Fanny to a rooming house on Cross Street, a stone's throw away.

Fanny did not resist. Her mind had stopped functioning. She felt his kindness and responded blindly to it. She had no where else to go. The landlady had tried to evict her that very day.

The room was modest in size, but pleasantly furnished with a large bed, a linen press, and a pine commode. Two overstuffed chairs were drawn up to the hearth. Fanny allowed Joshua to settle her in one of the chairs near the fire. He handed her a glass.

"Here," he said, "drink this." Fanny drank and choked on pure Barbados rum. The liquor revived her enough so she could speak.

"I can't stay," she stammered. Her presence there was a terrible mistake. She had to go home.

"You don't make a very good doxy, Fanny-whatever-your-name-is. Too much pride. No experience. I suggest you give it up"

His words struck like a slap in the face and she felt herself blushing. Her mind cleared and she stopped crying. An odd calm settled over her.

"I intend to, Mr. Stetson."

"Ah." Joshua lifted his glass in a mock salute. "My reputation has preceded me I see. Never fails." He refilled Fanny's glass. She demurred.

"Drink it," he commanded.

Joshua lounged easily against the mantelpiece, regarding her with an air of detachment, as if she were an insect on a blade of grass.

He was, Fanny supposed, about thirty, not handsome though he had a pleasant face. He did not smile and she wished he would.

"Now that you've thawed out some," Joshua said, "I'll take you back to your lodging."

Fanny stood up quickly. "I've troubled you enough, Mr. Stetson. I thank you for your kindness. I know my way back to Fore Street." She did not want him to know she had no place to go.

"Will the landlady be pleased to see you, I wonder?"

Joshua had not taken his eyes from her face and Fanny stirred uneasily. She clutched her shawl tightly around her. She felt that he had the power to probe her mind, to strip her of her façade and reduce her to the nakedness of her folly. She avoided his eyes. He tipped her chin up with one finger so she had to look directly at him. If she said anything but the truth, he would know.

"The landlady will let me stay one last night and in the morning I'll borrow some money from Nance and go home to my father and sister," she said meekly, miserably. Tears trailed down her cheeks again. He had been kind. Perhaps he would also be compassionate.

Joshua's gaze roamed Fanny's body and came to rest on her bulky midsection. She blushed to the roots of her hair and tore her eyes from his snaring stare.

"So that's it," Joshua said softly. "You are in circumstances of, shall we say, a rather delicate nature." He reached for Fanny's left hand. "No narrow gold band. No money to pay the landlady. And no prospects in sight." He seemed pleased with the idea.

"Thank you for your kindness," Fanny said stiffly and turned to go.

Joshua moved around her and leaned against the door so Fanny could not open it. His brown-blue eyes darkened with an expression she could not fathom. It came to her that she ought to be frightened. But it was not fear that she felt. It was fascination. And something more, something deeper that responded to his impulsiveness and roused similar feelings in her.

"Stay here. The rent is paid. It's warm. And safe."

Fanny did not feel safe. Wild, Nance had called him. She felt the wildness in him, an untamed spirit that reawakened the sense of adventure she thought she had lost when Robert had gone away.

"I don't work for nothing, Mr. Stetson." Fanny tossed her head and made her hair fly to let him know that there was wildness in her, too, and even though she was vulnerable, she still had fight left.

Joshua's face collapsed into a grin and he laughed. The smile transformed his wildness to playfulness.

"Oh, I like your spirit, Fanny," he declared. He took a long drink from his glass and his face clouded again. "My dear Fanny, don't you know what's out there?" He swung his arms out in an expansive gesture. "There are mariners out there who would think nothing of dragging you into an alley with no intention of paying you for the convenience. There are men who would abduct you and force you to sell yourself forty times a day and pocket the money they earned from it. There are even women, lovely Fanny, who would strip you naked just so they could sell your clothes for what little they'd bring. Stay here. You can decide what to do in the morning."

Joshua put on his stovepipe hat, swung his evening cape around his shoulders, bowed formally from the waist, and left.

Fanny stared, dumbfounded, at the door as it latched behind him. She sat back in the chair, feeling suddenly weak and nauseous. The warmth of the fire lulled her. The chair was very comfortable. It wouldn't hurt to stay just this one night. She gave in to the fatigue that had crept into her body. The rum she'd drunk made her sleepy.

When she awoke the next morning, Joshua Stetson's evening cape was tucked around her knees.

3

THE CLOCK ON THE mantel said 9 A.M. Alarmed that she had slept so long, Fanny kicked aside the cape and searched frantically for her own shawl, finding it laid neatly on the bed. She wrapped its familiar folds around her shoulders. Her hand was on the door latch when Joshua eased into the room with his arms full of brown paper parcels and bandboxes. He was dressed as finely as before, but in ordinary clothing—a gray tweed jacket, a modest white neckcloth.

"For you," he said breezily, laying out lengths of woolen and cotton stuff, gloves, two bonnets, laces, ribbons, and sewing supplies. "Can you sew?"

Fanny nodded dumbly. She recognized the impulsiveness of his gifts, but felt a sense of calculation in his action. She knew, from what Nance had told her, that Joshua Stetson never did anything for nothing.

"Good. Make yourself something that fits." He indicated the yard goods he had brought.

"Mr. Stetson," Fanny said carefully, "I can't take your presents. I—I have to go." A plan began to form in her head. She could accept his presents and after he'd gone she could sell everything.

"Where, Fanny? Home to Papa?" Joshua's words were mocking and full of needles. "Out into the street into the clutches of the first drunken sailor who comes along?"

"No!" Fanny cried. "I'd never do that again. I must go home." Her lips trembled when they shaped the word "home." She was on the verge of tears. Her back ached and she was hungry. And this perverse man apparently took pleasure in tormenting her. She abandoned her half-made plan to accept his gifts. She held out her hand. The adventure was over.

"Good bye, Mr. Stetson. I'm grateful for your kindness."

Joshua ignored her hand. He did not try to block her from leaving. He clasped his hands behind his back and stared morosely at the cold ashes on the hearth. He might have been the minister come to Sunday dinner or a little boy whose favorite plaything had been put away.

"You could stay here." It was a request, a suggestion, not a command. The sudden, unpredictable change in his manner made Fanny hesitate. There was no wildness, no playfulness in his voice or manner. She could not define what it was in him that kept her from opening the door and leaving.

"It won't be easy at home, you know," Joshua said softly.

That was true. If Fanny went back to Fort Point, her life would be that of a spinster with a bastard child to raise. She would be invited nowhere, not even welcome at church. And worse, her child would suffer from the pointed fingers and remarks whispered behind the backs of hands. Nor would Pa ever let her forget her sin. Mercy would be kind, but would take Pa's part to keep the peace.

Fanny looked around at Joshua's room. It was spacious, airy, and full of light. The furniture was comfortable and the floors were clean. It was much nicer, by far, than the room she had lived in at Fore Street. She felt a sliver of temptation creep into her. It communicated itself to Joshua. He turned and fastened her with a speculative look.

"If I stay, Mr. Stetson, than surely you will expect something from me in return." Fanny removed her hand from the latch. No harm in testing the waters a bit.

"Nothing you won't be willing to give, when the time comes, Fanny-whatever-your-name-is." Wildness edged his words and Fanny thought perhaps adventure hadn't gone to sea with Robert after all.

"Hogan. My name is Fanny . . . Hogan." She lied to protect Pa and Mercy and knew she retained a small shred of decency.

"You have nothing to lose if you stay, Fanny. All any woman has of value is her virtue. Obviously, you've already lost that." Joshua's words robbed her of that small sense of decency. Shame bit at Fanny's face. She drew her shawl closely around her. For the first time, she felt like a fallen woman.

Fanny settled in. The days passed in a haze of unreality marked by Joshua's erratic comings and goings. She expected Joshua to assert the right to share her bed, but he did not. Mrs. Winship, the landlady, brought meals three times a day, and Betty, the hired girl, came once a

week to clean. Fanny did little but sew and sleep and watch her abdomen round out until she could no longer fasten her old dresses around her.

Other packages arrived. Perfumed soaps. A music box that played a tinkling tune. A length of rust-colored silk that make Fanny gasp with pleasure. All her life she had longed for gaiety and pretty things, but Simon had not approved of the pleasure she yearned for. There had been no money for fripperies. She and Mercy had spun or sewn or baked everything they had. Thus, each present Joshua sent took on fairytale proportions. It was a dream that wrapped around her like a spider's silken web. She was caught and did not care. She took whatever Joshua gave. It did not trouble her that she was in his debt. He had promised to take care of her until mid-May when the child would be born. If this was to be an adventure, she made up her mind to enjoy it.

It was mid-December and uncommonly mild. It had rained every other day, keeping the streets full of churning mud. Fanny no longer went to the Inn. There was a new serving girl. Nance had gone to get married.

The harbor was nowhere near freezing. Shipping, and the bustling life along the waterfront, went on. It was unheard of not to have had cold weather by now. Fanny's pregnancy was in its fourth month. She no longer wanted to sleep all the time and the nausea of the earlier months had passed.

She heard the tap of Joshua's boots outside her room and a little ripple of pleasure gilded her being.

"Get dressed, Fanny." Joshua called through the door. "I'll come for you in an hour. Be ready."

When he returned, he raised his eyebrows in admiration and Fanny felt herself glow under his approval. She wore a high-waisted gown made from the rust-colored silk. She'd looked in the mirror and knew it set off her auburn hair and fair skin. The dress fit snugly under her breasts, now rounded like plump fruit from her pregnancy, and fell in soft folds to the top of her slippers. The neck was modestly filled in with lace and ruching. The sleeves fit snuggly at the wrist and puffed at

the elbow. She had learned more about dressmaking from Mercy than she had realized. She had never owned such a magnificent dress.

"Is it all right?" she asked, craving his admiration.

"My dear Fanny, you look like a queen." Joshua's words were like cream to a cat. He was not often inclined to compliments.

The rain had stopped. The mild weather held. Joshua handed Fanny into a hired conveyance. They rode in silence with only the sound of horses' hoofs to disturb them. Predictably, Joshua's mood had swung and he seemed preoccupied with his own thoughts. Fanny did not intrude. She went out of her way not to offend him. No sense in killing the goose that brought the golden eggs. Presently, Joshua rapped on the carriage roof with his walking stick and leaned out the window to speak to the driver. They slowed and stopped.

"We're on State Street, Fanny. No mud here. Proper cobblestones. Everyone who lives here has earned the right to." Fanny nodded and smiled. "I'm not talking about good deeds, Fanny. You see that house? That's my father's house." Joshua indicated a large brick dwelling with numerous chimneys and a wide curving drive. Wildness played in his eyes. "If it weren't for my stepmother, it would be mine someday, all of it. Everything. But Ellen . . . her hair is red, like yours, Fanny." He paused and the wildness faded, was replaced by the calculating mood Fanny had observed before. "I intend to live in a house like that again, Fanny. And not too many years from now. But not here. Not in Portland, where Ellen . . . The future lies up the coast, up the Penobscot River, at Bangor. This country is growing, Fanny. And the one thing that's going to make it grow is lumber. Lumber for houses and mills, for fine furniture, and ships, and wharfage, and boxes and barrels for shipping goods around the world. Bangor is where the lumber is, Fanny. Hundreds of thousands of acres. Whole townships are going up for sale by money-hungry proprietors who haven't the imagination to see how lumber can make wealthier men than State Street ever dreamed of." Joshua's eyes glittered with a light that burned hot enough to set his father's house afire.

Fanny thought of Nance's gossip about the Stetsons. It had a core of

truth. Ellen Stetson had somehow deprived Joshua of his eventual inheritance from his father. It did not seem an important piece of information to Fanny. Stepmothers, and the havoc they created in families, were as common as the day was long. What disturbed her more was his talk of Bangor.

"Drive on," Joshua said to the coachman. They moved slowly down State Street, onto Danforth, and finally back to Fore Street and on to a part of the waterfront Fanny had never seen. Here, they stopped again. A rickety wooden building, with a sign hung at a crazy angle, rose out of a tangle of grogshops, tenement dwellings, and stables. The sign said, ROOMS. A band of ragged children, without shoes, fought over a loaf of bread. A drunkard slumped in the doorway forcing pedestrians to step over him. Women plodded slowly by, dressed in drooping feathers and faded satin ribbons. Their faces were pinched and devoid of expression.

"Why are we here, Mr. Stetson?" Fanny stirred uneasily, searched for the wildness in Joshua's eyes. There was none.

"Don't alarm yourself, Fanny," Joshua purred. "I thought it might amuse you to see what you gave up when you decided to accept my good works. This, my dear, is a brothel. It's where fallen women, like yourself, go when they have nowhere else to go." A glint of sardonic humor flashed in Joshua's expression. But Fanny was not amused.

The air smelled of rotting fish and human filth. It made her queasy. She had not known that such squalor and degradation existed. She was appalled to think how easily she might have ended up in a place like that. She owed him so much, more than she could ever repay.

"Please, Joshua," Fanny whispered, using his Christian name for the first time, "let's go home." Joshua took her gloved hand and pressed it lightly to his lips. Fanny was enchanted by the gesture. It was the first time he'd touched her since the night he'd rescued from the terrors of the street.

He held her hand all the way back to Cross Street. She was sure he would come round and want to marry her. After the baby was born.

When they arrived at the rooming house, Joshua said, "I'm leaving

for Bangor tomorrow. This weather won't hold much longer and I want to get there before the Penobscot River freezes in for the winter. I've bought an interest in a lumber schooner and I won't be back. I've spoken to Mrs. Winship. I've paid her to see to your needs until after your confinement. I want you to join me once the child is born. You can be of use to me in Bangor. Send a message to Hatch's Tavern. But come without a child at your breast, Fanny. You'll be of no use to me with a babe in your arms."

He kissed her lightly, impulsively, on the lips and left.

<div align="center">4</div>

THE WALLS OF Fanny's room closed in around her after Joshua left. It was her nest. She feathered it with the small housekeeping tasks that Betty, the hired girl, did not do. Fanny shook rugs out the window, made her bed, kept things neat. She set to work on a set of childbed linens, the small garments, blankets, and diapers the babe would need. The time passed; if not quickly, then tolerably.

Fanny did not anticipate the infant's arrival with pleasure. The birth would free her body of its burden, but birth simply shifted the burden from within to without. She brooded about whether or not she would survive lying-in. Many women, she knew, did not.

Fanny had observed, at yearly intervals, the arrival of infants born to her mother, babes she never thought of as brothers, who sickened and died almost before they drew breath. She had noticed, too, how her father had become resigned and finally embittered as the sons he hoped for arrived, but failed to thrive.

Fanny's mother had always made extensive visits with the minister to ensure that her spiritual life was in order as childbirth approached. It was well she had. She died after giving birth to yet another stillborn son the year Fanny was thirteen.

The bigger Fanny's belly got, and the more active the unborn infant was, the more Fanny brooded. There was no word from Joshua. Her isolation increased as her size increased. She missed him. She chided

herself for the folly of thinking her arrangement with Joshua was adventurous. The impending ordeal of birth was not, she concluded, an adventure.

A cold snap at the end of December froze everything, then gave way to an unusually warm thaw. By New Year's of 1831, the ice left the harbor and did not return. Fanny eased her growing sense of doom and loneliness, her self-loathing for the fix she'd got herself into, and her resentment at how the unborn child had taken over her entire being, with daily walks up Cross Street.

Cross Street, despite its nearness to the seamy elements of waterfront life, housed a somewhat more genteel class of people. Yards were tended and pigs kept properly penned. The rooming houses, of which there were many, catered to visiting relatives, indigenous spinsters of respectable reputation, and an odd assortment of traveling merchants, itinerant preachers, and nomadic seamstresses.

The landladies of Cross Street tended to put on airs and were decidedly inclined to appoint themselves keepers of the public morals. They snubbed Fanny whenever she chanced to encounter them on her daily walk. Fanny was mortified at the way they drew aside the hems of their skirts and refused to acknowledge her presence by even the smallest nod.

Fanny had seen her landlady, Mrs. Winship, hobnobbing over back fences and knew perfectly well the lady's loose-hinged tongue had spread the tale of her predicament.

Fanny was dismayed, but not surprised, when Mrs. Winship asked to see her on a matter of the utmost delicacy.

Mrs. Winship stood as close to the door of Fanny's room as she could, as if she might become contaminated by Fanny's illegitimate pregnancy. She clasped her hands rigidly over her apron. Her faded hair was tucked severely under a white cap tied primly under her chin.

"I've been to see the Reverend Mr. Dow," Mrs. Winship said nervously, "and he fully agrees with me, as do all my near neighbors, that something must be done. You don't fool us with a Mrs. In front of your name. Why the very idea! I've never had such goings-on under my roof.

If it wasn't for Mr. Stetson being so generous about your keep and me in need of what he sends, I'd have turned you out long ago and sent you packing off to where you belong." Her eyes glittered hard and mean. Fanny thought of a weasel she had once chased from the chicken house.

"The ladies at church, and the Reverend Mr. Dow, have held a meeting and we've decided that the least we can do, as Christians, is point out the error of your ways and exhort you to pray for forgiveness. Since you are not fit to raise a young one, there are several God-fearing women in the church who can offer your child a decent home. The Reverend Mr. Dow begs you to allow him to call on you so he can pray with you. And I would be greatly obliged if you would find other lodgings as soon as your confinement is over." Mrs. Winship pursed her lips and looked down her nose.

Mrs. Winship's words coiled around Fanny's heart and squeezed. How could she be as evil as Mrs. Winship made her out to be? She had loved Robert Snow, had truly believed that they would marry and make a happy life together. What had she done wrong? Certainly, she had disobeyed her father. Wasn't that her only sin?

Deep down she knew it wasn't. She was bad, a bad woman, the kind of woman men made sniggering jokes about and decent women only spoke about in whispers. Nothing could change that; not prayer, or churching, or the exhortations of the Reverend Mr. Dow. She had made her bed, now she must lie in it. The thought enraged her.

"Get out! Get out! Get out!" Fanny screamed. Mrs. Winship did not move fast enough and Fanny picked up a book and threw it at the lady's head. It missed and bounced off the door frame. Mrs. Winship left the door open behind her.

LATE IN February, Fanny received a letter from Joshua Stetson.

February 26, 1831

My dear Fanny,

I arrived at Bangor the day before the Penobscot River froze after an easy Journey of three days. At present all the local Sages are prophesying the Imminent end of the World because of this most unusual warming we have lately Enjoyed. Indeed, a farmer hereabouts actually plowed his Fields this week.

I am told there are nearly 3,000 Inhabitants in Bangor, 16 of Them lawyers which will give you some Clue to the demand for their Service as land changes hands here as often as Woman changes her mind. I have been most Fortunate to arrange an Introduction to Mr. Rufus Dwinel and Mr. Samuel Veazie, who operate extensive lumber businesses. Without contracts from them to ship their Boards and Shingles downriver, one has little Chance of large success. These two Gentlemen are generally not on speaking terms and are constantly Suing one another for the most Petty infractions of the Law. That is how they accumulate various Properties which they in turn sell for a goodly Profit, and is, in fact, a very sound way of building one's Finances as I have quickly learned.

I have lately received a most hysterical communication from Mrs. Winship who complains of being Ungratefully treated and not Deserving of a book thrown at her head. I assume she refers to a Display of your defiant Spirit of which I was once the Unfortunate witness. I have written to Mrs. Winship to soothe her ruffled feathers and you may be Assured that she will not turn you out on the street where the neighbor Ladies would surely point their Fingers at you and shout, Shame, Shame, in your face. Perhaps, my Dear Fanny, your warring Spirit might be a boon to the Female scholars of Atkinson, not far from here, who have started a project calling for the Reform of ladies' fashion. Any person who joins them pledges herself to refrain entirely from

wearing Busks, Boards, Stays, Cushions, Pillows, Bolsters, or any kind of furnishing which is likely to cause consumption or endanger life. Life in this Wilderness appears to bring out the Wildest ideas in the Ladies and I am Convinced you would find yourself quite at Home here.

I assume you are unacquainted with any Ladies who possess the Skills you will soon require. The day I sailed for Bangor, I had a chance Encounter with Samuel Webber, a physician, with whom I was briefly acquainted at Harvard College and who now is ship's surgeon on my father's line. Webber's wife is living at Portland on York Street. Mrs. Webber is, according to her husband, a midwife of some Skill. He says you may send to her at any Time of day or night and she will assist you when the day of Confinement arrives.

Bangor boasts of any number of educated and genteel Ladies and Gentlemen who attend Lectures at the Lyceum. Many of these Lectures are printed in the Whig and Courier, the local newspaper. I shall send you copies. The lectures often devolve on the Question of Temperance and the Impropriety of selling spirituous liquors; in my Opinion a waste of breath, and clearly a means for the Rum smugglers to become Wealthy. Prosperity, My Dear Fanny, depends entirely on the wages of Sin. Would you not agree?

Until Future and as yet Unknown circumstances dictate that our Paths should cross again, I remain your most Humble and ob'dt Servant,

<div align="right">J. Stetson</div>

Fanny replied.

<div align="right">Portland

February 28, 1831</div>

Dear Sir,

I am most Grateful to receive your Kind suggestion that Mrs. Webber might be called to Aid me when my Time arrives. As for Mrs. Winship, that Woman has taken great Pains to avoid the sight of me, but does, I confess, continue to see that my Meals are sent, and what few small

Wants I have are met. The days have passed slowly and Unhappily for the most part, and I often wonder if I did the Right thing in remaining here. Perhaps it would have been better if I had ended up in that dreadful House you so Unkindly pointed out to me. At least then I might be Dead and released from these days of Discomfort and Isolation. I am reading the books and newspapers you have so Thoughtfully sent and I thank you for it. My Education, while adequate for most females of my class, did not cover the works of Milton. Mrs. Winship has slid any number of Religious tracts under my door, which I have used for kindling. She is a Baptist, a religious Sentiment which sits ill with the Congregationalist teachings of my late Mother. I have received the dear Gold Locket so nicely engraved with the letter 'F' and wear it Always as a token against the Days that are past and Those that are to follow. As for your Sanguine comment that 'prosperity depends of the wages of Sin,' I have only to consider my current circumstances and the Bountiful rewards you have heaped one me, and agree; provided you also Understand that I am also Rich in Guilt, Shame, and Lost Honor. I remain your Respectful and ob'dt Servant,

<div align="right">Mrs. Fanny Hogan</div>

Fanny blotted the ink, dusted it with fine sand, and left it on a table outside her door for Betty to take to the post office.

April, the last month of Fanny's time of being with child, left her lethargic and uncomfortable. Her ankles and hands swelled some and she hadn't the energy to carry on her ritual of dusting, sweeping the hearth, making her bed, and shaking the rugs. The loss of the comfort of that predictable routine deepened her gloom.

She thought often of her mother, the short intervals when her mother was not carrying a child. She and Mercy and Ma had picked field strawberries every summer, and made pots of jam. She remembered when the three of them had scrubbed fleeces after Pa had sheared sheep. Ma had used the tag ends to stuff the bodies of two identical rag dolls she had made. Fanny thought longingly of those days, and others like them, knowing full well they were gone forever. She cried herself to

sleep at night, gritted her teeth the next morning, and waited. She cursed Joshua Stetson part of the time and thanked God for him the rest. She wondered, more than once, if it would be easier to be punished for her sin than rewarded for it.

Fanny's travail began early in the morning of the second week of May. At first she thought it was indigestion, but the discomfort clutched the small of her back and eased around the sides of her swollen belly in slow, rhythmic intervals. She remembered her mother saying travail was like a strong hand clenching and unclenching its fist. Women from nearby farms had always come to take care of Fanny and Mercy and run the household. They had supported her mother in the birthing position, had rubbed her back, and soothed her with quiet words. They had included Fanny in these ministrations, allowing her to hold cool drinks for her mother to sip. But for Fanny, there were no helpful women wise in the ways of being female to call, except the midwife, Mrs. Webber.

Fanny eased herself out of bed and fumbled for the candle. The simple act of lighting it, of doing something ordinary in the face of the extraordinary thing that was soon to happen, calmed her. She caught a glimpse of herself in the mirror, was arrested by what she saw. Her face was haggard, thinner than it had been. She fingered the gold locket and wondered for the hundredth time if Joshua was fond of her, if she could get him to think about marrying her. She pushed her hair away from her face. Long strands spilled down her back in a thick tangle. Her belly protruded beyond her breasts. I look like a fat squash, she thought, and almost laughed, almost cried. She wanted her mother. She wanted Mercy.

Fanny knew enough about birthing to know that infants did not hurry from the womb. She went back to bed and waited until she heard Betty stir, than sent her to York Street for Mrs. Webber.

THE CLOCK ON THE mantel struck seven. It had ticked away the hours and days and months to this moment. Fanny lay in bed on her side, knees drawn up nearly to her chin, listening to the clock's steady tick. It was her life ticking away. On this day, she'd begin another life, that of a mother to a child.

The midwife's appearance was youthful, her age difficult to determine. Thirty perhaps. Or less. She was small and quick and her figure was as rounded as a well-fed winter chickadee. She wore no bonnet, a gesture that aroused Fanny's mild curiosity. Women wore bonnets when they went outside. But the midwife did not. Her hair was dark and straight and wisps escaped from a plain coil at the nape of her neck. She was not beautiful, nor was she plain. Fanny had the quick impression of warmth and concern. The midwife carried a scarred pine medicine chest under one arm. She set it on the floor near Fanny's bed and pulled off her jacket, which did not match her gray wool skirt, and dropped it unceremoniously in the nearest chair. She smiled and held out her right hand.

"I'm Maude Webber." Fanny took it and was struck by the smallness of Maude's fingers.

"I'm Fanny . . . Hogan." She still hesitated whenever she lied about her name. The midwife did not seem to notice nor to care that there were no women to assist, no anxious husband hovering outside her door.

"I understand from Betty that your child has decided to arrive today." Maude's voice was as softly padded as the rest of her, as calming as the whir of a spinning wheel.

Maude moved around the room in a brisk way. She inspected the ewer and basin, the chamber pot, fingered the childbed linens, and poked at the fire. Fanny suddenly felt she was in capable hands and uncoiled herself from the curled up position she had been in.

"The air is very stale in here," Maude commented. She opened the window and the cheerios of robins drifted in. "You'll be needing great breaths of air during your illness. When did it begin?"

"About four this morning. I thought . . . does it always feel like this, Mrs. Webber? I expected it to hurt more." In some ways, Fanny wanted the child's birth to hurt, wanted it to hurt a lot, to remind her that she had sinned, to punish her for it.

Maude smiled, a pleasant smile that held no mirth. "I've never birthed a babe of my own, Mrs. Hogan, so I cannot give you the benefit of my personal experience. I'm barren. However, you are a very long way from delivery and that accounts for the lack of severity of your illness. But you must not worry. I'll teach you how to use each pain to aid in expelling the infant from your womb when the time comes. You'll find it pretty hard work, a labor, indeed, but not so hurtful as you fear. You must get up, Mrs. Hogan. Your fingers are a bit swollen, I see, and your feet, too. I'll soak them is cool water."

A rap sounded at the door. Betty appeared with a large jug of hot water in one hand and a pail of cold water in the other.

"Put the hot water near the hearth," Maude directed. "I'll call you if I need something else."

Maude mixed some of the hot water with the cold and poured it into the basin. She placed Fanny's feet in the water.

"You will find this very soothing, Mrs. Hogan."

Fanny pushed a tangle of hair away from her ears. She liked the comfort of having the midwife in charge, of being taken care of.

"My mother used to wash my feet like this when I was a little girl and had been out all day with bare feet. She'd never let me go to bed with dirty feet," Fanny said.

"This will relax you. Relaxed muscles make for a much easier birth," Maude said as she bent over the hearth. "I'm making an infusion of willow bark," she continued. She rummaged through her medicine chest and drew out several small cloth bags containing dried herbs. Everything in the medicine chest, Fanny noticed, was perfectly ordered. "A willow bark infusion will ease your discomfort later on."

Fanny's pains had been coming every twenty minutes or so. She bent forward as another curved around her lower back. In an instant, Maude was at her side. She rubbed Fanny's back in slow circular

motions until the pain had eased. She removed Fanny's feet from the basin and dried them. Fanny thought she was to lie down again.

"Oh, no, Mrs. Hogan," Maude said. She took Fanny firmly by the elbow. "You must walk awhile. Come to the window. It's nearly summer outside for all it's only May. See how green the grass is, hear the birds. And breathe some fresh air."

Fanny spent the next hour pacing and breathing. Her white bedgown billowed softly around her heavy body. She rubbed her stomach as she paced and was only mildly uncomfortable. Perhaps, she thought, a terrible birth was not to be her punishment, after all.

Maude stripped away the bedclothes and tightened the rope webbing that held the feather tick. She shook the bedding out the window to air it. She smoothed the tick onto the rope webbing. Then she covered the tick with a large oilcloth to protect it from birth fluids. She drew a clean sheet from a parcel she'd brought with her and spread it over the oilcloth. She drew another, and spread it, folded double, across the middle section of the bed.

Fanny did not remember any such elaborate preparations at her mother's lying-in, but she liked the idea of order and cleanliness, longed for it.

Maude finished the bed and stirred the willow bark brewing in a pottery teapot by the fire.

"It's time to rest awhile, Mrs. Hogan. And I must make an examination."

Fanny obeyed willingly. There was such comfort in Maude's manner. It felt good to give herself up into the care of a kind person after the meanness of Mrs. Winship and the ladies of Cross Street.

Maude pulled a straight chair near the bed and sat close to Fanny. She smelled of clean fabric and fresh air. She placed her hands on Fanny's belly. Her hands left a scent of peppermint in the air.

The sensation of Maude's hands lying so familiarly on her belly struck Fanny as oddly incongruent. For nine months no one but herself had mapped the contours of her bulging middle; nor had anyone else witnessed the sharp kicks and rolling motions of the unborn infant. A

small pang of resentment at such intimacy crept into her mind, but another pain spiked across her back and all her concentration turned to breathing in slow, easy, instinctual puffs. Maude nodded her head approvingly.

"You're making excellent progress. The womb is tightening strongly, as it should. The infant's head is in the proper position," Maude said. She produced a horn-shaped instrument and applied it to Fanny's belly. Maude nodded her head in satisfaction. "The infant has a strong heartbeat," she said. Maude rose and went to scrub her hands with the lye soap she had requested from Betty. She drew spotless white sleeve protectors over her arms.

"There is no modest way to give birth, Mrs. Hogan. There are a great many doctors, and indeed midwives, who perform the delivery of infants under draperies. They never view what is going on with the mother. In other words, they rely solely on touch to determine how the birth is progressing. I believe this is a most dangerous practice. It's not my way, not the way I was trained. In order for me to understand the changes your body undergoes as the birth progresses, it is absolutely necessary for you to allow me to view the opening where the infant's head will emerge. And you must allow me to touch the area."

Maude plumped the pillows and arranged them comfortably behind Fanny. She showed Fanny how to sit in a half-reclining position with her knees drawn up.

Fanny cooperated, but her cheeks colored hotly at the thought of Maude inspecting her private parts. It wasn't decent. No one but Robert had ever seen her naked, and then only under quilts. When she had begun her monthly bleeding, she had not allowed Mercy to see more than her thighs, and only to let Mercy show her how to tie a pad of rags and cotton wool between her legs to collect the flow. But this was different, she told herself. This was a dangerous time. Her infant's birth could not be accomplished in safety without causing some embarrassment. Perhaps that was the beginning of her punishment, the price she would pay for getting herself into such a fix.

Fanny drew her bedgown up over her belly to indicate her coopera-

tion. The thin, pigmented line that ran along the contour of her belly was revealed. She screwed her eyes shut and held her breath. She expected discomfort, but Maude's fingers probed gently, explored and learned without invading. Fanny let out a great whoosh of air when the examination was finished.

"Do that again," Maude encouraged, "breathe in very deeply, hold it, and use your belly muscles to push the air out." Fanny complied. "As the pains get closer together, Mrs. Hogan, they will become more intense. During each pain you must breathe as I have just instructed you. It will aid the infant's journey as well as ease your travail. It will be some hours yet. You must walk some more. I am going to find Betty and ask her to bring you some broth. Please avail yourself of the chamber pot, if you feel the need."

Fanny lay against the pillows. She had expected childbirth to punish and cleanse and purify her soul. Instead, she found herself almost enjoying it. She smiled ruefully. But what about after the child was born, after Mrs. Webber had done her work and gone? How could she take care of an infant without money or friends to help her? She thought of the sign that said ROOMS and shuddered. She could go to Joshua. He wanted her, she knew he did. But he'd said not to come with the child. Perhaps Mrs. Winship was right. Perhaps she should give her infant to some good family to raise. Another pain clutched her back and canceled thinking. A strong one. When it eased, she drew up her bedgown and inspected the place between her legs where the infant would emerge. She had never been present at the moment of birth of any of her dead little brothers, but she'd seen farm animals born. Her father considered it a tedious, messy business. She had thought it miraculous, and now that miracle, in spite of the evil things she had done, was happening to her. It make no sense at all.

Fanny rose and eased herself heavily onto the chamber pot. It was awkward to sit so low to the floor. She emptied her bladder and tried to heave herself to a sitting position. She could not. She tried again and succeeded only in rocking herself from side to side, putting herself in danger of oversetting the pot. The rim bit painfully into her bottom.

She shifted her weight and giggled at the foolishness of her predicament, the absurdity of her entire situation.

"I can't get up," Fanny said when Maude returned a few minutes later. Her knees were scrunched up under her chin, her big belly sagging between them.

Maude's face broke into a broad smile. She took Fanny's hands and helped her carefully off the pot. Fanny linked her arm in Maude's and they strolled about the room. Fanny sipped the broth Maude gave her. She confided some of the recent events which had brought her to Portland.

"I had a letter from Joshua Stetson, Mrs. Webber. It was he who recommended you to me. He says he is acquainted with your husband."

"Oh, yes. Mr. Stetson was at Harvard College when Mr. Webber studied medicine there back in 1818, I think it was. I believe Mr. Stetson studied law, but did not stay long enough to take his examinations. My husband said Mr. Stetson's behavior was often wild and unconventional."

"I heard his father disowned him," Fanny repeated Nance's story. Talking to Maude Webber was as easy and as comfortable as an old pair of shoes. They might have been sisters instead of midwife and lying-in case.

"Oh, there's some truth to that story. I've heard a number of variations of the same one. Phineas Stetson does have a very young wife. And she is known to be the apple of his eye. And it is true that Mr. Stetson never sees his son. My husband is under orders to notify Mr. Stetson at once if Joshua so much as sets foot on the Stetson wharf."

So he is an outcast, too, Fanny thought, like me. The idea wrapped around her snuggly. Joshua was wild and no one wanted him.

"Joshua has been very kind to me." Fanny wanted Maude to know that. He was not just wild, he was kind. She loved him for being kind.

"Obviously." Maude paused, as if weighing her next words. "I have also heard that his stepmother sees to his financial wants."

Fanny stopped in mid-stride. She did not like the implications of Joshua and his stepmother . . . she turned from the thought and changed the subject.

SWEAT STOOD OUT ON Fanny's face, washed her in a slick stickiness that Maude's dabbing with damp cloths could not wipe completely away. She took deep breaths and pushed and panted to Maude's instruction. They had dropped all pretense of formality and called one another by their given names. They were Maude and Fanny, two women engaged in woman's most elemental experience, giving birth.

The thin angry cry of the babe trailed into the room. Fanny held her breath and listened. The burden of the last nine months was separate from her body. Relief kneaded her muscles and she relaxed, she realized, for the first time in months.

"You have a fine girl, Fanny," Maude called softly. She cut the cord and tied it. Fanny could feel these things happening, could see them. She did not yet comprehend them. Her abdomen, where Maude placed the wet, squirming child, looked like bread dough that had just been punched down.

"You two get acquainted while I finish on this end. The afterbirth will emerge in a few minutes, then I'll bathe you and the child and you can sleep for as long as you want," Maude said. Her sleeve protectors were stained with blood. Her hair slipped from its knot in unruly wisps. She hummed a few bars of "Greensleeves" and didn't seem to care in the least how she looked.

The infant waved her tiny arms and legs in jerky, spasmodic circles. She had stopped crying and was oddly silent. Her little pink mouth opened and closed with sift sucking sounds.

"Like a bird," Fanny whispered. "Just like a baby bird in a nest looking for its first meal. A perfect little birdie. Hello, Birdie." She was unprepared for the elation. Here, lying outside her belly was what had lain inside all those unhappy months. A moment ago, she had been just Fanny, one person, and now there were two, and that little pink birdie was a part of her, a part of Robert. She thought of her mother and wondered if she had felt like this after giving birth to her daughters. But even in the midst of the elation, the wonder of it, a part of her did not want to get too close to the infant.

"Have you thought of a name? Maude asked.

"No," Fanny replied. She hadn't thought of any names, hadn't considered until this moment that the child must, of course, have a name. "I'll call her Birdie until I think of one."

Birdie opened her eyes at the sound of Fanny's voice and searched for the source of the sound. Her eyes found Fanny's and even though Fanny knew that newborn babes did not see well, she felt certain that Birdie saw her.

Birdie's dark hair was wet to the touch, yet downy, like a new chick. Fanny stroked Birdie's cheek with her finger and she turned her head to follow the touch. She found Fanny's finger and sucked. Fanny allowed a little bubble of laughter to break the quiet. Maude looked up and smiled. She had finished her work.

"A little less humor, if you please, Fanny," Maude said with mock severity. "This is not a laughing matter." She showed Fanny how to hold Birdie to her breast. Birdie found the nipple, latched on, and sucked greedily and Fanny felt herself flow through the milk in her breast into her newborn child. She felt as if Birdie had somehow snared her in an invisible web, a web so strong she never wanted to free herself from it.

Maude gave the baths she'd promised, made the bed up clean, and gave the news to Mrs. Winship and Betty. Fanny lay back in the pillows with Birdie in her arms and slept.

May 18, 1831

Dear Sir,

Four days ago I was delivered a Fine Girl by Mrs. Maude Webber, the same Lady you so kindly recommended to me. Mrs. Webber has stayed here with me since then, sleeping on the floor on a pallet quite grudgingly provided by Mrs. Winship. Mrs. Webber leaves this Day, but will call to see me each day for the next several weeks. Her service has been most valuable to me. Her fee is five dollars Silver Money. I am Most desirous that you send that amount to her at her lodging on York Street. I had thought, also, to give her my Locket, the one you sent that

is so dear to me, but she would not have it.

Thank you, Sir, for your kind Treatment of me in this very melancholy time. I remain forever in your Debt, Sir, and your most humble and ob'dt servant,

Fanny Hogan

Fanny gave the letter to Maude to take to the post office. Maude read the address and weighed the letter in her hand.

"You'll be going to Bangor when you are able to travel." It was a statement, not a question.

Fanny avoided Maude's eyes. She avoided a direct reply. She did not know what she would do.

"I owe him more than I can ever repay," she said.

"What about your father and sister? Will you write them about Birdie's birth?" Maude's eyes held no judgment, no censure. She knew Fanny's story and cared only that Fanny and the child would not suffer any deprivation.

Fanny shook her head, no. She couldn't tell Pa and Mercy. But she wanted to.

"What will you do, then? Once Joshua gets this letter, his support will end."

"I know, Maude. I'll manage. Somehow." Fanny fingered the fine material of the dress she wore, thought of the beautiful rust-colored silk gown she had made. There was no way she could ever provide for herself and Birdie to match the splendor of the things Joshua had given.

"I see. But even if Joshua changes his mind and wishes to continue his support, you must consider Birdie. If you accept the financial aid of a man who is not your husband, Birdie's chance for a normal life will be compromised."

Fanny had not thought of that. She reached instinctively for her child as if to protect her from the judgments of society at large. The bond that had formed between them stunned Fanny with its strength. She rubbed Birdie's narrow back. Birdie drew up her legs and nestled into Fanny's neck. She had not counted on this bond between them.

"Go home, my dear," Maude said gently. "Your father won't cast you off. You can say you are a widow."

"You don't know, Pa, Maude. He'd never believe me. Pa is very changeable. He wants people to think very highly of him. He won't stand for anything that makes him look bad." Her words lacked conviction and she knew it. Perhaps, Maude was right.

"Surely, your father and sister are heartsick at not knowing where you are, or what has become of you. I'll mail your letter. Get plenty of rest and stay off your feet."

Fanny watched Maude's tweedy figure recede up the road toward York Street with a sense of wrenching loss. Home. She wanted to go home.

<div align="center">8</div>

IT WAS NEARLY EVENING when the coach pulled into the yard outside Lane's store in Fort Point. The coach had rocked and swayed all the way home from Belfast until Fanny's teeth shook. Birdie, wrapped in a thick shawl, resembled a bundle of clothing. She had slept through it all. Fanny did not recognize any of the other passengers and spent the entire trip ignoring them.

The moment Fanny had dreaded was upon her. The coach rattled to a bumpy stop, and Fanny stepped awkwardly out into the yard, pretending she did not see old lady Twining's eyebrows disappear into her ruffled cap. She eased around the far side of the coach out of sight of the village layabouts who always gathered to watch the coach arrive. She saw Cale Adams whisper something behind his hand to his cronies. The men slapped their thighs and laughed so loudly they startled a flock of starlings. Fanny's face burned with shame. She was convinced the men were making sport of her. She shifted Birdie to her other arm, hefted the bandbox, and started off up the main road toward home.

The dust on the road sifted across the toes of Fanny's walking boots, marring the shine she had so carefully given them. She had dressed

herself modestly, choosing a dark dress and simple hat, to achieve the look of quiet respectability that Pa expected from his girls. As usual, she could do little about her hair which escaped in orange-brown puffs from beneath her bonnet. Her hair refused to be harnessed into any of the sleekly composed fashions of hairdressing, and she fretted about it.

The road curved and dipped, crossed Butler Brook, then skirted John Nason's woodlot. The trees had leafed out into their summer shade, and wildflowers dotted the side of the road.

Fanny stopped to rest. She'd been almost seventeen when she'd left. Now, she was nearly eighteen. Had it been only a year? She picked the petals off a daisy and thought of the ones Robert Snow had given her. Her loves me, he loves me not. How could she have been so innocent? She scuffed the dust off her boots with her handkerchief. Birdie stirred and slept on.

Soon, Fanny came in sight of the long hayfield that marked the beginning of Pa's property. The road ribboned out, giving a clear view of the Penobscot River in the distance to the right. The early evening air was alive with birdsong and fragrances that Fanny had forgotten existed. The summer odors of damp earth, the slight tang of salt in the breeze, the unmistakable scent of manure set Fanny's heart racing with an exhilaration she had never expected to feel again. She quickened her step, was tempted to drop her bandbox and run. Her arm ached from carrying Birdie, and for one brief wild second she considered dropping the child, too, and running the rest of the way home.

She shifted Birdie to her shoulder and kept up her steady pace.

The farmhouse sat, just as she'd left it, on a gently rising knoll, a ways back from the road. It's silvery-gray clapboards shone in the fading light. Stone walls girdled the fields in sturdy dark bands just as she had left them a year ago. The fence around the front yard sagged a little more than it had, but Mercy's bed of perennials had come up and some were about to bloom. Grandfather Abbott had come from Eastham, Massachusetts, way back in 1795 and built the house and settled his young bride there. Fanny was the second generation to have been born on the farm, in Grandmother Abbott's wide tester bed. The

farm was not just home, it was as central to Fanny's being as the air she breathed.

The windows on the north side of the house were open to allow the cool evening air to circulate through the rooms. There was no one about, but a soft circle of lamplight drifted through the kitchen window.

Fanny found Mercy in the kitchen stirring a pot of pea soup. The aroma twisted Fanny's stomach into lumpy knots, reminding her that she had not eaten since morning.

"Mercy," Fanny called through the open door, "I'm home."

Mercy whirled around, her plain face stamped with disbelief. She dropped her wooden spoon with a clatter.

"Fanny! In the name of Heaven what are you doing here?" Mercy pulled her calico skirt away from her feet and hurried to close the door that separated the kitchen from the rest of the house. She drew Fanny inside and closed that door also.

"I've come home, Mercy. I know I've done wrong, but I thought Pa and you and I could overlook the past and . . ." Fanny trailed off, stunned by the stoniness of Mercy's eyes.

"Overlook the past! Fanny, Pa has been like a madman ever since you ran off. He's been to Belfast, to the docks, every week, *every week*, since you left. He's talked to every mariner he could find trying to find out what had become of you. And what he heard didn't please him much, I can tell you!"

Just as she had feared, Fanny knew the story of widowhood would not work.

"Mercy, it wasn't like that. Robert said he'd marry me. But he didn't. He left me."

"And why wouldn't he, with you acting like a common trollop?" Mercy turned back to her cooking. "Pa won't put up with your being here."

Birdie stirred and whimpered. Fanny tried to hush her, but knew from the fullness of her breasts that Birdie was hungry.

Mercy rattled dishes in the cupboard and clashed pot lids. Birdie let out a sharp cry and Mercy dropped a saucer. She sank slowly into a chair at the table.

"Fanny, it's bad enough having the whole village know my sister is a fallen woman, but a child! I never thought . . ." Mercy's face had gone pale. "Fanny, you can't stay here. Pa will be fit to be tied. I don't know what he'll do, seeing you so sudden. He's acted real odd for months now, more so than before."

Tears rolled down Fanny's cheeks. "I'm so tired, Mercy. Can't I just go upstairs to the spare chamber and rest? I'm so tired." Her tone was childish, almost peevish.

"I can see that," Mercy said softly. She lifted the edge of the shawl. Birdie's ice-blue eyes fastened on Mercy's face.

"Does the babe have a name?"

"I've called her Birdie since she was born," Fanny replied.

"Oh, Fanny, why is it you never think about anything before you do it. Birdie isn't a Christian name!" Tears trickled down Mercy's cheeks. "I've worried so much about you, Fanny. I tried to think if it was something Pa or I did or if you really were just plain foolish like Pa said." She took Fanny's hand. "You go up the back stairs. We'll decide what to do tomorrow. I've got to figure out a way to tell Pa you're here and get him calmed down enough to talk to you."

The chamber was unfinished except for the wide pine floor boards which were painted brownish-red. The rafters still had bark on them. They had been hand-hewn by Grandfather Abbott. The room was furnished with some of Grandmother Abbott's things—a big bed, a blanket chest, even the cradle that had rocked Pa and Mercy and herself. It was cozy under the slanting roof. For the first time since she'd arrived, with Birdie settled comfortably in the cradle, Fanny felt as if she were home.

Later on, Fanny heard her father come in, heard his boots hit the kitchen floor with two loud clunks. His voice rumbled, but Fanny could not make out the words. The soft murmur of Mercy's voice blended with the rattle of cups and plates. Outside a sheep bleated.

Fanny cowered in the chamber room, torn between a desire to run downstairs, confront her father, and get it over with, and the need to hide from his disapproval. Her father was not a cruel man; but he was

proud, fiercely proud, and he required that his name be above reproach. He paid his bills on time, provided as well as he could for his family, and went to church every Sunday. He was respected by his neighbors. His forgiveness, if it ever came, would not come easily.

Birdie's loud wail woke Fanny some hours later. She did not know how long the baby had been crying. Panic-stricken that Birdie's cries would waken her father, Fanny sprang up from the bed and lurched against the commode. A china cup crashed to the floor. Feet clattered on the stairs and the door flew open. Fanny cringed against the wall. Birdie lay in the cradle, wailing loud enough to wake the dead.

Simon Abbott's nightshirt was tucked hastily into his pants. He was barefoot. His gray hair was all awry, his beard scraggly in the light of the lamp he held aloft. His eyes burned with a glow Fanny didn't recognize. He looked like the picture of an Old Testament prophet Fanny had once seen.

For a long minute, the air between them lay dead and stale. Only the bleat of Birdie's crying and the strange unhuman fire in Simon's eyes disturbed the room. Fanny dug her fingernails into the beam behind her back.

"Jezebel! Daughter of Hell! Get out of my house!" Simon hissed. He did not move. His face was contorted into the most ugly expression Fanny had ever seen. She hardly dared breathe.

Mercy eased her way through the door and stood between Simon and Fanny. Her face was whiter than goose gown in the flickering light.

"Fanny will be gone in the morning, Pa. She just came to say she's sorry, Pa, to ask your forgiveness. Pray with her, Pa."

Simon Abbott glared at his elder daughter.

"Go back to bed, Mercy. Tell this whore to leave my house." Simon moved like he was made of wood. His eyes focused on the beam beyond Fanny's head. She tried to intercept his gaze.

"Pa," Fanny whispered, "Please let me stay until morning." Simon seemed himself again, but it was fleeting. Birdie's wail increased in volume and Simon turned to Mercy.

"I believe your dear mother has given me a son at last," Simon said

pleasantly. "Hear him crying? Bring him downstairs, Mercy. Your poor mother needs her rest." The sound of his footsteps retreated down the stairs.

Fanny dissolved into a sobbing heap on the bed. Mercy sat down beside her and stroked Fanny's hair.

"I've never seen him this bad, Fanny. He hasn't been right for months. Sort of far away. Sometimes he thinks I'm Ma."

Fanny beat the pillow with her fists for one furious moment.

"I know someone in Bangor who'll take me in, Mercy. But I can't take Birdie. Not at first. I'll have to leave her with you."

"Leave Birdie with me! Fanny, you're as confused as Pa is! I don't know how to care for an infant. And who'd feed her?"

Fanny's thoughts were racing. For the first time, she began to see an end to her burdens.

"Listen, Mercy. Pa thinks Birdie is his child. You could let him keep thinking that. It wouldn't be for long. A month or two at most, just until I can get settled in Bangor. It's not hard to take care of a child. No worse than taking care of motherless lambs. There must be someone around who's just lost a child and has plenty of milk and would hire out as a wet nurse."

"Why, yes, I believe Sarah Smith's just lost a babe. But we'd need money."

Fanny fumbled in her bandbox for some of the money Joshua had sent her. "I've got five dollars. And this locket. It's gold. You could sell it." Fanny unclasped it and handed it to Mercy. Mercy would not take it.

"I can't take your locket, Fanny," Mercy protested.

Fanny fastened the locket around Birdie's neck. "There," she said, "I've given it to Birdie. If you ever need money while I'm gone, you can sell it. Oh, Mercy, you've got to do this for me! There isn't any other way except for an orphan's home or finding a family to adopt Birdie and I can't do that. Here with you, she's with her family, her grandfather and her aunt. She's *home*." Fanny wiped the tears away from her face with the flat of her hand. Mercy was visibly moved.

"All right, Fanny. I'll do it. But just for a month or two. And if Pa gets right before you send for Birdie, I'll write you to come and get her." Mercy held her arms for Birdie and Fanny deposited the child into them.

"Would you give her a name, Mercy? Something pretty and dignified. Not right at this minute. You can surprise me when I come back to get her."

Mercy went back to her room taking Birdie with her. Fanny lay awake thinking about what she had done. The thought of leaving Birdie, even for a few weeks, cut across her heart like scalded milk. She did not know how she would endure the separation. But she knew she must.

And when she got to Bangor, she must convince Joshua Stetson to marry her. She'd do anything, anything to make life easier for Birdie.

9

FANNY STOOD ALONE and uncertain on the wharf at Bangor. Sail lofts, shipbuilding, grogshops, and establishments of dubious reputation crowded the water's edge. A few mariners eyed her curiously and she shuddered remembering her experience in Portland and how easily she might have ended up in the house with the sign that said ROOMS.

She trudged up the road to what she hoped was the center of town in search of Hatch's Tavern where Joshua had said to look for him. Carts and drays, hand barrows, and chaises rumbled around her in a bustle of commerce that attested to Bangor's determination to transform itself from an uncivilized frontier town to a gracious city that might someday rival Portland.

The road was damp and oozy, and the hem of Fanny's skirt dragged in the mud. Her breasts, tightly bound to cause them to stop producing milk, ached and she longed for her babe to relieve them. But she put her discomfort out of her mind. She had to find Joshua. The thought had goaded her all the way up the river, and she had despaired of the

wind ever blowing fresh enough to push the schooner she'd traveled on faster than a crawl. Now, she couldn't make her feet walk fast enough. Fanny passed a few frame dwellings, a distillery, and several shops. She came to a corner and was unsure which way to turn. A small boy ran out of a yard bowling his hoop. Fanny stopped him and asked directions. He pointed the way.

Impatience bit at Fanny's heels and she nearly ran the last few hundred yards. She had to find Joshua, find out how quickly she could send for Birdie. But not Birdie anymore. By now Mercy would have found a proper name for the babe. Something pretty, something dignified.

The tavern keeper was civil and polite.

"Joshua Stetson. Now let me think," the man said. He scratched his head and took such a long time thinking that Fanny wanted to shake him into action. "Seems as though I've heard that name somewhere. There's so many people from away gettin' off the boats these days, it's hard to keep track. You never saw so many men comin' up here to speculate in the wild lands. Gamblers, that's all they are. Lookin' to make some quick money. Some do, but most don't, now let me tell you. Joshua Stetson, you say? You let me ask one of the hired girls. And the cook. Those women, they always know what's goin' on."

The man was smiling when he returned and Fanny felt a wave of relief wash over her.

"Well, they say the man you're looking for has a place over on Summer Street. Nice place. Just been built. Been cuttin' quite a swath, they say. But I wouldn't go over there if t'was me. There's been a lot of fever here lately. They heard this Stetson is sick of it and his life not expected."

Relief turned to anxiety with a sickening lurch of Fanny's stomach. She did not worry about going somewhere there was fever. All she understood was that Joshua needed her, he was sick and needed her care.

"How do I get there?" she demanded.

The man hesitated in the most maddening way.

"You a relative?" he asked.

"Cousin. I'm a cousin. Lately widowed," Fanny said. The words rolled effortlessly off her lips. Joshua was sick. He needed her. This slow-witted man knew where Joshua was. She would have confessed to being Queen of England to get him to say where Joshua could be found.

"Go back the way you came to Union Street. Then take the second road on your left. That's Summer Street. The only new place there is the one you want. Big white columns on the front."

Fanny dashed out the door without so much as a thank you.

"Hey," the man called after her, "I do a little undertaking if you find out you need one."

Fanny ran. Undertaker. Find Joshua. Fever. The words nipped at her, made her feet travel the distance more quickly than she had thought possible.

The house looked like one that Joshua would choose for himself. It was an elegant house, a house with style and grace. Four large white columns rose the height of the two stories. They supported the gable end, which fronted the street, forming a narrow veranda. Two tall chimneys jutted out of the easy pitch of the roof. The earth around the house was still raw from the trampling of the builders' boots. There was no grass, none of the shrubs and perennial plants Fanny associated with home.

The house, she knew instinctively, was not a home in the sense that she understood the word. But Joshua was in there somewhere, and he was sick and needed her to take care of him. Taking care of people made a house a home. There was room to take care of a child here. Her thoughts flew wildly, like a flock of birds startled into flight.

Fanny lifted the brass knocker and let it fall. It was shaped like a man's clenched fist. She waited. No one came to the door. She tried the latch and the door swung open onto a long hallway with a graceful stair rising to the floor above. She made her way down the hallway, calling to Joshua as she went. Her voice echoed back from the high ceilings, lost in the formal proportions of the rooms. She had never seen so much

space for one person to live in. Her father's house would have fit easily into the downstairs rooms. She was awed by it, almost afraid of the splendor of it, but it drew her and she pictured herself the mistress of all this space and grandeur.

The rooms were sparsely furnished, as if the bulk of its expense had gone into its building. But what little furniture there was, was beautifully made. The floors were covered with lovely rugs of intricate design. She caught glimpses of tiled hearths, the flash of crystal, the sheen of polished metal, the dignified fold of velvet. If she could get Joshua to marry her, she thought, all this would be hers. Excitement at the idea nearly canceled her anxiety and a quick nibble of guilt put her back to her purpose. Joshua was sick. She had to find Joshua.

Fanny called his name again. There was no answer, but she thought she heard a muffled sound upstairs, like a cough or a moan. She made her way upstairs and listened again. She pushed open the nearest door and gasped at what she saw. She hurried to the figure lying in a tangle of blankets and sheets on the bed.

Joshua's face, what Fanny could see of it, was ashen, looked as if it hadn't seen a razor in days. His lips were dry. His nightshirt was soiled with vomit. There was no wildness in him.

The room was vile with the odor of an unemptied slop jar.

Fanny threw open the window and peeled the filthy covers away from Joshua's body. He did not move or respond to her action. Asleep or unconscious, she didn't know, couldn't tell.

"Joshua," she said softly, "It's Fanny. I've come to take care of you." He lay quiet and unmoving. Fanny removed her hat, flung it aside, and rolled up her sleeves. She found her way back down the stairs to the kitchen and brought back a basin of cool water and a towel. Cleanliness, that was what Maude Webber had said, the proper degree of cleanliness helped people get well and stay well. She bathed Joshua's face and washed his entire body, as if he were an infant. He felt cooler when she finished. Then she changed the filthy sheets, scrubbed the floor, and set the room to rights.

She went back to the kitchen, found some wood, and started a fire

on the hearth. She made a thin oatmeal gruel and tried to spoon it into Joshua's mouth, but he made no effort to swallow and she set it aside. She pulled a chair close to the bed and sat down wearily to watch. So much of a woman's life was spent waiting, she thought.

It was dusk. She had been up since dawn. Her eyelids drooped. Her breasts ached and milk seeped from them and wet the front of her dress. She was too tired to care. All that mattered was that she had found Joshua. Now she would find a way to make him well. And he would love her for it and want to marry her and she'd have a home for her child.

When Fanny woke, it was dark. The house was filled with dark, filled with the heavy velvet silence of it. There were no sounds from the street, no glimmer of lamps or candles anywhere. She groped her way down to the kitchen and used a coal from the dying fire to light a candle. She went back to Joshua's room and bathed his face and arms again with cool water. She leaned close to his ear and spoke his name. His eyelids fluttered, but if he saw her and knew her, there was no indication. He breathed deeply, almost a sigh, and lapsed back into the deep, sleeplike state he'd been in all day.

The next day he was delirious. Fanny tried to prevent him from thrashing. He muttered and rambled and she listened with a mixture of horrified fascination and undisguised curiosity.

"No, no, no, Ellen!" Joshua ranted. "You can't. Ellen, no!" And moments later, in a harsh cry, "You're old enough to be her father!" His facial expressions registered rage, despair, pain. Fanny stroked his brow and spoke to him in a wordless kind of crooning that women use instinctively to soothe a fretful infant. He calmed and seemed to sleep. Then he began again, over and over, repeating himself.

"No more, Ellen. He'll find out. Not another penny. I'll leave. Go to Bangor." Joshua's face contorted. "You filthy swine. You can't do that to me. No, Ellen, no!" Joshua's voice dropped to a broken whisper and a tear trickled out from beneath one eyelid.

Fanny pieced Joshua's ramblings together with what she'd heard from Nance and Maude and began to understand.

Apparently, the gossip was quite accurate. Ellen was no better than she ought to be when she married Phineas Stetson. But her hold on the old man was so great, she got him to change his will to make her his sole heir. Then Ellen had grown tired of Phineas and took to amusing herself with Joshua. She told Joshua about the will and said if he was nice to her, she'd see that he was taken care of. And, Fanny surmised, Ellen had taken care of Joshua in more ways than one. And the attraction had been a mutual one. Phineas had caught them together one night when Joshua was home from Harvard, visiting. Ellen let Joshua take all the blame. Phineas disowned him. But Ellen saw to it that Joshua was kept in funds.

Fanny heard and understood and her heart ached for Joshua. He'd been used so badly. No wonder he was so wild and difficult. Outcasts, he and she were both outcasts. There was a bond between them.

Two more days passed. Fanny was exhausted from lack of sleep and worry. She had not left Joshua's side except to bake some bread so she'd have something to eat.

It was Sunday. In the distance, a church bell tolled its urgent call. A breeze blew in the open window and fluttered the lace curtains. The sun was warm in her lap. She dozed. When she woke, Joshua's eyes were open and he looked right at her.

"Fanny," he said in a thin voice. "Don't leave. You can stay here."

She knew then that he would recover.

10

JOSHUA'S RECOVERY WAS slow. Fanny wrote Mercy to say she'd be unable to come for her child as quickly as she'd thought and would Mercy keep the babe a little while longer. She spent part of the money Joshua had given her for food to Mercy. There was no reply.

Fanny installed herself in one of the other bedrooms and ran Joshua's household as if she were his wife. She liked to pretend she was.

When Joshua was fully recovered, whatever notions Fanny had left about coaxing Joshua into a discreet wedding ceremony were quickly

lost in the swirl of attention he lavished on her. He sent for dresses and bonnets from the best Bangor dressmakers, selected a small library of books which he insisted she read. He employed a dancing master and a music teacher, and Fanny discovered she had a certain skill for singing. The days passed in a haze of cultivated activity.

"You're good to have around, Fanny," Joshua would say. He expressed no gratitude that she had nursed him back to health. And as his strength returned, so did his wildness. Once again, Fanny was caught up in the adventure of never knowing what Joshua would say or do next.

Fanny wrote Mercy twice more; once to send money and to say that she'd been taken in by an "old friend" who "urged her to stay another week or so." The second time was to ask Mercy to be patient a while longer, that she'd come to get the baby in a month or two. When there was no reply form Mercy, Fanny assumed there was no objection to the arrangement. Her twinges of guilt receded and vanished. Her milk dried up, her figure slimmed out, and Joshua made the days as easy and soft as a featherbed.

It was curious, but nevertheless a fact, Fanny soon discovered, that no one in Bangor knew anyone else; no one inquired too closely into one's family connections or social background. The newcomers, adventurers, and opportunists who flocked to the infant town on the edge of the vast northern wilderness speculated in land, established businesses, or worked as woodsmen, sailors, seamstresses, washerwomen, or innkeepers. They didn't care two cents about anyone's personal pedigree. What counted was how quickly one became affluent enough to build a house like the elegant mansions already entrenched on Broadway.

Bangor produced a surprising number of wealthy men and women in a very short amount of time—that this was often accomplished in less than legal ways didn't bother anyone much at all.

A few local washerwomen quickly realized there was more to be wrung from a man's pockets than dirty wash water. They adjusted their priorities and set up rival establishments to cater to the more urgent

needs of the woodsmen who emerged from the lumber camps in mid-spring after a long winter deprived of female company.

Rumrunners and grogshops prospered, too, despite the outcry of the local clergy, whom few took very seriously anyway. Sailors arrived almost hourly from ports all over the world. There was nothing like a good mug of rum to oil a parched throat.

To be sure, there were plenty of men, like Joshua Stetson, who could boast a Harvard education, but didn't, and a fair sprinkling of polished daughters fresh from Boston finishing schools. These young ladies were in much demand as wives. Such women added tone to the raw community and made their otherwise uncultured husbands appear more refined.

There was, also, a small core of native sons and daughters, as they liked to think of themselves, descendants of the men and women who settled Bangor in the 1770s when the region was called Sunkhaze. But even these select few preferred to steer conversations away from their antecedents; because everyone knew perfectly well that so and so's grandfather had jumped ship in Boston back in 1772, stolen a horse from a penniless widow, and headed north for the anonymity of the Penobscot settlements. And each of these select families had at least one female connection who was never mentioned for reasons best left alone. By tacit agreement, everyone simply ignored the whole distressing issue of personal pedigree.

It was, Fanny was quick to notice, much easier to determine one's position in the odd pecking order of Bangor's social strata by the amount of money one had amassed. That amount determined where one lived. If you had a lot of money, you went to the top of the roost over on Broadway. If you didn't have any at all, you ended up in the mire under the roost, in Joppa, down in the roughest part of the waterfront where the riff-raff congregated.

It didn't take Fanny long to figure out where she belonged. Without Joshua Stetson, she had no place; with him she was safe, taken care of, and protected from the harsher realities of life.

Fanny's twentieth birthday came and went and she had two small

diamonds in her ears to commemorate the event, a gift form Joshua. Under Joshua's guidance, Fanny evolved from a self-conscious farm girl into an accomplished young woman capable of planning and executing a dinner for twenty, managing the hired girls who did the domestic tasks, and conversing intelligently and wittily on the political questions of the day. She could charm a roomful of men with her artful rendition of "All Through The Night."

The businessmen, the lumber barons, the politically powerful whom Joshua brought to his house were, Fanny knew, deliberately wined, dined, and dazzled by her orange-brown beauty. Joshua introduced her as "my dear cousin Mrs. Hogan, lately widowed," but no one was fooled. Joshua was invited frequently to the Broadway mansions, but Fanny was not. And Joshua, in his perverse way, did not seek to impose her on his influential connections. It nettled Fanny to be left out. But she had to accept the snub. She was a fallen woman. And while her status as Joshua's woman prevented her from being included on Broadway, it did not prevent the Broadway gentlemen from enjoying her company. Because of her efforts, Joshua always got the political favors he sought. He prospered magnificently and, amused at Fanny's complaints about the snubs from the Broadway ladies, decided to indulge her. He built Fanny a house, more sumptuous and elegant than any Bangor had ever seen, on a parcel of land on Oak Street. It was directly adjacent to Broadway, as close as you could get without actually being there. In the summer of 1835, Fanny was installed there, much to the consternation of Mrs. Veazie who immediately relayed the news to all her acquaintances. Mr. Veazie raised no objections since he had enjoyed Fanny's singing very much on several occasions, but Mrs. Veazie made his life so miserable that he gave in, removed upriver to his mill site, founded a town he named after himself, and blamed the whole thing on Rufus Dwinel who had sold the land to Joshua in the first place. It kept him happily involved in litigation against Dwinel for years. Mrs. Veazie was mollified. The other Broadway ladies had to content themselves with refusing to nod whenever their carriages chanced past Fanny's.

Fanny's delight and enjoyment in the new house was marred by a note from Mercy. The note was dog-eared and bedraggled, as if Mercy had carried it around awhile before mailing it. The note said that Simon Abbott had died suddenly, that Birdie had been ill with croup, was now well but still weak, and Mercy hoped Fanny wouldn't think of sending for Birdie right away as the house was pretty empty with Pa gone.

Guilt pricked at Fanny's heart as she read the note. She ought to go home. That was the decent thing to do. But if she went home, she'd have to tell Mercy about the way she lived and she'd bring shame on Birdie. All of Fort Point would be able to tell, just by looking at her, that she wasn't respectable. She couldn't do that to Birdie, or Mercy. She had to protect them. She sent money instead, and that went a long way in soothing her conscience.

Soon, there were other matters to take Fanny's mind off Mercy and Birdie.

Fanny paced the library of her new house. She was oblivious to the exquisite inlaid furniture which had arrived on one of Joshua's ships. She was furious, so furious she had thought about driving down to Mercantile Row herself, then dismissed the idea, knowing full well Joshua would tolerate her temper in private, but would never allow a public display. Instead, she sent the housekeeper, Mrs. McGuire, with a discreet note requesting his presence at four in the afternoon.

Joshua came through the door as the little French clock on the mantel struck the hour. He fixed his eyes on Fanny and eased into the small, sardonic smile Fanny had come to know so well. Joshua had fleshed out a little since his illness, but he still retained the slimness and slightness of stature that inclined other men to misjudge his business acumen. He appeared to give the other party the advantage, but in reality, most of the profit went into the Stetson counting house. Fanny had learned to recognize his subtle manipulations.

"Joshua," Fanny said evenly, "I know what you're trying to do and I want no part of it. They have got to go, both of them! Today! I won't let you do this. I won't have it!" She glared at Joshua.

Joshua leaned against the mantle and lit a cigar, filling the room with acrid, blue smoke. He puffed a moment.

"Surely, Fanny, you aren't jealous."

"No, I'm not jealous," Fanny denied quickly, too quickly.

"Then what's troubling you, Fanny. Tell me, my dear, so I can make it right." Joshua's eyes glinted with mischief. Fanny knew the signs. He was playing with her.

"You know what I mean. It's those—women. Violet and Flora. They arrived this morning and said you'd employed them to entertain your business partners."

"And how is that distressing you, Fanny?"

"Because they aren't respectable. And because you didn't tell me they were coming. This is *my* house, Joshua."

With one fluid, catlike motion, Joshua left the mantel and drew Fanny to him.

"No, Fanny, this is my house. You only live in it as long as I choose to keep you here. Those two ladies, Violet and Flora, are here to do exactly as they told you. To entertain. Miss Violet is an accomplished singer and Miss Flora plays the piano in a most inspiring way. It is true, Fanny, that they have other, shall we say, talents. I want you to go on doing as you've always done—run this house, *my* house, which I had built just for you. Keep yourself looking beautiful in these expensive silk dresses I provide for you and be charming to the gentlemen who visit. Is that asking too much?"

"Joshua," Fanny burst out, "I will not live in a whorehouse!" Fanny stormed angrily around the room with her arms folded firmly across her chest. Fear nibbled at the pit of her stomach. The image of the sign on the Portland waterfront that said ROOMS clawed at her thoughts. Joshua had the power to put her in a place like that.

"A whorehouse," Joshua said, pulling Fanny to him again. "I don't know where you get such ideas, Fanny. And after all I've done for you. All I ask, Fanny, is that you supervise Violet and Flora, in any way you see fit. See that they are a credit to the hospitality the gentlemen of Bangor have come to expect from me. Surely, you can do that for me, Fanny."

Joshua tipped Fanny's chin so her eyes looked into his. She relaxed and laid her arms around his narrow waist. She put her forehead against his shoulder. He smelled of cigars, shaving soap, and fresh linen. She found the aroma alluring, and curiously calming.

Joshua did not share her bed. Had that fact been common knowledge, she knew no one would have believed it. Joshua seldom initiated physical contact, and Fanny yearned for the smallest touch of his hand, the briefest of caresses.

She leaned closer into his shoulder. She hated Ellen for what she'd done to Joshua. He never spoke of Ellen, but Fanny knew that what Ellen had done had made him bitter about life. She was jealous of the touches and closeness that Joshua must have shared with her.

She stood with her arms around his waist and her head tucked into the soft ease of is shoulder. She was even willing to risk another pregnancy if only he would show some sign of wanting her. The thought excited her. Another pregnancy might bring Joshua to marry her. But thus far, Joshua had been reluctant to accept anything more than fond embraces, as if he knew the scheme and was too wise to be caught in so ancient a trap.

What Fanny felt for Joshua was, she knew, very different from what she'd felt for Robert Snow. Joshua had rescued her, had treated her like a princess when everyone else had treated her like dirt. And she had taken care of him when he was sick. She did not think that her care of him canceled her debt to him. She thought it bound them more closely. If that was love, then she loved him.

Joshua smoothed a wisp of hair from Fanny's brow and smiled his slow smile, the lazy one that gave him a boyishness that belied his thirty-five years. His youthful expression, when he was relaxed, touched Fanny very deeply. Somewhere, beneath the self-made man, the man obsessed with power, was a boy, a child, who needed her love and protection, who needed to be taken care of. Who, in turn, would love her for it.

Fanny slipped her hand under the edge of Joshua's lapel, felt his heart beat strong and rapid. She loosened his cravat and nestled her

lips against his neck. He did not pull away as she expected. He buried his fingers in the thick coil of her hair and removed her hairpins. He dropped them, one by one, to the floor. Her hair tumbled about her shoulders in a springy orange mass. Joshua smoothed it with one hand; with the other he undid her bodice buttons and pressed his mouth to the hollow of her throat. He held her closely for a moment then scooped her into his arms and carried her to his private rooms down the hall.

<div align="center">11</div>

JOSHUA DEPOSITED FANNY in the middle of the bed in a room he reserved for himself. He set her down as if she were a rag doll put away in a convenient place by a bored child.

The bed was said to have once belonged to a member of British royalty. Joshua had acquired it from an English mariner down on his luck. Privately, Fanny doubted that it had ever belonged to a king, but she knew Joshua enjoyed thinking it did. It was too massive and ornate for Fanny's tastes. It was high and wide, curtained and canopied, and spread with deep rose silk which heightened the illusion that it had cradled the sleep of royalty.

Fanny smiled an encouraging, playful smile at Joshua.

"You'll have to do something about this spread, Joshua," she laughed, "it clashes with my hair." He was very particular about the colors she wore, insisting that any shade of pink was unbecoming to her.

Joshua regarded her thoughtfully for a moment.

"I've changed my mind. The color suits you better than I thought, suits the inconsistencies of your nature. Brash common orange against modest royal rose."

His words enchanted her. She had known there were wells in Joshua that ran deeper than anyone had ever dared dip into. She knew he read poetry and philosophy.

She could not read the expression on his face. It was soft, softer than

she had ever seen it before, and there was a light in his eyes that wasn't wild, only hinted at wildness. Little vines of cautious excitement grew in Fanny's heart.

Fanny's bodice was open to the waist, exposing the round contours of her breasts. She knew she had a beautiful figure. The dressmakers always commented on it. She was slender without being skinny, shapely without being voluptuous. Her skirts were pushed up around her thighs. Her bottom was bare because she refused to wear the new undergarments the dressmakers called drawers.

She pulled the petticoats a little higher, allowing full exposure of her legs. It was a simple gesture aimed at eliciting a playful response in Joshua. He did not, she knew, know very much about playfulness. Joshua liked things to happen according to his own design. That required work, scheming, not play. This was true in all aspects of his life.

Fanny did not know where, or if, he slaked his physical yearnings, but she was certain that his need to control and dominate every situation would extend to the bedroom.

She posed seductively, a bit artfully, appealing deliberately to his carnal appetites. Her desire for Joshua had grown to immense proportions and she had longed for this moment.

Joshua removed his clothes slowly, folded them, and laid them on a chair. He liked things orderly, was fastidious in his habits. Fanny eyed him carefully, gauging his actions, not quite trusting this new untried aspect of him.

Joshua's body was lean and angular without sharpness. He reminded her of a wood carving with the details finely made and the edges smoothed off. Pale blond hair tufted his chest and lay in a silken shadow on his arms, crept along his wrists, and spread like a glaze down the backs of his hands. His skin was very fair with a hint of ruddiness. His fingers were narrow and fine. Fanny's anticipation heightened as she looked at him. His hands would explore her body, soothe her, bind her to him with loving gestures. Her mind misted with the familiar haze she called love.

As if he had read her mind, Joshua slid his fingers along Fanny's arm to her shoulder, to her neck. It was a measured caress, long and slow. He drew her into the circle of his arms and brushed her lips with his, a brief teasing kiss that left her hungering for more. He moved his kisses to her cheeks, her ears, her chin.

Joy raced through Fanny's heart like heat lightening on a humid summer night. She had ached for his tenderness and caring, longed to lavish her loving on him. But there was a tenseness in him, some barrier that she had not breached. But it didn't matter. He wanted her, needed her, she knew he did. She floated on the pleasant passion his caresses aroused in her.

Joshua pulled at Fanny's petticoats, tearing delicate lace and silk. There was no violence, no haste, in his action. Everything he did was calculated to produce a desired result. He removed obstacles in the most expedient way possible to get what he wanted. And now, Fanny thought, he wants me, wants to give himself into my keeping.

Fanny was naked, the cool rose silk sleek beneath her back. She felt Joshua's passion flare and take fire. She waited for him to murmur endearments. But he was silent, and she felt a distance in him, as if he were merely an observer, not a participant. His fingers feathered her skin, glided and soared, sought and found until she gasped and trembled with delight. She gave herself completely to Joshua's expertise. She opened her body to him, opened her heart and soul, and reveled in the exquisite sensations his lovemaking produced.

Fanny spent her passion and Joshua eased away, slipped from her arms like a silverfish, and stood by the bed looking down at her. He did not look vulnerable in his nakedness. He wore his skin as it if were armor protecting some inner secret that he never acknowledged existed. She searched his eyes for a hint of tenderness, saw nothing but his perennial flint of amusement, his air of calculated detachment bordering on contempt. It was the same expression he wore when he'd manipulated a lucrative business deal or successfully extracted some political favor.

"Say something, Joshua. For God's sake, say something," Fanny

whispered, almost begging. She was stunned by the realization that the only connection between them had been with their bodies.

Joshua's expression did not change. There was nothing to indicate that he saw anything amiss or understood that Fanny was devastated by his emotional coldness.

"Very pleasant, Fanny. I knew the night I took you off the street you'd give a man a good tumble."

Devastation shifted abruptly to defiance and words hurtled off Fanny's tongue before she thought. "Is it Ellen?" she demanded.

Joshua's face tightened. The glint of amusement died. He grabbed Fanny's arm and squeezed hard enough to make her wince. She refused to give him the satisfaction of crying out.

"What the hell do you know about Ellen? He said in a tightly controlled voice.

"You talked, you rambled. When you were sick." She spat the words out as if she'd bitten into something too bitter to chew.

"Be a good girl, Fanny," he said slowly, "and I'll never have cause to send you back where I found you. You have a lot in common with Violet and Flora. And Ellen. Remember that Fanny." He kissed her lightly on the breast and went into the dressing room.

The kiss lay hot on Fanny's skin, as if she'd been branded. She touched her fingers to the spot, was vaguely surprised that it did not feel sore like her arm where Joshua had squeezed it. She lay quietly, barely breathing, the rose silk crumpled beneath her, her hair strewn about her head like dead autumn leaves. She heard the soft, muffled sounds of Joshua changing. He would emerge as a gracious, self-made man who dispensed favors like a monarch, the rich and powerful merchant who made it his business to see that everyone owed him something and that he owed nothing to anyone.

Fanny reached for her ruined dress and drew it around her, covering her nakedness, sheltering herself from this sudden knowledge. Her thoughts balked. But questions formed anyway. Was that all she was to Joshua, someone who owed him a debt, someone he could use in any way he saw fit? Certainly, she owed him loyalty for rescuing her from

the degrading life of a waterfront streetwalker. She would have been dead or diseased or both by now if it hadn't been for Joshua. She owed him a debt of gratitude for setting her up in this fine house and providing her with everything a woman could ask for. Except tenderness. And love. But did she have any right to ask for those things from Joshua when he was so obviously reluctant to bestow them on her? Didn't he owe her something of himself? She had saved his life when he had the fever. She had worked hard to create an atmosphere where he could entertain and dispense favors and use his influence, leading to the rapid success of his business deals in lumber and wild lands. The answers evaded her. All she understood was that he had used her body to put her more deeply in his debt, to remind her that without his protection she was nothing, had nothing. The weight of this revelation bruised her with its immensity.

What Pa had said was true. She was a bad woman, tainted, fallen, not worthy of anyone's love and caring. Not even Joshua's.

He came back into the room dressed in his evening clothes. He smelled of shaving soap and freshly ironed linen. She loved the way he looked in evening clothes and she hated herself for that one small loving thought.

He came to her with his usual cool approach, and something in Fanny responded. She allowed him to gather her into his arms. He searched her amber eyes with his cool blue-brown gaze. She let herself melt against him, hating herself again, but needing to try, just once more, to elicit some deeper response from him. She crashed into the stonewall of his indifference.

Joshua fingered the torn petticoats, crushed a bit of lace in his fist.

"Poor Fanny," he crooned, "you'll need a new gown. Two perhaps. Something pink. Lovely exquisite Fanny." The wildness was in his eyes. She knew he would do something with a purpose known only to himself. This time, she did not find it exciting, just frightening.

"Why did you do this to me, Joshua?" Fanny whispered. Her thoughts were agony. She was bad, unworthy. Joshua didn't love her and never would.

"I want to give you everything you deserve, Fanny," Joshua replied. She feared it was the only answer she'd ever have.

Fanny let Joshua hold her gently against his chest. He rested his cheek on top of her head. Suddenly, crazily, she thought of Mercy and Birdie. A wave of homesickness flooded her. She wanted to go home. But she had no home to go to anymore. Her badness would contaminate her daughter. She could never go home and risk destroying the one decent thing she still had the power to help.

The next day, workmen came. At Joshua's order, they painted all the chimneys a pale shade of rose. They put a small brass plate on the wrought iron fence that enclosed the grounds. It said *Pink Chimneys*.

12

AFTER HER ENCOUNTER with Joshua on the big rose bed, Fanny waited anxiously for her time of the month to come around. She was infinitely relieved when it did. She sought the advice of a midwife and got the recipe for lamb's wool and olive oil pessaries. She knew, pregnancy or no, that Joshua would never marry her. She knew, too, that if she wished to remain at Pink Chimneys, she would be expected to participate in other encounters with Joshua on the big bed. So be it, she thought. I've made my bed, in a manner of speaking, now I'll lie in it. But on my terms, she decided.

She let Violet and Flora know, in no uncertain terms, who was in charge of everything that went on at Pink Chimneys.

"Neither of you sets foot upstairs in the company of a gentleman without seeing me first with twenty dollars in your hand. Anything you can get above that is yours, including presents of jewelry. Agree to that and I'll see that you're fed, clothed, and housed. Cheat me, or bother Mr. Stetson with any of this, and you'll wind up in the dooryard so fast you won't know how you got there," Fanny said, bluntly.

That was the kind of talk Violet and Flora understood best. They were, Fanny supposed, barely out of their teens, not much younger than herself. But they knew the ways of the world and were quick to see

on which side their bread was buttered. Joshua had made it plain she was no better than they were. So be it.

She summoned Brown, the stableman. Brown was very large, very strong, and worshipped the ground Fanny walked on. He was not terribly bright, which suited Fanny's purpose, and he was willing to do as he was told without asking questions. She fitted him up in evening clothes and stationed him by the newel post with instructions not to let anyone upstairs without her personal consent.

Joshua, noting Brown's presence, accepted Fanny's glib explanation that she was afraid some of the gentlemen would behave in too rowdy a way now that Violet and Flora were fixtures at Pink Chimneys. She said she wanted Brown around to protect the furniture and the bric-a-brac. Joshua agreed, gratified, as Fanny knew he would be, that she was cooperating with his wishes and not getting all stirred up about it.

Violet and Flora were happy at being treated so fairly, and the men Joshua invited to be entertained at Pink Chimneys were pleased to have such a genteel and discreet atmosphere in which to fornicate, or not, as they chose, infinitely better than the raucous and probably unhealthy establishments of the washerwomen.

At first, Fanny did not know what to do with the money she extracted from the labors of Violet and Flora, beyond what she regularly sent to Mercy and Birdie. She accumulated two hundred dollars in an amazingly short amount of time. A bank was out of the question. Joshua sat on the boards of both banks. She thought of land or houses, but was discouraged by the thought that anyone, including Joshua, could walk into the deeds office and read of her transaction. Moreover, women simply didn't make those kinds of business transactions by themselves. Men acted as their agents.

She decided to risk seeking some discreet advice.

She maneuvered Rufus Dwinel off into a corner one evening when he was among the favored invited to enjoy the musical talents of Violet and Flora. Dwinel was small and dapper and handsome. He was best known for his eccentricities in business and his unabashed admiration for the ladies.

"Mr. Dwinel," Fanny said, flashing her most winning smile, "I wonder if I might have the benefit of your superior business acumen. I have put a small nest egg aside and I wish to invest it to the best advantage." She had learned the jargon from listening to Joshua; had, in fact, learned a great deal about the workings of business without Joshua being aware of it.

Dwinel nodded and smiled and accepted the flattery.

"Why I'm more than willing to be helpful, Mrs. Hogan. I'm shipping a cargo of the finest pine boards this very week. If you'd care to invest in a share of the cargo, I guarantee you'll double your money. But tell me, dear lady, wouldn't it be more likely for you to invest in one of Mr. Stetson's cargoes?"

Fanny had anticipated the question. She leaned very close to Dwinel, so close he could look down the neck of her low-cut gown. Dwinel greatly admired a well-turned figure.

"You've figured me out, Mr. Dwinel," she exclaimed. "I should have known, but can I trust you with my secret? That's the question."

"Since half the town of Bangor trusts its secrets with you, Mrs. Hogan, it seems to me that you might bring yourself to reciprocate just this one time," Dwinel said in a cajoling tone.

"Very well then. But you must promise not to breathe a word. I want to buy something very special for Mr. Stetson, for his birthday. He's very interested in racing. I want to surprise him with a Morgan stallion. Mr. Stetson says anyone smart enough to organize a racing association can make a lot of money."

"You don't say, Mrs. Hogan? Does Mr. Veazie know about this?"

"I'm sure he does not, Mr. Dwinel. Mr. Stetson has only just confided it to me and I have told no one but you."

An air of conspiracy was exactly the right way to appeal to Rufus Dwinel. Fanny gave him her money with every confidence. He doubled it and she received four hundred dollars in cash. He also confided that he'd bought two Morgan mares. Later on, she heard he was busily organizing a racing association and bragging about how he'd finally managed to put one over on Joshua Stetson.

THE CARRIAGE WHEELS whirred smoothly along State Street. It was autumn again, the time of year Fanny loved most. The black flies were long gone. The oppressive heat of summer was transformed into chilly October mornings.

Fanny settled herself a little more comfortably against the smooth leather seat. To the consternation of the Broadway ladies, she rode with the top down so she could enjoy the pleasant weather. She'd been snubbed a total of eight times since she'd turned the corner at Oak onto State. She kept count, finding it amusing. She inclined her head gracefully at each Broadway lady she passed, perfectly aware that her bonnet, trimmed with glossy feathers, framed her face in a most becoming way. She thought with satisfaction of the weight of the bundle of bills that rested heavily in her reticule. If things went the way she hoped, she'd be as wealthy, in her own right, as any of the Broadway ladies, who depended on their husbands for everything, including social standing. The comparison was not lost on Fanny. She depended on Joshua for everything, they depended on their husbands. All she lacked was the wedding ring.

Brown stopped the carriage at Wentworth's Dry Goods Store. Fanny was a regular customer there. Mr. Wentworth was unfailingly courteous, grateful to have an account supported by Stetson money. Fanny believed, however, that Mr. Wentworth liked her for herself despite the fact that his son was a mariner on one of Joshua's schooners.

Fanny went inside. Wentworth was busy waiting on a lady Fanny recognized as Hannah Bailey, whose husband had bought Joshua's Summer Street house. Their backs were to the open door which let in the pleasant autumn warmth. They did not notice Fanny.

"Oh, that's lovely cambric, Mr. Wentworth. I'll have that for a cravat for Mr. Bailey. His ship is due any day now."

"That's a fine piece of goods, Mrs. Bailey. He'll be proud to wear it. Say, did you hear old Doc Richmond died a few days ago? In his sleep I heard."

"Why, yes, I did, Mr. Wentworth," Hannah said shaking her head sadly. "He was a wonderful man. If it hadn't of been for Doc Richmond, Mr. Bailey and I would never have known about young Abner Giddings needing a decent home. When I think how the town might have struck him off to just anyone and him such a bright boy. I've never regretted the day I brought him home. Here, give me another yard of that cambric. Abner ought to have a new cravat, too, now that he's cabin boy for Mr. Bailey."

"I suppose with her father dead, Maude Webber will be coming home to settle the estate," Wentworth commented. "I hear she and Sam are poor as church mice and twice as happy."

"She's already home," Hannah confided. "I saw her yesterday getting off the boat. Hasn't changed much that I could see. Gained some pounds—like the rest of us. Mrs. Parker said Maude is going to stay and Sam will be here next week. She heard Sam still wants to coast, which is more that I can figure out, him being a doctor and all. Well, that's neither here nor there, but I'm some sorry old Doc Richmond is gone. He was a good man, better than most."

"That he was. He doctored my Jim more than once—Jim was always getting himself tore up—and wouldn't take a penny because he knew I didn't have it. But I always saw to it that Doc had some nice wool every fall for a new jacket. I think he would have gone with holes in his elbows if I hadn't."

"He would have. It's many a time I asked him to drink tea and filled him up with pie. Half the time he forgot to eat. Wouldn't Maude be fit to be tied if she knew that?"

"Well, he's gone now and when you're in the grave, it doesn't matter. Here's your parcel, Mrs. Bailey. Thanks for stopping by."

"Afternoon, Mr. Wentworth."

When Hannah Bailey was gone, Fanny approached the counter.

"Why, Mrs. Hogan," Wentworth exclaimed when he looked up and saw Fanny. "I didn't even see you come in!" He broke into a welcoming smile.

"I was over there in the corner looking for some cashmere for a

shawl. I didn't see any," Fanny said. She didn't say so, but she thought the entire stock looked depleted.

Wentworth's smile faded and he bit his lip with uneven teeth.

"Now, I'll tell you, Mrs. Hogan, I've had some hard luck. Made a couple of deals that didn't work out. I doubt if I'll have any of the better goods for a while. As a matter of fact, I've got a load coming on Job Bailey's schooner, but I'm going to have to send it back. I might even have to shut the store if things don't look up pretty soon." Below his sparse hairline, a worried frown creased his forehead.

"Why are you telling me all this, Mr. Wentworth?" Fanny asked. She'd noticed that Joshua always questioned what people said or did.

"I thought maybe you might be willing to speak to Mr. Stetson about a loan. The bank won't talk to me, said I wasn't a good risk. But I thought maybe Mr. Stetson, himself, might help me out."

Fanny looked carefully at Mr. Wentworth, trying to assess his honesty. He seemed like a good man, one who'd keep his word and his mouth shut. She laid her reticule carefully on the counter considering what she would say next.

"I never interfere in Mr. Stetson's business, Mr. Wentworth. However, I, personally, may be able to help you. How large a sum do you need?"

"I figure three hundred dollars ought to do it. That would take care of the seventy-five dollars I owe for the yard goods and the rest would pay off the other debts I owe. Now, I'm gonta be honest with you. I don't know how quick I'll be able to pay you back."

"What would you say, Mr. Wentworth, if I purchased the shipment of yard goods and loaned you the balance? I'd resell the goods to you, as you demanded them, at a small profit to me, of course. I'd expect the rest of the money to be repaid at the end of a year at five percent interest."

Wentworth's mouth dropped open and he rubbed his chin thoughtfully.

"Why I don't know. That's better than the bank would do. All right. It's a deal."

Fanny opened her reticule and counted out three hundred dollars.

"Now if you'll write me a receipt containing a brief statement of our transaction, and that if you default you forfeit your store to me."

"You drive a hard bargain, Mrs. Hogan," Wentworth commented as he dipped his pen and wrote out the document.

"Of course, you understand our business is to remain just between the two of us. I'm certain that if Mr. Stetson heard out on the street that you'd borrowed money from me, he'd feel obliged to interfere with your son's aspirations to become a master mariner on the Stetson lines."

Wentworth looked slightly hurt and Fanny felt a little ashamed at being so unfeminine.

"I'm an honest man, Mrs. Hogan. And a lot of honest men have silent partners. Here's my hand on it."

Wentworth extended his big calloused hand and Fanny grasped it firmly, the way a man would, her momentary sense of being unfeminine forgotten.

"Now, Mr. Wentworth, I'll have ten yards of that lace. And some of that pale cream silk, too. Twenty yards, I think."

Wentworth carried Fanny's parcels to her waiting carriage, a courtesy he always extended to her. This time, he even handed her up into the seat. He bowed respectfully and Fanny felt a strong current of pleasure course through her. It felt good to be in a position of power, to have something to do besides the usual female tasks of keeping house. The idea kindled within her, and she thought she was going to enjoy being a woman of business very much.

As Fanny drove away, she saw Mrs. Veazie's carriage passing. Fanny leaned way out and waved at the sour-faced lady.

Mrs. Veazie was not amused.

14

THE NEXT WEEK Brown brought the load of yard goods. Fanny made a foray up to the servants' rooms in the attic to see if there was room to store the merchandise. She had never been up to the attic.

She'd always felt it to be the personal domain of Mrs. McGuire, the housekeeper. To Fanny's surprise, only half the great space was partitioned off into the little chambers occupied by the household staff. The remainder was empty. It was simply one very large room finished off somewhat roughly. There was ample room for storing bolts of fabric.

Fanny opened the crate to see just what it was she'd gotten herself into. There were finely woven calicos, bolts of watered silk, figured taffetas, and yards of cambric and petticoat muslins. The shipment also contained reels of matching ribbons, fine laces, and sewing notions. She fingered the fabric, visualizing ways she might use it to make a little cash. Violet and flora were always needing new garters because the gentlemen insisted on carrying them off as mementoes. Bedgowns were constantly in need of repair. Each season new gowns were required. If she required a fee from Violet and Flora each time they needed new garters, or a gown, Fanny thought she might accumulate a tidy amount in the course of a year. She put the idea into effect immediately.

Fanny spent the rest of the week supervising the installment of shelves and a cutting table and bought dressmaker's tools. She hired a seamstress. The seamstress, however, proved to be the first of a very long series. She discovered she was sewing for Jezebels and left in a huff.

These small enterprises, the fruits of Violet's and Flora's labors, the garter fees, the profit from the fabric as she resold it to Mr. Wentworth, brought enough money to send to Mercy and Birdie, but little more. Fanny was dependent on Joshua for everything else. Pink Chimneys and all it contained belonged to him. She belonged to him. But she wanted to belong to herself. She knew the time had come to tell Joshua what she'd been up to.

Fanny was curled up on the sitting room sofa beside Joshua. Her hair was unbound and she wore the filmy pink pegnoir he had had made for her in Paris. It dripped cascades of delicate ruffled lace and whispered silkily each time she moved. Joshua wore a quilted silk robe in a rich shade of blue which gave his eyes a gray tint. He was relaxed and in an expansive mood.

It was late December. The Penobscot was frozen over. Shipping was at a standstill and would remain so until the spring runoff. Business was quiet, but Joshua had crews in the woods cutting timber and he'd have plenty of boards to ship when spring came. He could afford to relax. It had been a very prosperous year for him.

Fanny kept the conversation light, allowing him to direct its course as she always did. They talked of ships, of business, of the things that interested him. She waited for one of the small silences Joshua inserted into his conversation.

"Do you remember," she said smiling, "how I flew off the handle when Violet and Flora came here?" She watched his face from the corner of her eye. Nothing in his face tightened, none of the wildness flashed. He stroked her hair as if the motion, the contact with it, was calming and helped to remove some of the boulders in the stonewall that barricaded his feelings.

"I remember. You looked like an orange alley cat spitting and hissing. I was obliged to make you see things my way," he replied, alluding to the rose bed.

The remark stirred the hot current of Fanny's anger, but she forced a smile and pretended it wasn't anger she felt. Joshua was not intimidated by anger. Her anger merely aroused his anger. She had learned to keep herself pleasantly passive.

Joshua believed Fanny enjoyed the encounters on the rose bed. She encouraged him to believe it. What he didn't know, he couldn't use as a weapon. If you played Joshua's game, you played by his rules.

"Oh, I do see things your way, Joshua. Violet and Flora and I are sisters under the skin. We do whatever is necessary to survive."

Joshua stirred and stopped stroking her hair. His arm rested heavily around Fanny's neck.

"I'm not sure I take your meaning, Fanny."

"I've learned a lot from you, Joshua, about what's important," Fanny purred, ignoring his last remark. She slipped her hand into his, careful not to take too much physical liberty. He was touchy about that, preferring to be the one to initiate intimacy.

Joshua laced his fingers through Fanny's and tightened his grip hard enough to cause her discomfort without actually causing pain. He shot her a quizzical look and she saw a shadow of wildness come into his face.

"What the hell have you been up to now?" he asked suspiciously. His guard was up, his stonewall firmly in place. But Fanny knew a few of his niches, knew where the chinks were. She had to be careful, though, very careful. She must make him believe that he was in control of the situation. If she offended him, or if he thought for one instant that she was scheming to find a way out from under his control, he would turn her out into the street with nothing.

Fanny relaxed her body against his, kept her face pleasant and passive.

"You asked me to supervise Violet and Flora. I know you pay them for their, er . . . talents, but it seemed to me, that for all the trouble and expense you've gone to, you ought to realize something on your investment. I know you said I needn't involve myself with them, but I have," Fanny said and related the story, with certain bits of lavish embroidery, of her activities of the last few months. She did not mention deals with Mr. Wentworth or Rufus Dwinel. Both of those gentlemen had kept their mouths shut.

Fanny held her breath and waited. She could almost see the gears in Joshua's head turning. He rose from the sofa with a restless kind of energy and went to lean against the mantel.

"How much money are you talking about, Fanny?" he said looking interested.

"Oh, not much. A few hundred dollars. I've kept accounts. Here, let me show you." Fanny went to her little French escritoire and brought an account book to show him. The figures did not reflect the total amounts, and some of the expenditures were not precisely accurate.

Joshua examined the accounts. His eyes lost the look of a hawk about to dive for its prey. A little smile played at the edges of his lips.

"Pin money. Fanny, you do the damnest things," he said indulgently.

"But is it all right, Joshua? I had such fun keeping these figures and ordering Violet and Flora around. Could I buy a little bit of land? Or give something to a charity?"

The little smile on Joshua's face broadened to a genuine grin.

"You go ahead and play with your little pile of pin money. Buy a shop. Build a church. And if you lose your shirt, you just let me know." Joshua took Fanny's face between his hands and kissed her lightly. "But don't ever think you can beat me at my own game, Fanny."

To Fanny's surprise, Joshua laid his head on her breast. It was a rare moment. Fanny savored it, could almost make herself believe that he needed her, that he cared. She was still drawn to him like a magnet seeking steel. She did not call it love anymore, but she thought it felt something like that.

Joshua whispered into the gossamer folds of lace dripping down the front of her pink pegnoir. She thought he said, "Stay here."

15

IT WAS NEW YEAR'S DAY, 1835. Brown stood in his accustomed place by the newel post, intrepid and silent. Violet and Flora mingled with a small company of gentlemen, all of them from away, all possessing money or political power useful to Joshua. Fanny had withdrawn to her own rooms after she'd dined with the men. She had been witty and charming and had smiled until her face ached. She had found nothing in the men to admire; felt, if the truth were known, nothing but contempt for them and their posturing. She cast the thought aside quickly. She wasn't any better than they were. She sat down wearily at her little French escritoire.

There was a tap at the door and Violet poked her head into the room. Violet always moved cautiously, like a cat on unfamiliar ground.

"If you'll excuse me, Mrs. Hogan, could I speak to you a minute?" Violet said. She was more articulate than Flora and always spoke for the two of them. For all her cat-like stealth, her manners were demure and refined. Once, to Violet's great amusement, she'd been mistaken for the new schoolma'am who had just come to town.

"Come in, Violet," Fanny grumbled. She was in no mood for difficulties. Her head ached and she felt mean-spirited. "What's the trouble?"

"Oh, not anything serious, marm. It's just that Flora and I've been talking, and we think we need help. There's some of the gentlemen that come here regular that don't think they're getting their money's worth. Some of them are getting impatient with having to wait so long. Flora and I, we wondered if maybe you'd study on it and perhaps take on a couple more girls."

Violet's dark eyes had faint blue smudges under them. She looked pale and tired, the result, Fanny supposed, of so many late nights.

Fanny had avoided thinking about adding other ladies to her establishment. Thus far, all her sins were fairly small. She'd disobeyed her father, lived with a man she wasn't married to, earned money from the labors of two women who sold their bodies to men. She'd abandoned her child. Well, perhaps they weren't such small sins after all. Fanny laced her fingers together. What difference did it make anyway, whether she had two women, or four, working for her? They were all fallen women, fit only for one another's company. Nothing would ever change that. And besides, two more women at Pink Chimneys meant more money in her reticule, another parcel of land to be bought, money to send to Mercy and Birdie.

"Do you have someone in mind, Violet?"

"Why, yes, I do, Mrs. Hogan. But I'd have to go to Boston for a few days to fetch them. Friends of mine, you see, that want to better themselves."

"Then go ahead."

Violet dropped an elegant little curtsy. Her mannerisms were somewhat affected. She laid twenty dollars in the porcelain vase kept there for that purpose.

"There'll be plenty more where that come from, Mrs. Hogan, once the others get here. And things will be a sight easier for Flora and me."

After Violet returned to her duties, Fanny paced the room. It was snowing outside. She stood by the tall French windows and watched the flakes fill up the garden. She had not seen Joshua for a week. Though that was not unusual, the unbearable emptiness that had settled around her was. It had clung to her for days. The sound of music,

laughter, and merriment drifted into the room, faint and distant. She had no desire to rejoin the party. She knew from experience that one of the guests would fancy her and she'd have the delicate task of making it clear to him, without giving offense, that she was not for sale, that Joshua already owned her. She thought of the black reticule and how it contained the seeds of her future. But she didn't know what she wanted her future to be. She leaned her head against the frosty pane. She wondered what Mercy and Birdie were doing this day on the brink of a new year. Birdie was a big girl of four now. Fanny went to her desk and picked up her pen. DEAR MERCY, she wrote. No. That wouldn't do. Mercy didn't want to hear from her, had never once acknowledged the money Fanny sent so religiously. Mercy and Birdie were better off left to themselves. She could only bring them unhappiness and shame. Tears trickled down Fanny's face, fell in ugly splotches on her blue silk gown. She didn't care. Joshua would buy her another one.

By the time Rose and Lily arrived at the end of February, Fanny's spell of gloom had lifted. Joshua had been in constant attendance. He'd taken her to a play and sleighing on the river. He'd told her about a few acres out on State Street, a mile or so north of Pink Chimneys, and Fanny had bought the place. This cheered her and her patience improved so much she felt inclined to listen to Violet confide the histories of the new girls.

Rose, according to Violet, had been compromised by an uncle who swore he'd do right by her, but left her to fend for herself when his wife got suspicious. By then, Rose was in the family way, but had, mercifully, miscarried. She'd been sent to a distant cousin, a cantankerous old maid, to live and work as a hired girl, except she didn't get money for it, only room and board. Rose wasn't especially bright, but she was good looking, with a high proud bosom, nice round hips, and that pale pink and blue complexion men went so crazy over.

As for Lily, she'd been got to by her stepbrother, talked into it by promises of extra food. In a big family, where no one ever got enough to eat, it had sounded good. But Lily's stepmother had caught them at

it and threw Lily out. She hadn't been alone long before she'd been taken in by a young divinity student intent on, he said, converting her to the true moral principles, though how, Lily wanted to know, could that be done naked and under the covers? Anyway, Lily hadn't minded until the theologian had brought home a horsewhip and a pair of lumberman's caulk boots. Lily hadn't waited around to find out what he'd intended to do with them.

Fanny listened and understood. The stories weren't so very different from her own. The image of the sign that said ROOMS swung momentarily in her head. She had the power to keep her girls fed and clothed, to let them have pretty things. She had the power to keep them at Pink Chimneys, making it possible for them to stay because they wanted to. And as long as they stayed, Fanny told herself, there would be money to insure that Birdie was protected from poverty, that Birdie would never be forced by circumstance into the same world as her girls.

16

FANNY EASED HERSELF out of bed. The hired girl had pushed open the curtains and left hot water in the pitcher on the commode. Early morning sun slid into the room. Red-gold shafts of light fell in puddles on the carpeting. Usually, Fanny did not rise so early. Perhaps it was a premonition, the aftermath of the nightmare that had left her quivering even though she did not actually remember what it was that had terrified her sleep.

She splashed water on her face in an effort to wake up more fully. It's Sunday, she thought, attempting to organize her thinking away from the nightmare. It's May, springtime, a little more than a year since Lily and Rose came to Pink Chimneys.

Little wisps of the bad dream flitted through Fanny's head. It had something with a child crying, with being imprisoned in a huge house, of Joshua going away.

In a sense, Joshua had gone away, but Fanny hadn't expected that fact to give her nightmares. He spent little time at Pink Chimneys. He

had just finished building himself a stylish house on Penobscot Street, just off Broadway, not far from Pink Chimneys. He was full of ideas about how he would entertain the upper crust, talked of paying court to some respectable matron's marriageable daughter, had even got himself considered seriously as a candidate for some minor public office.

With the extra earnings garnered from Rose and Lily, Fanny had expanded her property holdings with alacrity. She had become adept at land speculation and put away quite a tidy sum in one of the new banks on whose board Joshua did not sit. As Joshua had predicted, Bangor was turning into a boom town. He continued to allow her to "play with her pin money," even encouraged her. He had not objected to Rose and Lily. He no longer asked to see her account book. Sometimes Fanny wondered if he had grown tired of her, wanted to be rid of her. Yet, he kept coming to visit her, especially when things didn't go just right. He still sent gentlemen to be entertained, still kept track of which nouveau riche gentlemen spent time at Pink Chimneys, and still used that information to his advantage. But he was more discreet about it. He was, Fanny concluded, so far as he was able, carving out a niche of respectability for himself.

Fanny couldn't quite put her finger on it. Nothing on the surface seemed to have changed, yet nothing was the same any longer. What was most important to her now was not whether Joshua would ever love her, but the power she had gained, not only as a landholder, but as the keeper of the sexual secrets of a good portion of the town's male population. More than once she'd used what she knew to force down the price per acre of some piece of land she wanted.

Her dealings with Mr. Wentworth had expanded into the biggest dry goods emporium in town. Wentworth was planning to build an imposing house, in the Italianate style, over on Court Street. Fanny continued as his silent partner. Wentworth was doing so well he'd persuaded his son, Jim, to leave off sailing with the Stetson lines and come to work in the store. The girls at Pink Chimneys were clothed all the more lavishly from this venture, and Fanny took great pride in that. The fact was she had done so well she could leave Pink Chimneys any time she

pleased. But she didn't. There was, she decided, no sense in leaving with only enough to keep her for a few years. If she waited, she'd have enough to keep herself, and Birdie, for the rest of her life.

All things considered, she should not have suffered such a strange nightmare.

Fanny had barely tied her robe around her waist when the hired girl burst in without so much as a tap at the door. Her eyes were wide with excitement.

"It's Miss Violet, marm. She says would you come *quick*!"

Fanny strode rapidly along the wide hallway on the lower floor, ran lightly up the curved oak stairway, and found Violet waiting on the landing. Violet's hair was uncombed, her dark eyes filled with fright. She hugged a thin silk kimono tightly across her chest.

"It's Rose, Mrs. Hogan. She's bleeding something awful. She's getting weak and ruining the feathers!"

Alarmed, Fanny went into Rose's room to see for herself. Rose lay on her side with her knees drawn up to her chest. She was very pale and moaned something about awful cramps.

"Get some towels," Fanny ordered, "and hurry. Tell Mrs. McGuire to send Brown for Maude Webber. I don't want anyone else. Tell Brown to bring her if he has to chase her all the way to Old Town." Fanny took the towels from Violet and wadded them between Rose's legs.

Within the hour, Maude arrived. She hadn't changed much, Fanny thought. She was still small and dark and round. Her clothes were neat but lacking in the details fashionable women cared about. If Maude recognized Fanny, she gave no sign. In precise, kindly words, Maude made everyone leave the room and shut the door firmly behind them. Fanny breathed a sigh of relief.

Fanny sent Violet to her room and went to get dressed herself.

It was noontime before Maude emerged from Rose's room and was conducted to Fanny's elegant gold and white sitting room.

"A miscarriage," Maude said without ceremony. "Not her first. She'll live, but she'll need to stay quiet for a week or two. Another one could

be fatal." The roughness of Maude's voice surprised Fanny, set her nerves on edge. She had remembered Maude as brusque, but not brittle.

"I don't suppose you remember me." Fanny ventured.

"Well, you suppose wrong, Mrs. Hogan. I remember you perfectly well. Since I came back home these two years past, that's all I've heard about. Everyone whispers behind their hands about the notorious Fanny Hogan and the scandal of her pink-chimneyed house sitting cheek to cheek with the pillars of Broadway."

Maude seated herself without waiting to be asked. Fanny remained standing, uneasy. She was tongue-tied in the face of Maude's directness. Maude had been so kind and understanding when Birdie was born. But people changed. Circumstances were different now. She wasn't the unfortunate victim of a ne'er-do-well sailor. She was Joshua Stetson's kept woman. It was to be expected that Maude would pass judgment just as everyone else did.

Maude surprised Fanny with a touch of her hand.

"Did you ever go home?" Maude asked gently.

"Yes," Fanny said, relieved to see Maude's kindness, yet shying from the question which roused painful memories. "My father wouldn't let me stay. I left Birdie with my sister when I came here."

"Whose idea was all this?" Maude asked with a gesture that included not only Pink Chimneys but the circumstances that had culminated in Rose's miscarriage.

"The house was Mr. Stetson's idea. The rest of it was mine." Fanny felt her cheeks go hot and hung her head, expecting, hoping for, she didn't know, Maude's disapproval.

"At least you didn't end up down on the waterfront. Down in Joppa. Disease and filth and human suffering beyond anything I care to see. Everything decent is gone—Mr. Barker's little store, Nat Thatcher's cabin." Maude laid her head wearily against the back of the chair. Strands of hair fell from the coil at the back of her head. "I don't suppose you'd be able to find me a cup of tea?"

Fanny rang the bell. When tea had been brought, Fanny settled herself in a chair near Maude. She no longer felt uneasy.

"I heard you'd lost your father. I wanted to call, but was afraid of what people would say."

"About you? Or about me?" Maude said. "I go where I am called, Mrs. Hogan. Rich or poor, pious or fallen, it's all the same to me. Those that object to my coming here will call someone else when they are ill. It's that simple."

"And your husband? Did he find employment?"

"Oh, yes, he's still coasting. Still ship's surgeon. For Joshua Stetson. Sam gets home every six weeks or so. There's no physician alive that knows more about setting broken bones and stitching up lacerations than my Sam. Mariners are always brawling, the predictable results of too much spirits. I wasn't in favor of Sam signing on with Mr. Stetson, but Sam has funny ideas. He always felt sorry for Joshua Stetson. Old Phineas used Joshua pretty bad. Phineas Stetson is dead now, you know. His wife sold the house and went off down South. I heard she's married again. I guess she's had quite a time with all the money Phineas left her. Well, enough of this gossip. I've got other things to think about." Maude's pleasant expression disappeared and was replaced with a long look that touched Fanny.

"Is something the matter, Mrs. Webber?"

"Maude. Call me Maude. Very often, when I am called to Joppa to attend a lying-in of someone in a very reduced circumstances, I'm asked to find a home for the babe because it isn't wanted. And there just aren't enough homes to put them in. What Bangor needs is an orphan's home. Probably one of the churches would organize one, but it would take years for them to raise enough money for a building and have enough left to run the place. You're very lucky, Fanny, that your little girl is being brought up by your sister. Do you ever hear from her?"

"No, but I send money every month."

"I see. I'm sure your sister is grateful for it. Well, I must go. I've other calls to make. If you ever have an idea about starting an orphans' home, I'd like to hear it." Maude set her cup down with a soft clink and stood up. She slung her cape across her shoulders and tied her bonnet under her chin. The ribbons were wrinkled and frayed at the edges.

FANNY WALKED ALONE in the rose garden. It was situated at the rear of Pink Chimneys, beyond the flagstone terrace that ran the length of the house. It was a beautiful house, Fanny thought, with its simple lines and wide windows and carefully tended grounds. She'd heard that not even the governor lived in a place half so nice. This was her realm, hers to reign over, its servants and events hers to command. She liked that feeling. She liked it very much. Her thoughts of leaving Pink Chimneys were not as important as they used to be. For a farm girl from Fort Point, she hadn't done so badly.

The roses were in bloom and their bright colors made fat splashes of pink and red in the greenery.

Fanny wore a white batiste dress, delicately embroidered and embellished with restrained touches of lace insertion. She held a matching parasol over her head. She wore no hat, though she knew she should. She freckled easily and no one, according to Godey's *Lady's Book*, admired freckles.

Fanny strolled slowly, deep in thought, her wide skirts barely brushing the closely manicured grass. She'd had the stable boy bring a few sheep to graze it just this week. A huge maple cast a comforting shadow into the corner of the garden. Beneath it, several wooden benches and Chinese tea tables were placed. This was her favorite spot on summer evenings after the black flies had gone and the fireflies lit up the deepest shadows. Fanny paused, still wondering after weeks of deliberation, what to do about Rose.

Rose, whom Fanny had sent for, appeared at the French doors that led out onto the terrace from the parlor. She made her way slowly, reluctantly, toward Fanny. She was still pale and frail-looking from her illness. She did not smile, seldom smiled anymore, and that bothered Fanny more than anything about the whole upsetting business. Rose was fully dressed today, for the first time since she'd taken to her bed. Her hair was unpinned and it fell in a blond cloud of ringlets down her back and fluffed in little swirls around her face. The discreet paint she

usually wore on her cheeks and lips was nowhere in evidence. Her doll-like pink and blue beauty had been a great favorite with the gentlemen. Fanny hated to see her go.

"Sit down, Rose," Fanny said kindly, indicating one of the wooden benches. She closed the parasol and set it aside.

"If you don't mind, marm, I'd rather stand," Rose replied in a false attempt at bravery.

It was not the attitude Fanny had hoped for, and the difficulty of what she had to say loomed large and menacing. She had purposefully chosen the garden for the interview in hopes that it would put both of them more at ease.

"Very well, Rose. I've spoken with Mrs. Webber and she says you are now fully recovered. But you must never expose yourself to the possibility of being in delicate circumstances again. If you do, she believes it will be fatal."

Rose's pretty pink lips trembled and she nodded her head miserably, refusing to look at Fanny. She was not articulate and tended to keep her thoughts and feelings to herself or allowed one of the other girls to speak for her. She was good-natured and easily managed, and the other girls liked and protected her.

"I can't keep you on, Rose. I want to, I truly want to, but I just can't risk having anything happen to you. Word gets around, and it's bad for business." When Rose did not respond, Fanny continued, "I'll give you enough money for passage back to Boston or wherever you want to go, and some to keep you for a month. I can't do any more than that." The words left a bitter taste in Fanny's mouth.

Tears brimmed in Rose's china blue eyes. She hung her head. Fanny was grateful for the blond curtain of hair that hid Rose's stricken expression.

Fanny picked up her parasol, relieved that the unpleasant duty was behind her.

Abruptly, Rose sat down and buried her fists into her lap.

"And where the hell do I go! There ain't no place. My people won't have nothing to do with me. All I know to do, marm, is entertain gentlemen."

The sign that said ROOMS swung and creaked ominously in Fanny's head. She had known it would, had been haunted with its shabby presence for days.

Rose sobbed silently. Her thin shoulders heaved and shuddered as if she, too, had seen the sign and knew what it meant.

Fanny set the parasol down again and paced distractedly. "You must have something put by, Rose. You've worked so hard. It can't be so bad as that."

"What I had I sent home to Ma for the young ones. Not that she'd ever say she was glad to have it," Rose said bitterly, "but I thought if I helped out some, Ma might let me come home if I ever needed to. Guess I might's well forget about that."

Fanny was deeply affected. Over and over again, she was struck by the similarities between herself and her girls and their reasons for staying at Pink Chimneys. Today it was Rose. Tomorrow or next month, next year, it would be someone else. Flora, perhaps. Or herself?

"Rose," Fanny said, "I want you to listen to me. I've got an idea. I don't know if it will work, but you'll have to be willing to try some other kind of work."

"Oh, God, marm, I'll try anything if you just let me stay." Rose's sobbing eased and she brushed the snarled curls out of her eyes. She was so lovely, so childlike. Without thinking, Fanny put her arms around Rose and held her as carefully as she'd once held her own dear Birdie. She made soothing sounds, clucked and patted, unleashing a well of maternal feeling she hadn't ever expected to feel again. She regained control quickly and drew away, swallowing a few tears of her own.

Fanny blinked rapidly as she spoke. "Rose, how far did you go in school?" Her thoughts tumbled crazily in her head.

"I went eight terms. But I wasn't much good at it. I kept having to stay home to help Ma with the babies." Rose's face fell, then brightened. "But I won a prize once, for drawing a picture. I was always good at that and using a needle. Nothing fancy. Mending mostly."

"Oh, that's very good, Rose, better than I thought."

"What are you talking about, marm?"

"I'm not sure, Rose. Maybe I've lost my reason, but don't you worry. I've got an idea and if it works you'll have somewhere to go, and you won't have to entertain gentlemen. I want you to tell Mrs. McGuire to find Brown and send him for Mrs. Webber."

At the mention of Brown, Rose's cheeks grew pink and her eyes brightened into a happy expression.

"I'd be pleased to tell him, marm. I saw him over by the stable."

"You're sure you won't tire yourself?"

"Oh, no. I'll be all right. Do me good to talk to Brown a minute. Brown and me, we understand each other." With that enigmatic remark, Rose flitted across the garden and disappeared around the corner of the house. Her step was lighter, her hair fluffed playfully in a sudden light breeze.

It was late afternoon when Maude arrived. She drove up in a chaise with peeling paint that looked as if it had seen better days. The horse looked well fed and cared for, Fanny noted. As usual, Maude's clothes were mismatched and rumpled. She wore a faded sunbonnet, the kind that farm women wore, with a frayed brim.

I must do something about that bonnet of hers, Fanny thought as she watched Maude alight from the chaise.

"Thank you for coming so soon, Maude," Fanny said.

Maude wiped her forehead with the back of her forearm and fanned her face.

"I'd of been here before this, but there's fever down in Joppa. Don't alarm yourself. I scrubbed myself raw and changed every stitch I had on before I set out for here. That's what took me so long. Bad drainage. Sewerage running in the street. Something ought to be done. Who's ill this time?" She reached for her medicine chest.

Fanny laid a hand on Maude's plump arm.

"You won't need that, Maude. No one is sick. I wanted to talk to you. About the orphans' home you said you needed."

"The orphan's home? Nothing's come of it yet and not likely to, but if you have some new idea I haven't already thought of . . ."

"I have more than an idea, Maude, I have a place to put it. Come and sit down under the tree. Have some lemonade."

They strolled arm in arm across the grass and settled themselves.

"I bought the Sawyer place awhile back. You know where I mean, the big house way out on State Street. I was going to sell it for a good profit this fall. Sawyer lost his shirt speculating in wild lands—the fool, serves him right—and had to come down a peg or two. So I bought the place. It's a big house. Must have a dozen or so rooms. Is that big enough for an orphan's home?"

Fanny fluttered her gloved hand at a few blackflies.

Maude echoed the gesture.

"Big enough?" Maude asked with a dazed expression. "That place is big enough for a whole army of orphans. I know because I was called to see Mrs. Sawyer about this time last year."

"What I have in mind, Maude, is this. If you can find some church that's willing to run the place, I'll deed it over to them. But I don't want anyone to know where it came from. And you're the only one I'll deal with. I'll have the deed recorded in your name, but no money will actually change hands. You can say some aunt left you a fortune. Then, in six months time, you can give it to the church to run."

"Why don't you want anyone to know?" Maude asked, the question obviously calculated.

"You know why, Maude! I'm not the kind of person that decent people want to associate with. No one would have anything to do with it if they thought . . ." Fanny paused, unwilling to continue.

"If they thought it was built with tainted money," Maude finished for her.

Fanny avoided the intensity of Maude's eyes.

"You know that's why, Maude, now let that be an end to it. Do you want it or not?" There was an edge to Fanny's voice.

"Yes, I want it, Fanny. I want it so I can show the good citizens of Bangor that there are better ways of alleviating suffering and want than casting a few crumbs to the poor once a year."

"There's a condition."

"What condition?"

"Rose. She's to have a place there, for as long as she wants it. She could take care of the little ones and teach them how to draw and mend."

Maude tugged at the strings of her sunbonnet and pulled it off her head. It hung in a limp, unlovely lump between her shoulder blades. She eyed Fanny carefully.

"Playing the ministering angel, are you, Fanny?" Maude said in her soft voice.

"I suppose you could say that," Fanny answered tightly, not willing to admit she'd been found out, though she knew perfectly well Maude saw through her motives.

"What about upkeep? Food and clothing and salaries for the staff?"

"I'll see to that for the first six months and pay Rose's way out of my own pocket as long as she stays. The church will have to shoulder the expenses after that. You'll have to see to it. And one other thing. I want Mrs. Veazie on the board of directors."

Maude laughed. She had heard the stories that circulated about Fanny's skirmishes with that lady.

"You want Mrs. Veazie!" she said.

"You needn't laugh, Maude. If Mrs. Veazie gives her approval to the home, so will every other society matron in town. You know that just as well as I do."

"Yes, but I never would have thought of it, not in a million years. Well, I guess I've got my work cut out for me. It will have to be the Universalists, I think. Their membership is small, but it's growing, and attracting a well-educated congregation with the means to do good works. They won't stuff the babes with hellfire and damnation first and feed them second. Won't make the Baptists too happy, I suspect, but they're pretty well occupied with the temperance question at the moment and may not take any notice at all."

"Then you'll accept my offer? You think it can work?"

"Of course, I accept! Work? It will work out just fine. Bangor's not the kind of place to look too closely into the mouth of a gift horse."

Maude held out her right hand. Fanny grasped it firmly, the way a man would.

"Thank you, Fanny," Maude said.

Fanny went to tell Rose. Later that day she ordered a hat from the best shop in town and had it sent to Maude.

PART THREE: ELIZABETH

1

THE HOUSE HAD AN abandoned, forlorn appearance. Elizabeth Emerson paced the rooms trying to decide if she were doing the right thing. Her footsteps echoed sharply on the bare floor. She had sold the bright braided rugs for enough money to book passage upriver.

Elizabeth Emerson's dark hair had auburn lights. It was arranged in sleek wings over her ears and looped up into a coil anchored by two wooden combs. Her eyes were an unusual shade of bachelor button blue with ice-blue flecks. Her face was a long, pleasant oval. She was tall and usually carried herself with confidence. But on this day, her shoulders drooped. Her mouth was a sad, curved line. She carried her head tilted slightly to one side as if it were too heavy to hold erect.

Neighbors down the road had offered her a home until she could find something more suitable, but Elizabeth had firmly declined. It had been bad enough having the whole town know the farm had been sold for nonpayment of taxes. She had no intention of living on the charily of others now that she had become a pauper. By now, everyone in Fort Point took it for Gospel that she had no other choice but to go to work in the spinning mills down in New Hampshire. But this Elizabeth was

determined not to do. She knew how to sew. She would use her skill to earn a living.

Yesterday, in the process of separating a few personal belongings from the things she must leave behind, Elizabeth had found a back issue of the Bangor Whig and Courier tucked in the bottom of Aunt Mercy's bureau. At first she thought the paper was a liner for the drawer, but it was folded too small for that purpose. She was about to discard it when she noticed an advertisement heavily outlined in pencil. It said: WANTED—YOUNG LADY OF GOOD MORAL CHARACTER TO DO DRESSMAKING AND MENDING. LIVE IN. INQUIRE BANGOR HOUSE, BANGOR, MAINE ON APRIL 28, 1852, MRS. HOGAN.

Elizabeth read the notice twice. Had Aunt Mercy intended to encourage her to apply? She didn't know, but it was the answer to her prayers.

It was just after dawn. No sails were yet visible on the Penobscot River. Elizabeth stood in the kitchen, her thoughts bound to the past. She could almost see Aunt Mercy, with her cat, Daisy, in her lap, rocking comfortably by the fire. The room should have been alive with Aunt Mercy's voice, the clatter of spoons and pots on the table, the clash of stove lids.

The ashes in the stove were cold and gray. The only sound in the house was the faint rustle of Elizabeth's own petticoats. The rocking chair, the pots, the farm—they all belonged to someone else now.

The kitchen smelled faintly spicy from a century of baking and pickling, an odor so synonymous with warmth and happiness that tears pricked Elizabeth's eyes. The spicy fragrance would fade from her memory, she thought, be as final as the days of her life within these walls.

Three weeks ago, Aunt Mercy had complained of a large pain in her chest and took to her bed, declaring she'd be up the next day but asking for an onion poultice in case it was the pneumonia. By morning, she was dead. And with the most ungracious haste, the town clerk had made it clear that the taxes were to paid without delay. Otherwise, the farm would be sold to the highest bidder. And so it had been.

A wave of loneliness swept over Elizabeth like autumn fog. She and Aunt Mercy had spent much of their time in the kitchen, the way women do. Here, they'd pared apples for pies, or stirred fragrant grape jelly bubbling in the big copper kettle. They watched ships pass on the river and sat near the window doing the bits of mending and dressmaking brought to them by the ladies of Fort Point. Sometimes they had spun their wool in the kitchen and shared the village gossip.

It was here in the kitchen, Elizabeth remembered, that Aunt Mercy had told the melancholy story of her parents. Elizabeth's mother, Fanny, and her father, Robert, had met in church and had fallen in love at first sight. Robert was a mariner from Portland, master of his own vessel. Robert and Fanny were married within a year of meeting. After Elizabeth was born, Fanny had stayed home while Robert sailed. But she pined for him so much her health was feared for, so Robert took Fanny on a short voyage down the eastern coast. They left baby Elizabeth in Mercy's care, expecting to return within a few weeks, but they ran into a terrible gale off the coast of Carolina. The ship went down and all hands were lost. That was how Elizabeth came to be brought up by Aunt Mercy.

Elizabeth fingered the little gold locket that hung around her neck. It had been placed there by her mother when she left on her fateful voyage. She traced the deeply engraved F with her fingers. F for Fanny. F for fate. F for forlorn.

Tears pricked Elizabeth's eyes again and she gave in to a huge wallow of self-pity and grief.

A faint mew at the kitchen door diverted Elizabeth's attention. Sometimes one of the half-wild barn cats grew brave enough to come and beg for a handout. She opened the door, unable to resist the soft, insistent call. Daisy strolled in, purring loudly, just as if she hadn't been missing for days. Daisy arched her back and rubbed against Elizabeth's ankles. Twice, the cat disappeared under the shroud of Elizabeth's dark wool skirt.

"Daisy! Where have you been?"

In all the confusion of Aunt Mercy's funeral, Daisy had disappeared.

Elizabeth had feared she'd run away in fright. Secretly, she had been relieved by Daisy's disappearance. It spared her the additional pain of leaving the cat behind.

Elizabeth scooped Daisy up into her arms and stroked her warm, tabby fur. Daisy rubbed her head against Elizabeth's cheek. How could she leave Daisy behind?

It was full daylight now. The dark shapes of naked trees stood out sharply against patches of lavender and gold sky. The quick movement of light reflected against a sail alerted Elizabeth that a ship was in the channel. Time had run out. She snatched up a basket that contained her extra pair of shoes and took them out. Aunt Mercy's gray shawl still hung behind the kitchen door. Elizabeth grabbed it, held it against her cheek for one brief second, and stuffed it into the basket. Then she dropped Daisy inside and shut the lid.

Elizabeth closed the door softly behind her, painfully aware of the final click of the latch. She hesitated on the door rock, looking down across the back pasture. The Penobscot River lay at the foot of it, and beyond, the hills of Castine contoured the horizon. Upriver lay Bangor and whatever new life she could make for herself.

Daisy stirred in the basket, uneasy at being confined, but reassured by the familiar smell of Mercy's shawl.

"Be still, Daisy," Elizabeth whispered. The words were more to quiet her own racing heartbeat than to calm the cat.

The sails were closer now. There was no delaying the inevitable. Elizabeth set off down the narrow track that edged the pasture. The grass, stiff and brown, caught at her skirt as she trudged. In one hand she held a much worn valise which contained a few articles of clothing; in the other, she carried the basket containing Daisy.

The sheep in the pasture drifted toward Elizabeth. A lamb bleated for his mother and an ewe hurried to his side to reassure him. If only life were that simple, Elizabeth thought, if only all I had to do was whimper and my mother would come to make Aunt Mercy's death and losing the farm easier to bear. But there was no family to turn to for comfort.

Elizabeth went on, running a bit, making sure she reached the boat landing before the vessel drew opposite. There was no way to know for sure if this ship would take her aboard, but she'd raised the large orange flag. She was prepared to wait all day until some vessel was inclined to give her passage upriver.

As the vessel drew opposite the landing, it slowed, appearing to drift of its own accord. Elizabeth's heart hammered. This ship was going to take her aboard. She hadn't expected that of the very first one to pass this early in the day. She could see sail being reefed.

There was no turning back.

2

ABNER GIDDINGS SAW the bright orange flag a long way upriver, an incongruous blot of color lodged against the tender green of late April. A tall, spare figure huddled in a heavy woolen jacket, he stood on the quarter deck. It was the custom of the farmers along this stretch of the Penobscot to hoist a flag when they wanted passage upriver. Local shipping often took these passengers aboard. Abner Giddings never had. But this morning the tide had not yet turned, the breeze was light, and he was running against the river current. It would cause him little trouble to do some local farmer a favor. He gave the order to Lovejoy Page, the mate.

"We're taking on a passenger."

The moment the words left his lips, he regretted them. He wasn't ready to resume command, not fit company for man or beast. He was better off left to brood by himself. No need to pretend to a good humor he didn't feel.

Abner Giddings was above six feet tall. His bones were slender and long. His face was weathered from sun and wind. Little lines crept out from the corners of his brown eyes even when he didn't smile. His dark hair was straight and long at the back and sides. It blended into neatly trimmed sideburns. He was nearing thirty and had lost the stripling look of youth. His body was settled into the strong, solid proportions

of maturity. His shoulders were broad; his hips were lean. His handsome face reflected his brooding mood in the tense lines of his cheeks, the inward expression in his eyes.

He went below. The steward rattled pots in the galley. He handed Abner a steaming cup of tea. Abner took a sip and burned his tongue. It gave him an excuse to reach into his pocket for the small flask he had carried with him since the night of the accident. He poured a large measure of rum into the tea, just to cool it a bit, he told himself. He wasn't a drinking man, but the rum had helped him through the last few weeks. He drank deeply and added more rum.

He heard the jolly boat launched, the easy bickering of the crew; his men were bored with their progress upriver. They were eager to dock at Bangor, anticipating the days of liberty before they signed on with some other vessel. As for Abner, he dreaded arriving at Bangor, dreaded the thought of seeing Maryanne's mother, of bringing her the details of Maryanne's death four weeks ago.

He didn't want to think about it anymore. So he sat, sipping his tea and adding rum until the tea was gone and only the sharp taste of spirits remained. The liquor settled warmly in his middle, his nerves began to relax. He had no idea how long he sat concentrating on the warm feeling in his stomach, averting all thought from the duties that lay ahead, the pain that lay behind.

Presently, he heard Lovejoy Page give the order to get under way. Page was a competent mate, knew his job and did it well, but the responsibilities of master were new to him and he simply did not have the necessary experience. The crew sensed this and had slacked off some since Abner abdicated. Abner knew he should go on deck to make sure they were still in the channel, make it look as if he were still in charge, at least for the moment. He lingered a bit longer, leaned heavily against the bulkhead, sagging slightly as if he were old.

He made a visible effort to pull himself together and went above.

Lovejoy Page had everything under control, and for some reason, irrational as it was, it irritated Abner to see how easily he could be replaced as master of the *Fairmont*. He made it a point, as all master

mariners did, to keep his relationship with the first mate strictly one of business. He had no good reason to resent Page's stepping into the master's shoes. Abner had relinquished his authority by his own choosing under a time of great duress. Still, there was that prick of resentment. Maybe it *was* time to put himself to rights and send Page back where he belonged.

The *Fairmont's* sails shook themselves out and filled away in the light breeze as pretty as a lady's petticoat on a March morning. The sight heartened him, lightened his doleful mood. He lifted his chin into the breeze, unconsciously imitating with his body the movement of the sails. He felt the power of the wind as it drove the vessel. What an exhilarating thing it was to guide the *Fairmont* through wind and water! By God! That was what he needed—the feel of the wheel under his own hand, the sure knowledge that his every order would be obeyed and the work well done.

Abner started aft, swaying slightly, not enough so anyone would know he'd been into the rum. He couldn't set a bad example for his crew, especially since spirits were now illegal in Maine. He had always run a clean ship. He gazed upward at the sails and smiled at the sight. Nothing like canvas aflutter.

Another bit of fluttering fabric distracted him. What was it? He'd seen it before. He couldn't breathe, or swallow, or slow the hammering in his chest. His body recognized what his brain refused to. That gray cloak, the graceful stance of the woman leaning on the rail—he knew them well. He'd never seen the blue hood, but that didn't matter. She was always knitting something—socks, mittens, scarves, warm things to shield him from foul weather. The name that escaped from his throat emerged soft as the swish of water against the ship's bow. He would have sworn he shouted.

"Maryanne."

The woman turned slightly, not enough to see who had spoken, turned so her face was in profile against the sparse April landscape. It was not Maryanne, not his dead wife.

Maybe he was drunk, after all.

"MARYANNE." IT WAS barely audible, a slight motion of air that might have been nothing more than a light wind tightening a sail. It was lost on a small note of agony and joy, and when Elizabeth turned to look for the speaker she saw no one but the crew running to and fro along the deck in response to shouted orders.

The *Fairmont* gained speed as more of her canvas was loosed to the wind. If someone had spoken, he had disappeared from sight. Perhaps she had imagined it. Still, she had the eerie impression that she had been mistaken for someone else.

The wind breached the folds of Elizabeth's cloak, numbed her fingers and toes. The sailor who had rowed her to the vessel was nowhere on deck. She would have to find her own way to her cabin. Daisy stirred in the basket and yowled.

As she made her way along the rail toward the companionway, the crew eyed her with curiosity and open admiration. Elizabeth wasn't accustomed to it, and their frank stares embarrassed her. They were a scruffy looking lot, some bearded, some toothless. She lowered her head, pretending she didn't notice how they looked at her.

The wind whipped her petticoats around her legs, forcing her to move the basket. Daisy meowed a loud protest. Elizabeth righted herself, took advantage of a sudden lull in the wind, and broke into a slow run. She thought she heard someone shouting a warning. But too late she saw the slippery patch of water, skidded, and lost all control of her body.

She pitched headlong down the companionway. Somewhere, very far away, a voice she did not recognize as her own screamed and was drowned by the hollow thud of boots running on the deck above. Then it was dark.

The scream harpooned Abner Giddings, tore open the wounds that had barely begun to heal. He sobered instantly and arrived on deck completely in control.

As he ran, he shouted, "Mr. Page, fetch Dr. Webber!" The crew paused imperceptibly, understood that the captain was back in charge and, to a man, made certain Abner was the first to reach the woman who lay crumpled at the botton of the companionway.

The accident struck Abner with all the horror and intensity of a month ago, but this time it wasn't Maryanne lying there. This time he could take charge, he could do something.

Only for a moment, when the cat untangled itself from the woman's skirt, did he experience any desire to bolt.

"It wasn't the cat's fault, Abner, not then, not now," Sam said as he bent to examine the women. "Nothing broke. Concussion probably. Let's get her to a bunk." He signaled to a seaman.

"No," Abner said, "I'll carry her. I'll put her in Maryanne's cabin."

After he had left the woman in Sam Webber's care, Abner returned to deck. Within the hour the patch of water had been removed and orders given that it was to remain that way. Mr. Page was deftly relegated to the tasks more usually associated with the first mate, and Abner stood at the wheel.

Elizabeth woke to find herself lying on a narrow bunk. Her shoes had been removed and a bulky bandage was wrapped around one ankle. She tried to sit up, but a steady throb in her head made her lie down again very quickly. She felt as if she'd been run over by an ox team, but remembered that she had fallen.

"Daisy," she whispered into the gloom. There was no answering purr, no furry body jumped up to greet her. There was no sound but the creak of rigging. She wanted to get up and search, to find someone who could tell her what had happened to Daisy, but she was so weary, her head hurt so badly. She drifted off into a fretful doze, and dreamed violent dreams.

She woke again with a start, crying out for Aunt Mercy.

She was not alone in the cabin. Someone had responded to her cry, had covered her with a warm blanket. She lay very still, hardly daring to breathe. A man stood in the circle of lamplight.

"You're awake, I see." The tone of his voice reassured her. It was deep, reminded her of Daisy's raspy purr, had the same rough gentleness. The exact contours of his face were blurred by the shadows, but Elizabeth saw that he was nearly as tall as the cabin was high. She threw the blanket up around her chin even though modesty was of no concern since she was still fully dressed.

"I'm Abner Giddings, master of the *Fairmont*." He was close enough for Elizabeth to see that his shirt was open at the throat. The light haloed his head, outlined his slender frame. She peered upwards, trying to see his face more clearly.

"I'm Elizabeth Emerson," she said with as much dignity as she could muster. Impossible to maintain one's dignity while lying down. She poked her right hand towards Abner Giddings.

"Pleased to meet you," she said primly. Silence grew between them, huge and awkward, threatened to split the bulkheads. Elizabeth twisted her fingers in the blanket fringe. She lowered her eyes and stared at the spot where she assumed Abner Giddings's boots would be. She fought an insane urge to pull the blanket up over her head.

Desperate to banish the silence, she asked, "What time is it?"

Abner drew a watch from his pocket.

"Nearing midnight. Webber, the surgeon, says you sprained your ankle and shouldn't walk for a day or two. You hurt your head, too."

Again, Elizabeth felt herself respond to the timbre of his voice.

She put fingers to the side of her head. A large, ugly knot stood out on her skull.

"Your cat ran and hid. When it's found, someone will bring it to you."

"Thank you."

Elizabeth hated the quiver in that small phrase, felt tears gathering beneath her eyelids. She shrank deeper under the blanket. Abner Giddings continued to regard her with the same neutral gaze. She felt like an insect on the head of a pin.

"Good night, Miss Emerson," he said with a stiff bow. The door closed behind him with a soft snap.

The next morning Elizabeth woke to a faint gray dawn. Her head no longer throbbed when she sat up. Her ankle ached some, but she put a little weight on it and hobbled to the wash basin.

The *Fairmont's* motion was slower, less rolling than the day before. Even the creak of the rigging was muted. It could only mean one thing. Sometime during the night they had reached Bangor! She gathered up her belongings in anticipation.

The light in the cabin grew bright enough for Elizabeth to observe her surroundings. The bunk where she had slept was covered by a soft gray wool. It was constructed of a wood unfamiliar to her, carved with flutings. Persian rugs made small islands of color against the floor. A guitar, its neck tied with red and blue ribbons, hung on the bulkhead. A lap desk sat on a slender-legged table. Beside it sat an intricately woven sweet-grass basket. Surely this was not the cabin usually assigned to passengers. She stroked the blanket on the bunk with practiced fingers. It was finely spun and beautifully woven. The cabin must have belonged to a woman of exquisite taste.

There was a light rap on the door.

"Come in." Elizabeth fully expected a lady of great elegance to enter. She was surprised to see a small man with graying hair, a ruddy complexion, and eyes the color of late summer blueberries. He carried a battered instrument case which he dropped, unceremoniously, on the bunk.

"Good morning, ma'am. I understand you're Elizabeth Emerson. I'm Sam Webber, ship's mate and surgeon. Feeling frisky this morning, are you? Let's have a look at that ankle. You're a very lucky young woman. I've seen stouter necks broken on sailors who've pitched down that companionway."

He examined Elizabeth's ankle gently.

"You've got a bad sprain there, but you'll be able to limp ashore once we get to Bangor. That may not be for another day or two. You'll have plenty of time to heal," Sam Webber said cheerfully.

"What! Aren't we in Bangor right now?"

"Why no. We're off Bucksport and likely to be all day. Two or three maybe. It happens quite regular on this part of the river. The current is strong and the wind has died."

"But I have to be in Bangor by tomorrow!" A shrill note crept into Elizabeth's voice. "I'll have someone row me ashore. I'll take the stage. I must get to Bangor!"

Elizabeth shrank under the stern look Dr. Webber fixed on her.

"That ankle won't stand too much gallivanting around, Miss Emerson. You've bruised a few ribs, too, not to mention that nasty crack on your head. Why you don't have a concussion is beyond me. You aren't in any condition to bounce around over bad roads. And besides, my dear, the mud is so bad now, you won't find a stage that could even get to Bangor."

Dr. Webber patted Elizabeth's hand. She snatched it away. She was in no mood to be comforted. All the fear, grief, and pain she'd suffered because of Aunt Mercy's death grew to enormous proportions. Great sobs shook her shoulders. Her chance to start a new life had evaporated with the wind.

Dr. Webber left without Elizabeth noticing. He wasn't gone long.

"Come now," he said kindly, "see what I found.

In his arms was Daisy.

4

SAM SET DAISY ON Elizabeth's lap, taking care that his hand supported the cat's hind legs. He liked cats, but his life at sea had made it impossible to get well acquainted with domestic animals.

Daisy moved nothing but the tips of her claws, kneading them into Elizabeth's skirt. She sniffed Elizabeth's hand, as though making sure this was someone familiar and trusted.

"I don't think she remembers me," Elizabeth said.

"Maybe she's confused by the smell of that liniment I put on your ankle," Sam said. He liked the way Elizabeth stroked Daisy's head. Daisy did, too, and a purr of magnificent proportions swelled in her chest.

Sam laughed, glad to see that Elizabeth was laughing, too.

"Was Daisy hurt?" Elizabeth wanted to know.

Sam shook his head, no. He settled himself into a seat and lit his pipe, filling the cabin with a sweet, pungent odor. He was in no hurry. There was nothing much for him to do anyway. The crew was healthy; Abner looked as if he had got himself pulled together and was leaving the grog alone. It relieved Sam's mind to see Abner come out of the depression that had gripped him since the accident. Sam had worried a lot about Abner, but had, for the most part, let him be. Grief resolved itself in stages, passed of its own accord if you let it. He'd said as much to Abner and now he was pleased to see that Abner was starting to heal.

"Now tell me, my dear," Sam said between puffs, "why are you in such a hurry to get upriver?"

Sam wasn't surprised to hear the sad circumstances of Elizabeth's immediate past. He had heard similar stories from Maude. He took the small scrap of newspaper Elizabeth handed him.

"Bangor House." Sam pursed his lips and smoke rose around his head in wispy circles. "That's certainly a respectable address. Lots of people by name of Hogan in Bangor . . ."

"Do you know Mrs. Hogan?" Elizabeth asked.

"No, I can't say as I do. I've heard of several Mrs. Hogans. One, in particular. But I'm certain she's not the lady you're looking for." Whenever he heard the name, Hogan, he always thought of Fanny and Pink Chimneys. Fanny Hogan was known, by reputation, to every person in Bangor, and to every mariner who came upriver. Why his own wife, Maude, was welcomed at Fanny's as a friend. But try as he would, he never could get much out of Maude about Fanny. What Maude knew, Maude kept still about. He'd seen Fanny dressed in the latest fashion, driving a well-turned-out rig pulled by a pair of Morgans that could make a man weep for all their beauty. Hell, for that matter, so could Fanny herself. Handsome woman with that orange-brown hair of hers. At one time or another, so they said, half the lumber barons in Bangor had been in love with her. Of course, everyone knew she was Joshua Stetson's woman. But that was neither here nor there. This

Mrs. Hogan advertising for a seamstress was surely *not* the notorious Mrs. Hogan of Pink Chimneys.

Sam roused from his mental meanderings.

"Forgive me, Miss Emerson. I seem to have misheard what you just said."

"I was saying, Dr. Webber, that Captain Giddings told me he'd have Daisy found and brought to me."

The cat curled up in Elizabeth's lap. It presented a cozy domestic scene, a woman stroking a cat, the cat purring. Sam looked forward to just this sort of domesticity in his declining years. Not that he'd ever get Maude to slow down much. But he'd decided that he wanted to stay ashore from now on. This was his last run down the coast.

"Giddings been here, has he?" Sam sat straight in his seat and removed his clay pipe from his mouth. Now that was a good sign. Abner hadn't been in this cabin since Maryanne died.

"Yes, last night. I thought he seemed very . . . unsettled. Almost angry. As if he were inconvenienced by my being here." She recalled his reticence, his reluctance to say much of anything.

"No, I don't believe he was inconvenienced. You were brought here at his order. Best place for you. More comfortable than anywhere else."

"Maybe he's superstitious about having Daisy aboard." Elizabeth stroked Daisy's back and the cat stretched and purred. "I kept thinking that I must have done something to offend Captain Giddings."

"You didn't offend him and it's not really Daisy either. The captain is just a little leery of cats, in general, right now. Especially after what happened to Maryanne."

Sam hadn't intended to give out even that much information about the accident, but there was something very kind-hearted about Miss Emerson, and he had spoken without thinking.

"Maryanne?"

Sam settled back into his seat, his pipe put aside, his fingers tightly laced across his navy blue jacket.

"Yes, the captain's wife. Maryanne Giddings. Pretty little thing. Her hair was dark like yours. Not so tall, though. This was her cabin." Sam tightened and untightened his fingers.

"When will I meet Mrs. Giddings?"

Sam stared at his hands.

"What about Mrs. Giddings? Will I be meeting her?" Elizabeth asked again.

"No."

Sam allowed himself to slip back to a memory that distressed him more than he cared to admit. As a physician he had seen much of life's inconsistencies and caprices. But nothing had ever bothered him as much as Maryanne's death. He hadn't talked to anyone about it, especially not Abner. He'd been too afraid Abner would go into a decline or drink himself into a stupor and fall overboard. Or worse, pick a fight and get his skull bashed in.

"Dr. Webber, are you all right? You were telling me about Mrs. Giddings."

"It was four weeks ago," Sam began. How much should he tell this obviously innocent stranger? Would she be shocked? He met her eyes, gauging her character, saw curiosity and something else. Compassion? Certainly she was compassionate. You only had to see how she handled the cat to know that. She was waiting to hear. And, surprisingly, he wanted to tell her.

"Expecting her first child, she was. I told her, stay ashore until the confinement is over. But Maryanne was never one to follow any orders but her own. Headstrong. Never knew when she'd stand watch with the captain, even in the foulest weather. Crew worshiped her. So she stayed aboard. Promised she'd stay below with her cat for company and plenty of books and sewing to keep her occupied. Promised me. Promised the captain she wouldn't climb up the companionway without help, to make sure she didn't fall." Sam spoke very softly, knowing from long experience that painful memories were easier to confront that way.

"Then, the day we cleared Charleston, the cat ran off. It was a foul day, windy, no one heard her call, the wind was so loud. So Maryanne went to look for her cat. She climbed up to the deck, calling the cat, soaked to the skin, the wind tearing at her hair." Sam took a deep breath and changed his position in his seat. "She caught her boot in her skirts and fell."

Sam stopped abruptly. Must be getting old, he thought. The mental picture of Maryanne's body lying in a twisted heap was like a wound.

"You'll feel better if you finish the story, Doctor," Elizabeth said. Sam saw compassion and kindness on her face and thought of Maude.

"When I saw you lying there all tangled up in your cloak, it was like Maryanne's accident all over again. The captain felt that way, too. Maryanne died. The child, too. Nothing could have saved them. I tried. I tried . . ." Suddenly, Sam was weary. He felt every one of his fifty-eight years. He longed for Maude's generous doses of warmth and sympathy.

Sam stood up.

"Well, I won't bother you anymore with my troubles. You have enough of your own." Sam retrieved his medicine box.

"Was Maryanne's cat ever found?" Elizabeth asked.

"Under the captain's bunk. It had never even got up on deck." Sam patted Elizabeth's hand. The gesture was meant to comfort them both. "No need to trouble yourself, Miss Emerson."

"What happened to the cat?"

Sam regarded Elizabeth with a long look. Apparently, she wasn't one to shy from the bitter truth. Maude was like that.

"The captain threw it overboard."

Except for a slight narrowing of the eyes, Elizabeth did not respond. Whatever life holds in store for this young woman, Sam thought, she's equal to it.

5

ELIZABETH THOUGHT ABOUT the terrible circumstances of Maryanne Giddings's death for a long time after Sam Webber left. If the tragedy still lay so heavily on the doctor, then naturally, it was all the more bitter a burden for Abner Giddings. He must have been out of his mind with grief. Elizabeth understood that. Her own feelings after Aunt Mercy's death had been akin to craziness.

It was all so awful. But she didn't know the captain. By tomorrow she'd be in Bangor and never see him again. She had problems of her

own to think about without taking on the ones that belonged to Abner Giddings. If Mrs. Hogan didn't take her on, she didn't know what she would do.

Time dragged slowly, seeming all the more interminable because the *Fairmont* was becalmed. There was no clock to mark the passing hours. Except for the steward, who brought food, Elizabeth was alone with her thoughts and tired of inactivity.

Her ankle didn't trouble her much. She moved about the cabin restlessly, testing the amount of weight it would bear, gauging the amount of pain it produced. She was quite well enough to go above for a breath of fresh air, but she didn't dare to. Dr. Webber had been firm about that. Nor did she care to risk another encounter with Abner Giddings. She did not want to be a reminder of his wife and child.

Elizabeth rustled a paper ball in front of Daisy, but the cat merely yawned, made one half-hearted swipe with her paw, and went back to sleep. Games didn't interest her.

Elizabeth limped around the cabin despite the fact that Dr. Webber had said to rest and stay off her feet. She limped past the table, the bunk. Around and around the cabin, until she stumbled over the sweetgrass basket and knocked the cover off. A few bright strands of thread spilled out from under a rumpled piece of white flannel. Her first thought was to replace the cover and move the basket out of the way. It was a lovely basket, woven, she was certain, by local Indians who peddled their handiwork to local folks. It smelled as sweet as a hay mow, reminding her of a similar sewing basket she'd had to leave behind.

Here, Elizabeth thought, was the perfect solution to the boredom and inactivity that was to be her lot for the rest of the day. Surely, Abner Giddings wouldn't mind if she did a little sewing. The stitching would keep her happily occupied; take her mind off her trouble; make time pass more quickly. She would be very careful to return everything, even the thread snippets, to the basket. What harm could it do?

Elizabeth drew the flannel fabric from the basket. It was an infant's dress, very tiny. She held it up, very tenderly, as if it held a baby, and then smoothed the dress with her hands. The fabric was finely woven,

soft as velvet. An embroidery had been started on it, one pink rosette worked on the sleeve. In her imagination, Elizabeth saw Maryanne reclining on the bunk, heavy with child, fashioning that one rosette. Was it then that the cat had run away?

At the bottom of the basket lay skeins of Chinese silks. Elizabeth stroked them, marveling at their beauty. There were shades of green, pink, cornflower blue, and yellow bright as the buttercups in the home pasture. A silver thimble, a carved ivory needlecase, scissors, and a small embroidery hoop also lay in the basket.

Elizabeth did not stop to consider the consequences—a trait Aunt Mercy had never quite managed to eradicate from her character.

Small patches of color grew quickly under Elizabeth's finger. She fashioned borders of rosettes and buttercups interlaced with intricate twinings of leaves and forget-me-nots. The small spark of guilt she felt at trespassing on another's property was buried in the joy of creating the designs.

The day passed; by mid-evening she had finished. She folded the dress and replaced it in the basket.

The steward brought tea.

"The wind's coming up, Miss. We'll sail within the hour. We'll be in Bangor tomorrow for sure."

6

IN THE MORNING, leaning lightly on Sam Webber's arm, Elizabeth limped along the deck. The buttons on the doctor's coat shown brightly. Elizabeth suspected he had polished them especially for his homecoming. His flat-crowned sailor's cap sat on his head at a jaunty angle, the narrow visor casting a shadow across the bridge of his windburned nose. The skin around his eyes crinkled as he smiled.

"We're in Hampden Narrows, Miss Emerson. This is the most notorious part of the Penobscot, you know. They say that back in the pod auger days the old mariners would send kegs of rum and molasses over the side and their mates would wait over on the Brewer side for them to

wash ashore. Then they'd take the kegs to the Smuggling Hole and sell them. That way they avoided the customs office. I don't know how much truth there is to that story, but I've heard that since spirits have been banned in Maine, the old Smuggling Hole is doing a lively business."

"You mean smuggling is still going on?" Elizabeth asked.

"Well, I don't quite know. The sale of spirituous liquor was prohibited three years ago, but everywhere you go you still see folks who look as if they've tipped a few."

"It's a very great evil. My Aunt Mercy was very much against intoxicating drinks."

"My wife, Maude, believes drunkenness is the primary cause of poverty and disease. I'm inclined to agree with her."

As the Penobscot widened, an increasing number of wharves, sawmills, and ice cribs appeared along both sides of the river. The *Fairmont* kept to the center channel, rounding each successive bend at a steady pace. Bangor lay scattered along the river bank, rising gently from shore in a series of rolling hills. A current of excitement gripped the entire crew and fastened on to Elizabeth. She leaned against the rail, her eyes fixed on the town.

"Ah, it's good to be home again," Sam remarked. "See that little cottage up there, the one with the red door? That's where my wife, Maude, and I live. Maude grew up there. Usually, when she knows I'm coming, she stands out on the doorstep and waves. I don't see her, though. This is my last time out, you know."

Sam leaned companionably on the rail beside Elizabeth and puffed his pipe.

"Will you miss coasting, Dr. Webber?"

"Probably. But I'll be busy enough. Maude's a midwife, and with my own doctoring to do, I expect I won't have much time to miss the seafaring life.

Sam puffed contentedly in silence, his eyes riveted to the shoreline. He pointed his pipe stem toward a row of brick buildings shadowed by the blurred greens and yellows of newly budding trees.

"Elms," Sam said, moving his hand in a sweeping motion that includ-

ed all of Bangor. "City's full of them. Oak, evergreen, maple, the whole region from here to Canada is nothing but trees. See that crowd of people over there at the steamboat wharf? Most of them are headed for California. Gold. Now I ask you, does that make sense? Trees are where the money is. Look at all the sawmills on this river. Both sides from Old Town, way up river, all the way down to Hampden. A lot of men in Bangor and Brewer are rich because of the lumbering. See that set of buildings over there? Rufus Dwinel's counting houses. Every unmarried woman from here to Boston set her cap for him—until he got to acting so odd. And those barkentines tied up over there? Joshua Stetson's. Lumber barons, both of them. Stetson owns other ships, too, and has more property and more influence in Bangor than any man around. Of course, Sam Veazie and Rufus Dwinel would take exception to that."

Sam lapsed into another comfortable silence. Elizabeth heard Abner Giddings directing the *Fairmont*'s progress with well-ordered commands. She had not seen him since the day of her accident. He was very good to look at, she thought, with his sunbronzed skin and dark hair that glinted with reddish lights. Every move he made was quick and efficient; he wasted neither time nor energy.

Elizabeth's stare was open and frank. If Abner Giddings noticed, he showed no sign.

Elizabeth's cheeks grew warm as she realized she was attracted to the captain. It was an entirely new, and unsettling, feeling. She didn't like it at all. She brought her attention back to Bangor. Somewhere in the midst of this bustling place was Mrs. Hogan.

Four slender white steeples, sharp as needles, rose above solid clusters of white houses.

"Bangor folk must be churchgoers," Elizabeth remarked, quite awed by this display of public piety.

"Some are, some aren't," Sam answered. "Same as anywhere else. Good and bad live side by side. You'd do well to remember that, Miss Emerson."

"Oh look, Dr. Webber, there's a house with pink chimneys, over there on that hill. I never saw a house with pink chimneys."

"That's, ah, a gentlemen's club, my dear, a place for men to conduct business and entertain their associates. I believe the chimneys were once painted red, so the story goes, but the paint was of an inferior quality and the sun has faded them to this, ah, unusual color."

Elizabeth had the distinct impression that Dr. Webber was not telling the exact truth.

From where they stood, on the deck of the *Fairmont*, the house with pink chimneys appeared large and well proportioned, of a size and style only the wealthy could afford. It sat a good ways above the harbor, yet close enough to be easily seen from the river. Except for a church whose steeple rose a bit beyond, the house had no nearby neighbors.

By now Elizabeth's excitement at having arrived, at last, was at its peak. She was full of questions.

"Is the Bangor House difficult to find?" she asked. The *Fairmont* had progressed into the midst of the harbor, beset on all sides by every possible kind of vessel from bark to brigantine, raft to dory. A paddle-wheel steamer slipped downstream, her whistle splitting the air with a rush of deafening sound.

The *Fairmont* slid by a large building whose roof bore the legend: LANCIL'S SAIL LOFT. Harsh masculine voices drifted across the water; more than a few of the words Elizabeth could make out were profane.

The clamor of ropes and pulleys increased, and the *Fairmont* slipped alongside the wharf to her moorings.

"It's not much of a chore to find the Bangor House," Dr. Webber replied. "That's it up on Union Street." He pointed directly up the street to a square brick building of four stories.

"It's much closer than I expected."

"Close enough for travelers to find easily and far enough away from the waterfront to be respectable." Sam resettled his cap on his head. Elizabeth took his proffered arm and they walked down the gangway. Elizabeth kept a firm hold on Daisy's basket.

"I'll hail a carriage for you, Miss Emerson. Your ankle isn't ready for the walk to the Bangor House."

"Oh, no," Elizabeth protested, "no, thank you. I'll be all right. I'll go slow, so as not to jostle Daisy." She didn't want Dr. Webber to know that what little money she had left after paying her passage upriver could not be spent on the luxury of a public conveyance. She would need food and lodging, if Mrs. Hogan couldn't take her on.

"See," Elizabeth said, in an effort to convince him, "I'm not limping very much at all."

The doctor gave Elizabeth a dubious look.

"All right then. I'll leave you here. Should you ever be in need of a friend, my dear, Maude and I aren't far away. Just ask anyone. Everyone knows Maude Webber, the midwife."

It was frightening to be left on her own after all the kindness the doctor had shown. But Elizabeth refused to give in to the megrims. She picked up her valise and Daisy's basket and started off for the Bangor House.

Someone called her name.

Abner Giddings strode down the gangway, his long legs covering the distance rapidly.

"And where do you think you're going, Miss Emerson?" The barely concealed fury in his voice caught Elizabeth off guard. He planted himself in front of her with such obvious belligerence that she took an involuntary step backward.

"Thought you'd gotten away with it, didn't you?" he demanded. His eyes bore into Elizabeth. "I know you've taken the Chinese silks. They aren't in the basket. I just looked, so don't deny it." He grasped her shoulder roughly, to prevent her from running away. "Hand them over," he said between clenched teeth, "or I'll have you arrested."

The loud words and hostile manner attracted the attention of the men at Lancil's Sail Loft, and a few drifted over to see what was going on.

"Leave the lady be, Cap'n," one man growled, but he made no move to interfere. Rather, he seemed to find the situation amusing.

Elizabeth had taken the liberty of using the silks, but she had not stolen them. She did not deserve such hateful treatment. She was furi-

ous beyond words. She twisted away from Abner's grasp with surprising strength and quickness.

The men from Lancil's applauded and laughed.

"Spitfire, ain't she, Cap'n," someone called.

Abner Giddings ignored the hilarity and stepped toward Elizabeth again. She dodged, humiliated to the bottom of her feet. She drew herself up to her full height of five foot eight.

"I did not steal the silks," she snapped. "They are still in the basket." She moved away, putting a margin of safety between herself and Abner Giddings. He grabbed her wrist.

"The silks are gone."

Elizabeth looked Abner straight in the eye the way Aunt Mercy had taught her to do when confronted with a ticklish situation.

"I stitched them into the little dress in the bottom of the basket. All you have to do is unfold it."

Abner dropped her hand is if it were on fire.

Elizabeth reached into her reticule, found a few coins, and held them out to him.

"Here," she said. "I'll pay you for the silks." Her voice broke into a tiny sob. "I didn't think you'd mind."

Abner made no move to take the money. She threw the coins at his feet. The crowd parted. Crude, boisterous laughter followed Elizabeth all the way up the street.

7

ABNER GIDDINGS'S ANGER evaporated as rapidly as it had taken hold of him. He stood alone on the wharf. The life of the harbor clanged around him. The men from Lancil's drifted away now that the excitement was over. Drays, carts with heavy wheels, and carriages rumbled and clattered in the cobbled streets, a bass counterpart to the shouts and curses of stevedores unloading cargo. All along the waterfront, seamen lounged in tavern doorways where rum could still be found if you knew

the right people. Bold-faced women competed for the seamen's attention with showy dresses and painted faces. Abner saw and heard and didn't give a damn. He had made an utter fool of himself.

Maryanne had been sewing the day she'd died; the sewing basket and its contents were the last things she'd touched. She hadn't been very good at sewing, but she had been very proud of the baby's dress and vowed she'd finish it before the child was born. As a means of encouragement, Abner had made her a gift of the silks. He remembered how pleased she'd been.

Abner had no wish to keep the sewing basket and its contents; they were too painful a reminder of what he had lost. He had been tempted to drop them overboard where they belonged—under fathoms of water with Maryanne, the infant, and the cat. Instead, he decided to take the basket to Maryanne's mother. It was the only gesture of atonement he could think of.

When he saw the silks were missing, something black and hateful had burned within him, canceled his ability to reason coherently. He had cursed himself for giving in to his ridiculous impulse to give the Emerson woman passage upriver. For all her reserved manner and pretty face, she was nothing but a common thief.

Abner shot one last look at the retreating figure of Elizabeth Emerson. He wanted to be glad to be rid of her, but he wasn't.

He returned to the *Fairmont* and went below. The sewing basket lay on the table exactly as it had the day Maryanne had died.

Nothing had been stolen, nothing defiled; the silks were there, stitched up in a way that Abner recognized as the work of a professional needleworker. The design, with its quaint sense of pastures and country innocence, made him want to weep. He'd misjudged the woman. She'd worked the dress with as much care as if she herself were expecting a child. Maryanne would have been delighted to see the dress so lovingly and beautifully finished.

But Maryanne lay at the bottom of the Atlantic Ocean, the child with her. He couldn't change that. But he could change the odds on whether or not Elizabeth Emerson found a place in the Hogan household.

Abner strode purposefully up Union Street with his jacket unbuttoned. The day had grown warm as it often did in late April. A light breeze fluffed his hair away from his ears. Later on he would report to Joshua Stetson. Then he'd go home to dear old Hannah Bailey. She'd be expecting him at her inn on Summer Street.

Abner spotted Elizabeth near a window in the lobby of the Bangor House. She stared intently toward the street as if searching for someone. She looked sad and very vulnerable. Right off the farm, so Sam Webber said. Daisies and buttercups. Nettles and brambles. Anyone could see that. She'd be a target for all the worst flesh peddlers in Bangor if she didn't find respectable employment.

How should he approach? She had seemed intimidated by his presence the night of her accident. He had called her a thief in public and had used her roughly. She had every reason to want to avoid him.

As he anticipated, she jumped to her feet the moment she saw him approach. Her fists were clenched into hard balls.

"If you have come to plague me with accusations . . ." she began.

"No. I've come to make my apologies."

"Apologies," Elizabeth echoed. She unclenched her fists and the anxiety faded from her eyes, eyes of a deep shade of blue. Tall, autumn asters.

"My wife died only a short time ago," Abner said quietly, not sure how to launch the errand on which he'd come.

"I know. Dr. Webber told me."

Abner nodded. He might have known old Sam would have paved the way for him. Sam believed in the truth, was always saying how most sickness would be cured for good if people would just talk straight to one another.

"My wife would not have begrudged you the pleasure of sewing, or the silks. Nor do I."

"Please," Elizabeth said, her eyes tightly closed to block out the expression of regret on Abner's face. "Please don't say you are sorry. I understand. I truly do. I lost my aunt, my home, everything I hold dear,

not long ago." Her dark lashes lay against her high cheekbones. She lifted one gloved hand, as if to hold back the apology he felt he owed her.

"The silks weren't valuable. Here's your money." He took her hand and pressed the coins into it. "I'd like you to have the baby's dress. Webber said you're a seamstress. I thought perhaps the dress might help you to get the job you're after, as an example of your skill." He thrust a brown paper parcel into her arms.

"Thank you. I know it will help. I sent a message to Mrs. Hogan. The clerk told me to wait."

"There's the clerk now."

"Mrs. Hogan's driver is here, miss. You better hurry. Mrs. Hogan don't like to be kept waiting," the clerk said.

"Let me walk to the carriage with you, Miss Emerson," Abner said.

Elizabeth did not reply, but she allowed Abner to take her valise and gave him a bright smile. He grinned back. It had been a very long time since he'd felt like smiling.

He handed her into the carriage and closed the door. The driver clucked to the horses and Elizabeth waved as she was driven away. Abner didn't wave back. He was staring at the driver. It wasn't the anonymous servant of some grande dame newly come to town. It was Brown, Fanny Hogan's bodyguard and right hand man.

The forsythia bush in the front yard was bursting with pale yellow blooms. Tulips and jonquils nodded in the breeze, content with the warmth reflected from the house's granite foundation. Sam Webber looked at the flowers with pleasure. There was nothing at sea to rival a sight like that.

The house hadn't changed; it sat low and snug on the river side of the road as it had since Eli Richmond had built it back in the late 1700s. Sam walked quickly through the gate; he would have run if he'd been ten years younger. He stuck his head through the front door, which he used only when he was in a hurry.

"Maude! Maude!" He called, "I'm home!"

Immediately, he heard his wife's soft tread in the upstairs hall and

she appeared at the head of the stairs. She was rounder than the day he'd married her thirty years ago. Her hair was graying some, but her dark brown eyes glowed with the same intense joy at the sight of him. Sam gathered her into his arms and swung her down from the last step and placed her firmly on the floor.

Maude laughed and kissed him. "You smell like the wind," she said. She always said that; it was a homecoming litany.

"Are you coming or going?" he asked. Maude had on her cloak and bonnet. Her medicine chest sat by the landing. Her smile vanished.

"Going, I'm afraid, Sam. I was worried I'd miss you. Sarah John went to sit with a sick child so there's not a meal ready for you. I'm sorry I can't put this off. The message was urgent."

Sam put his hat back on.

"Want some help?" he asked. "You always said you'd teach me the finer points of midwifing if I ever stayed ashore long enough to learn. All these years and I never did see you use those forceps you married me for."

Maude ignored the teasing.

"I wish you would, Sam. I've been called to the Bedford Inn. You know the place I mean. It stands almost where the Thatcher cabin did back in 1814. Not that I mind going alone. But sometimes I think I'll go mad if I have to deliver one more young girl. Some are barely sixteen and right off the farm looking for a better life in Bangor. And what do they find? Some seaman between ships. I think I'm getting old, Sam." Maude's jaw settled into the firm hard line Sam knew so well. Maude never drew any distinctions between those she would or would not attend. She treated everyone alike. It was one of the things Sam loved about Maude. She had brought Veazies and Dearborns into the world as well as Murphys and Reillys.

"You could find someone else." It was a purely rhetorical comment and Sam knew it. Once called, Maude went.

"No one else would go, Sam. Who but me would mingle with the baser elements in Joppa to deliver a fallen woman's child? The saints preserve us," Maude said with a bit of mock humor.

Sam picked up Maude's medicine box and tucked his own instrument case under his arm. Theirs was an odd marriage, he thought, strengthened as much by their separations as by the time they spent together.

They had never had children. He didn't regret the lack of children. He was glad Maude had been spared the burden of it, that he had her all to himself now.

The seedier part of the waterfront was known as Joppa. Here, the streets were lined with taverns and ale houses whose downstairs rooms catered to the rum guzzlers of the town, legal or no. The upper rooms of these establishments were often given over to pleasures of a more sanguine sort. It was to one of these back rooms that Maude had been summoned.

Their progress was slowed by a crowd of people clogging the narrow street. The crowd craned their necks and jeered at the fracas taking place outside the Bedford Inn.

"What is it, Sam?" Maude asked.

"I can't tell from here, Maude. Looks like we'll have to walk the rest of the way."

Sam helped Maude out into the street. A few people recognized them and the crowd parted slightly to let them through.

A group of men smashed hogs heads of rum in the street. The dark liquid trickled in the gutter and the air reeked with the sharp, sour odor of alcohol. The innkeeper screamed his outrage, but two hefty men held him at bay. Off to one side, a bit away from the melee, a member of the clergy ranted about the evils of drinking spirits and the perils of the ways of the flesh. Sam recognized the speaker as the Reverend Comfort Drummond, one of the local leaders of the temperance movement.

The crowd was enjoying the excitement and made no effort to interfere or aid the keeper of the Bedford Inn.

Sam picked his way through the puddles of rum and splintered barrels. Typically, Maude plowed through the wreckage without a moment's hesitation and no thought for the hem of her skirt.

Maude found the stairway inside the dim interior of the tavern. She had been there before. A woman in a dirty apron met them in a dark hallway upstairs. Her hair was untidy and her front teeth were black with decay. She might have been any age.

"Oh, Miz Webber," she wailed, "I thought you'd never get here!"

Maude pushed past the woman and entered the room she indicated. The place was small and bare except for a double bed and a washstand. A woman lay on the bed. She was covered by a threadbare blanket. She was very still. Too still. The air was foul and close.

"Open a window," Maude commanded. Sam was more than happy to oblige.

Maude examined her case quickly, gently. She used her hands and her eyes and she did not hide the distress she felt.

"She's dead. Aborted herself." Maude's voice was low and even, a sure sign she was furious. She did not take the loss of life easily. Never had.

Sam held out his hand, asking to be connected to her distress, her fury, her helplessness to do anything but let this one go. Maude took his hand and they stood, linked by a sense of defeat.

"Send for the undertaker," Maude said to the other woman.

"If it hadn't been for them holier-than-thous out there bustin' things up, I might a been able to git word to you sooner," the woman sniffled.

Maude laid her hand on the woman's arm.

"No, no. She was bleeding inside. There was nothing we could do to help her."

Sam thought, suddenly, of Maryanne Giddings lying in a crumpled heap at the bottom of the companionway, thought of the moment her canvas shrouded body was committed to the sea.

"Do you ever get over feeling powerless and ignorant when something like this happens, Maude?"

"I haven't yet, Sam. I haven't yet."

IT WAS ONLY a short distance from the Bangor House to the corner of Summer and Cedar Streets where Hannah Bailey kept her inn.
Abner walked slowly, his hands thrust deep in his pockets. Elizabeth Emerson was about to make a big mistake. What made him so sure, he couldn't say. Maybe it was the stories he'd heard about the goings-on at Pink Chimneys. Maybe it was just the tight feeling in his gut. He should have said something to her, warned her, but he'd made a fool of himself once already and wasn't about to repeat the performance. Elizabeth Emerson would have to take care of herself.

Yet, Abner thought, there was something vulnerable about the Emerson woman despite her spirit and determination. He liked that in a woman. She was good to look at, too, with her tall, straight figure, that dark hair and fair skin. He remembered the feel of her limp body in his arms after she'd fallen, when he was carrying her to Maryanne's cabin. She was no feather. As Hannah would say, a man wouldn't have to shake the sheets to find her.

He supposed it wouldn't take long for Elizabeth Emerson to get used to the ease and luxury of living at Pink Chimneys. She'd start out sewing, no doubt, but give her time and she'd be one of Fanny's girls. The thought rankled him. Well, it didn't matter one way or the other. He'd be at sea again within the week, and he'd never see hide nor hair of her again.

Abner walked up to the familiar porch with its white Doric columns, the distinctive feature of Hannah Bailey's house. The front room was full of the home-again smells of baking pies and fresh bread. A few men, mostly mariners who nodded to Abner, sat at stout tables in Windsor chairs.

Hannah's inn was a necessary outgrowth of her own kitchen. She was a widow, and in order to make ends meet, she had turned the front rooms into the most respectable eating establishment in town. She was best known for two things—the excellence of her cooking and her deep affection for Abner Giddings.

When Abner was about eleven years old, his mother had died of consumption. His father had been killed by a runaway ox cart. There were no living relatives to take him in, so he became a ward of Bangor. It was the practice, back in the 1830s, to sell the cost of an indigent's keep to the highest bidder. Abner had been given to Job and Hannah Bailey, who were childless. Hannah was so pleased and content to be a foster mother, she had not allowed Abner to go to sea as Job's cabin boy. She sent Abner to school, doted on him, and indulged him in every possible way. Job put up with it for a year, but on Abner's twelfth birthday, he put his foot down, insisted it was time the boy earned his keep.

Abner proved an able and willing apprentice. Under Job's careful and patient tutelage, he worked his way up to first mate by his eighteenth birthday. He and Job coasted together, on Job's schooner, until eight years ago. Abner had injured his arm and while he was ashore waiting for it to heal, Job's schooner foundered off Mt. Desert Island. The ship was lost, and Job was drowned. Abner was left with two choices since he had no money for a ship of his won. He could give up the sea or hire out to one of the wealthy shipowners. Joshua Stetson took him on.

The woman who bustled into the room was short, and soft rolls of flesh padded her ample figure. Her several chins were framed by a high collar edged with lace. She wore a white muslin cap tied firmly under her chin, a style popular twenty years back and worn only by married women. The voluminous white apron over her dark cotton dress was spotlessly clean. The crisp rustle of starched petticoats preceded her. She reminded Abner of a deep-loaded barkentine headed against a strong river current. Her face was alight. She was obviously pleased to see him. She laid her hand on Abner's sleeve.

"There you are at last, Abner Giddings. I had word of your sad loss from the captain of the *Defiant* even before you had time to get a letter to me. I can't tell you how grieved I am, Abner. Such a shame. Such a shame. But God does His will and those of us who are left have to endure." She shooed Abner to a table near the kitchen door. This spot

was reserved for "family," a term which included close friends as well as actual blood kin.

A mother seal herding her pup to a safe rock, Abner thought, glad for Hannah's concern.

Hannah had not, Abner knew, approved of his marriage to Maryanne Parker. Too young and too headstrong had been her main objections. But Hannah had been glad for his happiness and had truly looked forward to the birth of the child she had expected to grandmother with all the intensity of her thwarted maternal instincts.

Hannah disappeared into the kitchen and returned with soup and bread. She eased her heavy body into a chair and fanned her face with a small embroidered handkerchief quite inadequate for the job. Abner patted her plump hand. She still wore the narrow gold ring Job had placed there forty years ago.

"It's good to be home, Hannah," Abner said.

"Have you been to the Parkers yet?" Hannah asked.

"I'll go tomorrow."

"Maryanne's folks don't blame you, Abner. I went to call the minute I had the news."

"Thank you, Hannah. I knew you would."

"I didn't much relish being the bearer of bad news, I can tell you. Especially to the Parkers who've always appeared to me to think they were a cut above the rest of us. But that's neither here nor there. I never made any secret that I thought you were making a big mistake getting mixed up with the Parker family. I guess I always imagined you'd choose one of the Farrar girls or maybe little Abby Patten. Good, sensible girls who know how to be useful."

Abner let her talk, knowing full well that Hannah had always wanted the best for him, and in her opinion, the best wife for Abner Giddings didn't exist.

Hannah brought a pot of tea and some molasses cookies. No one ever left her table hungry.

"Heard any news since you got in, Abner?" It was a ritual question, one Abner welcomed since there were no newspapers at sea. As the

keeper of a public house, Hannah was privy to all the latest word-of-mouth news making the rounds of Bangor. She knew who had died, been born, or got married; who was shipping out on which vessel and where; and all the latest scandals that occurred in the upper echelons of Bangor society. There was no viciousness in her repeating what she knew. News was meant to be told. Abner counted on her to keep him current.

"The Temperance League is stirring up trouble again. They always do before a new mayor gets elected. And this time they want one who can walk on water and drinks nothing but. There's talk of putting every illegal rumshop in Joppa out of business. By fire, if necessary. Why, poor old Moses Carson, who never hurt a soul in his life and runs a cleaner place than most, was thrown into the street and every drop of spirits he had hidden away was poured into the gutter right before his eyes. Happened just a little while ago. Poor old man like to have died right there, I heard. He's ruined for certain."

Hannah paused to collect her thoughts.

"I can't say as I don't believe something ought to be done about those dens of iniquity along the waterfront. The law says that no liquor shall be sold in the state of Maine. And I say that's the way it should be. But men will drink, no matter what. Better the wharf rats stay down in Joppa than have them crawl up here to my place with their evil habits. I want no part of it. Someone said they saw Maude and Sam Webber show up in the middle of the whole thing, so heaven only knows what else was going on. You mark my words, Abner, before the summer's done, there'll be more trouble in town than there's been since the British came upriver in 1814. Come to think of it, Maude Webber, she was Richmond then, was mixed up in that, too."

"Who's running for mayor this time, Hannah?"

"George Pickering, for one."

"Who's running against him?"

"Joshua Stetson—on the Temperance ticket, if you can figure that one out."

"Why in the world would Joshua Stetson want to be mayor?"

"I've heard," Hannah confided, "that he's got his eye on the governor's chair. Being mayor is the first step in that direction, so I'm given to understand, old Ed Kent did exactly that back in '37. There's some that say Stetson will win it, too. Money can buy anything, Abner."

Hannah shook her head sadly and the bow under her chin quivered. Abner could see she had more to say and did not reply.

"Why, Joshua Stetson has even been down here to my place, shaking hands and telling people how this was where he got his start before he sold the place to Job. You'd be surprised at the people took in by that foolishness. Joshua Stetson got his start here all right, him and that flashy Fanny Hogan. Who does he think he's fooling? Why, the election isn't even until fall!"

"I'll be long gone by then, Hannah."

They sat a while longer, Hannah reciting her long store of verbal news. Abner, with his long legs stretched out comfortably under the table, nodded and listened and wondered whether Elizabeth Emerson had arrived at Pink Chimneys.

9

IT LIFTED ELIZABETH'S spirits to know that Abner Giddings was sensitive to the needs of others. His gift of the baby's dress had touched her deeply and this endeared him to her, stirred her interest in him. She looked back to wave, but he was gone.

The carriage moved slowly along the main thoroughfare of Bangor, past wooden buildings and brick banks and tiny shops. Signs coaxed one to buy cashmeres, corn, flour, salt, ginghams, and cheese. The city teemed with enterprises of all sorts—stove dealers, confectionary shops, furniture stores, booksellers, and dealers in ships' plumbing and chandlery. There was so much to see, Elizabeth could barely comprehend the vastness of it all. By comparison, Fort Point was merely a wide place in the road.

There were so many people, too. Children ran alongside the street, evading their mothers and frisking like new lambs in the spring

warmth. Men in dark coats and tall hats strolled along, bowing to the ladies they passed, giving way so the women had the dryer footing. A few women had already left off their winter bonnets and wore foamy confections of light straw, tulle, and silk flowers.

The carriage approached a steep hill in what Elizabeth assumed was the center of town. Traffic here was dense, but the horse pulled steadily, his hoofs making soft plopping sounds in the mud. At the top of the hill was a wide intersection which resembled a park. Tall, well-spaced elms grew in front of large white houses. The carriage turned right. A brick church, so new that scaffolding still stood around it, sat on a corner. The dirt around the church was packed down, giving the area a raw, unfinished appearance. There were no other buildings on either side of the street beyond the church. A tall, cedar hedge grew thickly on the left side of the street. Presently, the carriage turned and drove through a wrought iron gate in the hedge.

At the end of the long curving drive stood a large three-story house. The grounds surrounding it were brown, but blades of grass sprinkled the lawn with tender color. Large beds of yellow and purple crocus bordered the front walk. Flowering shrubs, still devoid of buds, dotted the lawn. The hedge enclosed the house on three sides making it well secluded from the street.

On either side of the house, semi-circular ells fanned out gracefully from the main structure. The windows were tall and wide, and french doors looked out onto the grounds.

As they rounded the ell, Elizabeth saw an orchard and beyond that a dense growth of pine which hemmed in the rear of the house.

Elizabeth stared. She had expected a large house, but this surpassed even her wildest imaginings.

She straightened her cloak with frantic haste and brushed wisps of hair away from her face. She longed for a moment alone to put herself to rights, to wash away some of the travel dirt and remove the wrinkles from her clothes. She wished she'd worn her good russet wool instead of her everyday navy skirt and severe muslin waist without lace or ribbon to brighten it.

The carriage stopped. Ready or not, she had arrived. The driver opened the door but did not help her alight or assist with her valise or Daisy's basket. It was a subtle reminder of what her station in this house would be.

They were at the rear of the house where yet another ell, this one square and at right angles to the main house, stretched toward the orchard. The drive, even here, was paved with finely crushed rock. Elizabeth eyed the house with a mixture of dread and profound curiosity. All the windows on the second floor had heavy curtains drawn against the early afternoon light. The third-story windows, nestled under the eaves, were smaller and hung with a shear material.

Elizabeth let her eye travel up beyond the sloping slate roof. Four pink chimneys blushed against a bright blue sky.

<div align="center">10</div>

HADN'T DR. WEBBER SAID the house with pink chimneys was a gentlemen's club? Had she been taken to the wrong address? Elizabeth had no time to contemplate. Without warning, a large dog of undetermined ancestry dashed from the pine woods. Elizabeth wasn't afraid, but it growled and snapped when she tried to calm it.

In her basket, Daisy trembled in terror and with one swift, fluid motion exploded from her confine and bolted for the nearest apple tree with the dog in pursuit.

With no thought for propriety, Elizabeth dropped her valise, hiked up her skirts, and ran across the soggy ground. Her ankle hurt, but she disregarded it.

Daisy sat hissing, her eyes glowing with fire, on an upper branch of the tree. The dog yelped and lunged.

"*Sit!*" Elizabeth commanded. To her surprise and relief, the dog sat and hung his head. Daisy retreated a little farther up the limb, for good measure. She lifted one paw and licked it daintily.

"Come on, Daisy," Elizabeth coaxed. "I won't let the dog get you. Here, kitty, kitty."

Daisy might as well have been deaf. There was only one way to rescue a cat. Elizabeth dropped her cloak on the muddy grass, tucked up her petticoats as if she were doing barn work, and swung herself up into the tree. The bark was rough and loose. It clung to her clothes and sifted into her hair. She snagged her sleeve but pulled it free and reached for Daisy. The cat sidled away. Below them, the dog lost interest and wandered off. Elizabeth reached again and this time Daisy condescended to be captured. She curled regally into Elizabeth's arms and they climbed down.

Elizabeth's first impulse was to run as fast as she could in the direction she had come. She'd go back to the *Fairmont* and ask Captain Giddings to give her passage back to Fort Point; she'd go to the spinning mills where she belonged.

The kitchen door swung open and a woman dressed in severe black covered by a white apron with well-starched ruffles stared at Elizabeth.

"We don't like beggars around here. Be off with ye." She rolled her r's, and her i's sounded like oi's.

Elizabeth's hand flew to her face. Her hair was a wreck and Daisy's muddy footprints blotted her blouse. Her shoes were caked with mud and her skirt was wet to the knees. Panic rose in her throat. She took a deep breath.

"I'm Elizabeth Emerson. Mrs. Hogan is expecting me. I'm here about the seamstress position."

Disbelief registered on the woman's face, but she stepped aside and motioned for Elizabeth to follow her.

"Leave those filthy things and come with me."

The door slammed shut behind them.

The woman behind the delicate oriental desk was, Elizabeth supposed, forty. She had expected someone much older. In that first moment, that split second when an opinion is formed about someone just met, Elizabeth thought of the exotic turk's cap lily which grew in the fields back home. There was a brilliance about Fanny Hogan, an orange-gold flush that shimmered from the softly fluffed tendrils of her

upswept hair to the apricot and ecru tones of her silk morning gown. She moved in a graceful way, arms and hands floating in easy motions, like wind rippling leaves, bending a plant's pliable stalk. Her eyes, Elizabeth saw, were a shade of brown that in bright sunlight would be praised as amber. Something in Fanny's expression, the orange-gold aura that clung to her, made Elizabeth think of goldenrod.

Lilies and goldenrod, she thought with embarrassment, to my burdocks and nettles.

Over the years, Fanny had interviewed many seamstresses. Usually they were well-scrubbed and neat, extremely biddable, until they discovered they were mending for fallen women. Often they were Irish, just off the boat.

The young woman who stood in front of Fanny's desk was none of those things. Nor did she lower her eyes when Fanny stared at her, a sure sign that this one was used to thinking for herself.

Fanny brushed back her brocade and rosewood chair and stood up. The faint rustle of silk eased the silence.

"I'm Elizabeth Emerson. I've come about the seamstress position."

Fanny almost laughed. She had never seen anything like it before. And God knew she'd had her share of trouble when it came to hired help. The woman was serious! Was, indeed, the same woman who had requested an interview not more than an hour ago! She thought to send this one packing, but there was something in her face, something familiar. She couldn't quite put her finger on it. Obviously, she was stubborn and didn't like to be defeated. That appealed to Fanny's tenacity and determination. She decided to listen to what Elizabeth Emerson had to say.

"Yes, Miss Emerson, I am looking for a seamstress. However, you are very young. I had in mind someone who could do dressmaking as well as simple mending, someone with a great deal of experience."

Fanny waved her hand to a nearby chair.

"I really shouldn't," Elizabeth said, brushing at the mud on her skirt.

"M-m-m, yes. Perhaps not. What experience have you had?"

With that question, Fanny expected to be rid of the unsmiling Miss

Emerson very quickly. She scanned the references Elizabeth produced and was not only impressed, but curious. From Fort Point. Could she possibly be acquainted with Birdie and Mercy? It was an idle thought, not one she really cared to pursue. Let sleeping dogs lie. At least for now.

"Very impressive, Miss Emerson. But I had hoped for someone a bit more mature . . ."

That was not exactly true. The response to her advertisement had been very poor and Fanny was faced with the prospect of doing without anyone, as she had the past few weeks. The reputable seamstresses in town, the ones who did the best work, refused to do her work. The whole of Bangor was getting insufferably moral what with this ridiculous election and the temperance people getting everyone to take the pledge not to drink liquor, and worse, not to associate with those who did. Well, she couldn't worry about it now. Didn't have to really. She owned as big a chunk of Bangor as anyone and could buy favors along with the best of them, but that wouldn't get the garters made and the sheets mended.

Fanny laced her fingers together and placed her hands on the satiny surface of her desk. She weighed each possibility as if it were precious metal. She eyed Elizabeth Emerson carefully.

"Mrs. Hogan," Elizabeth said quietly, "I have never until today had to beg for anything. All my family is dead. I have nowhere to go, no friends, no one. I have pinned all my hopes on you. Perhaps you would consider a week's trial. Then if you decide I'm not suitable, I'll find something else . . . the spinning mills or . . ."

Fanny waved an imperious hand in the air.

"I'm no stranger to hard times, Miss Emerson. Perhaps if I had an example of your work, I might be more inclined to take you on." As she spoke, Fanny stood up. The interview was over.

Elizabeth laid the brown paper parcel on Fanny's desk.

"Please open it, Mrs. Hogan."

Fanny withdrew the infant's dress and gasped. It was exquisite.

"Is it good enough?"

"The flowers. They remind me of a place I used to live." Fanny hadn't thought of the farm in years, not since she'd read in the newspaper that Robert Snow had been lost off the coast of South America. Funny how a little thing like a baby's dress could bring it all back.

"What about the job, Mrs. Hogan," Elizabeth urged.

"I'll try you for two weeks. If you don't suit, I'll help you find another place. If I like your work, I'll keep you on at four dollars a week and room and board."

Every instance told Fanny that she had made a bad choice. Elizabeth Emerson wouldn't last the two weeks. As soon as she found out about the girls she'd be on her way. Maybe it was for the best. She'd talk to Maude about finding someplace for Miss Emerson to go. Still, that back of Miss Emerson's had steel in it. She just might work out fine.

Fanny reached for the pull bell.

The same woman who had let Elizabeth in appeared with a soft swish of petticoats.

"Mrs. McGuire, take Miss Emerson up to the attic and show her the sewing room. See that she has supper and plenty of hot water."

Mrs. McGuire set her lips into a prim line.

"And what shall I do about the cat, ma'am?"

"Cat? What cat?" Fanny looked questioningly at Elizabeth.

"My cat. Daisy. That's why I look so—bad. She ran away and there was this big dog and I had to climb the apple tree . . ."

"I understand, Miss Emerson," Fanny interrupted. "Take the cat along, Mrs. McGuire. Tell Brown to bring a box of shavings from the barn."

When the door closed behind them, Fanny threw back her head and laughed. Oh, wait until she told Maude about this! No, maybe she wouldn't. Because she'd have to mention the baby's dress and Maude would know she'd been upset by it. The trouble with Maude was, when someone felt badly, she always wanted to fix it. And as far as Birdie was concerned, nothing could ever fix that.

ABNER'S CALL ON his dead wife's family went more smoothly than he had anticipated. The Lord gave and the Lord took away. Mrs. Parker was grateful for the sewing basket. Mr. Parker called Abner "son" and shook his hand, but made it very clear that Abner's tenure as a member of the Parker family had ended with Maryanne's death. They had not approved of their daughter's marriage, had hoped, Abner knew, that Rufus Dwinel might notice her or that one of the sons of some wealthy family would ask for her.

As for Abner, he was relieved to learn he had been formally dismissed and absolved of all connection to the Parkers.

Abner walked briskly toward Joshua Stetson's office on Water Street. In a few days his business in Bangor would be concluded, the *Fairmont* loaded and ready, and he'd sail with the tide. He would like to have had more time with Hannah, but she was well acquainted with the comings and goings of mariners and never grumbled about the brevity of his time ashore.

Elizabeth Emerson crossed his mind, and he toyed with the idea of making some inquiries about her well-being. Maude Webber was bound to know something sooner or later and if he asked, Sam would let him know. But no, it was none of his business.

Joshua Stetson's office was one of the many in a long brick building at the end of Water Street on the banks of Kenduskeag Stream. It was convenient to the shops, the mercantile banks and counting houses, and an easy stroll to the Bangor House where men met for luncheon or a cigar in the smoking room, or a discreet brandy in the gentlemen's parlor.

As Abner walked, he could see the harbor. The waterfront was a tangle of rocking masts and clanging rigging, a-bustle with every manner of conveyance from hand cart to heavy farm wagons, steamboats to canoes, the stylish rigs and glossy horses of the well-to-do.

This was a man's domain; women seldom ventured near. This was the heart of Bangor, the center of commerce and trade embodied in the

rustle of account books and the clink of coins, the rumble of traffic hauling goods to and from the ships that jammed the harbor.

Abner breathed it all in, the fishy smell of low tide, the odor of tar issuing from the sail lofts, the ever-present, overriding tang of new-sawn pine lumber. As far as Abner knew, Bangor was the best-smelling port anywhere in the world.

A small bell tinkled as Abner opened the door to Stetson's office. A clerk, recognizing Abner, waved towards a door. Every manner of man from common seaman to shipowner had stood in this office at one time or another. It was the sort of room that neither intimidated the lowly nor overly impressed the powerful. Stetson's desk, while of the finest mahogany, was restrained in style and showed signs of use. Several nondescript chairs, their legs scuffed and nicked, were placed near the desk. The walls were hung with a portrait of President Fillmore and a framed sketch of one of Stetson's first vessels. A small, glass-fronted bookcase contained some of the better-known mariners' manuals. But it was the man behind the desk who commanded the most attention. He was small, his pale hair grown paler with strands of gray about the temples. His beard was in the style of Prince Albert, the same pale shade as his hair. Abner had stood in front of him a dozen times before and he'd never gotten used to Stetson's cold, almost expressionless eyes. It was the eyes that held a man, though when he smiled, which he seldom did, his face took on an almost boyish cast.

Stetson rose when Abner entered. The hand that clasped Abner's was smooth and well groomed, making Abner acutely aware of the callouses and broken nails of his own hands. Stetson's expressions of sympathy regarding Maryanne were formal and brief. He concluded the business pertaining to the *Fairmont* cargo quickly and neatly.

"By the way, Giddings, the *Asia* is without a master. She's being refitted at the moment, but in six weeks or so she'll be seaworthy. I need a good man. A man I can trust. Interested?"

Abner hesitated. He'd never had much interest in the China trade. The voyages took years and there was the constant task of recruiting a new crew at every port, or at least taking on a few new men. And there

was the onerous duty of dealing with customs officials and the necessity of shipping out with a crew that often spoke any number of the different languages. Not that he didn't think he could handle it. But he was content to follow in Job's footsteps, to come home to Hannah's caring company. It took a certain kind of character to sail the China trade. Abner was certain he didn't have it and wasn't much interested in acquiring it.

"I thought Hosea Marshall was master of the *Asia*," Abner said, stalling.

"He was, but the last time out he had a bad bout of the fever and hasn't been fit since. Not so young as he used to be. He wants to sell his share, and I don't want it to go to just anybody. I've watched you, Giddings, I think you've got what it takes. What do you say?"

"Well, I'll tell you, Mr. Stetson, I'm a man of habit and I like things to stay as predictable as possible. Coasting is what I know the best and that's what I'd like to stick with. Not that I'm not grateful, sir."

"M-m-m. I was hoping for a more positive answer. But you don't have to make up your mind right this minute. Take your time. You'll have plenty of it. Lovejoy Page will be the master of the *Fairmont* this time out. He did such a fine job while you were under the weather after your wife's death, I thought he ought to be properly rewarded. I've had your belongings sent to Mrs. Bailey's. It may be some time before I can put you on another vessel. Unless, of course, you decide to take the *Asia*. The *Venerable* is due back in a month or so. I could put you aboard her."

Abner narrowed his eyes, felt his back stiffen, stunned by Stetson's words. Anger leaped inside him and fought for an outlet. But that wasn't the way to handle Stetson. You had to play his game, by his rules, as cool as he was. He sat still and pretended he didn't know the *Venerable* was one of the oldest, slowest, most accident-prone vessels in Stetson's fleet, in anybody's fleet. Mariners avoided shipping on her like the plague. Word had it that her hold reeked of the Barbados rum she regularly smuggled into the harbor.

"Let me think on it, Mr. Stetson."

"Good. I thought you might want to, Giddngs. I'll be in touch."

Abner held out his hand, playing the game, making the right moves. His eyes caught Stetson's and held. Stetson's face contained no hint of warmth, no clue as to why he had offered shares in the *Asia*, why he had made Lovejoy master of the *Fairmont*.

<div align="center">12</div>

FOR THE NEXT few days, Elizabeth threw herself into whatever task fell her way. She earned the undying respect and admiration of the two Irish hired girls when she pitched in and helped them scrub the sewing room floor on her hands and knees. Then she undertook the general upkeep of the adjoining room which served as her living quarters.

Each day fell effortlessly into an orderly pattern, and Elizabeth was reassured about her decision to work for Fanny Hogan.

Every morning at six, Elizabeth went down several flights of back stairs to breakfast with the housekeeper and the hired girls. She repeated the trip at noon and again at five o'clock. The hours in between she spent mending.

After breakfast on the third morning, Mrs. McGuire had said, "Here's the mending for the day. And Mrs. Hogan wants you in her office at eleven sharp."

Back in the attic, Elizabeth sighed and reached for yet another table-cloth that had been burned by a cigar. Most of the mending consisted of table linens or bed sheets, which she did not enjoy working on. She pawed through the pile, hoping for something a bit more interesting. Her hand found silk and she drew it out. It was a pair of red pantaloons with the knee ruffles torn and hanging loose. She spread the entire pile out on the work table and discovered a sheer white batiste bed gown with a gaping seam and several chemises, large and small, in a similar state of disrepair. Elizabeth held them up and examined them careful-ly. A faint odor of lavender and perfume tickled her nose. Was it possi-ble that the elegant Mrs. Hogan would wear red underwear or stir her-self to such activity as to produce such badly torn seams?

Precisely at eleven, Elizabeth stood in Mrs. Hogan's office.

"Can you drive, Miss Emerson?" Mrs. Hogan asked without preliminaries. This morning she was dressed in a pale blue silk dress with a wide skirt.

"Yes, I can, Mrs. Hogan." Elizabeth also knew how to harness a team to a farm wagon and on more than one occasion had driven a team of oxen, but she did not say so.

"I have a list of goods I'd like you to purchase at Wentworth's store. Brown will tell you how to get there. It's not far. Just tell Wentworth the things are for me. Brown will have the pony cart ready for you right after dinner. Can you be ready?"

"I certainly will be, Mrs. Hogan."

Elizabeth's mood was the lightest it had been since she'd come to Bangor. A chance to be outside for a while on such a beautiful day was more than she had dared hope for. And Mrs. Hogan was trusting her with an important errand. Surely that was a sign she was pleased with the sewing that had already been done.

She dressed herself carefully in a practical gray wool dress with lace at the collar and cuffs. She regretted having to wear her old winter bonnet and at the last minute decided to go bareheaded except for a little lace cap with blue ribbons.

She shut Daisy in the bedroom and pulled on her gloves. Back home, she'd driven the team barehanded and bareheaded, but this was Bangor, a city, and she'd been informed by the hired girls that everyone made some effort to appear genteel.

The pony pulled neat and steady along the drive at the rear of the house. Brown had told her it was the entrance used by the hired help and delivery wagons. It wound through the pine woods a short distance and exited on State Street just above Broadway.

A few shiny vehicles pulled by glossy Morgans whirled by. Birds chattered and sang in every tree. The little pony tossed his head and nickered softly.

Elizabeth found Wentworth's without difficulty and completed her errands.

Just down the street, a group of idlers leaned against a hitching post.

"Hey, ain't that one of Fanny's girls?" Elizabeth heard one man say.

"Naw," another replied, very loudly, wanting to be heard, "ain't flashy enough."

"Well, I tell you 'tis. I seen Fanny herself in that pony cart more'n once."

Elizabeth ignored them and concentrated on guiding the pony around a large mud puddle.

"Hey, darlin', what's it like up there to Pink Chimneys? Is it true they's mirrors on the ceilings?" said the man the others called Bob. He stepped out in front of the pony and Elizabeth drew up on the reins, causing the animal to stop sharply.

Anger bubbled up to Elizabeth's lips, but she had learned, from experience, it was best to ignore this kind of behavior if she could. Obviously, they had mistaken her for someone else.

"Oh come on, little lady, no sense in lookin' so stuck up. Whole town knows about you fancy girls dancing on the table in red silk drawers."

The men guffawed and Elizabeth felt her heart sink. Her cheeks went hot as the implication of Bob's remark became clear to her.

She spoke to the pony.

Bob grabbed the bridle and for the first time Elizabeth became alarmed. The hired girls had told stories about how the woods-queer loggers came out of the logging camps when the ice melted and roared into Bangor astride huge pine logs and turned the town into a turmoil. The town was full of them, with their red flannel shirts and green wool pants. Most of them, the hired girls had whispered, stayed down in Paddy's Hollow or over in Joppa, but every spring a few of them straggled up to Pink Chimneys and hung around outside the gate hoping for a glimpse of Mrs. Hogan and her girls. At the time, Elizabeth had refused to believe what the hired girls were hinting at.

Now the conclusion was unavoidable. Mrs. Hogan and her girls were women of dubious reputation, and these men thought she was one of them.

Elizabeth picked up the whip.

"Take your hand off my pony, sir."

Bob roared with sudden laughter and his cronies joined in. The pony twitched the muscles in his flanks and side-stepped uneasily.

"Now simmer down, little lady. All I want's to hear about the most famous place in Bangor. Folks like me ain't grand enough to get in there. So we'd like to hear about it first hand. You be sweet to me, and I'll show you how nice a riverhog like me can be. Ain't that right, fellas?"

A chorus of snickers and "ayuhs" fell into the street.

"You got 'er gentled now, Bob!" someone called.

Elizabeth measured the distance back to Wentworth's. It was too far to run, even if she'd been able to elude Bob's grasp. The street was devoid of traffic or pedestrians. She laid the whip down, giving the appearance of compliance.

"There now," Bob said. "Now we can talk proper."

Bob sidled along the pony's side and let go of the harness. The moment he did, Elizabeth grabbed the whip and brought it down as hard as she could across the pony's back. The animal's whinny cut across the buffoonery of the men. He dug in his feet and clods of earth spattered in every direction. Elizabeth held firm to the reins, but there was no doubt who was in charge. The cart careened around a corner, narrowly missing a wagon loaded heavily with large wooden barrels. She heard shouts of "runaway, runaway," as several men jumped out of the pony's path. They rounded another corner and directly ahead, crossways of the street, was a chaise. The pony slowed and veered at the last possible moment. The wheel of the cart caught the wheel of the chaise and dragged it a few yards before coming to a stop.

Elizabeth covered her eyes with her hands, not daring to look.

"I might have known it was you," said the driver of the chaise.

Elizabeth lowered her hands and opened her eyes.

"Captain Giddings!" she gasped. He was the last person she wanted to witness her humiliation.

The captain stood next to the chaise surveying the broken wheel, his face wearing the same angry mask as when he'd accused her of stealing the silks.

"If you don't know how to drive, Miss Emerson, you'd be better off to leave it to those who do!"

"Which most certainly does not include you, Captain Giddings, since you were taking up the whole road!" Her retort came quick, without thought.

She glared at him, but looked away before he did. After all, he had, for all his blustering and blowing, treated her kindly.

"I'm sorry, sir. I lost my temper. I was scared to death. A man over by Wentworth's spooked the pony."

There was no sense in mentioning Bob and his cronies.

"You're not hurt?" Abner asked.

"No. Just scared."

But it wasn't being runaway with that had frightened her. It was Bob's assumption that she was public property. She believed that she deserved respect because she was a woman. That's how men always behaved towards women. With respect. It puzzled her that Bob was different.

Several men came to help pull the damaged chaise out of the road. Another man felt the pony's legs and smoothed the horse's sides with practiced hands. He pronounced both animals unhurt.

Elizabeth gave silent thanks that the cart was also undamaged.

"If you'll tell me how much damage has been done to your chaise, I'll arrange to pay you for it," Elizabeth said.

"No need for that, Miss Emerson. I'll see to it."

"Please, Captain Giddings, I insist."

"Tell you what. I'll forget about the broken wheel if you'll agree to go to the Lyceum with me tomorrow evening at seven o'clock. There's a lady lecturing on the early history of the Penobscot."

Elizabeth gave Abner a long look. The tense, angry expression was gone. In its place was a friendly smile. His chestnut hair glinted red in the sun. He was very handsome in a dark green jacket and buff trousers. Her evenings were her own. Mrs. Hogan had said so.

"I can meet you at the State Street gate at seven o'clock, Captain Giddings."

The smile on Abner's face faded.

"Then it's true. You are working at Pink Chimneys."

"Yes." She avoided his gaze, knowing perfectly well why he had asked.

"I'll see you at seven, Miss Emerson. Tomorrow evening, then?"

"Yes. Goodbye, Captain Giddings."

Later that evening, after she'd had supper and lit the lamps, Elizabeth settled into her rocking chair thinking about the day's events. Mrs. Hogan had been pleased with the goods she'd selected. As for the row with the rivermen, Elizabeth said the pony had felt his oats and banged into another vehicle, but did not mention how she had been harassed. Nor did she say anything about Abner Giddings. That was her private affair and had nothing to do with Mrs. Hogan.

She took Daisy onto her lap and stroked the cat's silky fur. The cat pricked up her ears and refused to settle. She darted toward the door, intent on getting out if she could. The cat had not taken kindly to life in the attic after years of vast barns, wide meadows, and total independence. More than once she'd run off, only to be retrieved by Brown or Mrs. McGuire.

"Come in," Elizabeth called when she heard footsteps on the landing outside the attic door.

Elizabeth had never seen the woman who entered. She was wearing an elaborate evening dress.

"You the seamstress?"

"Yes, I am," Elizabeth replied, trying not to stare. Even in the lamplight it was plain to see that the woman's face was artfully painted. Her dress was cut very low, revealing her breasts and shoulders. The gown fitted more tightly than was quite decent.

"I'm Minta. Mrs. Hogan said you'd still be up. I busted a couple hooks. Can you fix me up? Without me having to take everything off?"

Elizabeth reached for her sewing basket.

"I think so, Miss—Minta. Are you here for the party? I heard the music start."

"Party?" Minta's blue-shadowed eyes were puzzled.

"I thought there must be a gathering of some sort because I heard music."

"Oh, there's a gathering all right. Always is except Sundays. Mrs. Hogan keeps the Sabbath. We all go to church regular. Mrs. Hogan likes to keep up appearances. That's what makes it so odd, you know. Sitting in church with the men that was here sinning the night before. 'Course we do everything in such a pretty way, the gents don't really believe it's sinning. This is the only place in town where the mucky-mucks can have a good time without their wives finding out." Minta laughed loudly.

"Hold still, please," Elizabeth murmured.

"You met the other girls?"

"Girls?" Elizabeth asked cautiously, remembering the riverman's remarks.

"Lily and Flora. They've been here forever by the looks of them, but they have their following. Then there's Susie and Frona. And me, of course."

"No, I haven't met anyone but the housekeeper and the hired girls. What is it that you and the girls do?"

Minta let out another gale of laughter.

"You are a card, Miss Emerson. Imagine asking what we do here. We entertain the gentlemen, as if you didn't know."

"There, that ought to do it, Minta. Your dress would last longer if you let it out a bit and loosened your corset."

Minta eyed Elizabeth carefully.

"You don't know much about men, do you? Men like a smooth-fitting dress. Gits them interested in finding out what it's covering up. Know what I mean?"

"Yes, Minta, I believe I do."

"Well, honey, I gotta go. Mrs. Hogan don't like it if the gents have to wait too long. Makes 'em pugnacious. Say, could you fix the lace on my nightdress? Old man Parker got himself all tangled up in it last night. Maybe you could make it a little shorter. It always was too long. Sort of

help the old geezer out. He's one of my regulars. Nice old guy. I heard he just lost a daughter."

"Send it up, Minta, I'll see what I can do."

After the door had closed softly behind Minta, Elizabeth wandered to the window and looked down on the front drive. Lamplight spilled onto the terrace and strains of the Strauss waltz drifted up to her ears.

Well, she thought, that certainly explained the red silk drawers and different sized underclothes. She was mending for a houseful of fallen women. Jezebels.

13

"DR. WEBBER SAID you seldom stay ashore this long, Captain Giddings."

Elizabeth sat on a stiff-backed bench near the rear of the Lyceum. The lecture had not yet begun, although it was already past 7:30.

She and Abner had walked slowly to the gathering, her long legs easily keeping pace with his. They had talked of the weather, he had commented about the great stir the temperance movement was causing, she mentioned that she was happy with her position and thanked him again for the infant's dress.

The hall where they sat was full and a low buzz of conversation blurred the air. Elizabeth had dressed carefully for the evening. Her russet cotton dress had been newly pressed, her bonnet refurbished with matching ribbons she'd found in a cupboard in the sewing room. As a mark of how special the evening was to her, she had worn her locket outside her dress. She touched it, tracing the engraved 'F' with her finger.

"Mr. Stetson has offered me a berth, Miss Emerson, but I haven't decided whether or not I'll take it," Abner replied.

His spotless white cravat lay like the cap of a wave against his deep blue jacket. He shifted in his seat, trying to gain room for his long legs, and in doing so, his thigh pressed pleasantly against Elizabeth's.

"Mr. Stetson is your employer?"

"Joshua Stetson is more than my employer, Miss Emerson. He's the fuel that fires Bangor. If he blacklists a man, chances are he'll never ship out of here again."

"Have you been blacklisted?" It seemed to her that this was his unspoken meaning and she allowed her curiosity to override courtesy.

"I'm just between ships, that's all. It happens from time to time," he said.

She suspected, though he had not said so, that it had never happened to him before. She could see that he was troubled and ill at ease about it. She wanted to squeeze his hand and comfort him. Instead, she sat up a little straighter and turned her attention to Miss Clark who was detailing the early forays of French fishermen along the Maine coast, the subsequent establishment of a colony known as Pentagoet, near Castine, and the eventual rise of civilization on the banks of the Penobscot River.

After the lecture, people milled around the hall calling to friends. A great sea of dark-colored skirts ebbed and flowed, stirred the flotsam and jetsam of greetings and goodbyes, until the eddy revealed a dapper figure with a familiar face.

"Oh, look," Elizabeth cried with pleasure, "there's Dr. Webber."

"Old Webber seems to have made a great impression on you, Miss Emerson. I envy him."

Elizabeth's heart lurched and she looked deeply into his eyes; she saw amusement, caring, and comfort.

"No need for envy, Captain Giddings," she said carefully, trusting that his ears would hear what her heart was saying.

Sam's eyes had not lost their blue twinkle.

"Maude," he said after he'd shook Abner's hand and greeted Elizabeth, "this is Miss Emerson, the young lady I told you about."

To Elizabeth, Maude Webber appeared as drab as a female pheasant with her unfashionable gray dress and crumpled gloves, but it was her manner which struck Elizabeth most forcefully. She did not immediately release her grasp from Elizabeth's hand, but held it warmly, as if she could assess one's character with a touch.

"Indeed, Miss Emerson, Sam hasn't talked about much of anything else since he got home."

Maude Webber was, Elizabeth saw immediately, a woman you couldn't keep things from. She felt herself go suddenly shy, unwilling for Mrs. Webber to discover her feelings for Abner Giddings. She suspected it was already too late for that.

"Come over here and sit down, Miss Emerson. The men always like to discuss business without the ladies." She linked her arm through Elizabeth's and drew her to an empty bench nearby.

"I've been meaning to come see you, Sam," Abner said. "What do you make of Lovejoy Page taking the *Fairmont* out?" He could not bring himself to phrase the question to imply that he'd been replaced.

"Nothing to make of it, Abner. Stetson's a strange man. You know that same as everyone else. Likes to play God. And this time he's decided to play with you. Don't read more into this than there is."

Sam shoved his hands deep into his pockets, a gesture Abner found oddly comforting.

"I've tried to figure it out Sam, but I haven't got very far. I don't have a thing that's any use to Stetson." Abner glanced toward Maude and Elizabeth. She looked very fetching in russet.

"Now that, my boy," Sam said, "is where you're wrong. You've got plenty a man like Stetson can use. He's making quite an effort to surround himself with solid citizens, hometown boys with integrity, like yourself. He knows darn well that rubbing elbows with a few common folk can't hurt any when it comes election time. Putting you on the *Asia* makes him look good. You get a big promotion, make a sizeable chunk of money, and there you are, right in his pocket ready to do whatever he wants."

"Then he doesn't know me very well."

"Doesn't have to. It's been his experience that money, enough of it, can buy him anything, corrupt anyone. My advice to you, Abner, is sit tight. He'll tip his cards when he's ready."

"My husband tells me you are a seamstress of some skill," Maude said.

Elizabeth nodded. How much did Mrs. Webber know about her? Was she able to divine a person's deepest thoughts with a few searching looks and the touch of her hand? The next question did not surprise her.

"Mrs. Hogan is treating you kindly?"

"Yes, but she hasn't decided whether she'll take me on permanently. She said I was not mature enough."

"Perhaps what she meant, Miss Emerson, is that you are too inexperienced to live under her roof."

"Why would she think that?" Elizabeth countered knowing perfectly well Maude Webber was alluding to Minta and the others.

"One has only to look at you, my dear, to see that you've been decently brought up, taught that there are some situations which are best avoided."

It was no use. Maude Webber's wisdom was boundless.

"You mean Minta and Frona and the others."

"Yes, I do." Maude stuffed her crushed gloves into her equally bedraggled reticule.

"It doesn't matter. Mrs. Hogan likes my sewing. I hardly ever see the others. What they do has nothing to do with me."

"Then if Mrs. Hogan wants you, you expect to stay?"

Elizabeth felt her stubborn streak uncoil itself. She was doing honest work. She had a decent room and decent wages. It was far better than the spinning mills in New Hampshire.

"Yes, I expect to stay." Elizabeth glanced at Abner, and Maude followed the glance.

Maude rose. Elizabeth rose, too, in deference to the older woman, as she'd been taught. She straightened her shawl. Out of habit, she touched her locket, to make sure it was still there.

"A lovely locket, Miss Emerson."

She should have known Maude's sharp eyes would not miss the gesture.

"It was my mother's. Her initial is carved on it. An 'F', for Fanny."

Maude touched the locket and let it lay in her fingers. She gazed at it intently, turned it over in her hand.

"I take it your mother is dead." Her eyes probed, but it was a gently searching.

"She died when I was an infant. My aunt Mercy raised me. She died recently." Why was it impossible to keep anything from Maude Webber.

"I believe Sam said that your aunt's death was why you came to Bangor. Sam said they took you aboard at Fort Point."

"Yes. I grew up there, on the farm."

"How old are you, Miss Emerson?"

"Nearly twenty-one."

"Nearly twenty-one seems very young when one is past fifty, as I am. Come along, my dear. Sam has the fidgets and the Captain has been glancing this way far too long."

Maude lay propped against the pillows in the big bed. Sam leaned over to turn down the lamp. He laid a warm hand on her thigh. His familiar touch was calming.

"Spit it out, Maude. Something's got you wound up tighter than an ice-bound block and tackle. You've been quiet as a grave ever since we got home. I know it's got something to do with the Emerson woman. And don't tell me Abner Giddings is in love with her. Any half-wit can see that."

Maude rolled her eyes at Sam, fixing him with what she hoped was a scathing look, but apparently failing, because he snuggled closer and the gentle stroking of her thigh continued. She clasped her hands across her stomach. Tonight she'd welcome being called out. She was sure she wouldn't sleep a wink. She sighed deeply and faced Sam.

"Elizabeth Emerson is Fanny Hogan's daughter."

Now that she said it, it didn't seem to be quite the dilemma she'd thought it was. Sam stirred and rustled.

"Can't be. Doesn't look a thing like the madam of Pink Chimneys."

"She was wearing the locket, Sam. The same locket Fanny tried to give me after I'd delivered her child. Out of gratitude, I suppose. I wouldn't take it."

"How do you know it's the same locket, Maude? Twenty years is a long time."

"Women don't forget details like that. Besides Miss Emerson said she'd been raised by her Aunt Mercy, the same name as Fanny's sister, in the same town Fanny was from. And she was born in 1831."

"But her name is Emerson, not Hogan."

"Well, neither is Fanny's."

"The point being, my dear, that you don't know what Fanny's family name is anymore than I do."

"Doesn't matter, Sam. This Aunt Mercy could have changed it to protect her niece from ever discovering who her mother really was. One thing's certain, her name isn't really Emerson, or Fanny would have known right off. As I recall, Fanny always called the child Birdie. The aunt must have changed that, too. I'm not wrong about this, Sam. Elizabeth Emerson didn't lie. Her face is like an open book, no artiface or affectation. She's Fanny's daughter. I'd stake my life on it."

Sam sat up and fumbled for the lamp. The gloom gave way to a warm, golden glow.

"Maude, if you must involve yourself in this, and I know you must, think of Abner and how he'd feel to learn that the woman he doesn't even know he's in love with yet is the daughter of a fancy woman. Couldn't you just stick to the temperance crusade or the Orphan's Home, or just plain delivering babies?"

Maude slumped down further into the pillows, ignoring Sam's plea.

"Fanny will figure it out sooner or later, Sam. I'd rather she heard it from me than just have it fall in her lap. I owe her a lot. First the Orphan's Home, and now the Home for Indigent Women. All supported with her money."

"You never told me that," Sam said accusingly.

"And don't you tell anyone, either. Both places would close their doors for good if the upright ladies of town knew where the money really came from."

Sam reached for Maude and she nestled into his arms. It was good to have him home every night. She hadn't realized how much they'd missed all these years of being apart. Not that she regretted any of it. They'd both done what they wanted to do in life and loved and respected one another all the more for it. She sighed a little satisfied sigh.

"You never fail to amaze me, Maude," Sam murmured against her hair.

"Why do you say that, Sam?"

"You're the only person in town who doesn't regard Fanny Hogan as a fallen woman."

"She's not. She simply had the misfortune to believe it when a glib-tongued sailor said he'd marry her. Society did the rest, assigned the labels. She's done what she had to do with what she's had to work with. Just as we all do. It's like Papa always said, life turns in odd ways."

14

THE INVITATION WAS little more than a note, delivered by a water-front urchin, written in flowery script. It read: You are expected for supper and a musicale Tuesday next at Pink Chimneys at 8 P.M.

Abner turned it over in his hand and read it again. He lay in his room in Hannah's house on the big cannonball bed that had been specially built to accommodate all six feet of him. A fresh, late May breeze fluttered the white curtains at the open window, like a sail filling away.

He had been idle more than a month,, but the time had passed agreeably enough. In the company of Elizabeth Emerson, he had attended lectures, gone for evening walks and drives, listened to the Bangor Band give outdoor concerts, canoed on the river. Their acquaintance had blossomed into friendship. Try as he would, though, he could not get her to talk much about Pink Chimneys. He had tried to convince her that it wasn't proper for a young, unattached woman to work there, but she had silenced him with a hard look and a clamping of the jaw, saying that Mrs. Hogan had given her a chance when no one

else would have, that she was doing honest work, that it was her business, not his. He had retreated, admittedly with little grace, and accepted the fact that she wasn't going to change her mind. She was not easily led. Still he worried. What if Joshua Stetson got his hooks into her, dazzled her with silk dresses and gold chains? The thought disturbed him. He was very fond of her, had even told her so, and her eyes had gone all misty blue, the color in her face as pretty as a wild rose.

He had wandered around the waterfront, too, watching the destruction of demon rum as attacks on the illegal grogshops became more frequent. He had hung around in some of these smokey, thick-aired dives listening to the talk, the scuttlebutt that flitted like moths in the dim light. He didn't like what he heard. Stetson was smuggling rum like it was water, yet his ships were never searched, nor were the taverns that sold his kegs ever attacked. There was ugly talk about showing Stetson for what he really was, but no one volunteered to organize such a movement. The general consensus was that the temperance movement was the real culprit, because Stetson was using it as a lever to get his hands on the mayorship. This contradiction didn't seem to bother anyone. Joshua Stetson was known to tack his course even when there wasn't any need for it and to veer from the main channel when it was least expected.

Abner lay back against the pillows which Hannah had plumped for his comfort. She had sputtered and fussed when he'd told her about being replaced by Lovejoy Page.

"You mark my words, Abner, there's trouble brewing. If I were you, I'd ship out on a garbage scow before I'd hook up with Joshua Stetson again. Why the very idea! Lovejoy Page the master of the *Fairmont!*"

Abner accepted Hannah's concern as motherly flutterings. She loved him dearly, he knew, and still tried to protect him despite the fact he was nearing thirty years old.

He had thought seriously of going up to Boston and finding a vessel there, but that would be construed as running away, a smirch on his integrity as a man. Bangor was his home. Job had set a path for him to follow. He would stay.

There were other cargoes to ship besides lumber—bricks and pottery from Brewer, or ice. All his inquiries had been hemmed and hawed at, set aside, or refused. No one cared to risk the ire of Joshua Stetson. Business was risky, they might need a loan, and Stetson sat on the board of the bank. Abner realized he'd been blacklisted. It was the *Asia* or nothing.

Abner placed the note on the washstand by the bed and lit his pipe. Like a majority of Bangor's male population, he had never been to Pink Chimneys. One only gained entry by personal invitation. But he had heard of its opulence; the Chippendale mirrors, Hepplewhite furniture, crystal chandeliers, and velvet draperies; of singers and musicians who performed there; of elegant, beautiful women who mingled with the guests and were available for more private entertainment. Everyone knew that railroads, steamship lines, even the Penobscot Boom itself had been built, in theory at least, in the best whorehouse in Bangor.

Indeed, local people talked of little else, and not all the talk was negative. There were merchants who were more than glad to fill Fanny Hogan's orders for satin sheets, silver cutlery, and French wallpaper. Without the income generated from Pink Chimneys, a lot of people would have starved.

Abner chuckled to himself. Invitations to Pink Chimneys were sought after by anyone who had even the smallest claim to fame, wealth, or political influence. Once inside Pink Chimneys, you had reached the pinnacle of success as measured in Bangor, Maine, in 1852. And all he had was his mariner's skills, as common as alewives in Kenduskeag Stream in May.

He puffed thoughtfully, his thoughts drifting once more to Elizabeth Emerson. Someday, he supposed, when this whole mess was straightened out and he was back to coasting, he'd ask her to marry him. But first he had to do something about the bind Joshua Stetson had him in.

He rose, dipped his pen in ink, and wrote a brief acceptance to the invitation.

IF ANYONE HAD SAID, right after Aunt Mercy had died, that she'd be this happy by the first of June, Elizabeth would not have believed it.

Everything had fallen comfortably into place. She was now a permanent employee at Pink Chimneys. Mrs. Hogan paid her her first wages. She belonged somewhere. And though it wasn't precisely what she had envisioned when she'd arrived, it would do. She was happy because of Abner, with his slender bones and warm and bristly moods. Whenever she was with him, she thought of copper pots, bleating sheep, and the tide lapping at the river's edge. He felt like home. After they'd spent time together, she would savor the details of each moment, like a child sucking on a peppermint drop. She loved him, and she hugged the knowledge to herself, telling no one but Daisy, who merely blinked her yellow feline eyes and kept quiet.

Elizabeth shook out the nightdress and matching robe which lay in a heap of foaming lace on the work table. It was the one old man Parker kept getting tangled up in. She had left it until last, trusting that Minta would return for a fitting as she said she would.

Suppertime came and went. There was no sign of Minta.

Elizabeth lit the lamps. Minta had left instructions that the garment was to be finished as quickly as possible. She settled into the rocking chair and threaded her needle.

It was the most beautiful nightdress Elizabeth had ever seen. It was a delicate shade of blue, like bachelor buttons, a color that was, Elizabeth knew, most becoming to her eyes. She held it up to see the effect it made. Her imagination glided like a hawk over a meadow. Would Abner think her beautiful if he could see her dressed in it? She imagined herself on her wedding night, wearing this nightdress, seeing the fire of passion kindled in Abner's eyes. She stroked the fabric with her fingers. Minta had said make it shorter, but Minta had not stood long enough for her to mark the hem.

The moon had risen and hung round and golden just beyond the window. The fabric caught the light and shimmered like the evening

surface of the river. Elizabeth swirled the nightdress around her feet, holding it with one arm against her waist. She could kill two birds with one stone. If she tried it on she could estimate how much to cut off the bottom . . . and see how she'd look in the moonlight wearing a lace nightdress as soft as a lupine petal.

The fabric slithered silkily over her head, fell in cool folds against her arms. It was cut very low and revealed the soft white curve of her breasts. She slid into the matching robe and tied the ribbons at her waist. It, too, was constructed to reveal instead of conceal.

Elizabeth preened in front of the mirror, turning this way and that, allowing the yards of material to cascade around her bare feet. She pulled the pins from her hair and let it fall to its full length down her back. The gold locket gleamed around her throat.

Music drifted through the window and Elizabeth executed a few waltz steps, slowly and gracefully, pretending she was in Abner's arms. She closed her eyes and turned and swayed until the skirt flew in a great circle away from her legs.

Daisy crouched under a chair, her eyes wide and nervous at such strange goings-on. The skirt swirled closer and the cat darted toward the door and scratched at it. The door opened a crack, one well-practiced paw pried the opening to cat width, and Daisy trotted, not down the back stairs, but down the passage that led to the hallway to the bedrooms of Fanny's girls.

Elizabeth stopped abruptly in mid-flight just as Daisy's tail disappeared through the open door.

"Oh, Daisy," she called, "not again!" and sped after the cat. Mrs. McGuire would not be pleased.

For a brief instant, Elizabeth thought of the way she was dressed, that Mrs. Hogan had said specifically she was not to visit the second floor. But Mrs. McGuire had said if she found Daisy roaming the house one more time, it was out in the barn for Daisy.

At this hour, Elizabeth knew, everyone would be on the first floor having supper. They only came upstairs later. Much later. No one would ever know. No one would see her wearing Minta's finery. She

tiptoed along the dimly lit hallway, her steps padded by a Persian runner.

Daisy crouched near the landing that led down to the first floor and lashed her tail perversely as if she'd been into a bed of wild catnip. Elizabeth bent to pick her up, but Daisy scampered halfway down the main staircase.

The music was louder now, more rollicking, and a female voice sang a snappy tune. Elizabeth could not make out the words. Laughter punctuated the music and Elizabeth guessed the song must be a humorous one. The hallway below was empty. The door to Fanny's office was closed. Brown was no where in sight.

Elizabeth's heart pounded in her throat, her armpits suddenly damp, but she descended the stairs one careful step at a time. It would be easy to sidle quickly down to Daisy, grab her, and run back to the attic. But Daisy sidled, too, all the way to the bottom step, and sat purring in the middle of the hallway perfectly content with herself.

Poised on the bottom step, Elizabeth saw it was useless. Her courage faded and she turned to go back to the attic.

Without warning, the door to Mrs. Hogan's office snapped open. In the doorway stood Mrs. Hogan, a small man with pale hair, and Abner Giddings.

The man with the pale hair recovered first.

"Well, Fanny," he purred, striding to Elizabeth and taking her hand, "you certainly have outdone yourself with this one. Quite a beauty." Elizabeth tried to draw back, but to her horror, he cupped his hand under her chin, and kissed her lightly on the lips.

"Welcome, dear lady, to Pink Chimneys."

His breath smelled of spirits.

Elizabeth stiffened, panic rising. Before she could react, a hand seized the man and Abner Giddings swung him around.

"Get your filthy hands off her, Stetson. You swine!" he spat out. He used a few other words Elizabeth had always associated with sailors, stevedores, and teamsters.

Sanity returned and Elizabeth found words forming in her mouth.

"Abner," she cried, "you've made a mistake!" She grabbed Abner's arm, but he shook her loose and smashed his fist against Joshua Stetson's mouth. Doors opened, the hall was flooded with light, voices, people, confusion. Elizabeth grabbed the banister as her knees buckled.

"You'll never be mayor in this town, Stetson. I'll see to that," she heard Abner say. He turned and the look he threw at Elizabeth was filled with bitterness and betrayal. It was as if he had struck her, too.

She watched with a sinking sensation as Abner tore open the front door, allowing it to crash against the wall. He strode, with rage in every step, out into the night.

For a moment, Elizabeth was too stunned to move. She clung to the banister, anchored to the floor as if she was suspended in some strange half-world where nothing registered except the fact that the man she loved thought she was a fancy woman and had made a fool of himself, yet again.

Her feet regained movement. She flew out the door after him. She had to make him understand that it was all a mistake, that it was Daisy's fault.

The darkness hindered her view. She ran a little ways toward the main gate, saw nothing but the moon laughing in her face. Then she heard hoofbeats and knew he'd taken his horse out the rear entrance. She reversed her direction, her bare heels pounding as furiously as the horse's hoofs, keeping time with the drumming of her heart.

She was glad she was a farm woman, used to heavy work, to walking long distances, used to running across hilly pastures in search of tardy cows. She would catch up with him, explain how he'd been mistaken, quit her job, beg his forgiveness.

She reached the gate. It stood wide, yawning into the night. She stopped running, stumbled, and fell. Seams ripped, hair matted around her face, sweat trickled everywhere. She wept silently, violently.

The voice, when she finally heard it, was only dimly remembered. She opened her mouth to scream but a hand that smelled of pine pitch clamped over her teeth.

"Now, little lady, your're gonta show old Bob what a Pink Chimneys fancy woman is really like."

16

"THEY FOUND HER an hour ago, Maude. In the woods behind the house. She hasn't said a word, barely blinked her eyes. She just stares at nothing," Fanny whispered. She kept her voice low. The atmosphere in the room was like a funeral. She averted her eyes from Elizabeth Emerson's blank face.

"Shock," Maude said tersely as she bent to work.

Brown had raised Fanny shortly after dawn. It was now her nerve-wracking task to try to keep the incident quiet.

Fanny dabbed at Elizabeth's face with a damp cloth where an ugly bruise discolored her temple. There were scrapes on her arms and legs. The lace gown was in shreds. Fanny glanced again at the smear of dark blood on Elizabeth's thighs, found it too unsettling, and left the area to Maude to tend. She let the ugly word form in her mind. Rape. Visions of the sign that said ROOMS leaped into her mind. She pictured tight-laced ladies in black dresses whispering behind their proper, gloved hands. If it became common knowledge that Elizabeth had been raped, Elizabeth would be blamed; accused of inciting her attacker to passion with immodest conduct; painted as a woman of depraved instincts; in short be branded a fallen woman. Ask any of the girls at Pink Chimneys. They knew.

Fanny sat straight-backed in a chair by the bed. From the moment she'd laid eyes on Elizabeth Emerson, she'd known she meant trouble. Women like Elizabeth didn't belong at a place like Pink Chimneys. She was decent. She should have been a farmer's wife raising sturdy children, tending animals, and going to church every Sunday with a man who appreciated her.

Fanny reached for the basin of water, intending to empty it. She discovered her fingers were shaking. She sloshed water on the floor.

"Get hold of yourself, Fanny," Maude said brusquely, "or leave the room."

"It's all my fault," Fanny said, dullness in her voice. "She's ruined. If this gets told around town, and it will, the Temperance Union will use it as one more excuse to descend on me like a plague of black flies. They'd like nothing better than to close me down. And what will Joshua say?"

The thought of Joshua pained her more than she cared to admit. Once, she had seen in him glimpses of the man he might have been, the man she'd fallen in love with, still cared for. But those glimpses were rare now. Joshua's money and power had corrupted him. She did not miss the irony of it. Joshua, who had sought to corrupt, had become his own victim. He still came to visit her. For comfort? For friendship? She didn't believe so. Because he needed her? Ah, yes, Joshua needed her. She was a stand in for Ellen, whom Joshua loved and hated, adored and abused, petted and punished. She'd known that for years, and she'd stayed. Out of hope, she supposed, hope that he'd change, hope that he'd forget Ellen, hope that someday he'd want *her*, Fanny, for herself. But she knew, now, that would never happen. She'd been thinking seriously of going to California. She'd heard that the gold miners out there didn't see women for months on end and were inclined to propose matrimony to the first one they saw, no questions asked. She could go out there, get married, just disappear. But she'd done nothing about it. Maybe she wasn't ready to leave yet. Maybe it took the rape of an innocent young woman to make her take a good look at her own life.

"Here," Maude said, "lift her shoulders and help me get this bed-gown over her head."

Deftly, Maude arranged Elizabeth neatly in bed. Fanny was always impressed by Maude's devotion to those in her care, the tender way she handled them and mended their ills. Everyone's mother, Fanny thought. Tucking people in bed like Ma did when I was a girl. The thought was a stray one. It prompted Fanny to reach for the brush on the washstand. Ma had always brushed the tangles out of her hair at night. It was relaxing, Fanny remembered. Perhaps the motion, along with the sleeping powders Maude had administered, would soothe Elizabeth, help to ease the stricken look on her face.

"Prop her up a little more, Maude," Fanny murmured. "I'll brush the pine needles out of her hair."

Fanny worked carefully, separating the long strands of dark hair with her fingers as she worked, picking out bits of moss and dried grass. The brush caught in a dense tangle of hair.

"Hand me your scissors, Maude, there's something shiny caught in her hair. I think it's a gold chain."

Fanny snipped the lock of hair and bent toward the window to examine it. Perhaps it would offer some clue to the identity of the attacker and pave the way for the administration of private justice since public justice was out of the question.

The only sound in the room was the soft swish of Maude's skirts, the barely audible whisper of Elizabeth's breathing.

Fanny smothered a little cry with her hand.

"It's my locket!" She gasped, "The one Joshua gave me, the one I gave to Birdie twenty years ago!"

Fanny closed her eyes and opened them again quickly. The locket felt heavy in her hand, familiar yet remote, like her memories of her mother. She stared at Elizabeth Emerson, and the girl Fanny had been in 1831 merged with the woman she was in 1852. It wasn't possible. Her mind pulled down a shade.

"How do you suppose Elizabeth Emerson got Birdie's locket?" She saw the answer written on Maude's face.

Fanny was glad for the chair she sat in. She clutched the locket to her breast, swallowed the tears rising in her throat. She touched Elizabeth's hand. It was cool and still. She stroked the smooth skin, remembering when that hand was as tiny and soft as a rose petal.

"You knew, Maude," Fanny whispered. It was an accusation.

"I was going to tell you this very week."

Fanny had never seen Maude look so distressed. "How did you know?"

"The locket, same as you. She wore it to the Lyceum one evening. When she was with Abner Giddings."

"Abner Giddings! You mean he, she . . ."

"Very attached to one another, I'd say. Sam thinks so, too."

"Oh, my God," Fanny breathed. Now it all made sense, was even worse than she imagined. Abner Giddings thought Elizabeth was one of the girls. Elizabeth had run after him to explain. And some filthy wharf rat had made her a fit resident for Pink Chimneys. The sins of the mothers, she thought ruefully. She choked back a hysterical laugh. The hateful irony of it struck her like a hammer blow. Rage, bitter and black, roared up into her throat. The laugh dissolved into a strangled cry that unleashed twenty years' worth of tears. She let them flow and, with a savage swipe of her hand, accepted the handkerchief Maude offered.

So be it. But she wasn't going to let her child suffer any more humiliation or degradation. She'd abandoned Birdie once, but not again. She had money, knew people who owed her favors. She'd see that Birdie—no Elizabeth, she must remember that—Elizabeth, had the respectability she'd never had.

"She'll mend, Fanny," Maude said in her soothing way. "She'll mend."

"You're damn right she will. I'll make sure of that."

It was late when Maude went home. Fanny had cried herself dry. Elizabeth lay limp and sleeping. How she would react to her attack, Maude dared not predict.

Sam met her at the door; his dear face was full of concern. He took her cloak and untied her bonnet strings. Sarah John produced a pot of tea and thick slices of apple pie.

"Hannah Bailey was here today, fit to be tied," Sam said. He jabbed at the pie with his fork as if it needed dissecting.

Maude braced herself. She knew she didn't want to hear what Sam had to say. He had that look on his face. She stirred her tea noisily, chopped viciously at her pie.

"What did Hannah want?" She asked reluctantly. She was tired. She was angry at herself. She blamed herself. If only she'd told Fanny sooner.

"Abner didn't come home last night. They found his horse wandering around on Harlow Street. There was blood on the saddle."

"Hell and damnation, Sam!" Maude exploded. The teacup rattled on its saucer. "If you're telling me Abner Giddings has been accused of rape . . ."

Sam's hand was steadying on her arm.

"No, Maude. Listen. I went down to the waterfront after I talked to Hannah and asked around a little. Looks like Abner's been shanghaied. At least one person saw him carried, unconscious, aboard the *Venerable*. In irons."

Sam's face was grave. Maude reached for his hand.

"Joshua Stetson's ship. We have to do something, Sam. Tell the sheriff, the harbor master . . ."

"I've done that, Maude. But it's a tricky situation trying not to drag Elizabeth's name into it. Anyway, won't do a bit of good. The *Venerable* sailed for Barbados, so they said. Could be headed anywhere— Liverpool, South America. All we can do is wait."

"And pray."

17

ELIZABETH SEWED WITH furious concentration. She did not care what Mrs. Webber, or Mrs. Hogan said, she would not leave the attic. Someone would see her and they'd know she was different. She was safe in the attic, nothing bad had ever happened to her there. She didn't have to talk much, or smell the pine needles. She could even pull the black curtains she'd made across the windows so the moon wouldn't intrude.

She had not said so, but there was a pain centered in the pit of her stomach, a pain that got worse whenever anyone mentioned going outside. It was very odd, this pain, because it was her heart that should have hurt, not her stomach.

They'd brought Daisy back, hoping to cheer her up, she supposed, but she'd made them take the cursed cat away, she didn't care where. If it hadn't been for Daisy . . . She blocked that avenue of thought quickly. It led to the gate, and the gate opened on memories she'd chained to the cellar of her mind. She sewed on with greater concentration.

She'd thought a lot about Abner, but it was with grief, like he was dead, had died along with the pieces of her soul that lay buried out by the gate. That's why she wore the gray dress, to mourn Abner's death, the death of love. She and Abner had died together, out there. They had tried to talk to her about Abner, but she wouldn't let them. She couldn't bear to hear them confirm what she already knew.

She wore the dress because it protected her. She understood what had happened to her. It had put her on the same path as Minta and Susie—Mrs. Hogan, even. They never wore gray. Gray was an inconspicuous color. People wearing gray were left alone. Cool and distant.

One night she'd had a nightmare, woke screaming. She knew what was happening. The seeds of the nightmare were growing inside her.

The attic door opened, but Elizabeth did not look up. It was easier not to look into anyone's eyes. Cool and distant. But she knew it was Maude. Maude always came softly, wearing her wisdom like a magic robe. But she knew how to fight Maude, how to turn aside the probing knife of her eyes. Cool and distant.

Elizabeth stabbed her needle firmly into the towel she was mending. If only they'd leave her alone, she'd be all right. They were spying on her, trying to make her expose her pain. But they'd never penetrate her. Every day for three months it was the same. Mrs. Hogan in the morning, Maude in the afternoon, Mrs. McGuire in the evening.

"Good afternoon, Elizabeth," Maude said.

She was always pleasant, as if everyone ought to be pleasant, as if the world out there beyond the attic walls were pleasant.

"Hello." Monosyllables were part of her armor. They worked well at keeping the distance.

"Mrs. Hogan says you have been unwell the last few mornings."

"Yes." She didn't mind admitting that. Mrs. Hogan had seen her vomit.

"Can you describe how you feel?"

"A pain."

"Where?"

"Stomach."

Maude was smart. She knew about other people's armor and how to use it to her advantage.

"Vomiting?"

"Yes."

"When?"

"Morning."

"Every morning?"

"Yes."

"For how long?"

"Week, two, longer."

She bit the thread off with her teeth, rethreaded the needle, and picked up another towel. Maude would give up soon, would retreat as pleasantly as she'd come.

"Are you nauseated during the day?"

"Sometimes." If Maude did not give up soon, she'd go to her bedroom, lock the door, jump out the window. No. Cool and distant. That was the only way. They'd only hover more if she tried to run away from them.

She tightened the grip on her needle, poised it to pierce the towel, but Maude pulled it gently away. Surprised, Elizabeth glanced sharply at Maude's all-knowing face. She looked away again quickly.

Maude's movements fluttered on the periphery of her senses. Paper rattled, fabric was shaken out, a soft flannel garment settled onto the work table.

"Here, Elizabeth, I'd like you to mend this first." Still that pleasant voice.

Elizabeth reached for the garment, let her eyes center, a cool distant stare, at the thing Maude had laid before her.

The pain in her stomach ground to a new intensity. The cool distant stance vanished. The iron gate across her mind swung open on creaking, rusty hinges. The gray armor she'd girded herself with fell away.

She screamed a curse at Maude, and with a fury she'd never known, swept the baby dress Abner Giddings had given her to the floor.

18

EVENTUALLY, THE SCREAMS gave way to sobs, the sobs died to a small shuddering cushioned by Mrs. Webber's comforting arms. The cool distance around her melted away, and Elizabeth was left with the stark reality of her situation. She was pregnant by a man who had assaulted her, she was employed by a woman of dubious reputation, and Abner Giddings had left her. Now that Mrs. Webber had yanked her back from the brink of madness, all that was left was a black depression that left her irritable and listless.

Within the week she was removed from the attic and brought, in Mrs. Hogan's closed carriage, to Mrs. Webber's house. They installed her in the parlor with its old-fashioned furniture and large hearth. It was not so different from the one at the farm at Fort Point.

Elizabeth lay on the bed they'd set up for her, feigning sleep, and listened to the soft talk that drifted like woodsmoke into the parlor from other parts of the house. The most frequent topic of discussion was the recent election which Joshua Stetson had lost by a narrow margin. Mrs. Webber talked much of the infants she delivered to Irish immigrant families whose arrival had created a great degree of want and poverty. In spite of herself, Elizabeth pricked up her ears at this kind of talk. She knew little of childbirth, less of caring for an infant. Part of her did not want to know, part of her did. So she listened and pretended she hadn't. The weather was discussed, too, and the sensation caused by Reverend Comfort Drummond, the temperance leader, when he'd remarked publicly that Joshua had lost the election as a punishment from God. Stetson, in retaliation, revealed that the Rev. Drummond had, on more than one occasion, spent the night at Pink Chimneys.

There were frequent visitors. Mrs. Hogan called once each week, bringing exotic foods to tempt Elizabeth's appetite and bits of mundane mending. Elizabeth never quite knew when she first noticed the difference in Mrs. Hogan's attitude toward her. The elegant remoteness Elizabeth had been accustomed to was replaced with something akin to reverence. Mrs. Hogan tucked afghans around Elizabeth's feet,

— 257 —

inquired after her needs, her likes and dislikes, took every opportunity that offered itself to pat her hand, or adjust a bedcover. Elizabeth thought it odd, at first, but found the gestures comforting. She began to look forward to Mrs. Hogan's visits.

Dr. Webber, in his quiet, kindly way, spread the greatest balm on Elizabeth's tender soul. He brought bright ribbons for her hair, read poetry to her even when she turned her face to the wall in a gesture of despair. Often, he carried on a one-sided conversation with her, apparently not caring that she didn't respond. He brought her little things no one else thought of—a seashell he'd brought from the Carolinas, a red maple leaf, some dried weeds, a pretty rock he'd found. These treasures lined the window sill by her bed.

The household, commanded by Sarah John Thatcher's efficient ways, revolved around Elizabeth. She felt safe within it. A wounded thing forced back into a womb, just as the child within her had been forced into her womb. She recognized the parallel, knew that she must emerge from it, or die.

She was a mushroom growing in the dark corner of the Webber's parlor, rounded and misshapen, cultivated by Sarah John Thatcher's kindly care. Elizabeth's increasing pregnancy was a reality she could not hide from. The revulsion she had felt in the early months, for herself and the unborn infant, had softened as the infant took on an identity of its own. It rolled and thrashed beneath her belly button, kicking and poking, as if it were furious at having been forced into existence. Elizabeth found the idea oddly comforting, acceptable even.

Elizabeth stared at the great lump in her middle. Like a chrysalis, she thought, stroking the mound of her belly. She'd once brought one home to ripen in Aunt Mercy's kitchen. She remembered how a yellow and black butterfly had emerged from it, a poor dumb creature with no knowledge of its beginnings. She had felt a kinship with the creature whose beginnings were as obscure as her own.

The child within her fluttered and Elizabeth's abdomen rippled with the movement. Soon, the child would emerge, wet and wingless, into the world. Mrs. Webber had tactfully suggested that the Orphan's

Home might be the place for the child. At the time, she had tacitly agreed, glad to have the decision removed from her hands. But as she lay in the parlor, thinking of the butterfly, of her own tenancy in the womb of the parlor, she changed her mind.

Mrs. Webber interrupted her thoughts by coming into the room, her skirts whispering against the floor. She carried a large book under her arm. She sat down near Elizabeth. Uncharacteristically, she hesitated before she spoke.

"You've been idle long enough, Elizabeth. There's no reason for you to continue dragging yourself from bed to chair and back again. You've lain abed since September, doing nothing, saying nothing, allowing your misery to rule your life. If you are to put this tragedy behind you, you must find something useful to do. As you know, Dr. Webber and I are childless, but we have come to look on you as a daughter. We both greatly regret not having someone to pass on our skills to. We want to pass them on to you. Midwifing is not as much demanded as it used to be, but there's still a living to be made from it. That, and the simple doctoring Dr. Webber can teach you, will assure that you'll never starve. As for your reputation, which has suffered a blow, Mrs. Hogan has seen to it that the incident has not been connected with your name. She has smoothed it over. And once your infant is placed in the Orphan's Home, nothing can hinder you, except yourself."

Elizabeth sat up clumsily. Mrs. Webber could not have chosen a better time for her proposal. The confine of the parlor was now too small to contain the new Elizabeth Emerson who was beginning to emerge. She looked at Mrs. Webber with a new respect, admiration, and gratitude.

"You're right, Mrs. Webber. The time has come. And I've decided to keep my infant." Now that the words were spoken, Elizabeth felt easier, was glad to see approval on Mrs. Webber's face.

"There are miseries in this world far greater than yours, Elizabeth. It's time you learned that. Midwifing with me will teach you that."

"I'll try, Mrs. Webber." She owed the Webbers more than she could ever repay. How much easier it would have been for them, for Mrs. Hogan, if they'd simply sent her to the town farm.

"Life turns in odd ways, my dear. My father used to say that. It's a useful thing to remember."

"You spoke of protecting me from the gossips, Mrs. Webber. How can I possibly visit the sick in my present condition without causing talk?"

"You'll go out with me only at night, and only to the homes of poor women who won't know you or care to. It will be all right." Maude handed Elizabeth the book she'd brought. "My father's anatomy book. Study it. Learn. It will be all right. You'll see."

It was as Mrs. Webber said. The wives of Irish immigrants or the abandoned doxies of mariners cared nothing about Elizabeth Emerson's troubles. All that mattered to them was that Maude delivered their infants with the help of her apprentice, Lizzie, and charged them only what they could afford.

It was an odd time in Elizabeth's life. She felt as if she were a child exploring the possibilities of grown-up life. In a way, she believed, that was the case. The Webbers had become the parents she'd always dreamed of; she'd become the child they'd never had. The arrangement suited them both. But she knew once the birth of her child was accomplished, things would change. She would change. Life in the chrysalis had seen to that.

February arrived with a blizzard that tore about the eaves of the house and piled drifts ten feet high. It was, Elizabeth thought, a fitting night for her child to be born.

The birth was accomplished with a minimum of fuss, made easier by the knowledge Elizabeth had gained from assisting Mrs. Webber. There was only one troubled moment. Mrs. Webber held the infant up for Elizabeth to see. For a moment she could not bring herself to open her eyes, an image of the gate formed behind her eyelids. But she reminded herself that she was a butterfly now, not the pale larval creature of a few months ago. She opened her eyes quickly. The child was a girl. Her hair was red-brown. She looked exactly like Aunt Mercy. She named her Mercy Maude.

THE TIME HAD come. May had burst into a soft plume of green and pink. The windows in the parlor were thrown wide as Sarah John Thatcher scrubbed away all traces of the winter months, all evidence that mushrooms and butterflies had once lived there.

Sarah John paused in her flurry of dusting and bent over Mercy Maude's cradle, the affectionate look on her face making Elizabeth want to change her mind and stay.

"Can't make head nor tails of you, Elizabeth Emerson, wanting to go off by yourself when you know you'll always have a home right here with us," Sarah John said.

"Life turns in odd ways, Sarah John."

The housekeeper resumed her dusting.

"Guess you're right about that one. Who'd ever have thought I'd have ended up keeping house for the woman that delivered me? Always did think the sun rose and set on Maude."

The rattle of a carriage wheels slowed Sarah John's pace.

"Looks like Mrs. Hogan. Now that's an oddment. It's been awhile since we've laid eyes on her. Guess I'd better go put the kettle on."

Several months ago, shortly after Mercy Maude's birth, Mrs. Hogan's visits stopped abruptly with no explanation. She had resumed her cool, elegant attitude toward Elizabeth, and her clumsy attempts at maternalism had ceased. Elizabeth assumed she had tired of the role of benefactress. When she remarked of the change to Mrs. Webber, her reply was equally enigmatic.

"There are some things I cannot discuss with you, Elizabeth," Mrs. Webber had said.

Today, Mrs. Hogan wore an uncharacteristic melancholic look about her eyes, as if she'd suffered some secret sorrow. She was as elegantly dressed as before, nary a hair out of place. But something about her was different, something Elizabeth couldn't identify. It gave her a prickly feeling, like stepping barefoot on a thistle.

"Mrs. Webber is out, Mrs. Hogan," Elizabeth said pleasantly, hiding behind civility.

"It's you I've come to see." Mrs. Hogan placed herself rigidly in a carved side chair, appearing ill at ease. "From the day I first set eyes on you," she went on, "I knew you'd cause an endless amount of trouble."

Mrs. Hogan did not look directly at Elizabeth, glanced instead at Mercy Maude.

Elizabeth knotted her fingers together in her lap. A little surge of resentment nipped at the pit of her stomach.

"I'm very sorry if I've caused you any trouble Mrs. Hogan. I had no idea when I came to Bangor . . ."

She was cut off in mid-sentence.

"No, no, Elizabeth. I'm not talking about then. I meant the day you were born."

The nibble of resentment vanished and another emotion swept into its place. Elizabeth could not name it, but it made her mouth go dry, her palms go damp.

"The day I was born? I don't understand."

"No reason why you should." Mrs. Hogan's beautiful eyes met Elizabeth's.

Turk's cap lilies, Elizabeth thought, frantically blocking any other thoughts.

"Please go on," she said in spite of herself.

"I've spent the last two months fretting about this, trying to decide if I should tell you or not. Maybe you'll think I'm cruel, but I have to tell you because everything that's ever happened to you is my fault. I think if you know, then you'll be able to make a better life for yourself than I could ever have given you."

"Please, Mrs. Hogan . . ."

"No, don't stop me, I've made my mind up."

Mrs. Hogan raised an imperious hand and took a deep breath.

"My name isn't Fanny Hogan. It's Frances Mary Abbott."

Silence settled into the room; a bit of dandelion fluff drifted through the open window and settled on Elizabeth's lap. The curtains made a sudden flapping noise in the breeze.

"Abbott," Elizabeth breathed, stirring the bit of dandelion fluff.

The story flowed from Mrs. Hogan's lips in a rapid stream of words, and with each sentence, Elizabeth felt her brain grow numb with the enormity of it. She neither moved or spoke; the unnamed emotion curled in the pit of her stomach chained her to the chair. It was a fairy tale, a figment of Fanny Hogan's imagination, but little by little, the details of her early life were revealed and the gaps Elizabeth had always felt were closed.

Fanny Hogan's face was a mask. It had cost her a stiff emotional toll to reveal her past life and how it was connected to Elizabeth.

"Now, you know," Mrs. Hogan said so softly Elizabeth could barely hear her. "I don't expect love or loyalty from you, nor friendship or even for you to like me, considering how I've lived my life. But I made the best of a bad situation. I decided to tell you because I'm leaving town next month and I'll never see you again, never have the chance . . ." She faltered and tears welled up in her eyes. She reached for a dainty handkerchief with tatted edging.

The motion jarred Elizabeth into action. She rose and bent over Mercy Maude's cradle, adjusting blankets that didn't need it. She shut one window with a sharp bang, flicked an imaginary speck of dust off a small cherry candlestand. She was in perfect command of her external surroundings. Inside, chaos had full rein. She didn't know, as Aunt Mercy would have put it, if she were afoot or on horseback.

Gradually, the chaos sorted itself out. She felt no hate for Fanny Hogan. After all, Aunt Mercy's life had been made happier for having a child to love and bring up. Nor was she angry because she'd been abandoned. She'd never felt abandoned. Aunt Mercy had fabricated a wonderful romantic tale of the death of her parents. Elizabeth had never questioned it. What baffled her now was the suddenness of being required to think of Fanny Hogan as her mother instead of a benefactress. It was too vast a chasm to leap all at once.

"I believe this will take some getting used to."

Mrs. Hogan stuffed her wet handkerchief into her black leather reticule.

"All I want is to see that you're provided for. I've bought you a dress shop over on Union Street. Respectable neighborhood. Maude said you'd decided you'd rather be a seamstress than a midwife. The shop has rooms above where you and the baby can live. Here's the deed." She handed Elizabeth several folded documents. "I've deposited money in the Bangor Bank in your name. Sam and Maude have agreed to act as your agents if you need them."

Fanny Hogan rose stiffly, retreating into the old formal elegance Elizabeth was accustomed to.

"I don't blame you for being ashamed of me, Birdie. I never meant you any harm," Mrs. Hogan whispered as she turned to leave.

At the sound of her childhood nickname, the unnamed emotion in Elizabeth's heart uncurled itself and fled. Life turned in odd ways, indeed.

"I've heard your story, Mrs. Hogan. Perhaps you would like to hear mine."

Fanny sat down abruptly, as if her knees had suddenly given way.

Elizabeth told of growing up happy and poor, of there never being enough to make ends meet, of taking in sewing.

"But I sent money," Mrs. Hogan interjected. "Lots of it."

"I remember letters from Bangor arriving every so often," she said. "I was never allowed to read them. Aunt Mercy would be very agitated. She'd talk a lot about the wages of sin and how I must always do honest work for honest pay. Then she'd pay a visit to the preacher and be herself again. She must have given everything you sent to him."

They talked on until Sarah John came to light the lamps.

20

ELIZABETH TURNED THE SIGN in the door of her shop so it said CLOSED. She leaned against it, feeling slightly smug at the thought she'd earned nearly twenty dollars this week alone. Her success, she believed, was due, in part, to the new mansions being built on Bangor's West Side and the shop's proximity to the Bangor House. The Bangor

House drew all manner of important people, and it was quite common for their wives and female connections to need a new bonnet or some essential repair made on a ballgown.

Local women made up the bulk of her business and if any one of them had the least suspicion that Elizabeth Emerson was Fanny Hogan's love child, they never let on. They did, however, hand on whatever news they happened to have heard.

Pink Chimneys, Elizabeth learned, had been the target of picketing by the Reverend Comfort Drummond and the Temperance Union in retaliation for the slur Joshua Stetson had cast on that gentleman's character. As a result, gentlemen with reputations to protect had drastically reduced their visits to Pink Chimneys. Pink Chimneys, more often than not, was dark and empty. They whispered that Joshua Stetson spent a good deal of time drunk, but that rumor was quickly dispelled when he appeared, sober as a judge, at several public gatherings. Others whispered that Stetson was gravely ill. Some said it was God punishing Stetson for his sinful ways. This story was the one most of Elizabeth's informants preferred to believe. This was reinforced when news arrived that the *Asia*, the star of Stetson's fleet, had gone down in the middle of the Atlantic with all hands lost. Then, to add fuel to the fire, word came that the *Fairmont* had run aground with a hold full of rum bound for the Smuggling Hole on the Penobscot River. No amount of money could prevent customs officials from swarming Stetson's office asking pointed and embarrassing questions.

Earlier that day, Mrs. Webber had stopped by for a visit. She said Mrs. Hogan was planning to leave for California in a few weeks. Mrs. Hogan had not yet told Stetson of her plans. Mrs. Webber was worried that there might be consequences.

A muffled wail pulled Elizabeth away from her mental musings. She bent over the wooden packing crate that served as Mercy Maude's daytime cradle. The child had been fretful all day. Teething, Mrs. Webber had said.

Elizabeth nursed the child back to sleep. She resumed sewing on the last of the hooks on a black mourning dress. Usually, she did not stay

so late in the shop, but the demand for mourning dresses had risen after a recent outbreak of fever had struck down a number of people.

The door opened and closed. Annoyed that someone had disregarded her CLOSED sign, Elizabeth rose to ask whoever it was to come back tomorrow.

A tall, slim man dressed in the dark navy wool of a mariner stood near the door. His face was in a shadow.

Elizabeth's heart lurched, the memory of rape always just below the surface of her conscious thoughts.

"I'm closed for the day, sir," she managed to say in calm way. "If you'd care to come back tomorrow . . ."

The man stepped into the light and Elizabeth's knees turned to jelly. The floor swayed like the deck of a ship on a rough sea. She backed slowly away from the man, found the counter with her hands, gripped the edge. She hated the way her face flushed with shame as the man's eyes traveled from her face to Mercy Maude's improvised bed, and back again.

"Abner," she whispered. There was only despair in the sound, none of the joy of a year ago, none of the hope.

The one thing she had never been able to bring herself to discuss with the Webbers was Abner. Whenever they'd tactfully broached the subject, she'd cut them off, or became so agitated they did not press her. She believed he was dead. She didn't want to know any different.

But now, he was here, all long bones and navy blue, his hair tumbled across his brow, his skin deeply tanned, a new scar angling from eyebrow to ear.

She uttered his name again. There was nothing else to say. His face registered a series of emotions, none of which Elizabeth dared to identify, and settled into an unreadable mask.

"I've heard," Abner said quietly. He removed his hand from his jacket pocket and pushed his hair away from his eyes. "I got in this morning. I went to Sam Webber's house. He told me where to find you."

There was no reading his face. Was he angry? Had he come to castigate her? What did he want? She wanted to die from shame.

"You've found me Abner, now go away. I'm not fit company for you anymore. It's over and done. All I want to do is forget."

But it wasn't over and done, and she had never forgotten.

Her heart raced with relief to see him alive.

She'd been so wrong to think that her love for him had died. But it was too late, too late.

She saw the hardness in his face, a ruthlessness that had not been there before. She did not understand it, did not understand why he had come here, except to torment her. She felt as if she'd been torn up by the roots.

"Please leave, Abner," she pleaded, "go back to where ever it was you ran to that night." He did not move, his look did not soften. "Why are you here?" She was almost shouting now. Mercy Maude stirred and whimpered. "To gloat? To see what a fallen woman looks like up close?"

Her words stung him, she saw, and she took a perverse pleasure in seeing him upset. She strode angrily to the door and flung it open.

"Get out! Leave me alone!"

But even as she said the words, she regretted them.

Abner closed the door gently and leaned wearily against it, his eyes closed. He opened them and said, "Then you didn't have anything to do with it. Sam insisted you didn't, but I wouldn't believe him, didn't want. I thought, I was so sure . . ."

"What Abner, what?" Elizabeth urged.

"That you put Stetson up to the idea to shanghai me. I thought you were in it together."

The enormity of his words took the wind out of her sails, immobilized her thoughts.

"Shanghaied," she croaked in disbelief.

"Yes. Forced to work like a slave all the way to South America with a crew of cutthroats fit only to run a garbage scow like the *Venerable*. All the way around the Horn. God only knows how we ever made it. The weather was that fierce, but we made it to California. I jumped ship there, lucky for me, or I'd have died of scurvy for sure. As soon as I felt well enough, I signed on with a schooner bound for Chile. From there I traveled back around the Horn on a bark carrying guano, bird drop-

pings used for fertilizer, a stinking, filthy cargo. The only thing that kept me going was thinking how I'd have my revenge on you and Stetson when I finally made it home."

The bitterness in his voice struck Elizabeth like a lash. She made no attempt to hide the tears that trickled down her cheeks.

For a long moment there was no sound in the shop except for the insistent ticking of the clock and the soft stirrings of Mercy Maude.

She felt Abner brush away the tears. And without thinking, Elizabeth flung herself into his arms, as wanton and shameless as any of the women at Pink Chimneys. The brass buttons on his jacket bruised her ribs, his unshaven face scratched her cheeks and neck. He smelled of foreign places, of the wind, and the open sea. Here, at last, was the safe harbor she had longed for all those long, unhappy months. She clung to him like a barnacle, but he pushed her gently away. The air between them cooled.

"I'll be back for you, Elizabeth," he said, brushing her face with the tips of his calloused fingers. "I have an old account to settle."

The door clicked shut behind him. She made no attempt to stop him. She watched until he was out of sight.

<div align="center">21</div>

THE CROWD OUTSIDE the Oak Street gate at Pink Chimneys milled as restlessly as June bugs near a lit lamp. The sound of scuffling feet, a sharp cough, the clearing of several throats marred the serenity of the evening. Daylight had just begun to turn to dusk, but Abner spotted a familiar face here and there among the crowd—businessmen, a few between-ships mariners, idlers with nothing to lose. The taste of excitement was in the air.

The Reverend Comfort Drummond stood on an overturned soapbox. His face was pocked by the dim flare of torches held aloft by some of his most loyal followers. In one hand he held a spirits bottle, in the other an open Bible. He waved the bottle over his head, and liquid sloshed out of its top.

"Look at this, my friends, and remember my words! This is the devil's brew! Concocted by heathens and idolators on wicked islands in the Caribbean. This, this poison corrupted my soul, debased my integrity, made me unfit to minister the Word of God! The fires of hell and damnation are waiting inside this bottle, waiting for you, waiting inside this bottle, inside the walls of the den of iniquity called Pink Chimneys!"

Cries of "Amen" rose from the rear of the crowd and there were a few enthusiastic cheers.

Reverend Drummond smashed the bottle to the ground and held his Bible aloft.

"This is the Way!" he shouted. "This is the Light! Repent as I have repented! Save yourself from the tortures of hell as I have been saved! Together, we'll destroy the evil in our midst!"

The crowd stirred restlessly and edged closer to Reverend Drummond.

Abner skirted the extreme edge of the crowd, making his way toward State Street and the rear entrance to Pink Chimneys. No one took any notice of him or appeared to recognize him.

He had slept little in the past few days. The closer he'd got to Bangor, the deeper his need to settle accounts with Joshua Stetson became. Even now, it whirred within him, a deadly engine powered by the fuel of revenge.

In the months of believing Elizabeth had deceived him, he'd blotted her from his mind, had forgotten her pride, how her eyes were the color of asters, how his heart quickened and sang at the very sight of her. Tonight, it had all come back to him. They still had a chance for happiness together, no matter what she said, despite what had happened to her, and to him.

He wasn't yet sure how he'd have his revenge. He believed in an eye for an eye. Perhaps he'd arrange to have Stetson shanghaied and forced to work in one of the camps in the far north. That idea was the most appealing. The mental image of Joshua Stetson obliged to fend for himself in a louse-infested, rough and tumble woods camp amused him to

no end. Still, he'd sharpened the knife he always carried in his pocket. Maybe he'd cut off Stetson's ears. There was also a piece of stout twine in his pocket. He wouldn't mind seeing Stetson hanging by his thumbs in Haymarket Square.

His thoughts were very calm, too calm, Abner believed, recognizing a capacity for violence in himself that went far beyond the amusing idea of giving Stetson a taste of his own medicine.

Stetson had attacked the very core of Abner's manhood, had deprived him of liberty, stripped him of dignity and self-worth, had changed all his guideposts and taken away his direction in life. It had very nearly been a mortal blow. There would be no such thing as forgiveness.

Abner fingered the knife in his pocket.

Pink Chimneys was dark except for a light in the window where Abner remembered Fanny's office was. The stableyard was deserted. No horses stamped in their stalls. Not even a cricket chirped. The only sound was the distant murmur of the crowd gathering force by the front gate. The only sign of life was the bright orange glow of lamplight spilling onto the terrace.

Abner made his way around to the front of the house where things were more familiar to him. It seemed a century since he'd stormed out that door stung by the humiliation Elizabeth had heaped on him, bent on destroying Stetson's chances to become mayor. But Stetson had lost the election on his own, and Abner had never had the chance to open his mouth.

Life turned in odd ways. He'd heard Sam say that. Now its turnings had brought him back to the steps of Pink Chimneys just as it had brought Elizabeth and Maude Webber here. And Fanny herself.

He peered upward into the darkness, his eyes barely able to discern the roofline. A few stars twinkled cold and distant. There was no moon. He shivered involuntarily. What was it about this place that drew some and repelled others? He was not prone to philosophical thoughts. It disturbed him.

The rumbled voices of the crowd drifted over the hedge, louder and more menacing than before. Someone yelled, "Burn it! Destroy the evil among us!"

Abner hurried toward the heavy front door. The crowd was getting nasty, there was not time to lose.

He had no clear idea of how he knew he'd find Joshua Stetson inside Pink Chimneys. Something in his guts told him so. He trusted his guts; every mariner worth his rum ration did, except when it came to women. It never worked with women.

Abner turned the knob with no intention of knocking. He wasn't surprised when the door swung open on silent hinges. His gut was always right about these things. He moved stealthily into the entry. The place was quiet as a church on Monday morning. The newel post was ornamented with a naked marble cupid whose outstretched arms held a lit oil lamp. Shadows flickered up the stairwell as a current of air disturbed the flame. The house seemed to hold its breath.

Abner's eyes adjusted to the light as he adjusted the door, leaving it ajar, wide enough to catch any change in the tempo of Reverend Drummond's harangue. He stood very still a moment, his ears bent with the effort of listening, sounding the atmosphere of Pink Chimneys as if it were a dangerous river channel.

An almost inaudible patter of sound led him toward the door to Fanny Hogan's office. With caution in his fingers, he opened it a crack and peered inside.

Joshua Stetson lounged casually in an overstuffed leather chair.

Every cell in Abner's muscles urged him to pounce, but with a will of iron, he held himself back and listened.

Fanny stood on the far side of the room, near her desk. Her hair was in disarray, her face tear-stained, her elegant bearing only barely sustained.

"I'm going, Joshua," Fanny said, the bitterness in her voice like a lash.

"Then you'll go in a coffin, Fanny, my dear. I decide what you do. I've decided that from the moment I fished you out of the gutter in Portland twenty-odd years ago." He laughed nastily and Abner clenched his fists. "Thought you could sneak out, didn't you, Fanny," Joshua went on, "thought you could beat me at my own game, speculating in land, collecting fees from the girls. Money hasn't made you

anything better than you are, Fanny. You were born on a dung heap, Fanny. You'll die there. It's what you deserve."

"What I deserve, Joshua? Or what you deserve?" Fanny said. The expression on her face was deadly calm.

Joshua laughed again, without mirth. The sound grated against Abner's nerves, but he stayed where he was.

"Oh come now, Fanny, we've had our differences before, but you've always grown to see it my way. California is no place for you. You have responsibilities. To me. To Pink Chimneys. I lost the mayorship. That doesn't mean I'll lose the governorship. You'd make a splendid first lady of Maine. You can be a big help to me, Fanny."

"No, Joshua."

"I understand that delicious Emerson girl has a place over on Union Street. I wonder if she's happy. Perhaps she needs the protection of an older and wiser man?"

Rage surged in Abner's chest, but he did not betray his presence. His gut held him steady. Something told him that Fanny could handle the situation, but she was visibly rattled and he was worried.

The color drained from Fanny's face. Her eyes were amber pools reflecting—fright? Indignation? Despair? Abner couldn't tell for certain. He only knew the time wasn't yet right for him to burst into the room.

"Elizabeth Emerson has nothing to do with you, Joshua," Fanny said. Her back was steeled, her words barbed with ice.

Joshua lounged a little more deeply into the chair. He extended his legs so they made a barrier between the chair and the desk. Fanny had no choice but to step over them or stand where she was. She did not move.

Abner held his breath, chafing with indecision, hating himself for not acting, for hesitating so long.

"Thought I wouldn't find out about her, didn't you? You and that frumpy Maude Webber. If you want your bastard child and her misbegotten brat to stay in good health, you'd do well to see things my way, Fanny."

Joshua was almost purring.

Defeat was written on every part of Fanny's body. Her face was haggard, her shoulders sagged, dark circles of perspiration stained her pale mauve gown. She eased away from the barrier of Joshua's legs and sat down heavily behind her desk.

Abner waited. He was mesmerized with what he'd seen and heard. It was if he were caught up in the action of some diabolical play, a play in which he hadn't known he had a part. His concentration was so intense, he was only dimly aware that the commotion out at the gate was growing steadily louder.

"All right, Joshua," Fanny said. Her voice broke as she went on, "I'll stay. I'll do anything you want. The deeds to my properties are in my desk. I'll give them to you."

Fanny rummaged through the desk drawer. When she withdrew her hand, it did not contain documents. She held a small derringer. With a sudden rustle of silk, she stood up and pointed the gun at Joshua.

For one long breathless moment, Joshua did not move. When he did, it was with snake-like precision, with extreme caution. He eased to his feet.

"Come now, Fanny," he purred. "Our little game has gone far enough."

"Our game, Joshua," Fanny said, her voice expressionless, "is over."

Before the words were out of Fanny's mouth, Joshua's hand flew toward Fanny's wrist. She threw herself sideways to avoid him, pulling him over onto the floor. Bric-a-brac crashed and clattered.

From where he was stationed, Abner could not see exactly what happened next. Fanny and Joshua struggled. There was a stifled scream, a harsh groan, then a quick report as the gun went off. Then silence.

"You can stay . . ." Abner heard Joshua say. Then nothing more.

Fanny dropped the gun and buried her face in her hands.

The sound of Fanny's weeping broke the spell, and Abner was released from his part in a play he hadn't chosen. His first coherent thought was of the crowd. They were roaring now, moving closer. He realized with a start that they meant to burn Pink Chimneys. He did not

stop to think whether or not it was right or wrong to rescue Fanny. He only knew he wouldn't allow Elizabeth to be hurt again.

Abner burst into the room just as Fanny pointed a second gun, a mate to the first, at her heart. When she saw Abner she dropped it in surprise. He kicked it under the desk.

"Let me do it, let me die!" Fanny moaned.

Abner grabbed her shoulders and shook her until hairpins flew. If he didn't keep her quiet, they didn't have a chance. He knelt next to Joshua, felt for a pulse, and found none, confirming what he knew.

"We can't stay here," Abner said. "Comfort Drummond has a gang headed this way and they won't stop until Pink Chimneys is in ashes."

Fanny's eyes were focused on a plane just beyond Abner's shoulder. Her face was whiter than a sheet. He shook her again, gently, this time.

"It's Abner Giddings, Mrs. Hogan," he said.

"I've killed him. Oh dear God, I've killed him," Fanny whispered, collapsing against Abner.

"Mrs. Hogan. Fanny. Listen to me. How do we get out of here? Where's the back door? No one has to know what happened. It was an accident, Fanny."

"But I wanted to kill him, I wanted him dead," she said in a strangled croak.

"If you hadn't, Fanny, I would have," Abner said bitterly.

Fanny gave him an odd look and pulled away. There was steel in that lady, Abner thought, more grit and determination than anyone ever gave her credit for. He felt something akin to admiration for Bangor's most notorious lady.

With a visible effort, Fanny took command of herself. She did not look at Joshua as she led the way out into the hallway. She stopped and let her gaze travel to the mahogany staircase, the silk wallpaper, the exquisite carpets.

"No one will ever know the price I paid for all this," she said to herself.

"Hurry, Fanny," Abner urged. "The mob is halfway up the drive. If they discover us with Joshua, they might lynch us right on the spot." He grasped her arm, but she shook him off.

"Damn Comfort Drummond and his hypocrites. I'll see them in hell before they destroy what I paid for with my self-respect."

She reached for the lamp held by the marble cupid. With one swift, defiant motion, she hurled it against the wall. Little licks of flame sped along the trail of spreading oil, traveled across the parquet floor, and swooped up the velvet drapery.

Abner grabbed her hand and pulled her roughly along until they were out of the house and running along the rear drive. When they emerged onto State Street, they turned back to look. Already, a heavy shroud of smoke billowed upward and angry tongues of flame lapped against the night sky.

The clamor of the mob rose to a crescendo of surprise and excitement, then turned into cries of, "Fire!"

Abner reached into his pocket and drew out his knitted watch cap.

"Put it on," he said tersely. He slung his jacket around Fanny's shoulders. "Lean on my arm and pretend we've had a few. Quite a few."

Fanny was shaking, not from cold, Abner knew, but from the shock of having killed Joshua Stetson.

"I can't," she said through trembling lips.

"Do it for Elizabeth, Fanny. How would it look if my future mother-in-law were hanged for a crime she'd prevented me from committing."

It was not the time for humor. Neither of them laughed. But Abner could see that his words struck a chord. Fanny linked her arm in his. They affected a staggering, drunken walk and struck up a chorus of "Drink To Me Only With Thine Eyes."

Their raucous voices drifted crazily into the night. All around them people ran toward Pink Chimneys to watch it burn.

22

ELIZABETH HEARD THEM before she saw them. And when they finally arrived at the shop, she stared at them in disbelief.

Abner's shirt was untucked and rumpled, caked with grime. He reeked of cheap spirits and by the looks of his pants, he'd crawled some of the distance on his hands and knees.

She peered carefully at the woman leaning on his arm, was shocked to recognize Fanny Hogan. Fanny's silk dress was tucked up in front, revealing a wide expanse of lace petticoats and quite a bit of trim ankle. Her unbound hair fell in snarled hanks down her back. She, too, was grimy, and reeked of rum.

Elizabeth bristled, too shocked to speak.

"Hold on," Abner said as he deposited Fanny in the nearest chair.

Elizabeth held her tongue, waiting, knowing that something had happened, that Abner in his perverse way had tried to make it right. She knew, too, without his saying so, that the account with Joshua was settled.

The story he told her was brief. Fanny and Joshua had argued. Joshua had been violent and fallen, knocking himself senseless. Fanny had panicked when she heard the mob at her door and had overset a lamp and set the place afire. Abner had found her running for help. She'd begged him to save Joshua. But it was too late. And she was afraid the mob would harm her if they found her, that they'd accuse her of harming Joshua.

"So you pretended to be drunkards out having a good time."

Abner nodded.

Elizabeth did not press him for details. It was enough that he had come back to her.

Elizabeth helped Fanny to bed. She poured water for Abner to wash in. When he had dried his hands, he held out his arms and Elizabeth moved into them eagerly. She laid her head against the soft ease of his chest. He still reeked of the rum, but it didn't matter. She'd have wanted him near if he'd smelled of guano.

She felt no need to talk. Whatever talking they must do would come later. For now, touching him was enough.

They stood a long time by the window watching long fingers of flame stab the midnight sky, the ruddy glow blotting out the stars. Elizabeth watched it with an odd sense that a part of her life was going up in smoke along with Pink Chimneys.

As they watched, a wind came up and blew sparks toward the river,

igniting the rickety wooden buildings along the waterfront. Soon, the entire waterfront was ablaze and constables began going door to door asking for volunteers for the bucket brigades.

"I have to go, Elizabeth," Abner said against her hair. The thought of leaving his warm embrace was distasteful, filled her with tension. She rested against him a moment longer. Then she let him go.

"You'll be back," she said, needing to extract a promise from him.

"I'll be back," he answered firmly, kissing her roughly on the lips. She did not cling to him, though she wanted to.

After he was gone, Elizabeth stayed by the window. It was a hallowed place now, the place where they had spoken to one another without words, where they had looked for love in one another, and found it.

The fire spread rapidly, working its way downriver to Joppa. It hesitated at Kendusdeag Stream, leaped across, and swallowed up more buildings.

Another constable rapped on the shop door.

"We're taking anyone we can get now, Miss. Men, women, and children. About all we can do is keep the surrounding roofs wet down. So far, that's doing the trick."

There was no danger to Union Street or the shop. Mercy Maude and Fanny would be safe. Waiting for Abner would be easier if she were busy.

Elizabeth knelt by the bed and roused Fanny.

"Mrs. Hogan. Fanny," Elizabeth said. The name felt strange on her tongue. "Fanny," she said again, making the word more familiar by repeating it. "I'm needed to fight the fire. Take care of Mercy Maude for me."

Fanny opened bleary eyes and Elizabeth was relieved to find the effects of the rum had worn off.

"Be careful, Birdie," Fanny said, "you're all I have left."

The heavy, acrid smell of smoke bit Elizabeth's nose when she stepped out into the street. The roar of a fire out of control filled her ears. It was a short walk to Water Street and within minutes someone thrust a bucket into her hand and she took her place in line.

She lost all track of time. The buckets passed from hand to hand in an endless procession of sloshing water. The fire snapped and sizzled as buildings collapsed with great belches of flame and smoke. Her back ached and her hands grew blistered. There were few injuries. The fire had given people plenty of warning. Now, men and women worked side by side, their collective energy galvanized to save what they could of Bangor's waterfront.

By mid-morning, Elizabeth decided she'd done enough. Her un-nursed breasts ached and she was anxious to get back to Mercy Maude for relief.

She found that Fanny had bathed the baby and put fresh clothes on her. Elizabeth settled into the rocking chair to nurse the child.

"As soon as I can hire a horse, I'll be leaving," Fanny said without preamble. All traces of the rum-sodden harlot had vanished. Her hair was pinned into a severe knot. The gown she'd borrowed from Elizabeth was demure. Gone, too, was her aloof elegance. Elizabeth barely recognized the woman who sat opposite her. There was nothing to indicate that Fanny had ever been connected with so infamous a place as Pink Chimneys.

"Will you go to California?" Elizabeth asked. The idea of Fanny leaving did not trouble her. At best, whatever association she and Fanny might be able to achieve would always be clouded by the events that had shaped them into the women they were. They were blood kin, mother and daughter, but they were strangers.

"No," Fanny said, "Fort Point. I bought a farm there a few months ago."

"Starting over again?" Elizabeth asked. It was a rhetorical question. She had learned from Maude that life doesn't allow for new beginnings; it only allowed for growth, for new leaves to sprout from old roots.

"No, Birdie," Fanny said wistfully, "to find Frances Mary Abbott."

EPILOGUE

THE GUESTS IN Hannah Bailey's parlor were few in number. Sarah John Thatcher bounced Mercy Maude on her knee. The baby giggled and drooled.

Sam and Maude Webber had agreed to sign the wedding certificate as witnesses. Maude, for once, had a bonnet that matched her dress and the lace jabot at her throat wasn't rumpled. Sam was dapper as ever in his navy blue mariner's coat.

Hannah bustled back and forth from the kitchen to the parlor, determined to supervise every aspect of the wedding breakfast, but equally determined not to miss anything going on in the parlor. Her cap ruffles quivered with her activity and she kept repeating, "Dear me, I'm all a-flutter!"

Outside, the thud of hammers and rasp of saws created another kind of din. The ashes of the Great Fire were barely cool, and already new buildings were going up along the waterfront. In all, a whole mile along the river, from Oak Street to Joppa, lay level and blackened. Joshua Stetson's charred remains were found in the cellar hole where Pink Chimneys had stood. Stories made the rounds speculating about the circumstances of Joshua's death, but Elizabeth turned a deaf ear. Whatever had happened that night at Pink Chimneys was over and done and best forgotten.

The only person missing from the gathering in Hannah's parlor was Fanny Hogan, now Frances Mary Abbott. Talk about what had become of her had been rife. But only Elizabeth and Abner, and the Webbers, knew she was living quietly on a farm in Fort Point. Fanny had sent them a letter of congratulations in the form of a business proposal. She had bought the controlling interest in a small lumber schooner. She wanted Abner to be the ship's master. The excitement of that communication still clung to Elizabeth as she stood beside Abner and repeated the vows that made them husband and wife.

Maude was the first to kiss Elizabeth and wish her happiness.

"Sam and I have a little gift for you, my dear—nothing to compare

with the one from Fanny, I'm afraid. Wait," she said as she disappeared into Hannah's kitchen.

She returned with a basket. A cat's round yellow eyes peered over the rim. It jumped out and made straight for Elizabeth.

"Daisy!" Elizabeth cried, pricks of tears stinging her eyes.

"She's been the star boarder at the Orphan's Home," Sam said. "Maude figured it was as good a place for an orphaned cat as an orphaned child."

Daisy wove in and out of Elizabeth's skirts as if she hadn't been absent for months. After she'd been petted and praised, she jumped back in the basket and made little chirring calls. A chorus of tiny meows answered.

"Daisy has a family," Elizabeth exclaimed. She let her eyes meet Abner's and he touched her cheek with one long, calloused finger. He reached for Mercy Maude and took the child from Sarah John. He cradled the baby in the crook of his arm. With the other he circled Elizabeth's waist.

"So do I," he said proudly, "so do I."

QUESTIONS AND ANSWERS (2007)

This year, 2007, marks the twentieth anniversary of the first publication of Pink Chimneys. Are you surprised that the book is still in demand after all these years?

Yes, I am very surprised and pleased that Pink Chimneys is still inde-mand after 20 years. When it was published in 1987, I figured it would enjoy a year or two of popularity and fade gracefully away.

Was there a specific event that sparked your interest in Fan Jones and - her place in nineteenth century Bangor?

Two things sparked my interest in Fan Jones—my general interest in the history of women and their place in the history of Maine, especial-ly women who were off the radar, the ones who didn't leave written tracks, and the ones, like Fan Jones who existed only in whispers. The second spark was the story a friend told me about Fan Jones and her house of ill-fame which had pink chimneys—my friend got the color wrong—it was blue chimneys. But something about the phrase 'pink chimneys' intrigued me and I remember thinking, 'I can do something with that'—which was unusual because I had never written a word of fiction. I was a kitchen table poet at that phase of my writing life, but I had written some nonfiction.

Do you think nineteenth century Bangor was more colorful than today and what is your favorite period of Maine history?

I like to think that 19th century Bangor was more colorful than it is today. The world came to Bangor's door then, by ship, by train, by wagon and carriage, bringing goods and people of all nationalities. Then, there weren't three bridges bypassing the city like there is now.

In the 19th century, local roads led to downtown Bangor. I think life was more of an active verb then than it is now. My favorite period in M a i n e history runs from the early 1800s to the turn of the 20th century.

If you were writing Pink Chimneys today are there things you would change?

I would expand each section by adding more information about each of the main characters, but I don't think I would change much else.

I know people ask you if you working on a sequel to Pink Chimneys, have you ever considered writing one?

I am writing a sequel to Pink Chimneys. It's called Abbott's Reach and I have written 200 pages so far. Only another 200 to go. In the story, Elizabeth's daughter Mercy Maude, who is called M, has been raised since she was 8 by her grandmother Fanny with the help of Sam and Maude Webber. Now she has grown up and marries Madras Mitchell, the sea captain son of a Searsport family. She and Madras embark on a honeymoon voyage that takes them around Cape Horn to Hawaii and finally to California—with lots of adventures along the way.

What kinds of books do you like to read?

Obviously, I like to read historical fiction, but I read fairly broadly, including the Bangor Daily News, The New Yorker, Martha Stewart Living and various fashion magazines. I have kept a log of all the books I have read since 1986 and some of the authors on the list are Amy Tan, Alice McDermott, Van Reid, Mary Ellen Chase, Calvin Trillin, Isabelle Allende, Cathie Pelletier, Margaret Drabble, Marguerite Duras, Kathy Emerson, Baron Wormser, Walter Mcdougall, Elizabeth Gaskill, William Faulkner and Jane Austen.

You now write the By Hand column in the Bangor Daily News *and also copy edit* The Weekly *section. Do you find yourself preferring journalism to fiction writing?*

I prefer writing fiction to writing journalism because I love adjectives and descriptive writing. I love inventing characters and thinking up trouble for them to get into. Writing fiction has no deadline and affords time to agonize over the placement of a comma or to spend an hour mulling over the precise word to convey the color of Maude's dress or the expression on Fanny's face. I do, however, like the immediacy of journalism and the challenge of gathering information in the morning and having the story written by afternoon.

Do you have any advice for today's aspiring writers of historical fiction?

Advice for aspiring historical fiction writers: Read everything you can find about the historical period and place that interests you—politics, dress, culture, diaries, letters, hair styles, transportation, government, architecture, medicine, whatever. Read books and newspapers from the period. Visit museums where you can see items from the era. Go to antique shops where you can handle and examine items. Talk to experts. Imagine what it would be like to live in that time frame. Listen to the voices in your mind—they might be voices from the past telling you a story.